sw

TITIAN

The Last Days

MARK HUDSON

WALKER & COMPANY

NEW YORK

Published by Walker Publishing Company, Inc., New York

All papers used by Walker & Company are natural, recyclable products made from wood grown in well-managed forests. The manufacturing processes conform to the environmental regulations of the country of origin.

LIBRARY OF CONGRESS CATALOGING-IN-PUBLICATION DATA HAS BEEN APPLIED FOR.

ISBN: 978-0-8027-1076-5

Visit Walker & Company's Web site at www.walkerbooks.com

First U.S. edition 2010

10 9 8 7 6 5 4 3 2 1

Typeset by Hewer Text UK Ltd, Edinburgh
Printed in the United States of America by Quebecor World Fairfield

For Rachel

Contents

'The act of putting brush to canvas is an act of lyrical intuition, and in that act, in that instant, the personality and indeed the spirituality of the artist is revealed.'

Francis Bacon

Prologue

Towards the end of his life Titian didn't finish his paintings. The ninety-year-old artist kept them in his studio, a draughty hangar of a place on the north side of Venice, continually reworking them in rotation, but never quite completing them – as though wanting to endlessly postpone the final moment of closure.

'He would leave a painting for months without looking at it,' wrote his assistant, Palma Giovane, 'until he returned to it, and stared critically at it, as if it were a mortal enemy. If he found something that displeased him, he went to work on it like a surgeon. And in the last stages he used his fingers more than his brush.'

No one was quite sure how old Titian was. He'd confused the issue so much – exaggerating his age to gain the sympathy and respect of his clients, just as he'd endlessly pleaded poverty despite his great wealth. But he must have been in his late eighties, at the very least – twice the average life expectancy of a man in sixteenth-century Italy. He had long since outlived his peers and rivals. Known from relatively early in his career as the Divine, ennobled by the Emperor Charles V, Titian had received as much in the way of wealth and material recognition as any artist before or since. He was probably the most famous artist in the world.

Now in his final years, with his eyesight failing, he worked only for himself. And where once the paint marks were as carefully sealed

into the surfaces of his paintings as if they'd been boxes, now there was nothing but paint – brush strokes flaring into each other like smoke, bringing every inch of the surface into agitated life; except where the canvas was left bare.

The mood of these paintings is remorselessly dark and bleak, the subject matter sometimes cruel. But occasional gleams of fugitive, even desperate spirituality shine through. And from the point of view of painting, these works were revolutionary. It would be centuries before paint was used with that degree of rawness and immediacy again.

Or that is what we surmise from the limited evidence available to us. The outbreak of the plague that finally killed Titian plunged Venice into chaos. His house and studio were looted, and many paintings stolen. Only a handful of Titian's final paintings remain in existence, dispersed through galleries around the world. And there are no dates or documentation attached to any of them. We don't know precisely when they were painted, why and for whom. One of them was discovered only relatively recently, hanging in a remote monastery in the Czech Republic.

But the only one to have remained in Venice is the last one, the final *Pietà* in the Accademia, where we see the once proud artist on his knees, bald and half-naked, peering at the body of the dead Christ – crawling towards God and his own death. It's a painting I feel I've been waiting all my life to see.

The doorway to Titian's house was set in a wall of worn pinkish brick, the door itself of dark wood, with square panels – old in style but relatively new. And set into it was a small panel that must once have formed part of an entryphone, with an area of brass mesh barely an inch and a half in diameter through which I could see into an untidy garden. There were a number of small, pseudo-classical sculptures of cupids and angels, of the sort you could probably buy at any garden centre, dotted about on unkempt grass. Rags fluttered on the clothes line, and from the corner of my eye I could make out a sheet of crumpled plastic lifting in the wind.

A succession of battered arches, designed for training vines and hung with cheap-looking 'Venetian' lamps, stood over the path

TITIAN

to the house, which had two main storeys, with arched dormer windows poking from the roof above. The rolling screen over one of the windows stood half-open. Everything else was firmly shuttered.

Feeling nervous of being seen peering into a stranger's garden, I turned. But the narrow street behind me was deserted. It was late afternoon in early spring, still cold, the last of the wan sun hitting the upper part of the house. Titian's studio was said to have been on the first floor, a large room with north-facing windows – as every artist's studio should have – looking out in the direction of the Lagoon, just as these did. Yet the literature spoke of a large mansion. Could this be it? Was this a large building in Renaissance terms? A certain down-at-heel air aside, it didn't even look particularly old.

A few yards away the street ended abruptly, and a shadowy space in front of a wall a little further on indicated the presence of a canal.

I found my mind going back to the moment when the paintings were taken from the house in the year of the plague. Had the thieves carried their booty away on foot into the warren of alleys behind the house? Or had they departed by boat? Did they drag the paintings over the wall beside which I was now standing? Or did they simply smash down the gate and the door of the house? Did they come in the dead of night or in the blazing heat of afternoon?

Venice was then the richest city in Europe, and one of the most stable and well-organised societies in the world. But at the time of Titian's death in August 1576, the city was in the grip of the worst plague epidemic in its history. Tens of thousands were already dead, their bodies burnt at the Lazaretto Vecchio or dumped in mass graves on the Lido. In the August heat, the stench of burning bodies drifting over the Lagoon, mingling with the reek of human effluent flowing unchecked through the canals, would have been unbearable.

A sixth of the city's population had fled in the early stages of the epidemic – including many of the wealthiest citizens – and their palaces and mansions stood shuttered and empty. Now all routes in and out of the city had been sealed off. Most business had been curtailed. Venice hung in limbo, cut off from the rest of the world, its streets and canals almost completely deserted.

The houses of the dead were sealed with planks nailed over the door in the form of a cross, to serve as a warning and to deter thieves

– though they were, of course, pitifully insecure. Among them stood the house of Venice's greatest painter, the city's most famous citizen and – you have to assume it – one of its richest. It is understood that the servants had fled.

The penalties for theft were draconian – death by hanging at the very least – but who would have been enforcing the law when many of the police were themselves dead? The *pizzigamorti* – the corpse-bearers who carted away the dead, who took the sick to the hospital islands and cleared and fumigated the houses of the dead – were mostly convicts let out of prison for the purpose, freed galley slaves or vagrants. These were the people who now ruled the canals and streets of Venice, and they were notorious for their brutality, for their pilfering and their fearlessness in handling the dead and the near dead. You saw them in the paintings of the time, portrayed always as massively muscular and near-naked, dragging the pitted corpses off the bridges and canal sides into their specially painted white boats.

Were the thieves the *pizzigamorti* who had carried away Titian's corpse and then returned to pick over the contents of his house? Were they a more organised gang who had targeted the house and its immensely valuable works of art? Or were they simply poorer neighbours out to grab what they could in the upside-down world of the plague in which thieves and beggars prospered while the noble and the great died in agony?

The report on the theft, filed to the Giustizia Vecchia, referred to the looting of 'innumerable paintings of no small value'. But were these major works of potentially incalculable importance to the Western tradition – the equivalent of, say, a lost Shakespeare play or Beethoven symphony? Or were they simply studio sweepings – minor, probably small works that the thieves could easily carry? Were they lost, destroyed or sold on? Did they reappear in Titian's *oeuvre* as other paintings we already know about? Or had the thieves simply panicked and dumped them in a nearby canal?

Most of the famous artists we make a fuss about today will be forgotten or reduced to mere footnotes in the history of art. Not because they're no good, but because that is simply the way things are. There are artists, like Rembrandt, who re-emerge into the light after centuries of neglect. And there are others, like Rembrandt's near contemporary

Guido Reni, who enjoyed hundreds of years as central figures in the Western tradition but are now almost completely ignored. But Titian has always been at the summit of artistic celebrity. He established himself as one of the world's greatest artists while still in his twenties, and, apart from a brief period immediately after his death, that status has never seriously been questioned.

Titian. Most know the name, almost all can pronounce it, a name that's become synonymous with the biggest, grandest ideas of high culture. Yet even among people who are familiar with his work, Titian's personality remains elusive. Unlike Leonardo, Titian didn't invent anything. He didn't wrestle with titanic philosophical concepts and shout at popes, like Michelangelo. He wasn't a romantic figure, prettier than most of his models, like Raphael. Titian is famous only for painting. And this sense of slightly impersonal grandeur is something the artist himself cultivated.

I could picture him in the most famous of his self-portraits: already in his seventies, gaunt, slightly rheumy-eyed, simply but expensively dressed in black, with a long but neatly trimmed white beard. And, despite the apparent modesty of the image, it's been carefully contrived to give an impression of austere, almost unapproachable venerability and greatness: the official image of the artist who worked only for the greatest and most powerful patrons, for popes, emperors, kings and dukes. And the imperial resonance of the three-quarter-profile pose would have been highly apparent to a contemporary viewer.

But there is another image, one which is rarely reproduced but gives a very different impression: a woodcut by the writer and artist Giorgio Vasari. It shows Titian again in old age, gnarled and ravaged, but retaining a feisty, flinty-eyed look, his gaunt features dominated by a massive and slightly bent hooked nose, the bags under his eyes extending halfway down his cheeks, while a flat beret is worn over his trademark skullcap at an angle that gives him a raffish, even piratical air. It's an image close to caricature, which must nevertheless contain at least an element of truth.

Titian shifted the emphasis of European art at least twice in his long career. And, because he lived to a very great age and carried on developing right to the end, the impression has remained of a figure of almost limitless creative vitality, who continually pushed forward

the boundaries of painting, creating images that have been drawn on by artists again and again over the centuries, until he arrived at those, stark final images.

And it seemed to me, as I stood in the fading light beside the entrance to the now rather drab, mundane-looking building in which these paintings had been created, that there were nothing like enough of them. How many were there? Six, maybe seven. Seven paintings created over the last five or six years of Titian's life, each with its ashy layerings of light and shade; the glowing colours of the earlier work muted into sombre autumnal hues. Seven paintings. Each with its own complex problems and mysteries. One painting every year. There must have been more.

And to the last of these paintings, the *Pietà*, which he intended would hang over his own tomb, he added a tiny painting within the painting, a small canvas leaning against a column behind the feet of St Jerome, showing a white-bearded old man and a younger dark-haired man kneeling before the Virgin. These figures were Titian himself and his younger son Orazio, his faithful assistant, who had managed his studio and business affairs for more than thirty years. It was an ex-voto, a plea that their lives would be spared and that Titian's studio, the family business, would go on, providing wealth and employment for future generations.

But by the time Titian died, Orazio himself had already been taken to the Lazaretto Vecchio, the hospital island beside the Lido from which only one in ten returned alive. Now a very different figure arrived on the scene and made his way directly to Titian's house: his eldest son Pomponio, a priest of dubious reputation, whom the artist had not spoken to or set eyes on in nearly twenty years.

I

Towards Titian

THE SUN WAS setting in a blaze of gold behind a gigantic multi-storey car park. As the vaporetto pulled away, I could see the cranes along the waterfront framed against the shimmering blue of the distant Dolomites. I could see railway sidings, vast tankers, pink light sluicing over the rolling waters of the Lagoon. I'd got off the airport bus, stepped straight on to a vaporetto and everywhere there was land and water, water and land, but in no obvious order. Everything seemed to be in motion. And everywhere there were clusters of those grey wooden mooring posts, the distinctive shape of which – wider and slightly rounded towards the top – can barely have changed in a thousand years.

I'd imagined a winter's journey in a dark, dead city, but it was almost spring, the early evening air sharp and bright. A jet soared vertical into the blue, and directly overhead a wedge of moon hung in the high, clear sky.

Ahead of the vaporetto a cluster of buildings was looming, what looked like a housing estate, a crowd of tower blocks apparently sitting on the water, surrounded by bare winter trees; though as we got closer, I could see they were washed in typically Venetian reds and ochres. The other passengers were all packed into the cabin at the back, only a young Japanese woman braving the cold to record it all on a digital camera. Then she too retreated and I was alone as

the boat ploughed on through the waves, pinkish-golden light rolling over the gelatinous swell. It was as though colour was not a mere fleeting impression on the retina, but a tangible substance floating on the water, as though you could have leaned down into the icy water and pulled out a handful of pink.

Then the boat swung round into the broad channel of the Canale della Giudecca – more a great river than a canal – and there were those eternal red-washed façades, the churches with their tall, white-lead Byzantine domes, a sight anyone, even if they'd never been to Venice – had only ever glimpsed one picture of the place – would instantly recognise. Most places look like somewhere else, but nowhere looks like Venice. Catching sight of it, even after only a relatively short time away, you felt wonder at the sheer fact of its endurance.

And there were the great plague churches, the Redentore, the Church of the Redeemer, built as the fulfilment of a vow at the end of the plague that killed Titian, and, rising out of the blue dusk, just visible above the huddle of buildings on the left side of the canal, the white dome of the Salute, that marked the end of another devastating plague sixty years later.

It was almost dark by the time we reached the San Zaccaria vaporetto stop. My hotel lay in one of the narrow streets just behind, in one of the most commercialised areas of the city, not far from Piazza San Marco. But the tourist season hadn't fully started, the night was well advanced by Venetian standards and the streets were already almost deserted. The room was perfectly clean and neat, but small and rather bleak, with a dim overhead light, and, while I had specified non-smoking, I could detect the furzy tang of nicotine lurking beneath the smell of air freshener. I opened the window and looked down into a dark, tomblike alleyway. It was quiet, ominously quiet. And that was exactly what I wanted.

The receptionist had a shaven head and an affable if slightly furtive air. 'Biri Grande?' he repeated in a tone of faint alarm.

'Biri Grande,' I said. 'Or Bia Grande. It's a street or . . . an area. Towards the sea.' It was a long time since my last visit to Venice. My sense of the geography of the place was extremely vague.

'Towards the *sea*?' he echoed. 'What is it that you are trying to find?'

'The house of Titian.'

'*Who*?'

'Titian. You know, Tiziano Vecellio. The artist! I want to find *la casa di Tiziano.*'

'Tiziano? You mean the Galleria dell'Accademia? La Chiesa i Frari?' This was a man who liked simple questions like, what time's breakfast served? Now he felt he was moving back on to home ground.

'No . . . I want the house – the *casa* – of Tiziano himself.'

He smiled and shrugged. 'Then I can't help you.'

While the air was cold, the light had an almost African brilliance – yet with a freshness and an intensity to the colour that felt very northern – the Venetians in their furs and loden coats, the young people in black puffa jackets, all in dark glasses. The streets around my hotel were crammed with pizzerias, cafés and souvenir shops catering entirely to the tourist trade. Yet even here you saw laminated placards fastened to the lamp posts with the blank features, name, dates and profession of some very ordinary-looking older person. They announced that another of Venice's dwindling indigenous population was no longer with us, and, conversely, that a real life of sorts was still going on.

I headed north along the canal banks and alleyways, passing the churches of Santa Maria Formosa and Santa Maria dei Miracoli until, somewhere north-east of the Church of San Canciano, the tourist city of carnival mask shops and perfumed soap emporia gave way to a more workaday urban environment: a network of bare, rather inscrutable alleys favoured by stonemasons and makers of funerary sculpture, their hammers and cutting machinery ringing and roaring around the empty streets. These blank thoroughfares seemed to run only in and out of each other, with almost nothing in the way of decoration; not so much as a hanging geranium pot, barely a shutter along their dour façades, just the occasional line of washing, duvet covers hanging like great banners across the streets.

Biri Grande, the street or area that was described in all the literature as the location of Titian's house, no longer existed. I'd surmised as much before I even came to Venice, having looked it up in every conceivable map, gazetteer and internet site. Titian's house

now stood in the Calle Larga dei Botteri, so my guidebook told me, the Wide Street of the Barrelmakers, at number 5179–83. The street was barely wide enough to take a cart, but still wider than any of the surrounding lanes. And having walked its length several times and wandered into the neighbouring alleys, I'd come to the conclusion that number 5179–83 didn't exist or – in a way I understood to be typical of Venetian addresses – was nowhere near where it was supposed to be.

I'd read that the house at Biri Grande was a 'large mansion' at the extreme seaward end of the city, which I'd taken to mean the east, towards the Lido, the strip of seaside resort that divides the Lagoon from the open Adriatic. Here we were on the north side of the city. The garden in which Titian had entertained King Henry III of France on his visit to Venice in 1573 was said to have stretched right down to the Lagoon shore. But this area had clearly been built up for centuries.

The only place that could conceivably be described as a large mansion was a big, dark, dilapidated building under renovation, the hoarding crowded with posters for a forthcoming election. A handsome Marcello Mastroianni type in hornrims represented a party identified by a hammer and sickle, while a blonde woman on a horse, naked except for an armoured sleeve, stood for who knew what. I needed to learn more Italian.

Immediately opposite was a blank stretch of wall between two masons' workshops. The larger one on the right was glass-fronted so you could see the men working in a rather desultory fashion on the marble gravestones. A man staggered out with a large chunk of stone, but I didn't feel confident enough of my Italian to ask him what he knew.

I headed north along the alley beside the hoarding, emerging on to the Fondamente Nove – the New Embankment – the white stone pavement from which the vaporetti depart for Murano and the northern outlying islands. As I stood on the quayside, a crane mounted on a boat drew in alongside one of the bobbing vaporetto platforms, its arms gripping one of the grey wooden mooring posts and sliding it up out of the water – its rotten base encrusted with barnacles and dripping green weed – laying the redundant post on to the bed of the

boat before replacing it with a new one, identical to all the millions and millions of others that had stood along Venice's canals over the centuries. Framed by the steel arms of the crane hung the shimmering blue curtain of the Dolomites, the eastern arm of the Alpine chain, that rose from the Venetian plain a hundred kilometres to the north. At first you were aware only of another area of luminous sky, until you noticed the snow-covered peaks merging into the white clouds. That was where Titian came from. One of the first things you needed to know about him was that he wasn't from Venice, but, like many of the city's greatest painters, was a *forestiere* as the Venetians airily dismiss the inhabitants of the mainland. I remembered having read that Titian had chosen to live in this part of the city so that on a clear day he could see his distant homeland from his house.

A few yards along the waterfront stood a small hotel whose windows looked up and out over the Lagoon towards the far-off mountains, a place that named itself after Titian's own family – the Hotel Vecellio. It occurred to me for a moment that perhaps this was Titian's house. I stepped over a doormat emblazoned with the legend 'Vecellio T' into a cramped and nondescript foyer. An unshaven man in a T-shirt appeared, working the remains of his breakfast round his gums with his tongue.

'Do you speak English?'

'Sometimes.'

'I'm trying to find Titian's house.'

'Turn left, then right. It's right in front of you. But there's nothing to see, nothing to visit. It's just a private house.'

I turned left, then right and found myself standing in front of the hammer and sickle hoarding. Looking up, I saw a woman regarding me from the balcony of the adjacent building.

'*La casa di Tiziano?*'

'Right there.'

I turned and faced the blank brick wall between the masons' workshops, then I looked back at the woman.

'*Sì, sì!*' she called, waving towards the wall. And, looking up, I saw an inscription carved in stone and set over a doorway so blank and nondescript I hadn't even noticed it – 'Hanc Domum Colvit Titianus Vecellius'. It was relatively new, as indeed were the stone roundels

carved with interweaving bird motifs in a quasi-Romanesque style that was doubtless intended to convey an impression of oldness and augustness, but had nothing to do with Titian's time. Standing back and peering over the wall, I could just make out a stretch of unremarkable tiled roof with an arched dormer window edged in white stone – all, again, looking relatively new.

Down the side of the mason's workshop stood a long wall topped with barbed wire over which could be seen small trees and, some distance beyond them, the house with its arched windows, all firmly shuttered.

From this angle, the house ran a fair way back from the street, with space for a good five or six windows along its side elevation. But it was still hardly what you'd call palatial. And it was on the *landward*, rather than the Lagoon side of the street as I'd expected. Scruffy as it was, the garden was large by current Venetian standards. In Titian's time it must have been vast. All the land between here and the water, with the hammer and sickle tenement, the Hotel Vecellio, the whole of the nearest stretch of the Fondamente Nove with its cafés and bustling vaporetto stops, had been part of Titian's garden.

Yet something about the whole set-up didn't quite ring true.

While Titian's house had been spared the indignity of being renovated with UNESCO grants and turned into a sad little museum, four and a half centuries of gradual but directionless renovations had turned it into something else – a completely ordinary and relatively new building.

And while the place might be large for a private home in modern Venice, it hardly seemed big enough for Titian. The artist had been a multimillionaire by the standards of his time, his house known as the Casa Grande – described in one tome I had read as 'a large palace'. Maybe this was another, earlier house. Maybe the Biri Grande house where Titian had died and from where those dark, mysterious final paintings were looted was somewhere else entirely.

I headed back to the Fondamente Nove and the Hotel Vecellio. The receptionist looked at me sceptically.

'Titian's house,' I said. 'Is it the house where he died?'

'No, it's the house where he lived.'

'I mean was it his last house . . . his *ultima casa*?'

He winced in exasperation. 'How do I know? I know a few things, but I'm not a genius.'

The Franciscan Church of Santa Maria Gloriosa dei Frari – popularly known as the Frari – dominates a whole quarter of the western part of Venice, an immense pile of washed-out medieval brick in every conceivable state of browning and greying desiccation, its listing campanile, high, bare walls and the intricate, rather Islamic-looking decoration of its west end looming over the surrounding rooftops and alleys. The first church on this site was built very quickly during the religious revival of the mid-thirteenth century, but, such was the scale of the crowds pressing in to hear the Franciscan preachers, it was pulled down and the current vast structure erected over a period of a hundred years. The Dominican order, meanwhile, constructed their own enormous church, Santi Giovanni e Paolo – more commonly San Zanipolo – in the north-east of the city. These two rival complexes expanded to include living quarters, cloisters – two in the case of the Frari – hospitals and kitchens, until the authorities took legal action to prevent them taking up any more of the city's precious building space.

While the friars of the mendicant orders had taken vows of poverty, renouncing the ownership of property, and much of their work was with the poor and the sick, their churches became the pantheons of the Venetian elite, their walls crowded with the chapels and votive altarpieces of the great aristocratic families, with the tombs of doges and military captains of every degree of beauty and bombastic hideousness.

Yet the Frari is still so vast and bleak and bare as to seem almost empty, its bare vaults and immense piers held apart by a criss-cross of colossal wooden beams – a structure that feels it must be too big, too heavy for a city built on wooden stakes driven into mud.

In 1516, Titian was commissioned to create a painting for the high altar, a painting that would proclaim the message of the church's name – St Mary in Glory – the Divinity of the Virgin, a cornerstone of the Franciscan ideology that was refuted by the Dominicans. The position was probably the most prominent and prestigious for any painting in the entire city, and, from a visual point of view, one of

the worst – surrounded by the windows of the west end, the blazing sunlight from which would reduce it to a dark blur.

Titian was about twenty-seven. His teacher and principal rival for the crown of Venetian art, Giovanni Bellini, was on his deathbed. Another potential rival, Titian's sometime friend Giorgione, had died of the plague a few years before; a third, Sebastiano del Piombo, had gone to work in Rome. The field was open for Titian.

It was to be the largest altarpiece ever created in Venice, the largest painting on panel created anywhere in the world. It took two years to complete – not long by the standards of the time. And while Titian was working on the painting in the cloisters of the convent, he received frequent visits from the prior, Father Germano. The friar appeared perplexed as to why Titian had made the figures of the apostles, who crowded round the tomb at the base of the painting – figures for whom he had used fishermen as models – so large in relation to the rest of the painting and to the figure of the Virgin in particular. Titian explained that the apparent disproportion in scale was necessary to account for the vast size of the church, for the height at which the painting would be hung and the distance and angle from which it would be seen. The father would have to take his word that the effect would be quite different when the painting was finally in place. Germano retained his misgiving, but decided to wait to see the reaction of the congregation when the painting was unveiled.

That event took place on 20 March 1518, the eve of the feast of San Bernardino. The lanes and alleys around the Frari were crowded with people, the canals choked with the gondolas of the faithful, all on their way to see Titian's painting. There were rumours that the friars had refused to accept the painting, that Titian had threatened to withdraw it. Yet there it stood over the altar, a painting the height of a house. *The Assumption of the Virgin*, the Mother of God with her arms raised, her cloak floating out around her as she was swept heavenward on a billowing carpet of clouds and putti. And while the March sunlight came flooding in around it, from behind the figure of the Virgin herself came the white glow of another sun – radiating around her in a yellow as warm and rich as egg yolk. And as for the size of the apostles, gesticulating and gazing up in astonishment from around the tomb below – trapped in the blue, overcast light of

the earth beneath, but aware of the scene of blazing transformation beyond the clouds – you were hardly aware of them. They registered only as a blur of gesticulating limbs and emphatic profiles as your gaze was drawn inexorably upward towards the figure of the Virgin and Her eyes raised towards God the Father, who looked down, stern but benevolent, from on high.

Anyone familiar with artistic developments in Rome at the time would have said that there was more than a little of Raphael in the womanly beauty of the Madonna, that the sheer scale of the painting seemed a challenge to Michelangelo's work in the Sistine Chapel. But very few among the crowds thronging the Frari would have been even remotely aware of such things. Titian himself had never seen a painting by Raphael or Michelangelo. His knowledge of developments in Florence and Rome – in the mainstream of Italian art – of what we think of today as the High Renaissance, of the heroic endeavours of Leonardo, Michelangelo and Raphael, was drawn from drawings and engravings and from the awestruck reports of travellers and fellow artists. And when the eye hasn't seen, the imagination is freer to make its own journeys, to build its own structures. In creating a monumental work that would rival Michelangelo's Sistine ceiling or Raphael's frescoes in the papal apartments – a work that would put Venetian art and, even more importantly, himself on the international art map – Titian created a statement that neither of those other artists would ever have arrived at.

Rather than creating a number of perfectly contoured, idealised figures and then slotting them around each other, as Michelangelo or Raphael would have done, Titian had sublimated everything into one, single upward-sweeping effect, giving us something that is closer to what the eye might have seen in a real assumption of the Virgin than had ever been seen before.

The Assumption of the Virgin was commissioned at a critical moment in Venice's history. Since early in the previous century Venice had been expanding her territories on the mainland, moving westward into northern Italy, in reaction to the erosion of her eastern maritime empire by the Muslim Turks. But in 1509 the other major Western powers – the Papacy, France and the Holy Roman Empire – powers that were otherwise permanently at loggerheads, formed the League

of Cambrai to put an end to Venice's ambitions. Venice suffered the
most humiliating defeat in her history, at Agnadello. Her cities on
the mainland, Bergamo, Brescia, Vicenza, Verona and Padua, fell
in rapid succession, and the forces of the League pushed as far as
Mestre on the western shore of the Lagoon. But the egos, jealousies
and millennial rivalries of the great rulers meant they were unable
to maintain this unity. The great families of Europe and the ruling
aristocracy of Italy all married each other, allied with each other,
betrayed and fought each other as a matter of course. Only Venice
remained stable. Only Venice, the democracy of a thousand years,
the merchant oligarchy ruled by its elected duke and impenetrable
system of checking and balancing committees, kept its political and
mercantile interests entirely to the fore.

The League of Cambrai had threatened to wipe the Most Serene
Republic from the map. But within a few years, through a mixture of
military astuteness and diplomatic ingenuity, Venice had won back
every inch of its territory on the mainland. As *The Assumption of the
Virgin* was unveiled, Venice was once again in the ascendant. There
was no talk now of the friars rejecting the painting. The ambassador
of the Holy Roman Emperor offered to buy the painting for a vast
sum, but was told it could not be sold at any price. This was the
apotheosis of Mary, the apotheosis of Venice, the apotheosis of Titian.

Catching sight of *The Assumption of the Virgin* across the freezing
marble floor of the Frari, the vast church darkening around you,
glimpsing the great glowing mass of colour between the dark towers
of the choir stalls, you can't help but be impressed. I doubt if anyone
could leave that church without having at least some reaction to
the painting. But once you get outside the church, what are you left
with? With its great banks of tambourine-wielding putti framing the
ecstatic yet demure figure of the Virgin, God the Father, a bearded old
man looking down from on high, it's just a big, grand, old religious
painting of the sort you'd expect to find in a big, old Italian church.

The Assumption of the Virgin was a painting ahead of its time,
a baroque painting a hundred years before the event. But that
information doesn't help most of us to empathise with it, to feel more
strongly about it. Titian created some four hundred paintings, about

three hundred of which survive. A large number of them qualify as among 'the greatest', 'the most important', 'the most influential' on one level or another. But as soon as you start using such terms, as soon as you start pleading for Titian in terms of 'great art', you start to lose the immediacy and the physicality of the paintings themselves. Titian becomes a subject for academic study, something that is dustily, worthily and safely in the past. He becomes 'art history'. And that isn't something I've ever been particularly interested in.

I discovered Titian as an eighteen-year-old art student, sent to the National Gallery in London to draw from 'that painting which seems to you most marvellous'. I chose Titian's *Bacchus and Ariadne*, a great jubilant shout of a painting, a whirl of love, lust and *joie de vivre* with so much triumphal noise and energy coming off it, such an all-encompassing range of colour and movement, there seemed hardly any competition.

The painting was a relatively early work from the 1520s, one of a series painted for the *camerino d'alabastro* of Duke Alfonso d'Este, a legendary room in the Palace of Ferrara. But I didn't know that, and it wouldn't have interested me if I had. I knew Titian's name, and the fact that he was, I understood, revered by other artists and known as 'the painter's painter' gave him a certain cachet. But beyond that my approach was simple: did the painting give me a buzz or not?

I was a naive adolescent, only a few months out of school. Yet in one way my approach had a certain validity. Titian, above all, was the artist who established painting as a language, a medium of expression in its own right – who proverbially 'freed painting from drawing' – who made the brush mark physically apparent on the surface of the canvas, allowing the physicality, the fluidity, the viscosity of paint to be something more than a medium for filling in pre-drawn shapes. Every artist whose work depends on the painterliness of paint – from Rubens to Rothko – owes an enormous amount, if not their entire career, to Titian.

My teachers were artists, from academic realists of the Euston Road School to hard-edge abstractionists, and the thing they had in common was a reluctance to consider anything outside the frame of the painting. Sentimental stories about artists' lives, an interest in questions of iconography, provenance and attribution – what the

third cherub on the right was actually doing, who had commissioned it and why – were considered a bit lightweight, the province of amateurs and academics. These people didn't need an 'expert' to tell them whether a painting was a genuine Titian. They'd make up their own minds about whether it was a good painting or not, based on what they could see. They weren't entirely indifferent to matters of art history. They'd read plenty of books. But first of all they absorbed the work visually, through detailed interaction with the paintings. They weren't quite anti-intellectual, but it was a different kind of intellectualism – an intellectualism of the visual. And in this way of looking at art, no artist was entirely dead. When you were looking at Titian's paintings, he was alive, and these paintings weren't historical artefacts, they weren't evidence about the past. They were as immediate and real as if they'd been painted last week.

This was the way I'd begun looking at Titian, and the way I'd gone on looking at him over the subsequent decades – searching his paintings out, whenever I had the opportunity, in the great galleries of the world. I'd see them come to London in blockbuster exhibitions, and then a couple of decades later I'd see them come around again. I hadn't entirely blocked out the art-historical. I knew a fair bit about Titian the man and his era, about the people he'd painted, about the meanings of his paintings in terms of mythology and the Bible. I'd made close observations of the way he used paint in comparison with other artists, and I'd come to my own conclusions about what that meant. But I hadn't committed a word of this to paper. I'd never read a book on Titian from cover to cover. I didn't own any books on Titian. Since his paintings were so reliant on the physicality of colour and surface texture they didn't reproduce well. And, living in London, I'd had the immense privilege of being able to look at masterpieces by Titian in the National Gallery whenever I wanted to – for nothing. There were paintings in that place I'd been looking at in detail – on and off – for thirty years. I could hardly have known them better if I'd actually owned them.

Now I was in Venice, moving towards Titian, as I liked to think of it, and I could see the limitations of the way I'd been looking at and thinking about Titian over all those years. If I was going to get to grips with the meaning and fate of Titian's final paintings, I was going to have to go back and read all those books. I was going to have

to sift through five centuries of thought and scholarship and changing opinion on Titian's art. I was going to have to look at as much as I could of the physical evidence, the letters, laundry bills, police reports and lawyers' affidavits. But at the same time I was looking for other, more elusive things. For experiences that were equivalent in some way to a personal involvement with Titian and his time. Things that were so subtle and oblique I couldn't quite put them into words.

And there must have been people alive in Venice whose ancestors had commissioned and owned Titian paintings – who might conceivably still have Titian works, no matter how minor and in no matter what condition: studio works, prints, misattributions, even fakes. There must have been people among the Venetian aristocracy with personal connections going back to Titian's time. There must be dealers with links to people who had sold off critical collections over the centuries, who were – for all I knew – still selling the stuff off. And then there must be enthusiasts: people who understood what it meant to live in the city in which Titian had lived – who were passionately, even obsessively, interested in what had happened where; people who might have amassed large amounts of material of their own. Not just the academics who had spent their lives researching these things from the comfort of university teaching posts, but people who had done it all at a more grassroots level; retired teachers and civil servants perhaps, local historians and folklorists. And if these people were a shade eccentric, so much the better.

Titian may not have slipped in his position as one of the true greats, but the way his art has been perceived has continually shifted over the centuries. In his own time he was seen first and foremost as a portrait painter, who created near-miraculous likenesses of some of the greatest and most notorious characters of his time. To the immediately following generations, he was the great connoisseur of voluptuousness, unequalled in the depiction of the plasticity of flesh, particularly female flesh. In the eighteenth century, he was seen as a conservative artist, the favourite painter of the landowning classes, but in the nineteenth and early twentieth centuries he was rediscovered as radical: the great champion of the physicality and sensuality of paint, as the First Modern Artist.

But in our own time it was only those final paintings that spoke of Titian's radicalism. I'd been told by a curator at one of Europe's major galleries that artists today would be more likely to look at Tintoretto or El Greco – both pupils of Titian and very much in his shadow during his lifetime – than to Titian himself; unless it was to those final paintings. In an age in which so much that was once unassailable has been devalued and trivialised, it perhaps took images of that degree of rawness and extremity to really arouse the imagination. There have been a few artists who have pushed themselves to a final distillation of their ideas that is at once a summation of everything they've done before and an embarkation into stark new territory that seems to break with everything of the past. Goya did it in the Black Paintings, Beethoven in the late string quartets. Titian did it in a handful of his final works. And it was the tantalising thought that there might once have been, might still be, more of these paintings that had brought me to Venice.

I found the final *Pietà* in an upstairs room in the Galleria dell'Accademia.

In summer, the gallery attracts immense queues but now it was towards closing time in early March and the place was practically deserted. The room was hung with enormous paintings by Titian's followers Tintoretto and Veronese. The latter's *Feast in the House of Levi* filling the entire end wall, while the former's St Mark cycle hung opposite – paintings whose exuberance and jewel-like colour made the *Pietà* look dark, almost muddy in the fading light, and, although it was over ten feet high, almost small. A dark slab of a painting in muted earth colours – deep umbers, greenish ochres, greys and blacks – so dark in its overall tonality it seemed to be draining the light from the room.

Before a monumental niche, framed by inert grey stone and lit by torches, the Madonna sits calm and serene, the body of her dead son sprawled across her knees. To the left the stricken figure of the Magdalene, the prostitute redeemed by Christ, the chief witness of the Resurrection, strides forward out of the painting, bearing down on us, hair loose, arm raised – a hellish, Fury-like figure who appears to be simultaneously protesting Jesus's death and proclaiming the Resurrection.

Balancing the composition on the right, naked but for the pink cloth associated with St Jerome, is the figure of an old man, grey-bearded, balding, kneeling as he peers up into Christ's face, taking Christ's hand in his left hand, placing the other under Christ's shoulder. And whether this figure represents St Jerome – translator of the Bible into Latin and a very popular figure in Titian's time – Nicodemus or Joseph of Arimathea, his features are those of the artist himself.

Night is upon us. Traces of ivy suggest we are in a garden, a corner, perhaps, of the cemetery – the Place of the Skull – where Jesus was buried, and above these living figures are sculpted images of Moses, bearing the Tablets of the Law, and the Hellespontic Sibyl, holding the cross, both of whom foretold Christ's death and subsequent resurrection.

The painting originally comprised just the central group of Virgin and Saviour, but the composition had been expanded with the addition of six or seven other pieces of canvas and, close up, you could see the joins in the seven pieces of differently textured coarse-grained canvas, the unevenly matt and shiny surface, the cracking in the paint that was thickly impasted in some areas – like Christ's legs – and so thin in others – the Magdalene's feet – it barely covered the canvas. And while some parts of the painting, such as the Virgin's head, were painted with a wonderful serenity and assurance, in others, like Christ's body, the waxy-looking paint appeared stabbed on to the canvas by a hand barely in control of the brush. And there were great chunks out of the paint surface, barely covered by centuries of crude varnishing.

Titian had intended the painting to hang over his own tomb in the Frari near *The Assumption of the Virgin* and another groundbreaking work of his early years, *The Madonna di Ca' Pesaro*. But although the *Pietà* was exhibited in the Frari while Titian was still alive, it was removed at the request of the papal authorities for reasons that have never been made clear.

Nearly sixty years separated the broad, confident uplift of *The Assumption of the Virgin* from this dark and anguished final statement. The *Assumption* was a bravura piece of public painting in which everything seemed certain of where it was going – upwards into light

and glory. The *Pietà*, intended for the same very public place, felt a personal, even a private image, and while the message of Resurrection that was reiterated throughout the imagery of the painting suggested hope, the way it was painted – with its dark tonality and ominous mood, its apparently random transitions between rawness and finish – seemed to embody a feeling of uncertainty, even pessimism, that felt extremely modern.

But were these last paintings the final testament that writers since the early part of the twentieth century believed them to be? Had they evolved a new way of working, a grand and tragic language of pure paint that would change the way we think about art? Or were they simply a collection of unfinished paintings as some experts now believed? Paintings whose appearance was essentially accidental, that might have looked very different – more 'finished', more conventional – if the artist had had more time to work on them.

Here I was sitting in front of one of these paintings. After Titian's death, his former assistant Palma Giovane acquired the painting and made certain additions, before adding an inscription at the base of the painting: 'What Titian began, his pupil Palma brought to a state of completion.' And Palma, who must have understood Titian's intentions as well as anyone, had done remarkably little to it. He'd added the slightly sinister-looking putto who hovers around the top of the niche, and a few very fine layers of paint to other areas. But the parts you assume he'd have thought cried out for attention – like the pallid, barely choate form of Christ's body, which looks like the kind of thing the Russian expressionist Chaim Soutine was doing in the 1920s – he'd left completely untouched.

And if the other paintings weren't finished, it wasn't as though there hadn't been the opportunity. Some of the paintings, like *The Death of Actaeon,* had hung around the studio for more than ten years. And from what you can gather about the artist's personality, it wasn't as though he wasn't interested in the money.

Yet once you'd got it into your head that the appearance of these final paintings might be essentially accidental – that the whole idea of the 'radical' late Titian might be wilful delusion, it was difficult to quite remove it from your mind. And the matter was confused by the fact that Titian had produced other paintings at around the

same time – assuming we knew when the 'raw' paintings actually were painted – that were definitively finished, that were dispatched to their eventual owners and were considerably more conventional in appearance.

As I sat there in the fading light, the forms of the *Pietà* seemed to dissolve back into the darkness of the canvas as though into a well of shadow. I became aware of a conversation taking place on the seat next to me. A big fair man in glasses was sitting forward on his large hams, staring blankly at the dark painting, as a thin, dark woman leaned in towards him, speaking in a soft, fluid monotone. And after a few moments, I realised she was speaking in English. I could catch little of it, but she was clearly talking about the painting and the circumstances of its creation.

The woman must have been a guide, the sort of one-to-one guide whose expertise is available only to the very well heeled, a qualified art historian in all probability, and, since this was Venice, she would naturally be something of a specialist on Titian. How could she be anything else? She would know every corner of the city even remotely connected with the artist – and she would know anybody and everybody who could be even slightly helpful.

As they got up to move on to the next painting, I proceeded quickly after them. 'Excuse me,' I said. 'I'm sorry to disturb you. Are you a guide?'

'Yes, I am,' said the woman. She had a narrow, very pale face, rather fox-like, with narrow, slanting eyes and a gamine shock of very dark red hair, clearly dyed. She was wearing a bright orange raincoat, short and stylishly tight in the arms.

'I don't want to keep you,' I said, glancing politely at her client, a burly, slightly dishevelled figure who stood there looking glassily on. 'Do you have a card?'

'Ah, yes.' She turned to the man. 'If you remember, I gave you my card. I wonder if you wouldn't mind.'

'Oh, sure,' said the man, pulling abstractedly at his jeans pocket. 'I er . . .' He had a rumpled, slightly hapless air surprising in someone able to afford this woman's services. But, then, he was an American. He opened the big wallet, sending the contents showering on to the ground.

The woman leaned forward. 'Ah, yes,' she said, deftly picking a small cream card from the mound of banknotes, flyers and credit cards and leaving the man to deal with the rest. 'If you phone me this evening, we can discuss the possibilities. But I must warn you that I will be very occupied over the next two days.'

'Oh,' I said. 'That's absolutely fine.'

She gave me a suave tilt of her narrow head, and turned back to her client.

A few minutes later, as I was walking down the steps out of the Accademia, I looked at the card: 'Dott. Alessandra Felzi.' *Dottora?* Fluent English, orange coat, PhD. It got better and better.

I couldn't seem to get warm. I could feel the chill and inescapable damp seeping up from the Lagoon mud, through the sodden timber piles that kept the city precariously afloat, and into the flagstones beneath my feet. When it rained you were more than ever aware of Venice as a city of water in constant movement. The damp plaster and ancient crumbling stucco, black skies and gaunt palazzi, reflected in the tremulous canals and rain-swept *campi*. The old people, jaded by history, sniffing their way along the alleyways with their big, black umbrellas. Long delivery launches squeezing their way around the narrow back canals, the back doors giving straight on to the water, algae floating around the slime-covered steps.

It wasn't as though I hadn't come dressed for the weather. I had my own umbrella, hat and padded coat, but, as I padded along the alleyways westward from the Church of San Francesco della Vigna, I could feel the chill damp passing up through my feet, binding itself around my head, penetrating every part of my body, as though I was never going to get it out again.

Venice was in many ways a poor place to have come in search of Titian. Having arrived here from the Dolomites at the age of ten, he had spent almost all of his very long life here. Yet you couldn't *do* Titian in Venice the way you can Velázquez or Goya in Madrid, Turner in London or the Impressionists in Paris. There wasn't a massive, defining body of his work here. While there were quite a number of Titian paintings dotted around the city's museums, churches and charitable institutions, few of them were of the first

rank. Once you'd sifted out the dubious attributions, the studio creations, the works that were too minor to be considered and the surprisingly large number of paintings that were downright bad (the *Transfiguration* in San Salvatore and *The Descent of the Holy Spirit* in the Salute being good examples), you were left with perhaps five indisputable masterpieces. And these five paintings were too diverse in character, too broad in scope, to give a sense of an immediately comprehensible artistic personality.

The artists who struck you most as you moved through Venice today were Titian's great precursor and sometime teacher Giovanni Bellini and his successor and sometime pupil Tintoretto. It was possible to read Venice through Bellini's exquisitely serene Madonnas and altarpieces and Tintoretto's magnificently dramatic narrative cycles for the *scuole grandi* – the city's great charitable institutions. These paintings felt intrinsically *of* Venice in a way Titian's didn't. Titian had got too big for Venice too early in his career. His clientele was international. He painted for the super-rich and the super-powerful all over Europe. There are more significant Titian paintings in Madrid than there are in Venice.

An outsider might take the view that Titian *was* Venetian art, but, to most of the people I spoke to, he was just another remote historical figure. I had been given the number of a famous writer, who I had been told would be happy to give me his personal tour of the city. But the famous writer had clearly given far too many tours to far too many foreigners over the years and seemed rather nonplussed by the purpose of my visit. He bore one of the great aristocratic Venetian names. A forebear had been a close associate of Titian's, painted twice by the artist. But the name Titian clearly evoked nothing special for him. Why, he said, with a shrug of the shoulders that was apparent even from the other end of the telephone, didn't I interview the director of the Accademia?

Mariella Minocci, another personal contact, had a wonderfully gracious manner, warm, friendly, yet imbued with a slight sadness at the inevitability of the fact that she would not be able to help me. I stood on the Accademia Bridge, clutching my mobile phone, the traffic of gondolas, vaporetti and cargo launches passing beneath as she ran through the great families of Venice, whose names were

written in the Golden Book, the fourteenth-century list of the city's nobility – people whose ancestors had been doges, some of whom still owned palaces on the Grand Canal – trying to work out which might retain some connection with Titian, however slight.

'There are the Grimani, of course. The Barbaro. The Pisani . . . I'm going through a list of my friends now,' she said with a warm and collusive chuckle. 'All these people have owned paintings by Titian at one time or another. But over the years, the centuries I should say, they have either sold them or . . . lost them.'

What about the Barbarigo? Hadn't they bought Titian's house and all the paintings with it?

'Ah,' she sighed. 'The Barbarigo no longer exist.'

What happened to them?

'A lot of families lost money at the time of Napoleon. They couldn't afford to remarry, and they simply . . . died out.'

But what about more marginal people? Local enthusiasts, amateurs, even eccentrics? She seemed sceptical. She was an art historian, and art historians, I was beginning to realise, only relate to other art historians.

'There was Professor Benvenuti. He had a wonderful collection of prints. But when he died, his son inherited it all, and as far as I know he isn't really interested.

'You know, if you ask anyone in Venice if they like Titian, they will say, of course, they love Titian. But to find someone who really cares is not easy. For one thing, it is all quite a long time ago. Now, if you had been asking about the eighteenth century it would be very different.'

Rather a long time ago, she'd said. I hadn't really taken time to think what that barrier of time meant, but I could feel it now like an immeasurable tonnage of grey rock – an insurmountable weight of inert time closing off that age from this.

And it wasn't just a question of time, but of place. The Venice I saw around me now looked more like the Venice Titian knew than I had any right to expect, but in its essence it had changed totally. Venice then was one of the richest, busiest, most dynamic cities on earth. But changes in trade routes and the rise of the nation-state had made Venice a political anachronism even two hundred years ago.

Venice now was just another museum city, the Middle Ages plus shopping – where churches, palaces and convents were sustained by and in turn sustained Benetton, Louis Vuitton, Prada and all the other branded retail outlets found in every city in Europe, as well as the souvenir shops, the carnival mask emporia, the purveyors of stale focaccia sandwiches and more bad restaurants than any city in Italy.

As you stood on the crowded middle deck of your vaporetto, the great pageant of the Grand Canal unrolling in front of you, there was the blackened hulk of the Palazzo Vendramin-Calerghi – long considered the most magnificent palace on the canal – now a casino. The hoardings covering palaces under reconstruction were emblazoned with life-size images – taken from historical engravings – showing what these buildings had once looked like and would soon look like again. Venice knew what the visitor wanted to see, and provided it, even if it was in a two-dimensional, digitally generated form plastered over the real thing. Meanwhile, the patterned marble of those already unveiled had a look of almost lavatorial starkness. Huge banners announced the imminent opening of more museums for tourists to wander around, bemused and mildly bored.

It wasn't as though I was one of those people who want to plug into a romantic aristocratic past and revile the presence of the common horde. God forbid. I was a tourist myself. If I was interested in Venice's aristocrats, it was because they had owned and controlled the city in Titian's time. And the fact was that Titian was now more alive, more relevant, in London or New York than he was here. His paintings were up there on the walls of the National Gallery or the Met, still influencing people, still being thought about – still fighting for their survival amid the cultural chaos of the modern world. Here they were just more quaint, worthy old stuff. Nothing of remotely artistic consequence had occurred here since the eighteenth century. Titian wasn't relevant here because there was nothing for him to be relevant *to*.

It was dark as I approached Titian's house. There were more people about now, making their way home along the bare alleyways from the vaporetto stops on the Fondamente Nove, clutching their briefcases and their bags of shopping. The washing lines had been taken down,

the underpants, socks and tracksuit bottoms folded and put away. At the corner of Calle Larga dei Botteri a woman was selling apples by the light of a very bright electric lamp. I bought two.

The mason's workshop on the corner by Titian's garden was closing. I was just bending to peer through the brass grille into the garden when I heard a rustling behind me and turned to see a middle-aged woman approaching, weighed down with sagging plastic bags full of shopping. She paused to reach for her key, looking at me in a not unfriendly way. She was fair-haired, with glasses and prominent teeth.

'Do you . . .' I struggled to summon the Italian, 'live here?'

'I do.'

'Is this Titian's house.'

'It is.'

'Is it his last house, the one where he died?'

She opened the door, lifting the heavy bags. '*Sì, sì*. If you go to the square at the back, you'll see the plaque.' She gave me a friendly smile. 'Good evening.'

I walked down the side of the mason's workshop, along the bare brick wall with its ornamental pediment and barbed wire and turned into a tiny square – hardly a square, more a short dead-end alley – Campo Tiziano, with five front doors in a neat if nondescript row, and above the last a plaque saying that here Titian had died – the plaque having been unveiled in 1976 on the four-hundredth anniversary of that event.

I'd been here before, trying to find the front of the house – or was it the back? But it hadn't occurred to me that it was part of the same building. But there it was over the door of the last house, the address I'd been looking for the whole time: Calle Larga dei Botteri 5179–83; though, as with all Venetian house numbers, it referred to the *sestiere*, the quarter, Cannaregio, not the street.

From this angle, the narrow house fronts gave Titian's residence the cramped, utilitarian look of public housing. It was pleasant, reassuring in some way, to think of Titian living and working in this modest artisan area. But then this apparent character was itself relatively recent. The masons with their gravestones and funerary sculptures had only moved here in the early nineteenth century,

when Napoleon had turned the nearby island of San Michele into a cemetery, and the area had in all probability changed its orientation several more times between Titian's time and then. The layers of history, social change and development had closed up over this area, leaving me looking at a building that was ancient in its ground plan and basic volume, but relatively new in its actual structure. I felt bemused and rather irritated – with myself, with the cantankerous topography of Venice and with history.

Back in my bleak little hotel room I took Dottora Felzi's card from my wallet and dialled the number. *'Pronto?'* came the rather breathless reply. 'Ah, yes!' she said. 'I remember you, of course. But I wonder,' she said, her voice half-engulfed by background noise, a metallic grinding and a great rush of other voices, 'if you wouldn't mind phoning me back in five minutes.'

I walked round the room, looked out of the window at the kitchen porter smoking in the alley below, examined my teeth in the bathroom mirror, then redialled.

'Ah, that is much better. I'm on a bus. This is the perfect time to talk.' Her voice was warm and full of expectancy, and she was on a bus. On her way back to Mestre, on the industrial mainland, home to all those who serviced Venice but could not afford to live there. She suddenly seemed a more homely, approachable figure. Still, she would be expecting to do business, and I was taking up her time.

'Are you a Titian expert?'

'Not exactly. I am a fully qualified guide with the official authorisation of the Veneto region. I have the necessary art historical knowledge to perform that function. But my professional qualifications are in philosophy. So if you choose not to pursue this conversation any further, I quite understand.'

Far from it. This woman knew Venice. She had knowledge that could be a great deal of use to me; even if she didn't herself yet know it. I briefly explained the purpose of my visit, that I was looking for places, sites that the average visitor wouldn't see, and, more than that, for people. And I tried to convey the sense that my resources weren't limitless.

'I've seen all the paintings,' I said. 'I've been to the house. I've done all that. Now I'm looking for other things. Deeper things.'

I won't say the warmth drained entirely from her voice, though its tone became flatter, more neutral. And I could hardly blame her for that.

'I'm sure the kind of people you are looking for exist, but I really don't know how you would go about finding them. There are people at the university, but their approach will be more academic.'

I explained that it was really Titian's last days I was interested in. The very last paintings. Titian's house, and what happened there just before he died. I wondered whether to mention the theft of the paintings. But it seemed rather ridiculous to be talking about a break-in that had happened 450 years ago. But, then, if she had any background in Venetian art, she would surely know about it.

'Yes, I think I do remember something about that, though nothing more than what you have just told me. But actually . . .'

'Yes?'

'There is one person who perhaps you should meet. Though it may be a little difficult.'

'Really?'

'Let me make some enquiries. I will contact you again.'

2

The Most Talked About
Building in Venice

THE FONDACO DEI Tedeschi – the headquarters of the German merchants – was and still is the largest building on the Grand Canal. A big, bare, box-like edifice (now Venice's main post office), it sits slumped into the water, just north of the Rialto Bridge, dominating the city's main thoroughfare at its busiest point. On the ground floor of the Fondaco the goods were weighed and packaged and stored, while around the balconies ringing the central courtyard were ranged the refectory, two palatial common rooms and some sixty bedrooms, all rented on an annual basis by the great German trading firms. From there the inhabitants could look down on the traffic of boats – the gondolas, skiffs, traders' launches, barges and pleasure craft – jamming the putrid waters of the canal. Behind the Fondaco ran the Merceria, the soigné street of the cloth merchants, its brick walkways always immaculately swept, lengths of cloth-of-gold and other exquisite textiles for which Venice was famous hanging from the upper storeys. On the opposite side of the Grand Canal stood the Palazzo dei Camerlenghi – the city's treasury – and beyond that, the Rialto market, the banking quarter and the residences of the city's most illustrious courtesans and prostitutes.

There were places like the Fondaco dei Tedeschi in every major European city. The Steelyard, the London depot of the Hanseatic League, stood by the Thames, on the site of what is now Cannon Street

Station. Foreign traders were obliged to operate from designated premises, just as certain caravanserai in Eastern cities were allocated for the use of specific Christian communities (the word *fondaco* comes from the Arabic *foundouk*, or inn). Venice was crowded with people from everywhere on earth – the Jews, of course, in their Ghetto, Greeks, Croatians, Levantines, Albanians, Armenians and Turks – each community with its own social network, charitable institution and place of worship. But the Germans, who had been trading from this site since the thirteenth century, were the richest and most powerful of the foreign trading communities.

The leading German commercial families sent their sons to Venice to learn business and imbibe something of the ways of the world, young men like Ulrich Fugger, scion of the Augsburg banking dynasty – proverbially the richest family in Europe – who had the wherewithal to commission a magnificent altarpiece for the German chapel from Germany's leading artist, Albrecht Dürer, when he spent several months in Venice in 1506. Yet the Germans, rich as they were, could only trade through designated brokers – all born Venetian citizens – and the Fondaco building, and every last cup and knife within it, was the property of the Venetian state.

When the building burnt down in 1505, a competition for a new design was held among the city's architects, and two leading young artists were engaged to provide murals for its exterior: Giorgio Barbarelli, better known as Giorgione, and his colleague and close friend Tiziano Vecellio. Giorgione was then in his late twenties and a cult figure among a group of wealthy young aristocrats who saw themselves as the city's intellectual vanguard. Titian was barely out of his teens and still very much an unknown quantity.

While Giorgione, supported by Doge Leonardo Loredan, was allocated the main frontage of the building facing the Grand Canal, Titian was given a much smaller area, around the building's back entrance on to the Merceria. But he hadn't been engaged as Giorgione's assistant, as has often been supposed. Titian, though he was only nineteen, had obtained his own commission through the influence of the Barbarigo family.

Giorgione was known for working without preparatory drawings, for simply improvising with paint, straight on to canvas. But fresco,

which is essentially watercolour painted into wet plaster, has to be carefully planned, and, for the Fondaco dei Tedeschi, Giorgione produced full-scale drawings – cartoons – which were traced on to the base layer of plaster, over which small areas of fresh plaster were applied – just enough to occupy an artist for a single day. They worked from the top of the building downward – in time-honoured fashion – to avoid splashing their already completed work. And as these murals are spoken of as having been unveiled, we have to assume that the artists worked hidden behind screens, probably those panels of reeds that covered all buildings under renovation in Italy until very recently.

From the moment of the unveiling of Giorgione's frescoes, the Fondaco dei Tedeschi became the most talked-about building in Venice, not just for the beauty of the startlingly realistic male and female nudes, ranged across the façade of the building, but because of the question of their meaning – or lack of meaning. The colour of their flesh heightened in flame-like reds and holding spheres and other enigmatic objects, these figures stood in *trompe l'oeil* niches, framed by swirling arabesques and other apparently random images and figures. Here was a cloaked Levantine, there a long-haired youth in the parti-coloured hose of the Compagnie della Calza – Societies of the Stocking – one of the elite social clubs of the Venetian *jeunesse dorée*. And over there was a figure resembling a then notorious criminal, someone immediately identifiable to every Venetian. But to what purpose? While the illusionistic niches around the figures created clear echoes with antique sculpture, it was difficult to perceive any obvious allegorical meaning. Were these naked women goddesses, graces, nymphs or just *nudes*? There seemed no improving message, no worthy figures from ancient or modern history, no references to the Bible or mythology, no narrative or meaning of any sort. Giorgione had been instructed to paint whatever he wished, provided he did 'everything in his power to create a work of the highest art'. And he had done precisely that, creating a bravura display of his painterly talents – letting his imagination run wild all over the newest, finest building in the most prominent position in the entire city – and all at the state's expense.

Things proceeded smoothly until the uncovering of the frescoes on the Merceria side of the building, the one over the entrance showing

the figure of a formidable woman seated, sword raised, with the head of a man at her feet, the very image of the biblical Judith, but engaged in conversation with what looked like a German mercenary. While there was much speculation on the meaning of the image – whether it referred to the current political situation in which Venice was on the verge of war with the German emperor Maximilian – all agreed that these were the most vivid and lifelike of the frescoes to have been unveiled so far.

Giorgione was accosted in the street by a group of his friends who congratulated him on these new frescoes, telling him that he had now done his best work, that his frescoes in the Merceria far surpassed the ones he had executed on the canal side of the building – not realising that these had been painted not by Giorgione but by his younger friend and rival Titian.

Seething with rage and humiliation, Giorgione returned to his house and refused to leave it until Titian had finished his share of the work and it was common knowledge who had painted which part of the building. And from that day onwards, he never spoke to Titian again.

That story, however true it is – and you tend to assume it must be at least partly true – comes from Giorgio Vasari's *Lives of the Artists*, our principal source of information on what artists felt and did and thought during what Vasari referred to as the Rinascita, the Rebirth of the Arts – what we have come to call the Renaissance. A loose string of biographical sketches – some cursory, others near book length – covering most of the significant Italian artists, from the early fourteenth to the mid-sixteenth centuries, *Lives of the Artists* was an immediate bestseller on its publication in 1550. Revised and expanded by Vasari himself, it has been in print ever since. A painter and architect of no small stature, Vasari knew many of the artists he wrote about. He was a close friend of Michelangelo, and was present at the only recorded meeting between Titian and Michelangelo – an event we know about only because he recorded it. *Lives of the Artists* is probably the single most influential book in the entire history of Western art.

Yet Vasari can't entirely be trusted. While he was highly successful as a court painter, decorator and architect, he was – all commentators

agree – an extremely mediocre talent. Vasari gets the facts endlessly wrong, continually contradicts himself and never loses an opportunity to promote his own contribution to the events he writes about. And while much of the book is actually extremely boring – just lists of paintings – he can't resist a good story. Once he'd heard the tale of Giorgione, Titian and the Fondaco dei Tedeschi, he would have had to have used it, even if he wasn't entirely convinced of its veracity.

Yet if you want to go beyond 'art history', to get back to what the Renaissance actually felt like, there really isn't anything else. If you want to fight your way back through all the edifices of theory and ideology that obscure our sense of the people and the paintings, shoving your way past monumental constructs like 'the Early Modern' and 'the Renaissance' – a term that was only coined in 1867 – moving on through the thickets of argument and counter-argument, the questions of iconography and attribution, the endless talking of scholars to each other and no one else, backwards through all the ponderous genuflecting before the masters, the great towers of billowing, unreadable, rhetorical guff, the endless courtly, sycophantic waffle which passed for centuries as art criticism – if you want to get past all that to come out on a canal side on a bright morning in early sixteenth-century Venice, with two young artists high up on scaffolding on the Fondaco dei Tedeschi, working under separate contracts, yet in a kind of spiritual tandem that is soon to be violently disrupted . . . you'll find yourself exactly where you started: with Vasari. If you've got the time and the linguistic skills, there is, of course, the documentary evidence – the letters and laundry bills, the chits, order forms, diary entries and police reports (or what's left of them). There are other biographers close to Titian's time: Dolce (who also knew Titian), Ridolfi and Paolo Pino. But Vasari was closer to the events he describes, and he's more gossipy and entertaining. If you want something to *read*, there's only Vasari.

And while Vasari was a mediocre artist, he fundamentally understood that. He positively venerated artists more talented than himself, and from boyhood he had amassed a collection of drawings, documents, notes and anecdotes on his heroes, the artists. One evening in 1546, when he was working in the Cancelleria in Rome for Cardinal Alessandro Farnese, he was supping with the Cardinal

and various literary luminaries of the time when the art collector and biographer Paolo Giovio raised the idea of a book of eulogies of great artists from Cimabue to the present. Vasari told the gathering that in the interests of accuracy he would be prepared to lend his collection of notes and memorabilia. But when he later came to present a selection of his papers to Giovio, the writer told him he wouldn't be writing the book. 'Then who will?' asked Vasari.

'You,' said Giovio.

And as he started to pull this material together, talking to more artists and those involved in art, continually adding more information, Varari found that a bigger story, an agenda, an over-arching idea was emerging. He had a positively visceral detestation for what we now think of as medieval art, for the Gothic, the Byzantine, the Romanesque, all of which was for him old, crude, grotesque. For Vasari, the artists of the ancient world had come close to reflecting the perfection of divine creation, before war brought a long period of darkness and stagnation. Then, in the generations immediately before Vasari's own, painting and sculpture began, 'through God's providence', to regain something of their former glory as artists began to look afresh towards the classical world, to try to discern the secrets of the Ancients.

Vasari was born in Arezzo, in the cultural sphere of Florence. He began his survey with Cimabue, mythic precursor of Giotto, tracing the beginnings of the Rebirth from the time of Giotto, developing his theme though a succession of almost exclusively Florentine painters, sculptors and architects – Paolo Uccello, Lorenzo Ghiberti, Masaccio, Brunelleschi, Donatello, Alberti, Botticelli, Leonardo, the list goes on . . . climaxing with his idol Michelangelo, to whose heroic achievements the whole of the Western tradition had been leading, and who through God's grace had surpassed even the greatness of the antique world.

After that, Vasari's account of Titian, while hardly grudging, feels something of an afterthought. For Vasari, the Rebirth was a phenomenon of central Italy. It had begun in Tuscany, the region of his own birth, in Florence, and reached its climax in Rome, the centre of the Western world, with the climactic works of the Tuscan masters – or with figures like Raphael, who weren't Tuscan but share an essentially Tuscan world view.

For Vasari, Venice and all its works were a sideshow. An important sideshow, but a sideshow nonetheless. Since Venice only came into being after the fall of antiquity, her artists had limited access to the art of the classical past. They were over-reliant on drawing from nature and – certainly in the generations before Titian – worked in a manner that was, in Vasari's opinion, 'arid, crude and laboured'. For Vasari, the art of Florence was epitomised by the idea of *disegno* – design or drawing – the art of Venice by *colore* – colour. Florence was about the mapping of space and volume through drawing, Venice about the apprehension of the physical world through light, texture and atmosphere. Florence was about paring back to essential form, Venice about the accretion of sumptuous decoration. Florence was cerebral, Venice sensual. And there was no doubt in Vasari's mind about which was superior.

This fundamental polarity remained current in the discussion of artists, in writing and thinking about art, for a good two or three centuries. And despite a century and more of debunking and deconstructing time-honoured truths about the Renaissance, this central opposition has never quite been overturned.

Yet if Titian was the greatest exponent of Venetian *colore*, Vasari had the greatest respect for him. For Vasari, Titian almost – but not quite – transcended the limitations of the Venetian tradition. And Vasari's take on Titian was that, while he was undoubtedly one of the greatest artists who had ever lived, he was, first and foremost, extremely lucky.

How can you write about someone – particularly an artist – when you don't know how old they are – if you can't tell if at any given time they were producing works of astounding, near superhuman precocity or simply what one might expect of a very talented adult of a particular age? If we accept one of Titian's estimates of his own age, he was eighteen when he worked on the Fondaco dei Tedeschi, about ten years younger than Giorgione. If we accept the other, the one he gave to the king of Spain and which gave rise to the long-held idea that Titian was over a hundred when he died, he was actually older than Giorgione – if, that is, we take Vasari's word on Giorgione's age. So let's, for the sake of simplicity, accept the currently favoured

view that he was born around 1489, which would make him nineteen
at the time of the painting of the Fondaco dei Tedeschi and veers
slightly more on the side of superhuman precocity.

Titian, like most geniuses, was from an essentially lower-middle-
class background, from a family of notaries and minor officials. He
had enough material ballast behind him to guarantee a degree of
security, to know that he would never starve. But at the same time
he had no significant familial tradition to live up to or live down. He
could see the way clear ahead. Titian's family were in fact reasonably
prominent in their own small ancestral region, but in the eyes of the
greater world they were small fry. When Titian arrived in Venice at
the age of ten, he was nobody.

The Cadore region lies high in the Dolomites, about a hundred
miles north of Venice, on one of the principal trade routes between
Venice and Germany; a region of vast mountains and narrow
valleys, prone to avalanches, calamitous fires and sudden floods
that swept away fields and entire villages. The main products were
timber, which was floated down to the sea on huge rafts, and iron
ore, an industry that was just developing in Titian's time. Since
ancient times, the three passes immediately to the north of Cadore
had marked the dividing line between the Italian- and German-
speaking worlds.

It has often been said that Titian came from a noble family – 'from
one of the noblest families in Cadore', as Vasari put it – but Cadore
didn't have noble families. The inhabitants had formed themselves
into seven communes – called 'centuries' after the Roman centurions
who had supposedly founded them – which ruled through a
parliament convened in Titian's hometown, Pieve. While Cadore
had been under the control at various times of the Austrian Dukes
of Carinthia, the Italian Dukes of Camino and the Patriarchate
of Aquileia, the people regarded themselves as an independent
democracy – the small isolated garrisons of the ruling power were
seen as guests and guarantors of the region's ancient freedoms rather
than as an oppressive occupying force. At times of invasion, the bulk
of the population would simply disappear, women, children and old
people removing themselves to hiding places high above the snowline
which had been known about by the Cadorini since prehistoric times.

At the time of Titian's birth, Cadore had been under Venetian rule for less than a century.

Pieve di Cadore, Titian's birthplace and notional capital of this mountain community, clung to a narrow shoulder of land beneath the castle that commanded the two principal roads through the region – the pack-horse track running due north along the banks of the river Piave and the north–west route along the Boita, the only road through the territory capable of carrying anything as wide as a cart. The ancestor of the Vecellio, one Guecello, was reputed to have been a *podestà* – governor – of the region, appointed by the Dukes of Camino. But if that is true, the family were soon settled into the fabric of Cadorin society. A Vecellio had been present at every event of any significance in the region from the thirteenth century onwards.

Titian's grandfather, known as Il Conte on account of his formidable personality, was one of the most respected members of the Council of Cadore. Called upon to arbitrate in local disputes, to represent the region in negotiations with the Venetian government, he attained the two most important positions open to citizens – consul and syndic. Like many of Titian's forebears, Il Conte was a notary, the most basic kind of lawyer required in a society of this kind, authorised to certify deeds, contracts, copies of documents and affidavits. The only one of his five sons not to have become a notary was Titian's father, Gregorio, who also served on the Council, and acted variously as the military captain of the 'century' of Pieve, superintendent of repairs to the castle and inspector of a network of recently opened copper mines.

Titian was one of four children of Gregorio and his wife Lucia, with a brother, Francesco, and two sisters, Dorotea and Orsa. It is not known in what order they were born, but the family had acquired patronage, through the dowry of an ancestor's wife, of a chapel dedicated to San Tiziano of Uderzo, an obscure seventh-century bishop, and Tiziano – Titian in English – became a common and honoured family name, which would most probably have been given to the eldest son. There was, for centuries, a touching supposition that Francesco was the elder, and that he accompanied his more talented younger brother to the workshops of Venice as guardian and protector, standing by him through thick and thin and eventually

becoming his assistant. It is far more likely, according to the values of the time, that Titian took initial artistic precedence simply because he was older and that Francesco joined his brother in Venice a few years after Titian's initial departure.

Under the artisan workshop system that then pertained, people generally became painters simply because their fathers had been painters, or because the master was a friend or business associate of their father's. Boys were sometimes steered towards a career in art because of outstanding talent, but it was by no means a prerequisite. But for this family of minor notables to have sent their eldest son to the distant metropolis at the age of ten, to be apprenticed in a trade in which the family had no experience and no contacts, you have to assume that evidence of truly remarkable promise had been shown.

In the nineteenth century, a small fresco was still visible on the outside wall of a house adjacent to the Vecellio home in Pieve di Cadore – of the Virgin and Child with an angel – which Titian is said to have painted as a child with the juice of wild flowers. How long would anything painted with wild flowers be expected to last? A couple of weeks? Had it been wild fruit, the story would be slightly more believable. By the nineteenth century, extensions had been built on to the house, moving this picture inside, and it had been so extensively retouched that it was impossible to get any idea of its quality. Nonetheless, according to a posthumous biography published by Titian's cousin Tizianello, Titian's father, relatives and friends were all truly startled at the 'charm of the colours'. Titian was taken to the local painter, Antonio Rossi, a practitioner of the primitive Byzantine tradition of the eastern Alps, and you can be sure that the old master told the father that he would teach the boy what he could, but if he really wanted to make the most of his abilities he must be sent to Venice.

3

The Sacred Conversation

THE SALA DEL Maggior Consiglio was an immense room on the second floor of the Doge's Palace, the biggest room in the entire ducal complex and one of the largest in the world in its day – the Hall of the Great Council, where the male members of the Venetian aristocracy met to vote on administrative legislation and to begin the process whereby all state officials were elected. In Titian's time there were some 2,500 of them.

Guariento's gigantic fourteenth-century fresco of the *Coronation of the Virgin* still filled the eastern wall above the doge's throne, though it was by now in a rather dark and forbidding state. Around the rest of the walls and in the spaces between the windows were more, slightly later, frescoes by Gentile da Fabriano and Pisanello, which told the story of the conflict between Pope Alexander III and the Emperor Barbarossa, and of how, in the eleventh century, Venice brokered peace between the spiritual and temporal leaders of Christendom, and received the gifts, including the ring with which the city was 'married' each year to the sea – an event which legitimised Venice's dominance of the waves.

This was one of the great Venetian state narratives: stories and allegories that validated the city's existence, that were told and retold throughout the ducal palace, in the cycles of frescoes and oil paintings that filled the great state rooms and council chambers, and in the

gilded mosaics that floated serene and majestic over the walls and great cupolas of the adjoining basilica. Images that told the story of the city's relationship with its patron St Mark. Of how the Evangelist rested on the shores of the Lagoon, to be told by an angel: 'Pax tibi, Marce evangelista meus. Hic requiescat corpus tuum.' 'Peace to you, Mark, my Evangelist. Here may your body rest' – words that were to be emblazoned, along with the image of the winged lion of St Mark, on every official building throughout the Venetian empire. And of how St Mark's remains were stolen from the infidel in Alexandria and brought to the basilica. Of how they were lost and miraculously refound within the basilica itself.

The maintenance and renewal of these images was Venice's great ongoing state art project, which provided employment for generations of artists and required that a body of specialist craftsmen should always be on hand in the city. It was a criminal offence to encourage any master craftsman to leave Venice.

In 1478, Gentile Bellini, the city's leading painter and head of its dominant artistic dynasty, was put in charge of the redecoration of the Hall of the Great Council, replacing the crumbling frescoes of Gentile da Fabriano and Pisanello with paintings of the same subject on canvas, an immense task in which, it was intended, every major Venetian painter would take part. By the time Titian entered Gentile's studio some twenty years later, this work was still dragging on.

We see Gentile in his own painting *The Miracle of the True Cross at the Bridge of San Lorenzo*, kneeling at the head of a group of worthies that includes his brother and fellow artist Giovanni. We see them in profile in the bottom-right foreground, looking on as a famous relic is rescued from a canal during a procession of the Scuola Grande di San Giovanni Evangelista, the School of St John the Evangelist, one of the six great charitable brotherhoods that played an increasingly important role in Venetian society during the fifteenth and sixteenth centuries. The incident had taken place over a century earlier, but Gentile has put himself and his brother into the painting – along with a large number of other contemporary figures – as a way of showing their closeness to this influential brotherhood and their centrality to the society in which they lived and worked. There's an Egyptian

monumentality to these figures in profile, and a touch of naivety, too: Gentile, his short, white hair swept back, faintly smiling; Giovanni, his dark hair cut in the pageboy style typical of the time, also faintly smiling, both of them immediately identifiable by their long, tapering noses – the family workshop as corporate body.

The Bellini were drawn from the ranks of the *cittadini originali*, descendants of the original citizens of Venice, and were thus considered gentlemen. The Bellini painting workshop had been founded by their father Jacopo and, during the course of the fifteenth century, they had gradually outshone their rivals the Vivarini to the extent that their supremacy, their rights over the Venetian art scene, had come to be seen as inviolable.

A slightly pompous but not unkindly man, Gentile was as much a politician as he was a painter. In the 1470s he was sent to Constantinople as a kind of goodwill ambassador, a role he fulfilled with great flair. He painted the Sultan and returned to Venice laden with gifts and honours.

But if Gentile had a natural seniority as the eldest member of the family, all the sources concur that Giovanni was the greater in art. Each brother had his own following, his own school, which came to represent the divergent poles of Venetian art. Yet if there was any rivalry and resentment between them, we don't know about it. Nobody managed to get between Gentile and Giovanni Bellini.

According to a tradition begun by the writer Lodovico Dolce, who knew Titian reasonably well, the artist began his training in the workshop of the mosaic artist Sebastiano Zuccato. And there's a pleasant logic in the idea that Venice's greatest artist, the one who did most to free it from the static, hieratic Byzantine world view, should have begun his career in the quintessential Byzantine medium – that he should have developed his feeling for colour, transparency and light by handling the *tessere*, the tiny glass tiles from which mosaics are formed. In fact, it's probable that Zuccato did nothing more than arrange for Titian to be apprenticed in Gentile Bellini's workshop. Titian's guardian in Venice, a maternal uncle – a civil servant named Antonio – passed Titian to Zuccato, who passed him to Bellini. And that's basically it.

As J.A. Crowe and G.B. Cavalcaselle point out in their monumental
two-volume 1877 biography *Titian: His Life and Times* (still the great
work on the subject), from the moment of Titian's entry into Gentile's
studio to his emergence as an independent master at the Fondaco dei
Tedeschi about a decade later, there is not a shred of documentary
evidence on Titian's activities, influences and the way he reacted
to the many important artists to whom he was in close proximity.
All we have are the anecdotal remarks of Vasari and other early
biographers, which are tantalisingly vague and often contradictory.
And while you might think it would be a relatively simple matter to
research the typical apprentice's life and extrapolate from that, very
little is known about the terms of tenure, the distribution of tasks
among the various members of the workshop or the way painting
and drawing were taught – if, indeed, they were.

But then having drawn a blank, having admitted to the hopelessness
of the task ahead of them, Crowe (an Englishman) and Cavalcaselle
(an Italian) plunge into a vivid picture of life around the Piazza di
Rialto, the commercial heart of Venice, near which, they claim, lay
Gentile's studio; of the 'privileged members of the mercantile and
senatorial classes' meeting at noon to talk money and politics in
the shadow of the ancient Church of San Jacopo, while the foreign
merchants gathered in the colonnades opposite. Of the narrow
streets crowded with drapers' booths, the bankers' counters set up
along the colonnades, the sound of voices and the tinkling of musical
instruments drifting through the windows of the many schools of
music where, Crowe and Cavalcaselle speculate, Titian's friends and
colleagues Giorgione and Sebastiano del Piombo may have gained
their expertise on the lute. Of Bellini's house in the Rivalto, crowded
with paintings and mosaics and his collection of antiquities, which
included a head of Plato and statue of Venus allegedly by Praxiteles.

They press on, building a giddy picture of life in the teeming city,
whose population was at least double what it is today and where –
again in marked contrast to today – much of the real life went on
at night; a picture which, you notice, glancing at their footnotes, is
gleaned mostly from the writings of Francesco Sansovino, son of
Titian's great friend Jacopo Sansovino (a coincidence, though this is
Venice, and everything fits together). Looking at Jakob Burckhardt's

1860 tome *The Civilization of the Renaissance in Italy* – a book that can lay claim to having defined the concept of the Renaissance – we find a remarkably similar picture, drawn this time from the observations of the Florentine scholar Antonio Sabellico, who adds the details of the tall ships drawn up beside the Fondaco dei Tedeschi, the quaysides swarming with porters and beyond the Rialto, in the direction of St Mark's, the perfumers' shops – in an area that was even then entirely devoted to luxury goods.

And if we apprehend the Renaissance first and foremost through the mind of the nineteenth century, our sense of the life of a young apprentice in the late fifteenth century comes principally from the imaginings of Victorian history painters and children's book illustrators: the carousing in the streets, the brawling with apprentices of rival guilds, the carrying of great banners through the streets on saints' days, the earnest labour in the studio of the master, the tights, the doublets, the pageboy haircuts, the little round caps that tell us we're in the cosily picturesque world of the Quattrocento – the Early Renaissance – whose modest scale and untainted optimism the Victorian mind esteemed almost more than the grander, but more self-conscious High Renaissance.

Here's Titian at the age of thirteen, lying on his narrow pallet in Gentile Bellini's attic, with his brother Francesco fast asleep beside him, looking out at the stars and dreaming of future greatness. Here he is at sixteen, supping at Bellini's crowded board (assuming he wasn't actually staying at his uncle's place), flirting with Bellini's daughters – more likely granddaughters – and servant girls, bullied and joshed in a more or less good-natured way by the older apprentices and assistants who, since Bellini was then at least seventy, would have been his principal teachers. There's Titian running errands through the crowded alleys, sweeping the floor, grinding pigments amid the reek of rabbit-skin glue, turpentine and linseed oil, and always with some now famous masterpiece standing half-finished on an easel in the background.

And who's to say it wasn't more or less like that? This was a hierarchy of male labour with its banter and nicknames, its endless effing and blinding and innuendo, a collective enterprise in which it was understood that many hands would be involved in each work,

with the transitions between the different contributions rendered as smooth and imperceptible as possible. Every man and boy strove to paint and draw as much like Gentile Bellini as possible. Yet, at the same time, the young apprentices were watched to see who betrayed the strongest signs of talent and originality.

And while music and poetry were classified among the liberal arts along with rhetoric, logic and philosophy, painting remained an artisan skill, a mechanical art ruled by the sign of Mercury, along with other crafts that involved the use of the mind – armoury, scrivening and the making of clocks and musical instruments. Art was a high-class craft, but at the same time just another shop-keeping trade: the masons' guild in Venice recognised no distinction between those who worked stone and those who simply sold it.

The painters' guild represented eight groups of artisans, including gilders, textile painters, painters of leather, painters of furniture, mask makers, book painters, makers of playing cards, as well as painters of religious images, known as *pittori di santi* – painters of saints. Every artist you've ever heard of belonged to this last group. Yet their products were still seen as fulfilling specific practical functions in churches and private houses. There is no painter of that period who did not at some time paint decorative panels – usually improving allegorical scenes – for furniture. There are paintings in all the world's great galleries that have been prised out of wedding chests and skirting boards.

Still, the idea, often expressed, that artists before Michelangelo had no more status than, say, plumbers have today is false. There always were famous artists, whose celebrity allowed them to dictate terms to even the richest and most powerful clients. And there were artists who were keen to thrust themselves ahead of their peers by any means at their disposal. The time when Titian arrived on the Venetian art scene was precisely the moment when the 'painters of saints' began to assert themselves in relation to the other artisans with whom they'd traditionally been grouped, when they began to claim a status beyond anything that had traditionally been associated with the visual arts.

All his life Michelangelo played down the fact that he had served an apprenticeship with the fresco painter Ghirlandaio, because he wanted to give the impression that the development of his genius was a matter between him and God – that it had no relation to the

old artisan system. So Titian told Lodovico Dolce that Gentile had reprimanded him for the bold and rapid manner of his drawing, and had warned him that no progress would be made by that route. Titian, in middle age, wanted Dolce to know – and through him posterity – that even in his early teens his genius was asserting itself, that even then he could see beyond the narrow, conservative approach of the seventy-year-old Gentile Bellini – that even then his own essential style and vision were fully formed. But if you examine Titian's early drawings, you'll see that they are as painstaking and as minutely detailed as anything by either of the Bellini.

At around the time when Titian arrived in his studio, Gentile completed the paintings for which he is best known, *The Miracle of the True Cross at the Bridge of San Lorenzo*, in which we saw him kneeling with his brother Giovanni, and *Procession in Piazza San Marco*. Both were painted for the Scuola Grande di San Giovanni Evangelista. In the former, Gentile showed the white-robed and hooded members of the brotherhood on their annual pilgrimage to the Church of San Lorenzo, crowding the bridge in the moments after their greatest treasure, a reliquary containing a fragment of Christ's cross, had fallen into the canal. In these moments, the reliquary was seen to hover over the surface of the water, eluding the grasp of all those who dived in to save it – all but that of Andrea Vendramin, Guardian Grande of the brotherhood, into whose care the relic had originally been entrusted.

But more important than the miracle itself, which took up a relatively small part of the fourteen-foot-wide painting, was the wealth of social detail crowded in around it: the canal bank packed with serried ranks of women in their gauzy finery and red-gold hair; senators and other important dignitaries picked out by their crimson and scarlet robes among the milling black-clad patricians – all detailed portraits of real people; while in the foreground, opposite the group containing Gentile, Giovanni and their associates, knelt Caterina Cornaro, tragic ex-Queen of Cyprus, the Princess Diana of her day. And all around rises the unmistakable architecture of Venice, the red-washed façades, the tall gothic windows and those flowerpot-shaped chimneys of oriental appearance. All of which seems barely to have changed to this day.

This is Venice shown to the Venetians – Venice celebrated and validated, not through symbolic events of the remote past, such as those portrayed in the frescoes and mosaics of the Doge's Palace and St Mark's, but through recent and current expressions of popular belief. The painting was one of nine commissioned for the great hall of the Scuola Grande di San Giovanni Evangelista, a group which, like all of Venice's great charitable brotherhoods, had developed out of the mania for public penance that broke out in the thirteenth century and reached its height during the Black Death. Membership of the *scuole grandi*, the great schools, was open only to the citizen class, the tier of Venetian society immediately below the aristocracy, and their feast-day processions had become part of the fabric of ritual that bound Venetian society together.

Gentile's paintings and those of his followers Vittore Carpaccio and Giovanni Mansueti didn't just show the rituals and the city whose quasi-spiritual identity they celebrated in vivid, near-documentary detail – they were themselves part of this fabric of ritual. Carpaccio took this peculiarly Venetian genre even further, shifting perspectives and conflating details till his crowded cityscapes took on a near-hallucinatory quality. And the huge popularity of these images triggered a rivalry between the confraternities, in which the *scuole grandi* competed in the lavishness of the decorative schemes for their respective halls and committee rooms.

These remain some of the most enduringly popular images of Venice, endlessly reproduced on greetings cards, book and CD covers. But from the point of view of Titian's development they were more important for the influence they *didn't* have than what they did. From the point of view of broader developments in art they remained a limited and essentially provincial phenomenon. The very particularity, the literalness with which they bind themselves to the city they portray, somehow limits their power of expression. In their anecdotalism, their concern with detail over larger dramatic content, they remain rooted in the decorative gothic tradition in which Gentile, Carpaccio and Mansueti had all grown up. Gentile's father Jacopo had been a follower of Gentile da Fabriano, arch-practitioner of the so-called International Gothic style, a painter from Le Marche who had been brought to Venice along with the Pisan Pisanello to

provide frescoes for the Doge's Palace at a time when no Venetian artist was considered worthy of that role. As far as Titian was concerned Gentile Bellini and Carpaccio's way of working referred back to a time when Venetian art wasn't making it. He seems to have decided even then that his talents were worthy of something greater than showing Venice to itself.

And while it might seem far-fetched to attribute that degree of acuity and ambition to a mere teenager, over a career of seventy-odd years in Venice, when the religious confraternities were at the height of their influence, he only ever did one narrative painting for them. And while there are odd glimpses of distant campaniles and the waterfront of San Marco, the material fabric of Venice rarely appears in his work. Venice's greatest painter didn't paint Venice.

One thing Titian seems never to have lacked is a sense of his own importance. He was after something grander and more universal than could be achieved through Gentile Bellini's anecdotal genre painting, and he would find that in the studio of his younger brother, Giovanni. He told Lodovico Dolce that he simply tired of Gentile's old-fashioned way of working and moved into Giovanni's studio. But how easy was it for an apprentice to transfer allegiance from one master to another, even – perhaps particularly – if they happened to be brothers? However he managed it, Titian found himself, at an unknown date, in the studio of the man history has deemed to be the first great genius of Venetian art, the progenitor of the Venetian Renaissance.

For two or three generations, almost every Venetian artist of consequence passed through Giovanni Bellini's studio. Among the older generation were Cima da Conegliano, Andrea Previtali, Vicenzo Catena and Giovanni Belliniano – who even named himself after the master. Closer to Titian's own age were Giorgione, Sebastiano Luciano, later to become famous as Sebastiano del Piombo – and Lorenzo Lotto, a moody, neurotic character who spent most of his career outside Venice. These were the people who did much of the work on the paintings that went out into the world under Bellini's name – and in some cases they did the paintings outright. They were known as Belliniani, and many went on to successful

careers producing similar works under their names. Bellini is said to have kept a paternal eye on their careers. Indeed, his historical image is of one of the kind, wise old men of Western art. Because his art is characterised by a mood of saintly serenity, we tend to assume that reflects something of Bellini's own personality.

Giovanni Bellini was born around 1430. His first major influence was his brother-in-law, Andrea Mantegna, a Paduan who had trained under a painter and antiquarian named Squarcione. Squarcione had indoctrinated Mantegna with his own obsessive passion for the antique world to the extent that Mantegna, according to Vasari, preferred statues to real people. Squarcione intended that Mantegna would marry his daughter, but when he visited Venice he fell in with Jacopo Bellini and accepted Gentile and Giovanni's sister Nicolasina as his wife – thereby earning the undying enmity of Squarcione.

Mantegna's images had a haggard intensity, his lines appearing incised, his forms chiselled, as though he were trying to cut to a deeper, more painful emotional sinew. While he painted his share of sugary Madonnas, he always seemed more interested in the ravaged matrons that surrounded them, their stricken faces expressive less of piety than of Roman qualities of duty and endurance.

Bellini was impressed by Mantegna's emotional urgency and high seriousness – qualities that ran entirely counter to the placid serenity of the Venetian tradition – but he gradually softened those severe, tendon-like lines. He prettified Mantegna's sulphurous colour, and brought more real light and air into the picture. Not the flat, unchanging, Mediterranean light of the Tuscan and Umbrian masters, but the cool, limpid, temperate light of Venice, which stood in his work for divine grace. Seated against placid rural landscapes in their cowls of regal ultramarine, bathed in luminous spring light, Bellini's Madonnas were plausibly attractive young mothers who have physically given birth to the little boys balanced in their elegantly poised hands. Yet they remained remote in their beatific self-knowledge. From a basis in Byzantine stylisation, they grow ever more realistic, while remaining essentially mystical in their unapproachable serenity.

Altarpieces provided some of the most prestigious and lucrative images for the painters of saints. They were intended to create the

focus for prayer – prayer for the souls of the family who had paid for
the painting, who had endowed the chapel that surrounded it. In the
traditional gothic altarpiece – the polyptych – the saints who flanked
the Madonna were confined to separate panels which functioned
as doors over the central image. But in Bellini's time these figures
moved out of the supporting panels into the central image in one
continuous, harmonious flow of space and light, in the form that
became known as the *sacra conversazione*. Bellini didn't invent this
form, which became ubiquitous over the following decades, but he as
much as anyone made it his own, developing it through a succession
of monumental masterpieces in which the images moved from a
portable wooden structure standing on the altar up on to the wall
above – into an illusionistic space which extends coherently from the
real space of the church. This false architectural space is bathed –
usually from the side – in a glowing beatific daylight, the Madonna
at the centre of the pyramidal image, raised on her throne, flanked
by the saints whose attributes and distinctive features would make
them instantly recognisable to the worshipper in the chapel below.
St Peter, almost always grey-bearded, in a toga-like robe of yellow
or orange, carrying the Keys to the Kingdom; St Paul, balding, yet
still vigorous with his full, dark beard, carrying the sword with which
he was martyred – which alludes too to the fierceness with which he
fought for Christ. If you saw St Francis in his grey-brown cowl with
his reed and his stigmata you were probably in a Franciscan church.
If St Sebastian was present, young and beautiful, his near-naked body
stuck with arrows, the image had probably been created as an ex-voto
in time of plague, or in thanksgiving at the end of an epidemic.

 Yet the figures in these sacred conversations don't speak to each
other, they don't interact. They just stand there in beatific stillness.
The sacred conversation takes place on the spiritual plane, because
these people have already achieved the ultimate state of grace. And
Bellini expresses this grace not only though light, but also through
colour, building the figures in layers of translucent pigment till they
seem to glow from within.

 Looking at a painting like the Pesaro Altarpiece or the San Giobbe
Altarpiece, how can you not, if only for a moment, believe? How can
you not help feeling a somehow better person for the experience? And

how can you conceive that the person who created it was not a nice man? Yet when Isabella d'Este, Marchesa of Mantua, commissioned a painting from Bellini in 1496, she found him nothing like as malleable as she'd imagined.

Isabella d'Este. Remember that name. Known variously as the First Lady of the Renaissance and the First Lady of the World, related by birth or marriage to every ruler in Italy, famously fluent in Latin and Greek (though nothing like as fluent in actuality), a keen musician, passionate letter writer and gifted political manipulator, Isabella d'Este was one of those upper-class women who think they can impose themselves on the spirit of their time simply by being bossy. If she'd lived in the eighteenth century she'd have been organising soirées for Voltaire and Diderot. If she'd lived in the 1960s she'd have summoned the Rolling Stones to her holiday home in Marrakesh. As it was, the poet Ariosto and Castiglione of *The Book of the Courtier* fame were counted among the members of her circle, as well as Raphael, Giulio Romano and Leonardo da Vinci, who immortalised her in a magnificent drawing.

She had somehow hit on the idea of turning her study – her *studiolo* – into a monument to the artistic achievements of the time in which the greatest artists would compete in a kind of artistic tournament. And she decided that this project would not be complete without a *fantasia* by Giovanni Bellini. But having accepted her commission, Bellini did nothing for five years. When pressed, he stated his reluctance to be seen to compete with his brother-in-law, Andrea Mantegna, who was by this time Isabella's court painter and was also working on the *studiolo*. He mentioned too his lack of enthusiasm for the proposed subject – which had been specially devised for him by the poet Pietro Bembo (another iconic figure of the time) – from which, he said, he could produce 'nothing of value'.

Aware of Bellini's advancing years, and anxious to acquire a painting from him while he was still able to paint, Isabella commissioned a small *Nativity*, but had to threaten legal action and the intervention of the doge before she received it. She then enlisted Bembo's help in reopening negotiations for a narrative painting. A friend and sometime patron of Bellini, Bembo begged Isabella to let Bellini interpret the subject in his own way, since 'very precise terms

do not suit his style, accustomed as he says he is to always roam at will in his paintings'. Isabella eventually backed down, conceding to Bellini the 'responsibility of conceiving the poetic invention', while hinting darkly at the humiliation she had received at the hands of the old painter. As far as we know she never received the painting.

In other words, Bellini could be bloody difficult. He knew his worth and wasn't going to be steamrollered by anyone. Titian, who was in Bellini's studio during the latter part of this fiasco, would have known of what was going on through the gossip of his fellow students and the occasional dry remark of Bellini's. And Titian learned the lesson well.

By the time Titian came into his studio, Bellini had almost completely abandoned tempera, the medium employed by his father and by all previous Venetian painters, in favour of oil paint. Consisting of powdered pigment mixed with egg yolk and thinned with water, tempera was opaque and durable, but, since it dried within minutes, difficult to rework. Oil paint, in which pigment was mixed with linseed oil, might take weeks to fully dry and allowed the image to be almost endlessly revised and refined. And depending on the amount of oil that was used it was capable of almost limitless textural variety, from thick, opaque impasto to fine, almost transparent washes.

While artists had been using oil to modify tempera for centuries, often adding a final oil glaze to 'pull the image together', the technique of building an image entirely through minutely fine layers of oil paint was developed in Flanders about a hundred years earlier. Bellini was said to have learnt it from the Sicilian Antonello da Messina, who became obsessed with the medium after seeing a painting by the great Flemish master Jan van Eyck.

Bellini himself was affected by the cool Madonnas of later Flemish masters like Memling, which he saw in Venetian collections. But if oil painting in Flanders was about fineness of detail, about exploiting the medium's transparency to achieve a uniform clarity of focus that might almost be described as photographic – if the notion had existed – oil painting in Venice was to become about something very different. In the transition from tempera to oil, paint had gone from something that dried, became permanent, became solid almost immediately,

to something that remained fluid, essentially liquid – a medium in which the image could remain almost endlessly provisional.

Titian and his contemporaries were the first generation of Venetian artists to learn to paint through the medium of oil – who had no experience of the patient gothic limning in which the Bellini had started their careers, who took the provisional nature of oil paint, as well as its physical richness and sensuality, for granted.

Titian broke open Bellini's box of beatific light and serenity. He brought more movement and drama into the frame, and with these more of the grit and mess of lived human experience. He allowed painting to become more dynamic and expressive. He robbed it of some of its potential as a devotional medium in one way, and introduced a more troubled, uncertain spirituality in another.

But before he could set about demolishing Bellini's world view, Titian had to become Bellini. Before he could paint his own paintings, he had to paint Bellini's paintings – literally. Titian was the last artist of consequence to emerge from Bellini's studio. Bellini was about sixty years older than him. Titian probably learnt more directly from the slightly older assistants than he did from Bellini himself. Yet they were all competing for the master's attention – to be more like Bellini than the man working beside them and to do it better. Titian's first paintings looked tentatively towards the efforts of other contemporary Venetian masters, to classical sculpture and to what he knew of developments in Florence and Rome. But first of all they were Bellini paintings. Bellini was Titian's master, his spiritual father. Still, it wasn't long before Titian was trying to do his old teacher down.

4

The Archetypal Man

W E SEE HIM against darkness, his big-nosed, heavy-lidded features framed by a mane of tousled curls, his chin lifted so that he seems to be looking down at us, with an expression that is proud, yet strangely remote. No, this isn't Titian, but an artist to whom he was for a time extremely close, one of the most mysterious and romantic figures in all of art – Giorgione. We see him in a painting that is a copy of a painting which may have been a kind of veiled self-portrait. The image appears to have been severely cropped at the edges. But in an engraving that is believed to show the whole of the original painting, we see that Giorgione's fingers are clutching the hair of an enormous bearded, severed head – the head of Goliath. This is Giorgione in the role of David, the archetypal king – the archetypal man.

A great lover – we are told by Vasari – adored by all who knew him, male or female, a fine musician, expert on the lute, and a passionate adherent of nature, Giorgio Barbarelli acquired his nickname, Big George, because of his physique and what Vasari called 'the greatness of his soul'. Like Titian, Giorgione wasn't a born Venetian, but hailed from Castelfranco, a small and rather nondescript city on the Venetian plain. Vasari asserted that Giorgione included in his works 'only what he copied directly from life', that he 'avoided copying what any other painter had done', but also that he absorbed the modern style – *la maniera*

moderna – from Leonardo da Vinci. How he would have done this is not clear. Leonardo paid only one visit to Venice, to advise the government on fortifications in 1500, when Giorgione was in all probability still painting house-front frescoes in Castelfranco. But then Vasari never knew Giorgione. By the time Vasari arrived in Venice, Giorgione had been dead thirty years and had already passed into legend.

The entire paperwork on Giorgione comprises only fifteen documents. Only a handful of paintings can be securely attributed to him – somewhere between three and eleven according to which authority you read. No two experts agree on the chronology and meaning of these works. And if you put these paintings together – the enigmatic nocturne *The Tempest* beside the apparently comedic *Old Woman*, the pasty-faced but bare-breasted *Laura* beside the golden-hued, homoerotic *Boy with an Arrow* – it is difficult to see that they have very much in common. Yet a certain mood and feeling emerge from the idea of Giorgione as much as from the actuality of the works, a mood and a feeling which, once experienced, are completely unmistakable.

A near-naked young woman sits in an overgrown wasteland outside the walls of a city, lightning spitting into the darkened sky overhead. A short distance away, on the opposite bank of a small stream, a tousle-haired young man with a staff stands watching her; except that he isn't quite watching her. Everything about the painting is inconclusive. While the woman is looking out of the painting towards us, she doesn't quite meet our gaze. The air feels heavy with the electrical tension of the approaching storm, yet the two figures remain untroubled, aware of each other yet isolated in their separate mental spheres. And those two neatly truncated columns that stand just behind the young man are so without any apparent purpose, you assume they must mean something. But what?

The Tempest was first recorded in 1525, in an inventory of the major Venetian collections made by the collector Marcantonio Michiel. It then languished, ignored, in private collections until the 1930s. Since then it's been subjected to more interpretation and symbolic analysis than any other painting. The woman has been variously described as a gypsy, the Virgin Mary, the mother of Moses, as a personification of

Fertility or Chastity; the man as a shepherd, a mercenary soldier or a member of one of the Compagnie della Calza. Yet eight decades of foraging through mythology, the Old Testament and contemporary literature have failed to yield a convincing subject for the painting. The scene has been interpreted as the Flight into Egypt, as a Venetian response to the lush landscapes of the south German Danube School, as a prediction of the great deluge predicted for 1524 – the year of the cataclysmic conjunction in Pisces. Traces of an earlier figure, a young woman, revealed by X-rays beneath the soldier figure, have led to the suggestion that the painting represents the Infanthood of Moses – and that Giorgione was Jewish. And it's been described as a dream narrative in the manner of Jacopo Sannazaro's pastoral romance *Arcadia*, in which the young man is dreaming the woman and the child as embodiments of an idealised bucolic existence. But, finally, it was the painting's enigmatic inconclusiveness – the fact that none of these or the dozens of other theories came anywhere near sticking – that appealed most to the twentieth-century mind. Indeed, the fact that Marcantonio Michiel's inventory referred to it simply as 'a gypsy and a soldier in a landscape' has led to the now generally accepted conclusion that the painting has no subject other than its own poetic mood.

But how likely was it, at a time when most painting was still tied to specific religious functions, when people looked for symbolic meaning in everything, when 'interpretation' in the most literal sense was a large part of the interest and enjoyment of any work of art, that an artist – even one as apparently revolutionary as Giorgione – would have dispensed with a clearly defined subject in favour of something as nebulous as *mood*?

The fingers of Giorgione's influence are all over Titian's *Gypsy Madonna*. This wasn't Titian's first painting – there were creaky, if sometimes charming semi-juvenile works – but it has come to stand for the beginning of his career: the first illustration in books on Titian, the opening painting in exhibitions. It is essentially a placid, rustic Madonna in the manner of Giovanni Bellini. Indeed, the composition is an almost straight mirror reversal of one of Bellini's own late Madonnas. But through it breathes a very different spirit, a spirit apparent in the subtly darkening landscape, the pensive and slightly

mysterious figure seated in the middle distance, in the dark-skinned Madonna's downcast gaze and attendant sense of remoteness.

While the defining light in Giovanni Bellini's paintings was the clear, all-illumining daylight that represented the unchanging light of divine grace, Giorgione was preoccupied with the transient light of evening, with the inescapable sense of pathos and melancholy that comes with the onset of night. And where Bellini made detailed preparatory drawings which were effortfully transferred to canvas, Giorgione seems to have dispensed with drawing altogether, conceiving his paintings directly on to canvas, improvising with brush and pigment. And if he didn't like the way they were working out, he'd simply turn the canvas upside down and start again.

Giorgione was a good ten years older than Titian. By the time Titian entered Bellini's workshop, Giorgione had probably already left and was – if the inscription on the back of his painting *Laura* has been interpreted correctly – sharing a studio with another Bellini alumnus, Vicenzo Catena. According to Vasari, Titian, having absorbed what he needed from Bellini, shifted his allegiance to Giorgione. But Titian was never Giorgione's assistant as such. Giorgione and Catena's studio was probably a fairly small-scale enterprise with perhaps a couple of errand boys to fulfil the most basic tasks. Most of Giorgione's paintings were fairly small in size. He painted only one major altarpiece, for a church in his hometown, Castelfranco. He received only two commissions from the Venetian state: the frescoes at the Fondaco dei Tedeschi, for which he was paid less than was originally agreed, and *The Judgement of Solomon*, intended for the Doge's Palace, of which no trace exists. Giorgione's career as a public artist was a non-starter. His paintings were created almost entirely for a small group of wealthy, influential and relatively young Venetian aristocrats for whom he was a star. Giorgione's vision and personality represented something they wanted, though what that was, and what they thought they were getting from it, is very difficult to interpret.

Titian, meanwhile, may have been receiving commissions on his own account from as young as sixteen – as Bellini had before him. But these paintings, like the *Gypsy Madonna*, were amalgams of other people's ideas and vision. Titian had the ability, the style, the technique, but he

was still looking for the vision to animate them. For all we know, he had his easel set up in a corner of Big George's studio and was working, literally, in the older artist's shadow. Yet over a brief period, perhaps three years, that balance of power and influence was to be reversed. Though quite how it happened is difficult to trace.

Some time in the early 1540s, Titian painted his largest group portrait, an image that has become an icon of Venetian male dynastic power – *The Vendramin Family Venerating a Relic of the True Cross*. We see them slightly from below, arranged over the steps of an altar, members of the Venetian ruling class, wearing the glistening robes that denote their rank. The white-bearded patriarch kneeling, looking challengingly out at us, one hand resting proprietorially on the altar, wears the deep violet of a treasurer, while the younger man, moving forward with a bowing motion, eyes fixed on the relic, is in the crimson silk of a senator. Around them are the younger members of the family, from the young man stooping behind them to the small boy seated beside the altar clutching a tiny dog. And whatever clutter Titian was originally intending would fill the background, he obliterated it at the last minute, blocking in the canvas around the figures with a cloudy blue sky, which lends to this icon of corporate familial power an intimation of the heroic and the eternal.

This is a family apparently without women, rulers of a city dominated not by a family, but by a class. They exude a sense of closeness, a toughness, a confidence that stems not only from their commercial abilities and their sense of their importance in the hierarchy of the city, but from their family's mystical relationship with the relic in the top right of the painting: splinters of Christ's cross set in a magnificent monstrance of crystal and gold.

Remember Gentile Bellini's *The Miracle of the True Cross at the Bridge of San Lorenzo*, painted for the Scuola Grande di San Giovanni Evangelista? Where the relic fell into a canal and could only be rescued by the Guardian Grande of the brotherhood, Andrea Vendramin? This is that same Relic of the True Cross. The figures in Titian's painting are the descendants of that same Andrea Vendramin who was entrusted with the relic on behalf of the brotherhood by the Chancellor of Cyprus, Philippe de Mézières, in 1369. Soap manufacturers and

dealers in oil, the Vendramin were raised from the citizen class to the patriciate because of Andrea Vendramin's lavish donations to the war effort during Venice's late-fourteenth-century struggles with Genoa. While the Vendramin could no longer participate in the running of the *scuola* – membership of which was open only to members of the citizen class – their sense of their destiny and spiritual wellbeing remained bound up with the veneration of this relic.

The white-bearded figure may be an imaginative portrayal of Andrea Vendramin, fourteenth-century architect of the family's greatness, while the younger man is almost certainly Gabriele Vendramin. A friend of Titian's, whose will was witnessed by the artist, Gabriele Vendramin built up the greatest Venetian collection of the age. And as a young man – a good three decades before this picture was painted – he had become Giorgione's most important patron and the owner of the artist's most famous work, *The Tempest*.

Arriving in Venice in 1470, the Roman historian Antonio Sabellico was astonished – and appalled – at the intellectual passivity of the city's ruling class. Accustomed to the 'frank loquacity' of students in other parts of Italy, he found the young patricians who attended his lectures reluctant to be drawn into discussion. 'When I ask them what they think of this or that movement in Italy, they all answer with one voice that they know nothing about the matter.' Things that did not directly concern them, that had no bearing on Venice's political and commercial interests, were, it seems, better not known about, let alone commented upon.

The poet Petrarch left his precious library to the city in gratitude for the state's hospitality during a period of exile, only for the books to be left to crumble and petrify through damp. In 1468, the great Byzantine scholar Cardinal Bessarion left over a thousand manuscripts and rare books to the city, a collection representing the most important classical texts brought to the West after the fall of Constantinople. It was decades before they were even taken out of their packing cases.

By the 1500s, however, the manuscripts were very much out of the boxes, destined to form the core collection of one of the world's greatest public libraries, the Biblioteca Marciana. Relaxed censorship laws had

drawn printers to Venice from all over Italy, turning the city into the publishing capital of Europe. The Accademia Aldina, a Neoplatonic 'academy' established by the maverick Hellenist and printer Aldo Manuzio – the father of publishing – included Erasmus and Pietro Bembo among its members. And one of Manuzio's publications, the *Hypnerotomachia Poliphili*, an erotic dream-quest, believed to have been written by a monk from the convent of Santi Giovanni e Paolo, became the first cult masterpiece of the age of printing. The black-clad oligarchs of Venice may not have felt that the upsurge in 'humanist learning' that had taken place in the courts of central Italy over the previous century was any concern of theirs (if they were even aware of it), but by the early 1500s a sufficient number of factors can be identified for us to assert that the Renaissance was finally happening in Venice. And among the Latinist literary circles that were springing up in the city's private houses and palaces – the Neoplatonic covens where astrology, hebraism and the kabbalah were discussed alongside philosophy and literature – the most exalted was the one that met in the *camerino* of Gabriele Vendramin in the Ca' Vendramin – described by the chronicler Francesco Sansovino as 'the meeting place of all the virtuosi of the city'. Only in his late twenties, Vendramin was already amassing his famous collection, an ever-expanding cabinet of curiosities that included antiquities of all kinds, ancient jewels, exotic marbles, Raphael drawings and Flemish Madonnas. His brother-in-law, Taddeo Contarini, another key member of this circle, owned three Giorgiones: *The Birth of Paris*, *The Underworld with Aeneas and Anchises* and the mysterious *Three Philosophers*. Gabriele himself owned Giorgione's *The Dead Christ*, long since lost, and the most famous of all the artist's paintings, *The Tempest*.

Vendramin, Contarini and their peers were part of a generation who are understood to have received a broader and more extensive education than their fathers, who had studied philosophy, natural sciences and classical literature at the universities of Padua and Bologna (Venice didn't have a university). And in this socially exclusive milieu, Giorgione shone out. It was here that Giorgione was called upon to sing and play upon the lute. Giorgione, the multi-talented genius, the singer, painter and social charmer who burned twice as brightly as anyone around him, the poor boy from Castelfranco who was

accepted by the future leaders of Venetian society as an equal and a friend. Giorgione is the artist who embodies this moment: the sudden advent of the Venetian Renaissance. Looking at *The Tempest* beside even the latest of Bellini's paintings, you realise that something has happened, that some fundamental shift in consciousness has taken place – the first stirrings, perhaps, of the Romantic sensibility.

But was the intellectual level of the Vendramin circle anything like as elevated as has been claimed? Were the Vendramin, the Contarini and their friends humanist merchant-princes who devised arcane, multi-layered subjects for their friend Giorgione to realise in paint? Or were they weekend hobbyist intellectuals who relied on their pet genius Giorgione to provide a bit of light relief in lives principally preoccupied with politics and commerce? And, as for Giorgione, was he anything like the pivotal figure that four centuries of 'tradition' and romantic anecdote have led us to believe?

From the point of view of documents and verifiable facts, Giorgione barely exists. Venice in the early years of the sixteenth century has been compared to early-twentieth-century Paris – the large number of astonishingly talented individuals sparking off each other, the sense of sudden, accelerated development; a scenario in which Giorgione stands in for Braque, Titian for Picasso. But while it is possible to trace what Picasso and Braque were doing practically day by day, all we have in the case of Venice are a couple of dozen mostly unsigned paintings and the names of a number of artists who we know were in Venice at the time – namely Giorgione, Palma Vecchio, Sebastiano del Piombo and Titian. And it is according to how you assign these paintings between these artists that you decide whether Giorgione was the central figure of the Venetian Renaissance, who introduced *la maniera moderna* and consigned the Byzantine-Gothic ways of the Bellini to the past, or whether he was a quasi-dilettante figure, who alienated powerful sources of patronage – the Church and the Venetian state – and never quite fulfilled his potential.

And we shouldn't forget that, far from simply enjoying the fact that it was now having a renaissance, Venice at this time was facing the biggest catastrophe in its history: its imminent destruction by the forces of the combined great powers of Europe – the League of Cambrai.

* * *

One afternoon, when I was sitting working in my overcrowded flat in north London, I received a surprise telephone call. The voice was higher and breathier than I remembered it. At first I thought it was someone in Bangalore trying to persuade me to change my mortgage.

'Mr Hudson, this is Alessandra Felzi in Venice.'

'*Alessandra* . . .? Dr Felzi!' Immediately, I was back in my hotel room in Venice talking to Dr Felzi on the Mestre bus – immersed in that strange mood of excitement and uncertainty. And I was painfully aware of how little I'd done over the intervening period.

'Mr Hudson, have you finished your project on Titian?'

'I've hardly started it.'

'Then I think I have someone who may be able to help you. But I must ask one small favour in return.'

'What's that?'

'You don't mention my name, or tell them that I sent you to them . . . under any circumstances.'

The following day I telephoned an acquaintance, an Italian artist now resident in Cambridge who had spent some years in Venice and retained good connections there. When I mentioned the name given by Dr Felzi, his tone became sheepish.

'Ah, yes. It did occur to me to put you in touch with this person, but I wasn't sure if it would be appropriate.'

'Appropriate? In what way?'

'You will find out when you meet him.'

'Who is he?'

'Some kind of printer, maybe a bookbinder. He has published something about Giorgione.'

'Is it good?'

'I haven't read it.'

The person I spoke to on the phone sounded disappointingly ordinary: polite, even deferential, apologising for his lack of English while speaking it pretty fluently. Yes, he would meet me, with pleasure. But when I phoned again, just after my return to Venice, to confirm our meeting, there was only the answering machine. Half an hour later my mobile jangled angrily into life. I received an earful of rapid and indignant Italian.

'I'm the English journ—'

'*Sì, sì*. And next time you phone, you leave a message!'

The phone was slammed down.

The address . . . No, let's forget addresses. Venice doesn't really do addresses. The place to which I had been instructed to go lay to the east of the great Dominican basilica of Santi Giovanni e Paolo in the *sestiere* of Castello, off a long, bare and rather draughty street in an area which, in Titian and Giorgione's time, was populated principally by workers from the Arsenale shipyard. Looking up at the corners of the buildings you could occasionally see small, carved images of St Barbara, patron saint of artillerymen and coal miners, indicating that the property once belonged to the Scuola di Bombardieri, charitable brotherhood of the cannon makers.

Turning south near the Church of San Lorenzo and the bridge where the Relic of the True Cross was dropped into the canal, I thought I'd got lost. Then, rounding a corner, I saw a small shop beside a bridge with a very low doorway, and, leaning out of it, a broad-chested, bearded man, glowering at me. As I approached, he pointed to his chest. 'It's me,' he said. He was perhaps in his late fifties, dressed in a thick woollen jumper, with a woollen hat pulled back from his broad brow, giving him the look of a rather angry fishermen, his beard, that must once have been jet-black, now mostly grey. He had a finely shaped, aquiline nose, and, regarding me from above a pair of half-moon glasses, intense, smouldering black eyes that appeared uncertain whether to tear me limb from limb or simply run away. I made a fumbling profession of my pleasure at seeing him. He nodded and turned into the shop.

The window was empty save for a single business card, but inside every surface exploded haphazard with heaps of card and paper, shelves crammed with ancient-looking ledgers, rolls of leather and lining material, and of course books, thousands of books, their spines black with age. There was the smell of leather and glue, and looming above the chaos the arm of a great press that only just cleared the ceiling beams, which sagged visibly so that you could feel the pressure of the upper storeys bearing down on the cramped space. In the centre of the room was a single cleared area of workbench, lamp-lit.

'You've seen these shops full of pretty notebooks, that everybody buys and nobody uses. We don't do that. We bind books for writers

and academics, using traditional methods.' He pointed to a cluster of framed photographs crowded into the only clear area of wall – faded pictures of middle-aged men. 'You know Thomas Mann? This is Hemingway with my father. Moravia, Italo Calvino.' Among them was a recent colour photograph of the sole woman. 'Danielle Steel – *un' americana*. They have all been here.

'You know this?' he said, placing a large, black-bound book into my hands. I could feel the spine cracking as I prised it open. The paper had an oddly translucent quality. *Hypnerotomachia Poliphili*. Of course! The great dream-narrative – first cult masterpiece of the printing age. There were the strange, oddly blank pictures that had influenced Aubrey Beardsley, Walter Crane and a thousand illustrators. 'The writer was a monk, just here, at Santi Giovanni e Paolo.'

'You did this yourself?' I asked.

'*Prego!*' he said, pulling the book quickly from my fingers. 'This is the original edition, 1499.' I glanced up at his black eyes burning into me with a look of intense reproach.

He shifted a great stack of papers from a chair, and gestured me to sit down. 'So you want to know something about *La Tempesta di Giorgione?*'

'*Sì.*'

'*Va bene*. There are thirty-three, maybe thirty-four theories concerning *La Tempesta*. But I have proposed something very concrete.'

His voice was slightly throaty, not exactly high-pitched, but with a sharp, slightly shrill edge, and his English, though pretty good, felt effortful, as though it were almost physically painful for him to cram his expansive vowels into the niggardly interstices of the English language. Whenever I arrived in Venice, I was always painfully aware of how small a role language played in the understanding of visual art. Titian and Giorgione were first and foremost Italians, they spoke and thought in Italian and must have conceptualised their work in some indefinable way in Italian. How could their work be apprehended through any language other than Italian?

And all the time I was aware of my host's angry eyes upon me, gauging the level of my interest, searching for signs that my attention

was slipping – that he was wasting his time – and yet becoming oddly absent as his speech gained momentum and he warmed to his theme.

'You must understand that when this picture was painted, in 1508, Venice was facing disaster. All of Europe was against us. The Pope, France, Germany, Spain. They form the League of Cambrai with the aim of destroying Venice. The *terraferma* . . . You understand the concept of the *terraferma*?'

'*Sì.*'

'The *terraferma* is the part of the mainland that belongs to Venice, and at this time it has become very . . . *lar-rge!* From Udine, close to what is now Slovenia, to Bergamo, beside Milano . . .'

I heard a creak behind me, the door swung open and I glanced round to see a stocky, grey-haired man with an oddly hapless air. He asked some apparently innocuous question, and I could immediately feel the growl boiling up in my host's stomach, sense the bile pulsing in his temples, the voice coming hard in my ear, urgent and menacing. The grey-haired man said something else. I glanced up to see my host beginning to rise from his seat, apparently about to launch himself at the other man. But Grey Hair was already retreating back into the street, closing the door behind him.

My host sank into his seat. He pulled off his woolly hat, ran his hand through his rumpled hair and sat there breathing deeply through his nose, apparently unaware that I was there. Then he turned and saw me. '*Sì?*' he growled.

'*La Tempesta?*'

'*Sì, sì. La Tempesta.*' He winced as though in pain, cursing under his breath. I wondered whether to make my excuses and beat a hasty retreat, but he was quickly back into his narrative.

'All of the *terraferma*, what we call la Marca, was under threat. So my essay is about the relationship between Giorgione and Bartolommeo d'Alviano. You know something about Bartolommeo d'Alviano?'

'Er . . . no.'

'He was a condottiere – a *capitano di ventura*.'

Now I knew who he was talking about. A *capitano di ventura* might sound romantic – a soldier of fortune. But Bartolommeo d'Alviano was a mercenary, one of the innumerable minor nobles who sold

their services in the endless wars that racked Italy in the late fifteenth and early sixteenth centuries. And he was, from what I remembered, quite an intriguing character, a Roman aristocrat of the Orsini family who commanded the Venetian forces in the campaign against the Emperor Maximilian, leading them to a famous victory – the so-called Battle of Cadore – that took place (by total coincidence) in the fields below Titian's home town, Pieve. Bartolommeo had been the hero of all Venice, until the Battle of Agnadello, the following year, when he presided over the most humiliating defeat in the history of the Republic. He had been taken prisoner by the French, and never set foot in Venice again.

But what had any of this to do with Giorgione?

'The whole of the *terraferma*, what we call la Marca – la Marca Trevisana – was exposed. Venice was preparing for war. Bartolommeo d'Alviano was sent by the Venetian government to inspect and strengthen the defences of all the cities of la Marca: Treviso, Vicenza . . .' He counted them off on his fingers, and I was just wondering when he would get to the point, if there even was one, when there was a thump behind me, a creak and there was Grey Hair again, his tone already defensive. My host's response was immediate, his tone murderous, as though something inside him were splitting apart. But the shorter man stood his ground, his voice rising indignant in some half-Croatian argot I took to be Venetian dialect. My host was on his feet, his voice rising in a simultaneous crescendo. His opponent made one last yelping exclamation before running, slamming the door behind him. My host stood over me, standing as upright as he could in that cramped space, breathing heavily, his coal-black eyes boring into me, but scarcely, it seemed, seeing me.

'What I am trying to say is that *La Tempesta* is a *copriritratto*.'

'Right.'

'You understand the concept of the *copriritratto*?'

'No.'

'Come with me.'

He locked the street door, then led me out of the back of the workshop, up a stone staircase caked in white dust and flaking plaster to a heavily padlocked door. 'Everything must be locked,' he growled as he fumbled for the key. 'Nothing is safe!' He opened the

door, clicking on a light to reveal a dim space heaped with old boxes and bags, dust-laden musical instrument boxes, a wrecked bicycle, a mannequin and, at the far end, in the glare of a single spotlight, a great mass of images that almost filled an entire wall. As I got closer I could see postcards, magazine cuttings, what looked like old engravings, and drawings and paintings that might have been quite recent. At a glance it looked like one of Rauschenberg's neo-dadaist collages, except that everything in it related to the Renaissance: portraits from paintings, old coins and medals, landscapes, cherubs, coats of arms, paintings and photographs of palaces and churches. And even at a cursory look you could tell that this great assemblage had a purpose, that it was a diagram, a map, leading towards something. And there in the centre, heavily worked in black ink on paper, was a drawing of *The Tempest*, more or less the same size as the original, just over two feet by nearly three. And as I got up close, I could see that every shadow on every last leaf had been densely hatched in with the super-fine point of that most neglected of graphic instruments, that great mainstay of 1970s design, the rapidograph. I hadn't realised they were still making the things. To have realised the painting in this degree of detail must have taken months, even years.

'This is my work,' said my host. 'The other things, the books, they are an obligation, to my father and my grandfather.'

He stood close to the drawing, seeming calmer now, completely absorbed in the obsessive, rhythmic flow of marks on paper. '*La Tempesta*, you see, is an allegory of the Venetian state.' He tapped his finger on the figure of the breast-feeding woman, the so-called gypsy. 'This woman, naked, defenceless, represents la Marca Trevisana – the *terraferma*. You see her feeding her child: she represents the land that must be defended, but is completely . . . *vul-ner-able*!

'And here in the background, the city without walls, which is, of course, Treviso.' Yes, Treviso, the city thirty kilometres to the north into whose nondescript little airport I had flown with Ryanair just two days before, which still did see itself as the first city of the Venetian *terraferma*. 'Treviso's walls were destroyed in the Middle Ages. So we have again the allegory of the *terraferma*, which is not protected. And here,' he pointed to the shepherd-soldier figure in the bottom left of the image, 'wearing his family colours, red and white, who do we see?'

'Er . . . Giorgione?'

'No! Not Giorgione! Bartolommeo d'Alviano! Bartolommeo d'Alviano dressed as a military engineer. The man responsible for defending the *terraferma*. So, here is the woman – the *terraferma* which is defenceless – and here is the man – Bartolommeo d'Alviano – who defends her.

'And you see the painting is small. Very small! It is very rare, in fact unknown, to find a literary subject, or a landscape of any kind in Venice of this size, except in the *copriritratti*. You understand?'

'No.'

'A *copriritratto* is a piece of wood, a panel – painted. It masks the portrait. You see the portrait . . . You move the *copriritratto* – sssst!' He made a sliding movement with his hand. 'The portrait disappears.'

'A portrait cover!'

'So! A portrait cover!' He pointed to the left of the drawing of *The Tempest* to a rather crude reproduction that appeared to have been cut from a magazine: a picture I'd seen before, the portrait of a young knight, a handsome, long-haired fellow in black armour, looking boldly back at the spectator, the head and shoulders of his squire squeezed into the top left of the image, which was dominated by the handle of the great broadsword held up by the knight, half-cross, half-phallus.

'You know this painting in the Uffizi? Attributed to the School of Giorgione. Started by Giorgione, maybe finished by a pupil. And you see, the features are very similar to the face of the figure in *The Tempest*. Look, they're almost the same!' I wasn't convinced they were so similar, but didn't feel inclined to contest it. 'And the most important thing, the dimensions of the two paintings are exactly the same!

'*La Tempesta* is the allegory of Bartolommeo d'Alviano painted as a cover for this painting – the portrait of Bartolommeo d'Alviano!'

But why would they have wanted to cover the painting?

'It was normal at that time! They could not bear to have the human face on the wall, looking at them, like this . . .' He pushed his face close to mine, almost giggling with excitement. 'They weren't used to it! They didn't have mirrors. They understood the profile as a memorial of the dead. But to have a life-size portrait always staring

at them? No! So they have another painting, an allegory of the person in the portrait, to cover it. Then, when they want to see the portrait.' He mimed the movement of the panel. '*Ecco!*'

He pointed to other images in his great assemblage, portraits by Lorenzo Lotto and the painted panels – generally mythological figures in landscapes now dispersed into other museums in other parts of the world – that had once covered them. There had been many such images, most of them lost or disassociated from the paintings they had once covered. It was one of those conventions of the time – like the covering of devotional paintings with curtains so that the gaze of the Madonna or Saviour would not shame the people in the room – that made you realise how utterly different people's ways of appreciating art had been.

And his theory was brilliant. Far from being an isolated, freestanding, inexplicable masterpiece – an unprecedented poetic work of unfathomable depth – which seemed to confound everything we knew about the culture of the time, *The Tempest* had been incidental to another work. It had served an almost banally practical function, providing a decorative cover – if one with an intriguing allegorical meaning – to a painting which was far less interesting according to our way of seeing things, but was accorded infinitely more importance at the time. A *copriritratto*! That was one step up from furniture painting. Never mind that the Uffizi painting was by no means definitively by Giorgione, that Bartolommeo d'Alviano had been short, fat and over fifty when *The Tempest* was painted – certainly nothing like the Wagnerian sex god in the portrait – the logic held good. It did nothing to diminish *The Tempest* as a work of art, but it showed that, far from operating outside the norms of his time, Giorgione had been very much defined by them.

But, still, hadn't *The Tempest* been commissioned by Gabriele Vendramin?

'*Fan-tasia!* The Vendramin circle, Pietro Bembo, Caterina Cornaro!' He threw up his hands – I was really warming to him now. 'All this is romantic fantasy! Gabriele Vendramin was twenty-eight. He *bought* paintings and objects, but he was in no position to play the *mecena* – the great patron.'

So had there been much interest in his theory?

He snorted. 'I am an artisan, not a scholar. I work with my hands. Who is interested in what I think?'

'But you published a . . . pamphlet.'

He gestured into the shadows, where I could see great stacks of dog-eared paper rearing behind the bikes and musical instrument cases. 'There is the pamphlet.'

I felt I should make some comment on it, but decided on another tack. 'How did you become interested in Giorgione?'

'I am a Venetian. Giorgione is Venice.'

'What about Titian?' I said, and instantly regretted it.

There was a silence, and I didn't dare look at him. Then I heard him speak in a dead tone. 'What about him?'

'Well, how does he fit in?'

'*How does he fit in?* You told me you wanted to talk about Giorgione, and now you're talking about Titian.'

'Well, I mean . . . you can't discuss Titian without discussing Giorgione.'

'We never mention Titian in this house.'

I was out of there in less than a minute.

Let's look at the most Giorgionesque of all Giorgionesque paintings, the so-called *Pastoral Concert*, one of the central images of the Western tradition, described recently as 'the greatest erotic masterpiece ever created' – an icon of youth, freedom and beauty that was reinvented by Manet as the great painted manifesto of nineteenth-century bohemianism, *Le Déjeuner sur l'Herbe*. It's a painting that's as responsible as any for the idea that culture is about attractive people doing attractive things in attractive places. Here are two handsome young men sitting playing music in a lush, sun-drenched landscape in the company of a couple of beautiful naked girls. It's an image the modern mind instinctively feels it understands: the long hair of the men and the easy nakedness of the women give them the look of a group of rich hippies getting it together in the country – an impression that even the floppy red beret and full-sleeved doublet of the lute-playing figure on the left don't quite dispel. And that, of course, was more or less what Manet gave us in *Le Déjeuner sur l'Herbe*: the two black-suited artists who have taken the train to the country for the

afternoon, their model girlfriends feeling so relaxed in the presence of nature they've thrown their clothes off – spontaneously. *The Pastoral Concert*, on the other hand, isn't quite as straightforward as it first appears.

The two young men, the lute player and his companion with the mop of sun-bleached curls, may look as though they've been friends for years, but looking into the shadows beside them you see that the latter is barefoot – indicating that he is probably a shepherd – while the other's parti-coloured hose and rich red velvet and satin garments would immediately identify him to a contemporary viewer as a member of one of the Compagnie della Calza. The instrument he's playing – the lute – would have been an expensive luxury item, an anomaly in this relaxed rustic setting. So what is this urban dandy doing in the depths of the countryside? Is he teaching the structured sounds of the metropolis to these earthy rustics? Or has he come to learn the organic, intuitive music of the earth from them – as the hero does in Jacopo Sannazaro's *Arcadia*, a contemporary bestseller that created a wave of nostalgia for a lost rural paradise?

And the two young women, one seated holding a shepherd's pipe, the other standing, pouring water into a stone basin from a glass jug? Absorbed in their conversation, the two young men seem hardly aware of them. And the more you look into the image, the more you start to wonder if the men can see these voluptuous figures, if they know they are there at all. Far from being a couple of floozies the young men picked up on the way, these beautiful, if rather heavy-limbed young women, probably represent muses, spirits of the landscape, who inspire the music of the two young men, but remain invisible to them.

Meanwhile, a shepherd drives his flock home in the background, the glistening summer air heavy with an almost electrical tension, the sky subtly darkening, showing that the afternoon is now well advanced, that this moment of enlightenment in the presence of nature is, like all things, transient. Yes, the ultimate Giorgionesque painting. The only problem is, it isn't by Giorgione.

If you look at a book on Giorgione published fifty years ago, you'll see *The Pastoral Concert* among the most prominently illustrated works. But if you look at a modern book on Giorgione, you'll find

that *The Pastoral Concert* and half the other paintings from the 1959 book aren't there. The *Storm at Sea*, cited by Vasari as an example of Giorgione's ability to capture sensations generally considered beyond the reach of painting, will now be found in a book on Palma Vecchio; the *St John Chrysostom with Saints*, another erstwhile Giorgione masterpiece, in a book on Sebastiano del Piombo. As for *The Pastoral Concert*, with its sumptuous textural transitions – between the damp grass, the warmth of the women's skin and the glinting silk of the young man's billowing sleeve – the balance of brilliant sunlight and impending darkness, who could it be by but Titian?

The sense of the oncoming storm – which remains just a hint in *The Pastoral Concert* – and the contrast between clothed male and naked female figures (not to mention the emblematic red and white clothes of the male) make the painting feel almost a continuation of Giorgione's *Tempest*. Yet in comparison with *The Pastoral Concert*, the Giorgione feels effortful, even slightly gauche. *The Tempest* gains much of its sense of mystery from the fact that the figures don't interact: like the figures in most Giorgione paintings, they just stand or sit there, waiting for the comprehension of the viewer to breathe significance into them. But in *The Pastoral Concert* there's a closeness and intensity to the conversation of the two men. The way the profile of the aristocratic young lutenist is caught in silhouette – shadow falling across his lute – his pointed features leaning intently towards the shepherd, pulls our attention into the painting, creating a new sense of movement and dramatic engagement.

But if this painting is by Titian, when did he paint it, and for whom? Giorgione, as we have observed, barely exists. But compared with Titian at this time, Giorgione resonates through history as a vital and clamorous presence. Titian, before his sudden appearance painting frescoes at the Fondaco dei Tedeschi, is just a ghost-like after-image barely perceptible in the wake of Giorgione – an adolescent boy who is always there following the great Zorzon around. From being Giovanni Bellini's surrogate grandson, Titian became Giorgione's younger brother, his spiritual disciple, his shadow.

Titian adopted Giorgione's way of working so completely, so perfectly, so wholesale – he became Giorgione to the extent that the two men's paintings were being confused even when Giorgione was still alive.

Titian usurped Giorgione's position, and over the succeeding centuries whole aspects of Giorgione's *oeuvre* have been subsumed into his.

Hanging from a pillar in the Church of San Rocco was a small and relatively unremarkable painting, *Christ Carrying the Cross* – the moist-eyed Saviour turning towards the viewer as a fierce-looking Jew dragged him along by a rope – to which, from about 1520, miracles began to be attributed. And as the church and the painting belonged to the Scuola Grande di San Rocco, a charitable brotherhood devoted to the patron saint of plague sufferers, it is likely that these miracles related to the plague. During the periodic waves of panic and the epidemics that laid waste the city's populations every two or three decades, this painting attracted more money in alms – as Vasari put it – 'than Giorgione and Titian earned between them in their entire lives'. It is said that the building of the nearby meeting place of the Scuola, with its two great cycles of paintings by Tintoretto, was paid for entirely from the revenue from this one painting. In the first edition of *Lives of the Artists*, Vasari attributed the painting to Giorgione, in the second to Titian. And this amendment was based entirely on information from one particular source. And who was that source? Why, Titian himself, of course. By the time Vasari arrived in Venice, Giorgione had been dead for three decades.

The first symptoms of bubonic plague are swellings in the groin, the armpit and the lymph gland, which cause severe pain followed by fever, headache and acute thirst. As the disease progresses the victim suffers diarrhoea and vomiting, secondary swellings and petechial spotting – small red or purple marks – across the entire skin. The stench from the body of the patient was said to be unbearable.

In 1509 there were a few isolated cases of the disease in Venice. The death toll increased dramatically during the following year, and, by the autumn, an epidemic had been declared. But Giorgione, who was having a passionate affair with a certain Venetian lady, went to visit her according to his habit, not realising she was infected with the plague.

Within weeks of his death, the big collectors of northern Italy were casting around to snap up any remaining paintings. On 25

October, Isabella d'Este, who had clearly never heard of the artist and knew nothing of his work, wrote to her agent in Venice urging him to acquire a painting she had heard was still available, 'a picture of Night'. He wrote back informing her that the aristocrats of Venice had had these paintings made to enjoy 'in their private homes', and would not sell the works of their lost friend 'at any price'.

Titian, meanwhile, was in Padua, painting frescoes for the School of St Anthony, and so missed the worst of the epidemic of 1510–11. But then, as Vasari maintained, Titian always was extremely lucky.

There he sits in one of his most famous portraits, looking out at the viewer with a frank, take-me-as-you-find-me confidence – not quite haughty, not quite arrogant, but without illusions – a man who wouldn't be easily impressed by anyone or anything; whose cool gaze suggests no cultural aspirations beyond what can be directly perceived through his own shrewd, sceptical intelligence – a quality expressed in the narrowed, slightly puffy eyes, the jutting beard and the very faintly sneering mouth.

The symbolic resonances of the Giorgionesque allegorical portrait – which allowed Titian's sometime mentor to portray himself as King David – are absolutely gone. There are no literary allusions here, no subtext. Titian, like the man in the painting, is interested in what is directly in front of him, in what he can see. And what is directly in front of him now is the magnificent padded sleeve of the sitter's blue silk doublet, its broad pleats steamed into a mass of transverse crumples that echo the contemporary fashion for slashing. It's the sort of sumptuous textural effect that Venetian craftsmen prided themselves on – and a nightmare for any artist. Titian, though, relishes the challenge, putting the sleeve bang in the middle of the painting, resolving it in a single, almost block-like mass while retaining the sense of sumptuous softness – the sitter's arm thrusting out of the painting at us, an assertion of his masculine force and of the painter's supreme skill.

This was one of Titian's very first portraits and already he'd hit on a compositional idea that was to be copied again and again by artists over the centuries, not least by Rembrandt, who saw the painting reproduced in an engraving. But who is this man who turns towards

us, the far side of his face in shadow, with that faint, but unmistakable and slightly arrogant tilt of the head?

Vasari mentions a portrait of a member of the Barbarigo family, a painting so realistic that the stitches on the silvered satin doublet might be counted, which so impressed the family that they pressed for his commission at the Fondaco dei Tedeschi; which means that Titian would have been only eighteen when he painted it – not entirely impossible. For centuries the painting was believed to show the poet Ludovico Ariosto, author of the verse epic *Orlando Furioso*, whom Titian met at the court of Ferrara, which feels too whimsical, too literary, too Victorian. No: the more you look, the more you begin to realise that the pose and the particular tilt of the head are exactly what the painter would have seen when turning to regard himself in the mirror. It might be difficult to believe that Titian was this much of a dandy, that he shaved his eyebrows. But would anyone look at someone with quite that degree of searching, disdainful candour, except themselves?

Looking at *The Man with the Blue Sleeve* beside the famous portrait of the black-gowned, white-bearded Titian at well over seventy, you saw that the two men were physiognomically completely different. Even accounting for the fact that as much as fifty years separated the two paintings, it was impossible to ignore the difference between the young man's straight, possibly slightly upward-turning nose and Titian's hawkish, aquiline slope.

But then, looking closely again at the painting, you saw that the features were drawn in very precisely, almost dryly, as though scratched on to the canvas with the hard end of a brush. And, while in most portraits the features start to dissolve as you move in close, these remained in focus, retaining that look of relentless, pitiless enquiry no matter how close you got.

Can Titian really have been born in 1489? This would have made him nineteen when he worked on the frescoes at the Fondaco dei Tedeschi, which isn't so implausible. But from there on, his rise seems too sudden, too dramatic, to be quite credible. With a few gauche, semi-juvenile works behind him, he's suddenly producing universal masterpieces of the order of *The Pastoral Concert* and *The Man with the Blue Sleeve* and moving into position as the de facto leader of the

artists of Venice. There is a small but influential body of opinion that Titian was a handful of years older than is now generally supposed, which would have made him in his mid- to late, rather than his early, twenties when he arrived at this point. But if that is the case, why aren't there more references to him in the letters and the literature of the time?

But whatever his age, with Giorgione dead and his most talented Venetian rival, Sebastiano del Piombo, having moved to Rome in 1511, only one artist now stood between Titian and complete domination of the Venetian art scene – his old teacher, Giovanni Bellini. Bellini was still venerated as the city's senior artist, looked to for the last word on any matter relating to the visual arts in the city. And he had no intention of moving aside for anyone. At over eighty, Bellini was still breaking new creative ground. He had absorbed the ideas of Giorgione, an artist fifty years his junior, smudging and darkening the edges of his forms and practically doing away with line altogether. He delivered his first major mythological composition, *The Feast of the Gods*, to the court of Ferrara when he was eighty-four, painted his first female nude, the majestic *Lady with a Mirror*, when he was eighty-five. Since his brother Gentile's death in 1507 he had been in charge of the city's great ongoing artistic project – the decoration of the Hall of the Great Council in the Doge's Palace. But the fact that this work had now dragged on for well over thirty years didn't reflect well on him.

Part of the problem was that the principal artists were paid not with cash, but with privileges, in this case through the complex mechanism of a broker's patent at the Fondaco dei Tedeschi. Since the Germans were not permitted to trade on their own account, and could buy merchandise only through the offices of a native Venetian, thirty brokers were at the disposal of 'strangers' at the Fondaco, positions that were in the gift of the Venetian government – a transferable sinecure, which the holder farmed out to his own commercial and social advantage. A number of these were used to pay artists for official duties.

Known as a *sanseria*, a broker's patent yielded the considerable sum of 100 ducats per annum with tax exemption of around twenty ducats and occasional fees for extra duties. The sinecure was for life,

an official pension, and, once in possession of it, the artist had little incentive to do any actual work.

With painful slowness, the frescoes in the Hall of the Great Council, showing the conflict between Pope Paul and the Emperor Barbarossa, had been replaced by oil paintings on canvas of the same subject by the Bellini, by Vittore Carpaccio, by Alvise Vivarini, by the Umbrian master Perugino and many other artists. By 1513, two of the paintings still hadn't been commissioned, and these, naturally, were the ones in the worst possible positions – between the windows on the south side of the vast chamber, where the blazing light from the Grand Canal would reduce the images to a barely legible smudginess.

Early in that year, Titian had been invited to Rome by the newly appointed Pope Leo X at the suggestion of his secretary Pietro Bembo, one of the iconic intellectual figures of the time, whom we've already encountered as art adviser to Isabella d'Este. While the idea of working in the greatest city in Christendom alongside the greatest artists of the time – Michelangelo and Raphael – must have been extremely tempting, Titian turned down the offer on the advice of another prominent Venetian intellectual (and probable rival of Bembo), Andrea Navagero, official orator to the Council of Ten, the body that effectively ruled Venice. Going to Rome wasn't just a matter of personal development, of absorbing new influences in a headily stimulating creative environment. It would have meant effectively renouncing his claims on the Venetian scene, of abandoning his hard-won position at the very moment when the ailing Giovanni Bellini was about to depart the stage.

Having politely declined the Pope's offer, Titian fired off a letter to the Council of Ten, telling them of the request of his Holiness and stating his intention to begin work in the Hall of the Great Council – 'if it meets with your approval' – on a battle scene that would hang between the windows on the south side of the great chamber, a position so difficult, he claimed, that no one but he had the courage to attempt it. 'I should be willing to accept for my labour any reward that might be thought proper, but being studious only of honour and wishing for a moderate competence, I beg to ask for the first broker's patent for life that shall become vacant at the Fondaco dei Tedeschi – irrespective of all promised reversions of such patent, and on the

same conditions, or with the same charges and exemptions as are conceded to Master Giovanni Bellini: two youths as assistants, to be paid by the Salt Office, and all colours and necessaries: in return for which I promise to do the work above-named with such speed and excellence as will satisfy Your Sublimity, to whom I beg to be humbly recommended.'

This is the first appearance of the Titian voice: cool, worldly, frank, homing in on its material objective with decisive sureness. Yet it is difficult to imagine anyone, even the most impetuous upstart, firing off a broadside of such breathtaking chutzpah – requesting – no, demanding – to be employed on the same terms as the leading artist of Venice, a man his grandfather's age, under whom he had himself studied – without having already received some assurance of success. It is probable that Navagero suggested this move, and even wrote the letter on his behalf.

And it is equally impossible to imagine that such a move would not have met with a robust response from those with long-vested interests in these matters, who had their own protectors and patrons in the highest echelons of the Venetian state. I'm talking not so much of Giovanni Bellini – though he can't have been pleased – but of an artist closer to Titian's own age, who had worked as Bellini's assistant in the Hall, who had completed his own painting there, and understood that the next available *sanseria* was earmarked for him. I'm referring to one of the great masters of the Venetian narrative tradition, the creator of the St Ursula and St George cycles, Vittore Carpaccio.

Titian's petition to the Council of Ten was accepted with all the conditions requested. He moved into a studio in the Parish of San Samuele, to the west of San Marco on the Grand Canal, in the shell of a building, an unfinished palace formerly belonging to the Duke of Milan, which was now the property of the Venetian state. Here he lodged with his two assistants, Antonio Buxei and Ludovico di Giovanni, both former assistants of Bellini who had been sacked for leaving work without permission.

The following March, however, the Council of Ten reversed its decree, declaring that Titian would not be granted a *sanseria* on the first vacancy but must wait his turn, while his assistants were to be struck off the government payroll with immediate effect.

Titian grumbled at 'the skill and cunning of those who do not want to see me as their rival'. In a letter of November 1514, he asked that he be given the *sanseria* that would become vacant on the death of Giovanni Bellini and that the Salt Office – the department responsible for maintaining public buildings – pay his assistants and the cost of his pigments, as before. This request was accepted, but, a year later, in December 1515, all artists working in the Hall were dismissed pending an inquiry into the spiralling costs of the project. Minutes submitted to the Council of Ten on 29 December claimed that the costs already incurred in providing paintings for the Hall of the Great Council would have covered the cost of replacing the entire palace or of three times as many paintings as had so far been produced. No accounts had been produced concerning the grants made to the artists or the cost of their accommodation, and two canvases for which nothing more than preparatory drawings had been produced had already cost more than 700 ducats. Such waste was inexcusable, the report concluded, when there were masters in Venice who could have completed each painting from scratch for 250 ducats.

It is probable that the artist who claimed to be prepared to work at such competitive rates was Titian, while the uncompleted canvases were those of Giovanni Bellini.

On 29 November 1516 Bellini died, and all the privileges and exemptions associated with his broker's patent passed to Titian. As for Vittore Carpaccio, who had assumed himself Bellini's natural successor, his vivid, anecdotal style was ideally suited to the kind of aggrandising official paintings that hung in the Hall of the Great Council. But he and his way of doing things – rooted in the International Gothic of Jacopo and Gentile Bellini – were already passing into history. Carpaccio lived another two decades but he never again received an important commission in the city of Venice.

As for Titian, as soon as he had obtained his *sanseria* he immediately dropped any pretence of interest in his obligations in the Hall of the Great Council. He had far bigger fish to fry.

5

A Moment of
Enormous Confusion

IT WAS APRIL, sunny but rather cold and windy. By seven in
the evening, the lights were on in the cafés along the
Fondamente Nove – the white stone embankment just north
of Titian's house – the plastic awnings that covered the outside
tables flapping in the wind. But there was still a blue glow in the
air, that sense you have at that time of year of the evening suddenly
rediscovered – of light paid back from the dark of winter. And
far away across the Lagoon, beyond the industrial suburbs and
the drear flatness of the Venetian plain, the faint outline of the
Dolomites could just be discerned among the clouds building on
the northern horizon.

Rolf Himmelheber was on his way to dinner. He came breezing
along the Fondamente Nove, trench coat flapping in the wind, a long
woollen scarf thrown back over his shoulder. I followed him to a
small table at the back of one of the cafés. Professor of art history at
the University of Cologne, and a leading figure in the field of Titian
studies, he was fitting me in before a dinner for which, he led me to
understand, lateness was inconceivable.

'It was a moment of enormous confusion. Enormous numbers
of people had already died. If you read contemporary or near-
contemporary accounts of the plague in other major Italian cities,

you will see that despite the precautionary measures that existed
in all of these cities, a degree of chaos was inevitable. The head of
the household, the great painter, has died. His faithful younger son,
Orazio, dies almost immediately. It's possible that at least one other
member of the workshop who may also have been living in the house
also died.

'In the midst of this confusion, Titian's elder son Pomponio, the
priest, the black sheep of the family, the good-for-nothing – who
hadn't spoken to his father in years, probably decades – arrived in
Venice. He entered this city where the plague was raging, with all
the danger that entails, and he came to the house here in Biri Grande,
just thirty metres from where we're now sitting. The house had been
sealed by the Venetian authorities, but as a priest he was able to gain
access, and the tragic thing was that as soon as he gained possession,
he sold everything he could find in the house. Everything, that is, that
hadn't already been looted by others.'

I had been led to understand from books by current authorities
that reports of thefts from the house might have been exaggerated.
But now I was being told that there was some looting – that there
was a break-in.

'We have to assume so. In fact, it's almost impossible to imagine that
there wasn't. It seems that for a critical moment the house was abandoned.
And it seems almost inevitable that some things have been removed by
third parties. Wherever there is confusion, people take things. You only
have to look at the recent circumstances in Yugoslavia. This seems to be
the way things go and I'm sure it happened here as well.'

And could any of these things have been paintings – important
paintings?

'It's a nice thought,' he said with an indulgent smile. 'There are
none that we know of, but it's not impossible. A few years ago, when
I was teaching at Princeton, I went to one of those big apartments
on Fifth Avenue to look at a Tiepolo painting. And the owner told
me that his neighbour downstairs had a nice picture that he thought
might be a Titian.

'This,' he said, 'is the kind of thing that happens between Fifth and
Park. It was in fact an unpublished late Titian – a St Sebastian.

'I'm just telling you this so you can see that this kind of thing can

still happen. So it's not impossible. But how you would go about researching that I can't begin to imagine.'

Professor Himmelheber looked at his watch. 'I wanted to meet you because I wanted to impress on you the many complexities and difficulties inherent in the task you have set yourself. And one thing you mustn't underestimate in looking at Titian is the importance of the Venetian tradition of the family studio.

'Titian had geniuses of the order of El Greco and Tintoretto pass through his studio, but they couldn't get space to develop, so they moved on. Titian preferred to have members of his family working for him – even if they were mediocre artists – rather than attract and keep the greatest artists who were available at the time.

'And these family members, Orazio, his son, Marco Vecellio, a second cousin, and Cesare Vecellio, an even more distant relative, acted for Titian not only as painting assistants, but as commercial agents – collecting money and arranging contracts. Titian retained strong links with his home region, Cadore. And he was able to use his position to manipulate the entire commercial dynamic of the area. His patent as Count of the Empire gave him the privilege of creating notaries. So he appointed people of his own choosing, creating a commercial network that allowed him to develop the family business, which was not, in the first instance, art, but timber.'

The foothills of the Dolomites rose very suddenly, in rocky hummocks topped by chalet-like houses looking back over the immensity of the Venetian plain. Jutting banks of grey stone gave way to immense sweeps of scree soaring towards cliff-like bluffs, all dusted in snow, the swarming tracts of deciduous forest discernible as a change in tactility, like a mauvish-grey fur. Ahead, the sheer white slopes of the Dolomites filled the horizon, and even under this iron sky they radiated a dazzling golden glare.

Serravalle, where Titian owned land, where his daughter was married into the local nobility, and nearby Ceneda, where Titian, according to tradition, would always stop to look at an altarpiece by his old friend Andrea Previtali, passed barely noticed as the autostrada leaped along the valleys, a journey that would have taken Titian days on horseback flashing by in what felt like minutes.

In my bag I had a breezeblock-size tome, published in London in 1867, entitled *Cadore or Titian's Country*, written by an English mountaineer who had travelled through the region, trying to link the landscapes in the artist's paintings to specific places and views. He described a visit to an immense forest, high among the crags on the eastern side of the valley, but completely hidden from below – known as the Forest of the Great Council, and entirely given over to providing timber for the shipyards of the Venetian Arsenal. I wondered if it was still there.

As Venice extended its territories north and westwards during the fifteenth century, it became the thing for well-to-do Venetians to invest in land on the *terraferma*. Titian had had a villa – perhaps more of a cottage – at a village called Castel Roganzuolo, set on the crest of one of the lowest ridges of the foothills, looking back over the plain towards Venice.

The stone for the house and the labour to build it were provided by the local villagers, in return for which, in 1544, Titian painted an altarpiece for the village church. Over the years he bought up various fields, meadows and other buildings in this area, situated conveniently midway between Venice and his hometown, Pieve di Cadore. His eldest daughter, Lavinia, was married here in 1555, as were various nieces and other relatives.

Titian never painted a pure landscape work – and rarely, in fact, painted real places. We think of him as the great master of light, colour and atmosphere, but it was the Englishman Turner who first saw Venice in those terms two and a half centuries after his death. Nonetheless, it was in Turner's time – the early nineteenth century – amid the Romantic upsurge of interest in nature, that Titian came to be acclaimed as the first real landscape painter, the first artist to breathe intimations of something greater – a sense of what was later to be called 'the sublime' into the depiction of the natural world.

And it was on his journeys outside Venice that this sensibility was developed, on the terrace of his villa at Castel Roganzuolo, with storm clouds massing over the peaks behind the village, the great banks of shadow building over the Alpine terraces, as golden sunlight flooded the plain below, the campanile of St Mark's just visible in the distance; and even more, perhaps, during the long days in the saddle between Venice, Serravalle and Pieve – seeing the mountains of his

homeland, Cadore, becoming ever closer across the plain, the sense of anticipation and rediscovery revisited again and again.

Belluno, the regional capital and the last town of any size before the Austrian border, sat on a rocky outcrop beneath the ramparts of the Dolomites. And there was something about the way the town hall with its ornate loggia dominated the sloping cobbles of the Piazza del Duomo that already felt Germanic.

The autostrada came to an end, the road bowling along the side of a broad valley with a vast sweep of mountains always just visible through the trees on the right. The villages were packed close to the road, the houses broad-gabled and deep-eaved in the manner of Swiss chalets, with firewood banked up between the back doors and outbuildings, the fields ranging up the hills behind, rolling and unfenced in typical Alpine fashion. Yet among the wide balconies and over-varnished fretwork, there were other houses in a very different style: taller and gaunter, with narrow windows and dark-green shutters, faced in generally battered, off-white stucco, topped by shallow, pyramidal roofs. Was this the original vernacular architecture of the Italian Dolomites that had been gradually overwhelmed by the tide of Tyrolean suburbia? Or was it an attempt to Italianise the architecture of this essentially Germanic region that had never quite caught on?

The road to Pieve suddenly sheered off to the left, climbing quickly through forest and fields, winding up round the back of a massively solid building of almost fortified appearance into a small square with an arcade along one side and – just a blur of verdigris as I went shooting past – a statue of Tiziano Vecellio.

My hotel was a tall, pleasant-looking building in a quiet backstreet behind a modern shopping precinct. Entry lay through the restaurant, a big room, dark and rather gloomy in the fading light – the tables with their starched linen, the chairs and fittings and the whole of the bar area done out in bright, polished pine. I might have been in Bavaria.

From my room up in the eaves, I looked out over the rooftops, a single majestic, snow-covered peak rising above them, perfectly triangular, like the Paramount film logo, glowing ominously in the last of the afternoon light. I wondered if this was the Antelao, largest

and most impregnable of the eastern Dolomite peaks, which on the clearest of days could be seen even from Venice.

The shopping precinct was just a takeaway pizza joint, a printer's and a hairdresser's with a larger-than-life-size and rather crude copy of Titian's *Tarquin and Lucretia* hanging, for no apparent reason, beside a group of wheelie bins – the lust-crazed Tarquin forcing himself at knife-point on the tearful, naked Lucretia.

Then you were back in the square, the old merchant houses standing at haphazard angles, as though for maximum adhesion to the rock beneath – four-square, thick-walled, built to withstand the mudslides and rock falls, the torrents of melted snow. Now banks and shops, they exuded a rough-hewn pride and confidence – the low arcades beneath supported by massively thick pillars – the bastions of men who'd managed to make good money from the toings and froings of this little mountain society. And in every direction you could see the snow-covered crags, some distant, others apparently very near, with glimpses of nearer pine-covered slopes still dusted with snow.

At the bottom of the sloping, lopsided piazza, dwarfed by a massive bell tower bearing the arms of Venice, stood the Palace of the Magnifica Comunità, the parliament of Cadore, where, since time immemorial, everything of importance concerning the life of the Cadorin people was decided; and where the Vecellio family had made their names as councillors and orators.

The few people crossing the square in their thickly padded coats had a buttoned-up, purposeful look – moderately prosperous, if none too stylish citizens of the EU. Heading into the tiny backstreets, beneath a squat arch linking two thick-walled medieval buildings, past wood-panelled cafés and small shops where people were making the last purchases of the day in subdued tones, I had to keep reminding myself I was in Italy at all. I'd been to places just like this in Austria and southern Germany: narrow, well-kept little burgher towns, where people got on with their neither-rich-nor-poor, slightly po-faced lives under the eye of the *Rathaus* clock. Yet while the Austrian border lay close by, the roads veered away from it. The German-speaking world was physically near, but ignored. Alto Adige, the region to the immediate west, had been part of Austria until 1918, and was still to an extent culturally German. But

Cadore had always been proudly Italian, the northernmost outpost of the Italian world.

There Titian stood, high on his plinth in the town square, tall in his fur-fringed gown, silhouetted against the snow-capped peaks, palette and brushes in hand, but with his deep-set eyes peering inward on his own inner landscape, towards his own genius. And on the plinth was the name by which he was best known to his contemporaries: 'Tiziano – Il Cadore'.

The Vecellio family house wasn't difficult to find. It lay just a few yards down the hill from the square, set back slightly from the road, between an optician's and a sportswear shop. It had a self-consciously archaic look that set it apart from the surrounding buildings: built of unrendered golden stone, with long fretwork balconies and an external wooden staircase supported by slender uprights and stained a blackish brown.

This, the guidebooks all said, was what the house of a well-to-do sixteenth-century Cadorin family looked like. Yet compared with the imposing merchant houses on the square it was very modest in scale and style – more like a farmhouse than the dwelling of local grandees.

There didn't appear to be any other guests at the hotel, and, once the heating went off, my room in the rafters was extremely cold. I'd noticed that the few people drinking and playing the fruit machines in the bar had kept their coats on. Hardy, thrifty mountain people. I pulled the clothes off the other twin bed, piled them on top of mine and lay there thinking of Titian, with his fur-lined cloak thrown over his nightgown, going round the big house in Biri Grande, putting out fires, snuffing out unnecessary lamps and candles.

While the ten *centurii*, or communes, of Cadore held equal status, Pieve was by tradition the first place in the region to have been settled, where assemblies were first held – the centre of the Cadorin world. The Vecellio family house lay just yards from the Magnifica Comunità. Titian was born practically in the cradle of Cadorin democracy. And immediately in front of the house passed the path up to the castle; the fortress, reputedly impregnable, that provided the key to the entire region. Whoever held the castle of Pieve commanded one of the most important trade routes between Italy and the north,

and maintained at least notional control over the three passes into the Austrian Tyrol.

No one had succeeded in occupying either the castle or the region for any length of time against the wishes of the local people. Cadore was effectively an independent republic in principle under the control of a governor appointed by the external power – be it the Austrian Dukes of Carinthia, the once-mighty patriarchs of Aquileia or the Italian Dukes of Camino. Since they did not believe themselves capable of maintaining their independence entirely on their own, the Cadorin people considered this negotiated feudalism inevitable. In 1420, they put themselves under the control and protection of the Republic of Venice, negotiating terms that were highly advantageous to themselves: that there would be no new taxes; that the power of making internal laws would remain with them; that no citizen would be required to perform military service outside their own territory; that a harbour would be granted in Venice for their sole use.

Titian's relatives and namesakes had been centrally involved in forging these conditions, men like his grandfather Il Conte, his first cousin Tiziano, known as Titian the Syndic, and the syndic's grandson, known as Titian the Orator – all lawyers who served as envoys from the Cadorin people to the Republic of Venice.

The staircase on the side of the house led into a narrow, wood-panelled hallway, with doors leading off into small rooms with authentically grubby plastered walls. One, panelled with vertical planks, was designated the study, while the large kitchen was floored with irregular flagstones, worn smooth over the centuries, with benches set around three sides of the chimney recess, and a cauldron hanging over the open fireplace. It must have been very cosy in winter. Yet, while the furniture was dark and plausibly old, any sense of atmosphere was destroyed by the cheap reproductions of Titian paintings hanging on the walls.

According to the seventeenth-century biography of Titian published by his cousin Tizianello and written by a gentleman styling himself 'Anonimo', the artist's house lay beside the place called the Arsenale. In the early nineteenth century, Giuseppe Cadorin, a priest and local historian, identified the tiny piazzetta, little more than a glorified driveway, beside the road up into the town, as the Arsenale, and the house beside it as the house of the Vecellio. The house was

then an inn, and the little piazzetta had acquired a fountain and a statue of the Jesuit saint John of Nepomuk.

While the house was declared a national monument in 1928 and owes its current form to the engineer Giuseppe Palatini, who ripped off the eighteenth-century third storey, restoring the traditional gable-ended wooden roof with little larchwood tiles called *scandolette*, it is essentially a creation of the nineteenth century and of a small group of local worthies who were determined to validate the relationship between Titian, the universal genius, and the obscure and impoverished region of Cadore.

Giuseppe Cadorin, along with Taddeo Jacobi, another priest, and Stefano Ticozzì, a civil servant, was responsible for rescuing Titian from the murk of mythic hyperbole, establishing him as a real person who had lived a concrete existence in real buildings, some of which still existed. Cadorin spent years rooting through the archives of the Venetian state, tracking down the private papers of various key families, notably the Sarcinelli of Serravalle, into whom Titian's eldest daughter, Lavinia, was married. In his book *Dello Amore ai Veneziani di Tiziano Vecellio*, published in 1833, he identified this house as Titian's birthplace and the house in Calle Larga dei Botteri as the artist's Venetian residence. It was Cadorin who discovered the document in which Pomponio and his brother-in-law, Cornelio Sarcinelli, filed their complaint concerning thefts from the house, giving rise to the idea that Titian's studio had been looted. Titian the man, as we've come to understand and accept him, was essentially a creation of the nineteenth century. And having unearthed the documents that established the key moments in Titian's life, Cadorin lost the lot. He took the documents home to work on, as was normal practice at the time, and when he died suddenly his family sold them. They haven't been seen since.

At the very moment when Titian the man was being rescued from the mists of the past, his principal monument in his home region was being destroyed. In 1565, Titian spent the autumn in Pieve, designing a scheme of frescoes and mosaics, to be executed by his pupils, that would completely cover the interior of the parish church. His workshop must have moved with him en masse, ready to start work, for a deed in which Titian appointed Fausto Vecellio a notary, on 1 October, was witnessed by three of his most prominent assistants:

Valerio Zuccato, Emmanuel Amberger and his second cousin, Cesare Vecellio. By March 1567, work had progressed sufficiently for the Cadorin council to order that fifty loads of timber be cut to meet the first instalment of Titian's payment. In the vault of the church choir, the Eternal Father was seen receiving the Virgin into Heaven, attended by the four evangelists. On the walls to left and right were the Annunciation and the Nativity, and, on the arch overhead, the Virgin lamenting with St John the Evangelist.

From the outside, the church had an impressively massive, almost fortified appearance, looming over the rooftops beside the palace of the Magnifica Comunità. The interior, though, was drab, sterile neo-classical – light in colour, but oddly gloomy. The original gothic church was demolished in 1813, and with it Titian's frescoes, and the present building was constructed from the rubble of the castle. And if the paintings there by Titian's cousins Marco and Cesare were anything to go by, the frescoes were no great loss. It wasn't that Cesare's *Last Supper* or Marco's *Dispute and Martyrdom of St Catherine* were outright bad – they were just a bit dull, a bit effortful, a bit illustrative.

The only painting still believed by some to be by Titian was a small work hanging in the Vecellio family chapel, a recessed altar on the left-hand side of the nave.

San Tiziano, the family's patron saint, in his mitre and white and gold bishop's robes, knelt in prayer, leaning in towards the Virgin, who sat with the Child contentedly and very absorbedly breast-feeding on her knee. Kneeling beside her, his head very close to hers, peering intently down at the child, was the bald, grey-bearded figure of St Andrew. And on the left, kneeling in the shadows behind San Tiziano – holding a crosier, presumably on behalf of his namesake the bishop – was the black-clad, grey-bearded figure of Titian himself.

According to a rather breathless booklet I had obtained from the Magnifica Comunità, the artist's visits to Pieve to plan the frescoes in 1565 had forced him to confront his own mortality. Spending time in the church in which he believed he would one day be buried, he was reminded of the death, just six years earlier, of his brother, loyal assistant and business partner, Francesco, portrayed here as St Andrew, while the Virgin bore the features of Lavinia, who, the booklet claimed, had died in 1561.

San Tiziano, leaning intently forward, his voluminous gilded cape riding up behind his neck, 'seemed to resemble' – the booklet said – Titian's eldest son Pomponio. Pomponio, the priest – or pseudo-priest – who entered holy orders in childhood, but scarcely, if ever, fulfilled any of the functions of a priest. Pomponio, the one great disappointment of his father's life, for whom Titian made endless efforts in terms of preferment, but who was unable or unwilling to make anything of the opportunities open to him. But in what way did the figure of the youthful bishop 'seem to resemble' Pomponio? In comparison with what? There was a mediocre portrait, of dubious authenticity, that was 'traditionally' regarded as being of Pomponio. But that idea was shot out of the water decades ago. Yet this suggestion did at least bring it home to me that Pomponio – who hadn't yet come into focus as a character for me, who had remained a disaffected blur on the edge of a story that is otherwise one glittering, unalloyed trajectory of success – was real enough to actually have an appearance.

The beard was no more than bum fluff, framing the pointed, rather handsome features, with pronounced shadow beneath the one visible eye. Yet the face was alert, intent, expectant. If this painting was done in 1565, Pomponio would then have been over forty – far older than the figure in the painting. But, then, when had Titian last seen Pomponio face to face? Never mind that the painting almost certainly wasn't by Titian: the artist – like most parents – probably pictured his son as far younger than he was.

Titian and his son hardly spoke during the last decades of the artist's life. But, then, Pomponio was his eldest son. However hard on them Titian was, however ambivalent his feelings towards his children, he must at some level have been caused pain by the 'loss' of his first child. Here he was in the place where he imagined he would one day be buried – an event not so far off. Perhaps the inclusion of his estranged son in this painting was an attempt at a kind of painted reconciliation – if only in his own mind.

Traditionally, every scholar castigated Pomponio for his profligacy, indolence and irresponsibility – for being a drain on the energies and emotions of one of the greatest geniuses who ever lived. But what, reading between the lines of the very limited correspondence in

which these matters were expounded, did this profligacy consist of? It occurred to me that, far from being just an inconvenient shadow cast across his father's life, Titian's eldest son was quite possibly the most interesting character in the entire story.

Beside Titian's house a track passed between the back of the Hotel Progresso and the driveways of various chalets and apartment blocks on to a woodland pathway, which snaked round the hillside above the town. The wide, spreading pine fronds created a screen through which could be discerned the milky glow of the lake to the north of Pieve and, above it, the peaks of the Cridole rearing gigantic through a silver haze.

It was early evening and the roar of the traffic was very clear, amplified by the bowl of the valley, buzzing out over the lake from the roads in and out of Pieve di Cadore and from the valley road far below. This whole area was much more densely populated than it initially appeared, the main road lined with an unending ribbon of small villages each with at least one factory for the production of optical lenses and glasses, the principal industry of the region since the eighteenth century. And while much of this manufacturing was now moving to China, there was the sense of a resourceful society that would turn its hand to support itself in any way it could. And all this commercial activity linked directly back to Titian. Those solid burgher mansions on the town square that made the Vecellio family home look so modest in comparison: far from being contemporary with it, as I had thought, they had been built some time later with the profits from the timber trade that Titian had simultaneously exploited and facilitated.

In his early years in Venice, Titian may conceivably have benefited from the influence of illustrious relatives – such as the then doyen of Cadorin society, Titian the Syndic – who may have recommended that their associates and acquaintances in the Venetian elite look out for this talented young man. But within a very short period this position had been reversed. Titian, the Republic's most famous artist, with his network of contacts throughout Venetian society, was one of Cadore's most powerful assets.

In 1534, Titian the Syndic wrote to the painter as his 'cousin and

all but brother', thanking him for 'all that we owe you in respect of numerous proofs of friendship shown to our community at large and especially to our envoys, for all of which you may be assured we have a grateful memory and a true sense of obligation', and soliciting his assistance in a dispute with the then Captain of Cadore – the Venetian military governor – who was using his position to create a personal monopoly in the trade between Cadore and Venice. The letter made clear the community's belief in the efficacy of Titian's 'favour and assistance' and begged to know to whom the money he had recently lent to the community should be repaid. Whether through Titian's intercession or through the cleverness of the Cadorin advocates, the Captain was ordered to cease trading with immediate effect.

Titian had acted as a banker to this entire region. For all the energy and enterprise of its inhabitants, Cadore was poor. The grain produced on its steeply pitching fields hardly saw its inhabitants through three months of the year. Every autumn, the Cadore council was obliged to buy corn under contract from the Tyrol or from the Italian lowland farmers, which was stored in the *fondachi* of the ten *centurii* and sold to the population – at a small profit to the more affluent and at below cost to the poor. In 1542, at a time of severe famine, Titian was instrumental in persuading the Council of Ten to permit the Comunità to import corn from Ceneda in the Dolomite foothills, thereby filling the *fondachi* of the region with grain. In 1562, Titian wrote to the Comunità demanding repayment with interest of a loan made during another period of hardship of the very substantial sum of 1,000 ducats. When you consider the size of the loan, the probably small returns in terms of interest and the inevitable risk, you have to assume that Titian's motives weren't entirely mercenary. At the same time, there are several letters in existence written in Titian's own hand, in a mixture of standard Italian, Latin and local dialect, bluntly demanding repayment of relatively small loans made to local citizens. In servicing such transactions, Titian was assisted by his brother Francesco, who managed the Cadore end of the family business.

Apprenticed as a painter in Venice alongside Titian – and whether he was slightly older than Titian or slightly younger has never been definitively established – Francesco had given up painting to serve in various mercenary armies during the Italian Wars of the

early sixteenth century. On their father Gregorio's death in 1520, Francesco moved back here, to the family house, from where he oversaw the involvement of the Vecellio in the timber business, their various properties and the many debts owed to his brother – while continuing to work as a painter on his own account.

That any citizen could fell timber in any forest (with certain exceptions, including those close to the border) is indicative of the sense of the limitlessness of the region's reserves. It's possible that Titian and Francesco increased the value of their timber by having it sawn into planks, in the two sawmills they owned, before it was floated down to Venice on the great rafts; though, according to a statement of Titian's assets made for tax purposes in 1566, both of these iron mills were let out. It seems that Titian and Francesco also owned iron mines in Cadore, which were managed for them by their nephew, Oderico Soldano.

After Francesco's death, his role was taken over by Titian's son Orazio, who had the backing of a number of relatives and associates whom Titian had raised to the position of notary; particularly his cousin Vincenzo Vecellio, appointed notary in 1540, and various members of the Costantini, Palatini and Genova families – family names that frequently occur in relation to Titian's dealings in Cadore.

An opportunity for Titian to intercede on a relative's behalf came when the Syndic's grandson, Titian the Orator, came into conflict with Oderico Soldano, chancellor of Cadore, who, in contravention of ancient custom, had had himself made governor of the rival commune of Dommege. Unfortunately for Titian's third cousin, the Orator, Oderico Soldano was the artist's nephew, son of his sister Caterina by Matteo Soldano, and had been appointed notary by Titian himself. The matter was taken to arbitration in Venice, and in the face of the manifest wrongness of his nephew's actions – and his abusive behaviour towards several of the Cadore councillors – the eighty-year-old artist used all his influence to have Soldano established in the disputed position. Soldano thought that, as the nephew of Cadore's most famous citizen, he could do what he liked. It seems he was right.

The bank behind me was steep, thick with fern and moss, ivy trailing round the matted roots of ancient deciduous trees that clung to the soil among the towering pines. This was the track up to the castle –

where there was nothing now but overgrown rubble – where Titian had played as a child and developed his ease and intimacy with landscape. While Titian lived in the city from the age of ten, the far distances and the extreme foregrounds of his mythological and many of his religious paintings – particularly those jewel-like Madonnas with the Mother and Child disporting themselves on the sward – are not only credible, but minutely, lovingly, observed: the wild flowers picked out with botanical exactness among the individually rendered blades of grass in the early works; the sense of distance increasingly mediated by light and atmosphere; the banks of pressure building over the Dolomite slopes penetrated by the low-angled sun, with the vast outcrops of the mountains themselves rearing beyond.

The particular upward thrust of the Dolomite stones, the way the strata strain to jut vertical from the earth, the mountains crammed together like jagged teeth, is something that Titian introduced into the backgrounds of innumerable paintings – a blue wave formation looming in the distance of various versions of *St Mary Magdalene in the Desert*, in the *Presentation of the Virgin*, where they can be seen far away between the walls of a rarefied, fantasy Venice, or rearing much nearer in the *Madonna and Child with St Catherine*, storm clouds gathering over the blue peaks of the Marmarole. Wherever distance appears in Titian's art, the landscape of his homeland invariably intrudes into the background, as something that is permanently in the middle distance of his thought, that never quite goes away. Every Venetian painter included blue mountains in the distances of their landscapes, but Titian made this generalised feature personal and specific. Yet he never showed this landscape under snow. For Titian snow wasn't a thing, but an accident of nature that negated beauty, that wasn't supposed to be there.

And, as Titian grew older, his approach to nature changed, became more about light, about space defined by the pockets of shadow forming around the rolling foothills, the vast forests and towering peaks. On his trips here in adult life, Titian must have been looking all the time, he must have been making notes and drawings – though few drawings of any kind survive.

Everywhere among the drifts of dead leaves, and the flaky, dry, piny soil were clusters of small, bluish-purple flowers. I picked a few. Violets. Yes, we will return to the subject of violets.

6

The Alabaster Room

ALFONSO D'ESTE ENJOYED the company of prostitutes and lowlife. He cultivated a gruff and taciturn manner, and wore a shirt of mail under his doublet for fear of assassination. Passionately interested in artillery and incendiary devices of all kinds, he maintained a small foundry in the garden of his palace in Ferrara where he experimented with smelting bronze for the creation of new and more deadly forms of cannon. During the War of the League of Cambrai, Alfonso allied himself first with the Pope and France against the regional power, Venice, then with France against Venice and the Pope. He rode with the French forces as they entered Bologna, and watched as the mob smashed to pieces Michelangelo's colossal bronze statue of Pope Julius II. He had the shards taken back to Ferrara, where a great cannon was cast from them, set up on the palace battlements and christened 'La Giulia' – after Julius; the head he kept in his dressing room as a souvenir.

Ferrara was one of the small city-states whose 'glittering' courts were so central to the version of the Renaissance sanctified in the writings of Jakob Burckhardt and Bernard Berenson. While Urbino under the Montefeltro had a greater reputation for elegance and refinement, Mantua under the Gonzaga a more extravagant sense of splendour, Ferrara under the Este was the largest of these states, and the one that came closest to becoming a real power.

Alfonso's grandfather Niccolò II had his wife and his son by a previous involvement murdered for an improper liaison. His father, Ercole I, had one of Alfonso's cousins beheaded for contesting his authority. Alfonso kept his own half-brother Giulio – already half-blinded in an altercation with another brother – imprisoned for twenty-one years for conspiring against him, while a third brother, also implicated, died in prison. Three co-conspirators not of Este blood were beheaded and quartered, their body parts hung on the palace gates.

Yet Alfonso was far from unpopular with his subjects. The Este family cultivated their relationship with their people – by extending largesse, by magnificent civic improvements, by encouraging identification with their own magnificence – to the extent that, by the time Alfonso acceded to the ducal throne in 1505, the Este *were* Ferrara.

We see Alfonso in Titian's portrait, one hand resting on the muzzle of an enormous cannon, the other on the gilded hilt of his sword, his elbows flexed slightly outwards, as though trying to monopolise as much of the picture space as possible. His coal-black eyes regard us warily, his nostrils flared, every hair of his short, curly beard bristling with energy.

Alfonso seems to have got the idea of creating a truly remarkable room from his elder sister, Isabella d'Este – Marchesa of Mantua; the same Isabella d'Este who came to grief when she commissioned a painting for her study from Giovanni Bellini. Alfonso's *camerino d'alabastro* – the Alabaster Room – was to become perhaps the most famous room in Western art. While he intended that it would reflect all the most important schools of Italian art, each represented by its greatest master, the room became dominated by one particular talent: Titian's.

When I first saw *Bacchus and Ariadne* it hung on its own screen in front of a huge doorway, linking two of the most important parts of the National Gallery. You could see it shining out from several rooms away, a jubilant shout of a painting: the great whirl of movement with its immensity of implausibly pure, undiluted ultramarine – the clearest and most expensive royal blue – into which the beautiful

Ariadne is pointing, the serpentine sweep of her scarf standing out in a stabbing jolt of vermilion; the crimson of the god's cloak highlighted with lead white, flung out into space as he leaps from his chariot in a movement that seems to set the whole composition in spiralling motion – his retinue of fauns and meat-wielding satyrs, nymphs crashing their cymbals and tambourines as they surge forward out of the viridian forest.

Clapping eyes on Ariadne for the first time as she searches for her rescuer and lover Theseus on the deserted shore of the island of Naxos, Bacchus leaps towards her, promising her the stars – in the form of the constellation, in the top left of the painting, that she will eventually become.

The painting has been moved several times around the gallery over the years, but wherever it is there's always a clamour around it. Admittedly, if you flag up a painting as a key work on the audio guide, and put a seat in front of it, people will naturally gravitate towards it. Yet people's eyes light up as soon as they catch sight of it, even if they don't know precisely what it is. The painting is, of course, one of the most famous in the world. The ecstatic tilt of Bacchus's vine-wreathed head as he leaps forward is an image most people will have absorbed, even if they can't remember where or how. And while the modern viewer might find a lot to criticise in the painting – if Bacchus jumped like that, he'd come crashing headlong some distance from his beloved, the static postures of the leopards pulling the chariot give them the look of stuffed toys – the sheer triumphal exuberance somehow transcends that. If the use of colour feels a touch literal – the way each garment or object is defined by a particular area of colour – the mind immediately locks into another way of understanding and appreciating the work – through its energy and vitality rather than its relationship to the real world.

This was Titian's second painting for Alfonso d'Este's *camerino d'alabastro*, a room that was to be a shrine to love. But not to romantic love or to Christian love, which are just two sides of the same coin. Not to Platonic love, an idea that was very fashionable at the time – nor even to purely physical, carnal love. No, the *camerino* was to be a celebration of pagan love – love subject to the arbitrary caprices of the gods, inspired by, sanctified by or thwarted by the ancient

spirits of the landscape. The gods who, heedless in their own beauty and perfection, are oblivious to our ideas of right and wrong. The gods, with whom we involve ourselves at our peril, who may open our eyes to worlds of beauty and pleasure that exist just beyond our mortal perception of existence, or who may ravish and destroy us – not out of malice, but because it is simply in their nature. Whose assistance may be invoked through sacrifice, but who are themselves subject to higher, crueller powers – just as Alfonso's authority existed in precarious relation to wider forces. Love that emanated directly from the Mediterranean earth – a fitting subject for a *man's* room – its bawdiness and carnality mediated by centuries of culture and literature.

And when you half close your eyes, the painting's disparate areas of colour start to resolve themselves in a very different way – into two diagonally divided zones. The top left is dominated by the dense, cold ultramarine of the heavens – a colour that has worn and faded over five centuries, but retains such exhilarating freshness and intensity you wonder what it could have been like when just painted. The blue of the open air and sky, the natural habitat of the pure and beautiful mortal Ariadne. And, on the lower right, the world of the forest, the shady realm of Bacchus – seen not as green, but as blue's compliment, a warm and earthy orange, the orange of the dusty forest floor, of the skin of that sun-burnt figure in the foreground, his arms and body coiled with writhing snakes.

On the one hand, the serene and soaring vault of the heavens. On the other, earthly chaos, the unheeding brutality of the forest, the joys and agonies of the flesh. On the one hand, the spirit, on the other, the body.

On 30 January 1523, this painting, then in an unfinished state, was carried by barge from Venice up the river Po to Ferrara. Payment was then made for a *facchino* – a porter – to carry the canvas on his back from the river port of Francolino into the city of Ferrara itself. Given that the painting was over six feet wide by almost six feet high and would have been robustly packaged – backed by board on at least one side – the porter must have been bent double as he staggered the eight miles, the assistants designated to courier the painting walking

alongside. Accounts show that on 7 February, the landlord of the Castello Inn in Ferrara charged for twenty-four meals to date, given to Titian's assistants who were lodging there. And the fact that the accounts in question are those of the Palace of Ferrara shows that Alfonso himself was covering all of these expenses.

Bacchus and Ariadne had been commissioned in April 1520, and from the outset Alfonso had applied continuous pressure on the artist, first to commence the painting, then to finish it. For the previous eighteen months, Alfonso had – through his agent in Venice Jacopo Tebaldi – variously threatened, tempted, cajoled, flattered and otherwise attempted to impel Titian to bring the painting to Ferrara to complete it under his own exacting gaze. Titian was paid an extra 'refresher' advance; invited to spend Christmas in Ferrara in 1521 (on the understanding that he bring the painting with him); invited to accompany Alfonso to Rome, a city he'd always wanted to visit, to pay homage to the new Pope, Clement VII – a gesture that was an immense compliment on the part of the duke. And all to no avail. Titian appeared first flattered, tempted, alarmed and then evasive – had always some other obligation, some illness or more obscure debilitation or commitment that allowed him to wriggle out of whatever was proposed. Now, nearly three years after the original commission was accepted, the painting was at last in Ferrara. Titian's assistants were ensconced in the Castello Inn ready to begin work – indeed, in all probability, had already embarked on the final stages of the painting. But where was Titian? Not in Ferrara, nor even in Venice, but in Mantua, engaged in discussions on further commissions with Alfonso's nephew Federico Gonzaga, son of his sister Isabella. What the hell was Titian playing at?

In fact, Titian was already snowed under with major projects when he was impelled to take on the commission for *Bacchus and Ariadne*. Within days of taking on his first painting for Alfonso's *camerino* – *The Worship of Venus* – he had been commissioned to create a massive monumental altarpiece for the Pesaro family in the Frari in Venice – which was still barely started. He had commenced work on two further large altarpieces for Brescia and Ancona, and had just received notice from the Venetian government that unless he attended to his obligations in the Hall of the Great Council – notably

the painting *The Battle of Spoleto*, which he hadn't touched for years – he would lose his *sanseria* (state pension), and be obliged to repay all advances so far remitted by the Salt Office – an amount running into hundreds of thousands of pounds by today's standards.

Titian, like all independent artists – like all freelances in any age – was dependent on a steady flow of commissions to keep his business afloat. Once the advance of a third of the final fee had been paid and a definitive start made on the work, it would be put to one side, and wouldn't be completed until the patron began to apply serious pressure. At this point in his career Titian could have delegated more to assistants. He could have loosened his grip on the quality of the output of the workshop ever so slightly, on the assumption that some of his assistants were almost as good as he was, and that the power of his signature having been established, the majority of patrons wouldn't have been able to tell the difference.

But Titian had no intention of doing that – certainly not with patrons of the stature and importance of Alfonso d'Este. The only way he could keep his stock intact, increasing his fame – giving himself a degree of power equivalent to his patrons' – was to keep on exceeding their expectations with every new work, to make each painting more astounding than the one that had gone before. And the only person who could make a Titian painting great was Titian himself.

So Titian moved between projects, trying to block out the noise from customers and their agents – reluctant to turn down commissions from powerful new patrons yet aware of the need not to push existing clients beyond reasonable limits. And of these there was one who was particularly vociferous, particularly impatient, whose interest was to be especially important in shaping Titian's career, but who had the resources and the influence to make things particularly unpleasant for the artist should his patience be tested beyond a certain point.

'We thought,' Alfonso d'Este wrote to his agent Tebaldi, 'that Titian, *the painter*, would some day finish our picture. But he seems to take no account of us whatever. We therefore instruct you to tell him instantly that we are surprised that he should not have finished our picture; that he must finish it under all circumstances or incur

our great displeasure – and he may be made to feel he is doing an ill turn to one who can resent it.'

It was in the summer of 1511, when the War of the League of Cambrai was at its height and Alfonso lay in bed in Ferrara, exhausted and sick with fever – the prospects for territorial expansion through this war looking bleak – that the duke conceived of a project that would bring a different kind of glory to himself and to Ferrara – a study or studio of his own, conceived in a similar spirit to that of his sister Isabella d'Este, but which would outdo anything she had achieved, a room located in his own private suite of apartments, intended entirely for his own personal use, but which would nonetheless become one of the talking points of Europe. And while the images in Isabella's allegories were ostentatiously worthy – *The Battle of Love and Chastity*, *The Expulsion of Vice from the Garden of Virtue* – those commissioned by Alfonso would be of subjects entirely appropriate to a man's room.

Formerly just a small, cell-like room where accounts were prepared, the study – the *studiolo* or *scrittorio* – was changing its status in this period, becoming a place where the man of wealth and culture could simultaneously withdraw from the world and advertise his intellectual interests.

One of Alfonso's father's courtiers, Antonio de Montecatini, had been shown round the Medici Palace in Florence by none other than Lorenzo the Magnificent himself, and had described the study created by Lorenzo's father, Pietro, a room, relatively small, but with 'copious quantities of books all worthy written with a pen – a stupendous thing! – the jewels, the vases, cups, hackstone coffers mounted with gold'. There were the ancient coins, the ceramic roundels on the barrel-vaulted ceiling, painted in emblems of the months by Luca della Robbia, 'the effigies and images of all the emperors and worthies there ever were'. A room that had begun as old Medici's counting room had become a cabinet of marvels, a private museum and library, and one of the focal points of any visit to the palace.

Isabella had sent her Latin tutor, the scholar and historian Mario Equicola, to Ferrara to report on Alfonso's health, and while there he was waylaid by the duke, who wanted to discuss his new project. The

inspiration, it was decided, would come from a book by the third-century sophist Philostratus – the *Eikones*, or *Imaginings*.

Consisting of descriptions of sixty-four paintings supposedly seen by the author in a nobleman's villa outside Naples, *Imaginings* provided the most complete view yet into the lost world of classical painting. While the formal language of Greek and Roman sculpture was all too physically apparent through the collections then being built up all over Italy, knowledge of classical painting was drawn almost entirely from literature; and particularly from an entire genre known as ekphrasis, in which the description of paintings was used as a starting point for displays of rhetorical skill and the opportunity to discuss the nature and limits of painting itself. Eerily, it was almost as though the ancients were providing a fund of inspiration and knowledge for later ages. But were the works described by Philostratus real paintings that the author had actually seen or inventions that allowed him to expound on the nature of perception?

After extensive discussions with Equicola, Alfonso fastened on the idea of re-creating this ancient picture gallery – if on a slightly more modest scale – a room where the walls would be 'resplendent with all the marbles favoured by luxury' and set with panel paintings which 'exhibited the skill of very many painters'. The content of the images would be decided upon by Alfonso in consultation with his scholar-courtiers and poets, but the realisation and interpretation would rely on the skill and vision of the artists he employed – artists who should, he decided, be the greatest masters of the most important Italian schools.

The first artist he approached was the greatest of all Venetian painters, Titian's old teacher and the very artist with whom his sister had had such problems when creating her own *studiolo* – Giovanni Bellini. While a decade of Isabella's bullying and cajoling had failed to produce an appropriate painting, Alfonso managed to get a large canvas out of Bellini in less than two years.

A conflation of two incidents from Ovid's poetic calendar of the months, the 'Fasti', the painting shows a picnic in an enchanted glade during which the gods, lulled by the wine provided by a diminutive blond Bacchus, fall asleep, giving Priapus, the libidinous protector of gardens and male genitalia, the opportunity to ravish the sleeping nymph Lotis.

While Bellini had managed to imbue this scene of woozy, sun-drenched antique rusticity with some of the immemorial serenity of his great religious paintings, his gods don't look very godlike. The helmet of the sprawled-out Mercury looks like an inverted chamber pot, and Neptune's trident looks more like a garden implement than a godly attribute. And while the sea god has his hand wedged between the hot thighs of Cybele, she looks too pissed to notice.

Still, Alfonso was pleased with the painting. To get a work of this scale with its sumptuous glowing colour and wealth of exquisitely rendered detail – which would be one of the last masterpieces of an artist who would surely rank among the greatest of all time – was an achievement even for him. It was only years later, when Bellini was long dead, that it was pointed out to Alfonso that the Venetian artist had used the wrong text – not Ovid's original, but a recently published illustrated edition, which set the story of Priapus and Lotis not among the deities, but among the ordinary people of Thebes. Incensed, Alfonso ordered his court painter Dosso Dossi to paint in the attributes of the gods – Neptune's trident, Jupiter's eagle, Apollo's fiddle – while adjusting the garments of the nymphs to expose more nipple and shoulder. All of which Dossi accomplished with sufficient skill that these amendments remained undetected for another four hundred years.

Since the promise of a painting from Michelangelo had yielded nothing (perhaps he harboured a grudge over the smashed statue), Florence was to be represented in the *camerino d'alabastro* by the worthy but slightly second-rate figure of Fra Bartolommeo, a Dominican friar who built a substantial career working in various courts around Italy. But to represent Rome, the duke had commissioned an artist who was already universally acknowledged as one of the greatest of all time – Raphael.

While Raphael was overwhelmed with other work, he managed to find time to provide a drawing of his proposed painting, *The Triumph of Bacchus*, a wild, hyperactive festival of a painting, which showed the triumphal return of the god from India.

Alfonso d'Este could hardly contain his excitement. Eager to see the effect of this sumptuous Raphael beside his Bellini – and suspecting that Raphael might take some time to complete the painting – he

commissioned the local artist Pellegrino di San Daniele to make a stopgap version from the master's drawing. Hearing about this from one of his students who had gone to buy pigments in Venice, the astonished Raphael wrote a somewhat bemused letter to Alfonso saying that, since the duke now had a perfectly good version of the painting he might as well paint something else, and proposing another subject from Philostratus, *Meleager and the Calydonian Boar Hunt*.

When Fra Bartolommeo died in October 1517, having completed only a preparatory drawing for his painting, *The Worship of Venus*, Alfonso still had only one painting to show for six years of planning, discussion and accumulating annoyance over the *camerino d'alabastro*. Commissioning a fourth painting, *A Bacchanal of Men*, from Dosso Dossi – who had no option but to comply with the duke's wishes as rapidly as possible – he set about rebuilding the room itself.

The *camerino d'alabastro* was situated in the Via Coperta, a suite of rooms that ran along the top of an arcade connecting the medieval fortress, the Castello Estense, with the Court Palace, the modern Renaissance palace. From this symbolic location, Alfonso could look down on the piazza, the great square, marketplace and site of tournaments and executions. First built in 1471, the Via Coperta was enlarged in 1499, then widened again by Alfonso on his accession as duke in 1505, to accommodate his own private apartments. Then, in 1518, in a further fit of agitation, Alfonso had the whole structure pulled down and rebuilt from scratch. But the room itself was never very large. High-ceilinged, it had doors at either end, so that it was effectively part of a corridor and was only just large enough to accommodate the five paintings.

Titian paid his first visit to Ferrara in 1516. The palace accounts show that he and two assistants lodged in the Castello Estense and were granted weekly rations of 'salad, salt-meat, oil, chestnuts, oranges, tallow candles, cheese and five measures of wine'. They were working on a 'bagno', a painting of naked or near-naked nymphs and goddesses in repose around some pool or stream: a perfect subject, in fact, for a man's room. Yet it doesn't seem to have occurred to Alfonso to involve Titian in the *camerino d'alabastro*. Venice was already represented there by the greatest of her masters, Giovanni Bellini. Why would he want to involve the upstart Titian?

But in March 1518, exasperated at the slow pace of the project, Alfonso suddenly commissioned Titian to paint *The Worship of Venus*, on the understanding that the painting be completed in six months. And, to speed the process up, he sent the artist not only the drawing Fra Bartolommeo had completed for his version of the painting, a copy of the text from Philostratus and detailed instructions of what he wanted the painting to contain, but the very canvas and stretcher it was to be painted upon. The fact that *The Assumption of the Virgin*, the painting that was to launch Titian among the foremost artists of his time, was about to be revealed to the world cannot have been coincidental. On 1 April, just ten days after the unveiling of the *Assumption* in the Frari, Titian wrote to Alfonso thanking him for his letter, enclosures, canvas and framing. He went on, waxing in the most nauseatingly oleaginous terms on the ingeniousness of the duke's conception:

'The more I thought it over, the more convinced I became that the greatness of art among the ancients was due to the assistance they received from great princes content to leave to their painters the credit and renown derived from their own ingenuity in bespeaking pictures.' But then, having expressed his intention to devote all his 'care and industry' to the painting, he intimated that the amount of time indicated by the duke, 'beyond which completion should not be postponed', might just not be quite enough for him to bring the painting to the degree of perfection he would like. 'Still, I mean to do my best to finish it at the appropriate time, so that should anything remain to be done, that little will be so infinitesimal as to excuse me from asking for delay.'

I was driving to Bristol, concrete bridges flashing overhead as lush Berkshire gave way to Wiltshire's rolling open hills. On the radio was a programme about the evolution of Picasso's *Les Demoiselles d'Avignon*, a painting that's come to be accepted as the single pivotal, defining work of the modern era – a painting which consigned the fixed perspective of the Renaissance world view decisively and permanently to the past. Drawing on his adolescent experiences in the brothels of Barcelona, Picasso showed an arrangement of five prostitutes, two of them holding back curtains, two with what looked

like African masks for faces, the two central figures staring out of a composition that recalls Ingres and Cézanne, but collapsed their classical balance inwards and outwards, breaking down the barriers between space and surface, between subject and surroundings – paving the way for Futurism, Constructivism and all the departures from representation that enabled pure abstraction, minimalism, conceptualism and everything we understand art to be today.

Titian's paintings for the *camerino* of Alfonso d'Este could be seen as every bit as pivotal in the development of form, instilling a greater sense of movement, rocking the static, pyramidal Byzantine composition off its axis, pushing form towards a new language of light and shadow while creating a vision of the pagan world that was to become the primary inspiration for European mythological painting for the next three hundred years. Yet it is impossible for us to empathise with Titian's achievement, to get inside his process of creation the way we can with Picasso's – partly because we have very much less information, but mainly because there are just too many people involved.

There was Picasso stripped down to his underpants as he worked day and night on the painting in the dust and filth of his studio in the Bateau-Lavoir – the very embodiment of visionary individualism as he dragged the painting out of the darkness of non-existence. The studio was poorly lit, unventilated, suffocating in the heat of summer. Picasso was alone with his ideas and his inspiration – locked in a ferment of passion and jealousy with his uncomprehending lover Fernande Olivier, isolated even from Braque and Derain, who would express horrified shock when they finally saw the painting.

Titian, on the other hand, didn't even have the idea for his own painting. While his letter to Alfonso d'Este – which he didn't, of course, write himself – praises the ingeniousness of his patron's conception, Alfonso drew on the expertise and scholarship of his courtier-poet advisers – his sister's Latin secretary Mario Equicola certainly and his own court poet Ludovico Ariosto, very probably. Studies of the creation of great Renaissance works of art often place far too much emphasis on the role of the patron, sometimes even referring to them as 'collaborations' between painter and patron. But Alfonso had a whole team of people putting their five penn'orth into Titian's paintings.

Yet the things that would make that painting talked about all over Europe, that would make Alfonso the envy of all other princes, lay not with Alfonso but with Titian. While Titian used assistants to do much of the groundwork and the more mechanical passages – and wasn't necessarily even present when much of the work was done – he couldn't have created paintings of that degree of power and invention without summoning the same degree of commitment and engagement that Picasso brought to *Les Demoiselles d'Avignon*. But it's getting to that intensity that's difficult. Because, while Alfonso's *camerino* generated a considerable amount of correspondence, not one word of it concerns the nature of the paintings themselves, how they were done or what Titian meant by them. *Les Demoiselles d'Avignon*, for all its apparent spontaneity, generated more preparatory studies than any other painting ever – hundreds of drawings that illuminate the artist's thinking through every stage of its genesis. For the *camerino d'alabastro*, in contrast, barely a handful of drawings exist, and, far from taking us viscerally into the processes of the artist's mind and hand and eye, most of them are simply not very good.

Fra Bartolommeo's drawing for *The Worship of Venus* had shown the ritual described by Ovid in which Roman women made offerings of incense to the goddess of love to cleanse all blemishes from their bodies. Around a monumental plinth, nymphs and cupids swarmed and tumbled, captured in a swirl of charcoal whose essentially pyramidal format made it a kind of pagan equivalent to the classic *sacra conversazione* – with the statue of Venus standing in for the Virgin at the apex of the image.

The scene depicted is from Philostratus's *Imaginings*, in which two visitors to the imaginary gallery describe cupids cavorting in an apple orchard, gathering the fruit – the tokens of love – into baskets, while being endlessly diverted. While Titian retained the statue of Venus, he shifted it to the right of the painting – just as he would move the Virgin to the right in the roughly contemporary *Madonna di Ca' Pesaro*, his monumental reworking of the *sacra conversazione* in the Frari. The centre was left free for the great crowd of cupids, who gambol over the sunny sward in a mass of dimpled flesh, so vividly realised you can practically smell the Johnson's Baby Powder.

After the fiasco of the Bellini painting, in which the aged painter used the wrong text, Alfonso had clearly ordered Titian to stick exactly to the given passage. And Titian has done precisely that, rendering every last detail of the story in painstaking, pedantic detail. Here are bonny, blond-curled cupids kissing, cuddling, talking, gorging themselves on apples, pelting each other with the fruit, shooting each other with arrows. There are the 'broidered mantles' they have discarded on the grass, the quivers they have hung from the trees, leaving their hands free to help themselves to the fruit, there are the little wings sprouting from the cupids' backs, 'dark blue and purple and in some cases golden', just as the writer describes them. These are the pagan cousins of the tambourine-wielding putti who bear Mary aloft in *The Assumption of the Virgin*, guiltlessly mimicking the adult world of love. 'This is friendship, my boy,' says one of the story's narrators, an older man who is looking round the gallery in the company of the owner's ten-year-old son, 'and yearning of one for the other. For the cupids who play ball with the apples are beginning to fall in love, and so the one kisses the apple before he throws it, and the other holds out his hands to catch it, evidently intending to kiss it in his turn, then throw back. But the pair of archers is confirming a love that is already present. In a word, the first pair are intent on falling in love, while the second are shooting arrows that they may not cease from desire.'

The setting of Philostratus's story is Naples, its spiritual landscape the baked earth of the southern Mediterranean, with the resinous scent of umbrella pines, the rattling of locusts in the parched underbrush, the mirage effects of intense heat. But Titian, who had never been south of Ferrara and knew nothing of that world, set the scene in a verdant, temperate meadow, dotted with wild flowers. The statue of Venus he copied from an ancient sculpture in the collection of Cardinal Grimani, Patriarch of Venice. Everything else he drew from his imagination, transposing the bare, bright Mediterranean landscape of the story into the lush, green north. The big trees are heavy with fruit, the warm air thick with the scent of fruit just on the turn. 'Can you smell the apples?' asks a character in the story, setting up one of those *paragoni* – comparisons – that Renaissance intellectuals loved so much: the idea that an artist might so surpass

the limitations of his medium that he could capture other senses . . . smell, taste, sound, touch. The faint golden glaze over the scene gives it a sense of ripeness and fullness, the feeling of late afternoon, of late summer, of imminent harvest.

Each of these little figures is perfectly realised and observed, idealised, yet not entirely sentimentalised. Looking at those big, bonny baby heads and, particularly, at the chubby little legs disappearing up into the trees, how can you doubt that Titian went and studied real children, and in some detail, in order to create this painting? You can peer into it for hours and you won't find anything lazy or generic in the mass of tummies, bottoms, chubby cheeks and curls stretching back into the picture. You want cupids? Titian is saying to Alfonso. You want apples? You want a mood of serene and mellow fruitfulness? I'll give you more cupids, more exquisitely and tenderly realised than have ever been seen before.

And over on the right-hand side of the painting, beside the goddess's shrine, are two young women whom we're going to meet again. One dark, looking away out of the picture to the right, the other fair, peering up into a mirror which she holds on high as she leans forward, apparently kneeling beside the rock on which the goddess's statue stands – a little stream flowing out to water the meadow below.

Are these the nymphs – whom Philostratus describes as the mothers of the cupids – who established the shrine to Venus? Or are they mortal women, dressed not in the diaphanous drapery of spirits, but in the heavy garments of the sixteenth century – though still fetchingly *en déshabille*? And, if the latter, what are they doing there? The ritual described by Ovid and alluded to in Bartolommeo's drawing, in which women made offerings to cleanse their bodies, took place on 1 April – hardly appropriate to this scene of harvest bounty. And these aren't the gauzily clad nymphs shown by Fra Bartolommeo, expressing gratitude for having been made mothers of the cupids. These are honest-to-goodness, flesh-and-blood mortal women come to perform their own kind of worship. Having dipped her mirror in the waters of the spring, the girl in red holds the looking glass up to the goddess, hoping to see there the image of her future lover forming in the droplets on the surface of the glass.

What have they to do with each other, these two narratives, the two strapping mortal girls rushing into the right side of the painting, and the great crowd of putti who continue their antics heedless of the human interlopers? But, of course: the human and the semi-divine exist in different dimensions. Just as the lute player and the shepherd in *The Pastoral Concert* were unaware of the naked spirits of the land beside them on the sunlit grass, so the cupids are invisible to the mortal girls. And, as for the cupids, they are simply indifferent to the presence of the girls. They are demi-gods; they just do what they do.

Here we see the two forms of the worship of Venus. The cupids, the purveyors and progenitors of love. The two girls, the recipients, the enactors of love. To the left, the cause of love, to the right, the result. And, lying on the grass in the foreground, we see the logical outcome of the whole process. Philostratus describes the 'broidered mantles' discarded by the cupids and their 'countless colours'. But these aren't countless in colour, and they aren't embroidered. There are only four of them, far too big for the cupids. The glistening crimson silk that fair cupid is sitting on as he snogs the only girl cupid is actually the skirt worn by the fair mortal girl with the mirror. The mound of rumpled white is her billowing camisole, while the blue silken garment thrown down beside it is exactly the same tone and hue as the dress that hangs loose, artfully exposing the full, pale breast of the dark girl on the right side of the painting. The worship of Venus has arrived at what, for the ancients at least, was its inevitable conclusion – abandonment to physical passion.

This was erotica at its most intricate and luxuriously discreet – a chain of elaborate conceits leading to a consummation that takes place so far off camera that only the very observant and the very cultured, only the true connoisseur, will even realise it has taken place. Perfect for the private room of the man who has everything. Alfonso was delighted.

Love and the fulfilment of love were in the air in Ferrara. Alfonso's second wife, Lucrezia Borgia (later to become notorious in relation to the murder of her previous husband), whom he had been obliged to marry in order to fulfil his father's obligations to the Pope, had died, leaving him free to enjoy the affections of his long-term mistress, Laura Dianti. Titian's painting expressed his mood

perfectly. On Raphael's death in April 1520 at the age of thirty-seven, his heirs wrote to Alfonso asking if he would like the long-promised and endlessly delayed *Meleager and the Calydonian Boar Hunt* to be completed by the painter's studio. Alfonso brusquely turned them down. Raphael's studio be damned! He immediately commissioned another painting from Titian.

In 1522, responding to Titian's claim that he was too ill to go to Ferrara, Alfonso's agent in Venice, Jacopo Tebaldi, went to see the artist in his studio. 'I have been to see Titian,' he wrote to Alfonso, 'who has no fever at all. He looks well, if somewhat exhausted, and I suspect that the girls whom he paints in different poses arouse his desires – which he then satisfies more than his limited strength permits. Though he denies it.'

There he stands, in the shadows of a painting that was long considered to have been done at the same time as his work for the *camerino d'alabastro*, a handsome young man with a curly brown beard, holding up a pair of mirrors for a young woman whose glowing, buxom form dominates the centre of the image. *The Woman with a Mirror* or – as it was known for centuries after it was first documented in the collection of Charles I of England – *Titian and his Mistress*. With something of the air of a hairdresser showing a customer the results of his labours, the painter holds a large circular mirror behind the model's head and a small rectangular one in front, into which she stares engrossed, enraptured at the sight of her broad white breast, the pleated blouse – just like the one worn by her blonde counterpart in *The Worship of Venus* – the green bodice she is practically bursting out of. Exposing her rounded alabaster shoulders, she holds up a hank of hair crinkly from plaiting and dyed that shimmering red-gold known to this day as 'Titian red'.

The mirrors are symbols of the *paragone* of painting, that represent painting's ability to show the subject from various angles simultaneously. And while there is a sense of intimacy in the physical closeness and the blowsy informality of the woman's dress, can it really be described as erotic?

To Victorian writers like Titian's biographers Crowe and Cavalcaselle and the mountaineering author of the doorstep tome

on Titian's home region, the meaning of such paintings was clear. They were symptomatic of the moral failings of a 'licentious age' – understandable in an artist living in a city with 11,000 prostitutes (never mind that nineteenth-century London had four times as many). The term 'bella di Tiziano' – appended to a number of paintings of this type – could only refer to a beautiful woman 'known' to Titian. Indeed, for centuries it was simply assumed that Titian availed himself of the women he painted in the kind of seigneurial, half-casual way that any great artist surrounded by half-naked floozies inevitably would – and which Tebaldi, a frequent visitor to his studio, clearly believes he did.

Yet in this painting at least, Titian, the enabler of female beauty, seems insufficiently proprietorial – seems to be assisting, even serving, the subject of the painting, while she seems entirely preoccupied with her own rather doughty charms. There he is, showing her to herself, demonstrating the *paragone* of painting – but to what purpose?

In the slightly later *Flora*, a painting with a superficially similar-looking model and a very similar pose, the subject is at once more overtly eroticised and more removed from reality and thus more 'sophisticated'. The filmy blouse – immediately identifiable as 'nymph-like' to a contemporary viewer – hangs low over her smoothly modelled breast, 'Titian'-coloured hair spilling over her warm golden skin, while a handful of flowers identify her as Flora, goddess of flowers, who was famous in classical literature not only as a nymph but as a courtesan.

While *The Woman with a Mirror* retains an air of vigorous, even slightly naive reality, *Flora* feels rather generic, idealised, classicised. But both belong to a quintessentially Venetian genre, of which Titian and his contemporary and rival Palma Vecchio were among the prime exponents. While portraits of real women were rare in Venice – a society where respectable women remained hidden in the home – there was a taste among the Venetian elite for paintings of anonymous young beauties; images that were lent a veneer of respectability by including – often very nominal – mythological attributes. And the models and exemplars for these images were provided by a class of women who were simultaneously reviled and idolised – the courtesans.

Established in luxurious state in their mansions around the Rialto, schooled in the arts of music and conversation since childhood, the courtesans of Venice were celebrated throughout Europe. They had become emblematic of Venice as a place and an idea.

But were these the kind of women Titian spent himself with? The most expensive women in the world? Hardly. He knew them, of course. How could he not, invited as he was to the sort of exclusive all-male dinner parties where the presence of at least one such woman was obligatory? He may have been close friends with some of them, as his friend, the poet Aretino, certainly was. And they undoubtedly posed for him on occasion. But he wasn't at a social level where he felt obliged to compete for such women. He was essentially in the same line of business as them – a purveyor of fantasy trying to get the highest price for what he had to sell – and from essentially the same customers.

And can you imagine Titian wanting to shell out that sort of money for sex? Why would he need to when he could summon very inexpensive girls at the drop of a hat? Sluts, wantons and jades of every order of prettiness, sweetness, kindness, outright beauty, outright nastiness, venality and criminality – girls who stood in for him as nymphs and goddesses, as saints, Magdalenes and as Our Lady herself; from among whom he chose at his leisure, handling them as he shifted them into the required positions – the supplicatory posture that would turn them into the Virgin of the Annunciation, sprawled out on a bed as the naked Venus, kneeling imploring as the Magdalene in the Garden of Gethsemane. As Titian's eye moved over every inch of their prone forms – masses of quivering, naked gooseflesh in winter barely warmed by inadequate fires, half-asleep in summer, swathed in heavy encumbrances of silk and cotton – Titian's hand and brush mapping the curve of flesh, the tension of legs and arms held in painfully unnatural poses, draperies describing the swelling volumes beneath.

Did he find himself drawn into the same desire his looking was designed to engender in others? Or did the process of analysing and describing force him into detachment until the moment of looking was over? As his eye and brush moved over his models' bodies, describing not only the contours of their soft curves, but their warmth

and plasticity, the tautness, the faint, almost imperceptible downiness of teenage flesh, the voluptuous, almost gelatinous pliability of older bodies, did he find his hand moving in sympathy over real, warm, living flesh? Or was that saved for afterwards? Titian was paying these women. Was a little of what they did best implicitly part of the deal? Or was that broached entirely separately? Was there a clearly negotiated fee or would Titian just throw in a few extra coppers as a kind of tip?

That is, of course, if any of this happened at all. The idea of sex and art flowing naturally in and out of each other – the artist capturing his lover's satiated body by the glow of the gas fire, sprawled out on love-soaked sheets – belongs to the bohemian age. Titian's studio in the old Milanese palace in San Samuele was no dingy garret but a semi-public professional workplace. Titian was never alone with his models. There were always at least two assistants present. And, while there would have been plenty of opportunities for liaisons outside the workplace, when he was working Titian was more likely to be telling them to lie still, to hold the pose, to stop chatting, to stop whinging than to be engaging in amorous overtures.

The only model specifically referred to in the documents was the daughter of a neighbour who sat for him as Mary Magdalene, and was made to hold the pose for so long that she burst into tears. Titian was so pleased with the effect that he kept her there several hours more, missing his dinner in the process.

At the time of his work for Alfonso d'Este, Titian was living in a rented apartment belonging to the Tron family in the San Polo area behind the Frari. In 1519, a young woman moved into his quarters: Cecilia, daughter of Master Giacomo, a barber of Peratoto, the village next to Pieve di Cadore. She had come to Venice expressly to act as Titian's housekeeper. If Titian was to be looked after, who better to do it than a woman from his home town, who understood the ways of his own region, who could cook the dishes he knew from childhood, whose family would have some long-standing relationship with his – who was, in effect, already bound to him? At what point did it become apparent that they would sleep together? Was it taken for granted that he would use her in this way – a natural outcome of the master–servant relationship? Or was it a question of familiarity

developing over a long period, so that intimacy occurred just of its own accord? Was she a simple village girl who could easily be exploited? Or did she have her own ambitions, with this position her means to social advancement? Either way, nothing was rushed. It was nearly five years before they had their first child together.

In August 1522, Jacopo Tebaldi made one of his regular visits to Titian's studio to ascertain the extent of progress on *Bacchus and Ariadne* and to attempt, if it were possible, to move things along. Staring pointedly at the canvas he observed that the car carrying the god Bacchus and the two leopards pulling it had been completed alongside two finely realised figures. But the rest of the figures and the surrounding landscape were not even begun – though the artist insisted that the painting would be finished over the following fortnight.

After it had been agreed that the painting should be shipped to Ferrara in October, and Tebaldi was about to leave the studio, Titian suggested that it might be necessary for him to receive a letter of safe conduct before he made the journey to Ferrara, so much had he tested the duke's patience. Tebaldi was at once impressed that the painter still regarded his employer with some degree of awe and fear, and amused and exasperated by Titian's protestations that he would take on no more commissions, not even from God himself, until he had finished the duke's painting – the like of which he had heard so many times before.

For Tebaldi, Titian was an intriguing character. His venality and transparent duplicity were contemptible, yet understandable in someone of his background. 'He is a poor fellow,' he wrote to Alfonso, 'and spends freely, so that he needs money every day and works for whoever will provide it, so far as I can see.'

Tebaldi had also been shown the Averoldi Altarpiece, a large polyptych, painted for the papal legate, which contained a panel of St Sebastian, considered by many, including the painter himself, to be among the finest things, if not *the* finest, he had ever done. When Titian grumbled that he had agreed to let Averoldi have the painting for 200 ducats, when the St Sebastian panel alone was worth at least that price, Tebaldi suggested that he sell the St Sebastian to his

master, replacing it with a replica by his workshop. It would be some recompense for the inconvenience and irritation he had caused the duke, while mere priests and friars would never know the difference. While first protesting outrage at the very suggestion, Titian eventually agreed to sell the panel to Alfonso for just sixty ducats – nervous, no doubt, at refusing an outright request from his foremost patron and a potentially very dangerous enemy.

Alfonso eventually decided against buying the panel for fear of provoking the enmity of the legate, but continued his enquiries into the progress of *Bacchus and Ariadne* with increasing fierceness – causing Tebaldi's visits to the painter's studio to become even more frequent. Emboldened, Titian informed Tebaldi that his friend Niccolò de' Martini was fond of hunting and would enjoy a day's sport occasionally on the duke's lands on the north banks of the Po. If his friend were granted this favour, he would ensure that the two principal figures on the canvas were the best he had ever painted. Tebaldi laughed this off as mere banter, simultaneously exasperated and amused by Titian's chutzpah, and knowing he was only doing what every man of his station, every artist – every tradesman – did as a matter of course – trying it on. Yet Tebaldi, like his master Alfonso, had no doubt of Titian's capacity to produce a masterpiece. That was the power Titian had over them. And Tebaldi confided finally to the duke that he had no option but to humour the artist by giving him more money.

As for Titian, his first concern was to maintain his independence. If you became over-dependent on these people's patronage, if you allowed them to get their claws into you, your life wouldn't be your own. He'd seen what had happened to Andrea Mantegna, brother-in-law to his teacher Giovanni Bellini, court painter at Mantua, who had been mercilessly hounded by Alfonso's sister Isabella d'Este. Or his acquaintance Ludovico Ariosto, court poet at Ferrara, who had dedicated his masterpiece, *Orlando Furioso*, to the glory of the Este and been treated like a glorified servant, given a miserable pension and finally made governor of the bleakest and most bandit-ridden district in the Apennines. No, the only way to retain these people's respect was to assert your independence, to make them aware that there were other, equally powerful people also pressing for your services, while

always using the correct formulas in addressing them, always making the appropriate ritual obeisances and remembering not to push them too far.

For his last painting for the *camerino*, Titian returned to Philostratus's *Imaginings*, for the story of the Andrians, inhabitants of the island of Andros – 'where the earth is so charged with wine that it bursts forth for them in a great river'. As Bacchus's ship arrives in the distant background, the islanders drink from the river, singing and dancing, or sprawl out on the deep-green sward in a party scene that was intended as a direct challenge to Giovanni Bellini's *The Feast of the Gods*.

Titian's old master had been dead a good eight years. Why would his most brilliant pupil still want to compete with him, still want to do down the artist to whom he owed most in the world? Simply, because he could. With the delivery of *Bacchus and Ariadne*, Alfonso's scheme for the *camerino d'alabastro* was apparently complete. Yet Pellegrino di San Daniele's *Triumph of Bacchus*, mugged up as a stopgap from Raphael's drawing, clearly didn't cut it when seen between *Bacchus and Ariadne* and *The Feast of the Gods*, and Alfonso decided to commission one last painting from Titian, a work that would make his study truly a wonder of the world.

Titian, seeing where the painting was to hang, directly to the left of Bellini's *The Feast of the Gods,* saw an opportunity to tackle a similar subject, but take it further, in the light of everything he now knew but Bellini never had – a painting that would echo many of the same elements but in a far fuller, richer, better way.

While the action in Bellini's painting feels somnolent, almost static, the figures arranged in frieze-like bands through a shallow space along the front of the painting, with everything fairly evenly lit, in Titian's painting every figure is in motion, arranged back through the picture space in dynamic postures, interweaving in looping arabesques that are artfully orchestrated, but feel so loose and spontaneous that they make *Bacchus and Ariadne* seem stiff and posed. The light flooding in between the tree trunks on the left leaves the centre of the painting – traditionally the most important part – in shadow, the whirling limbs of the revellers half-silhouetted against the towering, sunlit cloud that dominates the background.

And yet if you look at the two painting side by side, you will see that some of the shapes created by Bellini's figures are still present in Titian's painting. It's as though Titian had begun by copying Bellini's composition and only then started breaking it apart. And maybe laziness had something to do with it. Having been asked to repaint parts of the landscape in Bellini's painting so that it blended more smoothly with the paintings hanging around it, Titian knew the picture extremely well. Asked to paint an al fresco drinking party *al antiqua*, and having no ideas of his own, why not use the painting that was to hang beside it as a starting point?

Whole areas of the Bellini composition are lost altogether – the figure of Silenus with his ass replaced by the sunlit torso of a magnificently muscled male nude, reaching over to pour wine, which is in turn balanced by a shaded figure to the right. Others remain with surprising clarity, but changed into completely different forms. The demure, yet slightly drunk Cybele has become a reclining male nude copied more or less directly from Michelangelo's cartoon for *The Battle of Cascia*. Hermes, the largest figure in Bellini's painting and the one closest to us, has become a pair of reclining women, his white sleeve, an essential highlight of the original painting, transformed into the sunlit shoulder of the darker of the two women, who lies with her back to us, engrossed in conversation with a woman with the typical red-gold Venetian hair. The nymphs approaching with pitchers of wine in Bellini's painting have become a group of dancers, a girl's diaphanous skirts lifted by the wind to reveal 'the lively whiteness and incomparable softness of her beautiful legs', as Carlo Ridolfi, Titian's seventeenth-century biographer, put it.

But let's go back to the two women – one dark, in blue, one fair, in red. A dark woman in blue, a fair woman in red. Where have we come across that combination before? Why, in *The Worship of Venus* – in the two robust damsels paying homage at the shrine of the goddess. Is this them again – present, yet oddly absent from the orgy of the Andrians? The fair girl holds up her dish to be filled by the standing naked man, while the magnificently muscled reclining male appears to be fondling her calf. Yet all parties appear peculiarly indifferent to each other – the girls in their sixteenth-century Venetian clothes, deeply absorbed in their conversation, the Andrians in their

diaphanous classical garb – or in nothing at all – carried away in the heedless whirl of drinking, dancing and singing.

Are we back with the pastoral convention, seen in *The Pastoral Concert* and *The Worship of Venus*, where the gods remain invisible to the paintings' mortal narrators? The two young women each hold recorders, while on the ground beside them lies the music to the song they have just been playing or are about to play, its words in French just discernible, 'Qui boyt et ne reboyt, Il ne scet que boyre se soit' – 'He who drinks and does not drink again does not know what drinking is' – as clear a statement of the hedonistic principle as you can get. And the recorder, of course, is a phallic symbol.

And tucked into the blouse of the fair woman, the one who faces us and thus commands our attention, Titian has painted, flush to her creamy breast, a *cartellino*, an illusionistic scroll of paper on which he has signed the painting – and beside it a tiny spray of violets.

Violets. I said we'd come back to them. The *cartellino* was popularised by Bellini, a device designed to draw attention to the artist's skill. But while Bellini pinned his signature to a barrel in *The Feast of the Gods*, Titian placed his name in *The Andrians*, not on inert wood but against a woman's living flesh. And to the right of the painting, in the place occupied by the sleeping Lotis in the Bellini picture, but pulled forwards, so that she fills the whole of the bottom right-hand corner of the painting, is a magnificent female nude – her head thrown back in a way suggestive simultaneously of wine-induced slumber and erotic stupor, her flesh exuding a creamy glow that makes poor Lotis look pale and wan by comparison.

There she lies, her right arm raised, so that as much of her soft ripeness is visible to us as possible – her throat and breasts and stomach and legs catching the glow from the left of the painting – so that flesh and light are indissolubly welded – flesh seen though light, flesh emitting light. She appears at once vulnerable in her naked unconsciousness, yet remote in her very perfection – available through the sense of sight, her pliant skin remaining beyond the sense of touch.

But who is she? Another reveller sleeping it off? Is she perhaps dreaming the entire scene, Alice-like? Or is she the nymph and hence the source of the river from which they are all drinking? The large

urn lying on its side, forming a kind of pillow beneath her head, is a device suggestive of a source, though the red stream that runs along the bottom of the painting, into which a small boy – a cupid? – is pissing, and into which the naked man to the left of the young women is dipping his jug, seems to emanate only indirectly from her.

Essentially, she's there for your enjoyment, just as the revellers are enjoying the wine and the warmth of the sun. The dancing girl meets the eye of one partner, while holding the hand of another, who appears far more interested in his glass ewer of wine, while a third watches her with all too clear intent. This is free love enabled by wine, a world of heedless pleasure, untrammelled by any hint of Christian morality, by the need to impart any kind of message beyond 'Keep on drinking! Enjoy!' – a purely pagan mood that Titian has captured more effectively than any other artist up to that time, perhaps because he has no deep-seated moral vision of his own.

It was Carlo Ridolfi who first suggested that the fair girl in *The Andrians* – the one with the violets and the artist's *cartellino* secreted in her warm bosom – represented Violante (Violet), a woman 'loved by Titian'. And with the idea of Violante comes the notion that, hidden inside Alfonso d'Este's pagan allegory of wine and pleasure, is Titian's own allegory of love – that the fair girl in red (always the more active and demonstrative of the two) is on a quest for love through the paintings in Alfonso's *camerino*, and that the face she hopes to see formed in the droplets of water on the mirror in *The Worship of Venus* is Titian's own. He, of course, is the author of the letter pressed against her breast. Ridolfi's contemporary, the writer Marco Boschini, believed Violante to be the daughter of Titian's sometime colleague and rival Palma Vecchio – a romantic idea except that Palma was scarcely older than Titian and never had any daughters. The eighteenth-century French critic Louis Hourtiq identified Violante as *Flora* in the Uffizi, as the two women in *Sacred and Profane Love* in the Borghese Palace and *The Woman with a Mirror* in the Louvre.

No one, though, has suggested that this figure – secure in her carefree sylvan mythic world – flushed and eager, eyes intent on her companion (and what can they be talking of but love?), might represent the real woman in Titian's life at this time, his housekeeper Cecilia, who gave him his first son, Pomponio, in 1524. Maybe

those earlier writers understood implicitly that Cecilia, the faithful drudge from Cadore, wasn't a romantic figure for Titian. Sent to Venice to wash his smalls, impregnated by him because he couldn't be bothered not to, she may have been regarded by him with some embarrassment. It's difficult to imagine she can have been much of a looker. While Cecilia has been identified as various other figures in Titian's paintings – as the Virgin in the majestic Pesaro Altarpiece in the Frari and the exquisite, jewel-like *Madonna with a Rabbit* in the Louvre, both coolly pretty if slightly anonymous young women – there's hardly a character in Titian's life who hasn't been tied to a figure in one of his paintings at some time or other.

And then again, maybe her role as housekeeper was more elevated than I've supposed. Maybe the pan scouring and floor swabbing were done by other, lowlier skivvies. Maybe Cecilia's primary role was to keep the painter in order. Maybe she really is the cool and serene Madonna who looks down from the monumental Pesaro Altarpiece – that majestic, asymmetrical reworking of the classic, pyramidal *sacra conversazione* of Giovanni Bellini. Maybe the little boy standing on her knee, raising his mother's veil in a gesture that looks quite comically realistic in that exalted setting, is not simply the Infant Christ, but also Titian's eldest son Pomponio.

Maybe. But we only know of Cecilia's existence through two documents, one of them an affidavit produced fifteen years after the event, in which the two witnesses – Titian's then fifteen-year-old assistant Girolamo Dente and a goldsmith named Niccolò – vouchsafe that they were present at the brief ceremony in Titian's apartment in 1525 in which he married Cecilia. Cecilia was at that moment critically ill giving birth to their second son, Orazio. And it has generally been assumed that Titian married her only because it was his last opportunity to legitimise the two boys, should Cecilia die.

7

Sixteen Positions

'TRUMPI NOTICED THAT despite a predominant exegetical tradition that suggested differently, Vasari's passage on Donatello and Luca della Robbia comes surprisingly close to the original meaning of Horace's original analogy.' Am I stupid? Yes, I realise that, when the reckoning is made of the most tortuously hermetic sentences committed to paper with the purpose of disentangling the complexities of representation in Western culture, that won't even get into the last couple of million. It isn't even one of the more difficult sentences I've encountered in the literature on Titian – and somehow, some way, it does relate to Titian. In fact, as these things go, it's hardly tortuous at all. No, it's the thought of how many more such sentences there are in how many more hundreds of books – all of which appear indispensable – that is making me dizzy, the prospect of negotiating four centuries of academic literature on my chosen subject that is making me feel slightly ill.

I'm sitting in the National Art Library in the Victoria & Albert Museum in London – up an airy stairwell lined with gilded, nineteenth-century mosaics of the Renaissance masters (Titian included), through a pair of glass doors into an airy reading room hung with big globe lamps. Green-shaded lights protrude over each of the reading spaces, the rich, polished mahogany covered in dark green leather which has been touched by the hands of how many

hundreds of thousand of scholars? There's a power point to plug your laptop into. Otherwise the place has barely changed since it opened in 1852. It's a privilege to be here – a privilege of which I'm making extremely poor use.

You're not supposed to order more than eight books in one day, but I didn't realise that till I'd ordered at least thirty – and they kept arriving, piling up around me in great cliffs of paper, buckram and cracked and ageing leather. I flicked through them in a state of rising panic – from Crowe and Cavalcaselle's biography to the recent *Titian and Tragic Painting*, which relates the artist's last works to Aristotelian 'poetics' (whatever they are) – hardly able to concentrate on any of them for more than a few sentences at a time. I fell on the monumental *Titian's Women*, till I read, two-thirds of the way through the first page, that the author had nothing further to say on Titian's relationships with or feelings for real women. So what the hell was the rest of the book about?

I thought art history was literally the history of art – and I'm saying this as someone who wrote an art-historical thesis in order to complete a degree in painting (for which he did no painting). I'd even thought it might be art plus history. In fact, art history is about establishing provenances for the benefit of dealers and collectors. It's about documents, evidence and attribution. It's about allowing scholars to secure tenure by publishing books and articles that show they've got to grips with the immense body of scholarship that already exists.

And the most frightening thing was how little concrete evidence this vast scholastic edifice was built on. Once you'd familiarised yourself with the basic facts of Titian's life, you kept coming across the same few details and anecdotes endlessly recycled and reinterpreted from book to book, article to article. One book led into another – each with a subtle shift in emphasis – like a succession of interconnecting circuits that kept bypassing the same points. The history of art was a hermetic, self-perpetuating intellectual system, and I was getting trapped inside it.

A young female assistant approached and slipped a slender volume on to the edge of my desk. Shifting aside *Titian's Women*, I opened the book at random:

Let's fuck, my love, let's fuck!
Since we were all born to fuck!

This was more like it.

You adore the cock and I the cunt.
The world would be nothing without this act!

The poem went on, a woman's voice interjecting:

Let's stop chatting – stick your cock in till it reaches my heart!

This was one of the 'Sedici Modi' – the 'Sixteen Positions' – sixteen sonnets written by Pietro Aretino to accompany a series of engravings from designs by Raphael's protégé Giulio Romano – images that pulled the curtains back on the Renaissance bedchamber, revealing men and women at it in the most unlikely, uncomfortable and downright ridiculous postures: the man squatting crab-like as the woman impales herself on his member, the man standing and holding the woman upside down for mutual oral stimulation and even on a small trolley – with Cupid himself drawing it along on a string:

You little prick! Don't keep pulling the cart!
Cupid, you bastard, stop it!
I want to fuck her in the cunt not the arse.

Aware of a presence beside me, I turned to see the young female assistant. 'I'm afraid the other book you requested isn't available.'
'Right,' I said, discreetly sliding the 'Sedici Modi' out of view.
'It may be being rebound. I'll make some enquiries.'
'Thank you,' I said. She moved away, and I returned to the book. Why I should feel even the slightest bit awkward being seen reading sixteenth-century pornography I couldn't imagine.

Push harder, your prick's slipping out.
I swear if I'd waited one moment longer for release I'd have died!

This was the past speaking to me as raw and immediate as I could want. And there was no need of academic mediation, what with the sheer vigour of the plunging haunches, convulsive thighs and contorted faces crowding every millimetre of the accompanying woodcuts; though they were relatively crude copies of the original copper engravings, almost all of which were destroyed on papal orders on the book's initial publication in 1524. Indeed, there was said to be only one copy left in existence.

And even here the Renaissance mind couldn't help introducing a classicising element. The heroically muscled male – bearded, middle-aged – was a kind of Jupiter, the woman – quite as insistent on her pleasure – a Juno, even as they appeared about to pass out through their frenzied, flailing coupling.

The book's engraver and publisher, Marcantonio Raimondi, was imprisoned, and Aretino would have suffered the same fate if he hadn't already left Rome. Poet, scabrous playwright, satirist, author of religious tracts, professional letter writer, art critic, Aretino was the first writer to boast of his inability to speak Latin and the first person to become rich and famous for shooting his mouth off in print. He published several bestselling volumes of his correspondence, his outspoken political views – carefully slanted, according to who was paying him at the time – earning him the soubriquet 'scourge of princes'. He was by far the most important proponent of Titian's art, and – famously – Titian's best friend.

A cobbler's son, born in Arezzo in 1492, and therefore just a few years younger than Titian, Aretino ran away from home at fourteen. Apprenticed to a painter in Perugia, he was turned out for creating a blasphemous image of the Virgin, and wandered Italy, publishing his first poems at twenty and arriving in Rome in 1516. Attached to the fabulously wealthy banker Agostino Chigi, patron of Raphael, Sebastiano del Piombo and Giulio Romano, he became a central figure in that sub-stratum of Roman society where the curia – the papal court – interacted with the demi-monde. Famed, feared and hated for his pamphlets and satirical poetry, he was stabbed on the orders of one of his 'victims', losing part of the use of his right arm, and thought it wise to leave Rome on the election of the conservative Pope Adrian VI in 1522.

Once again at large in Italy, a pen and a mouth for hire, he served first the warlord Giovanni delle Bande Nere – Giovanni of the Black Bands – so-called 'last of the condottieri', then Federico Gonzaga, Marchese of Mantua, before settling in Venice, where he was to spend the rest of his life, in 1527.

Aretino arrived penniless, but almost the first thing he did was to commission a portrait of himself from the city's most famous and, needless to say, most expensive artist. We see him in a later portrait by Titian, in middle age, his bullet head with its formidable brow, full, sensual mouth and furious sprawl of beard radiating a saturnine energy – and all pushed towards the top of the image, so that he almost completely fills it; his capacious girth sheathed in a coat of magnificent deep Indian red, its massively broad satin collar giving a sense of imposing frontality – as though his personality and presence were too enormous to be contained by a mere canvas; though I suspect that Aretino was, in reality, quite short.

And Aretino had no sooner laid hands on Titian's portrait than he sent it to his former patron Federico Gonzaga – as a present. From our perspective it seems a quixotic, perversely egotistical gesture, but what better way to remind his former patron that he was still in business? It was the precariousness of his position at the Gonzaga court, the uncertainty of Federico's loyalty, that drove Aretino to leave Mantua and seek refuge in Venice. And a portrait by Titian – Federico's favourite artist – would show that, far from having slipped into ignominy, far from disappearing conveniently from the scene, Aretino was very much alive.

Federico wasn't going to put a Titian painting in a cupboard, whatever his feelings about the subject. The painting would be prominently displayed and much discussed. And Aretino's ability to talk up its qualities, to eulogise it and its creator in letters that would be published and read all over Europe, would give the painting a whole other existence, another level of celebrity that extended way beyond the walls of the Gonzaga palace.

Titian himself understood that. Far from casting himself into further penury to obtain the portrait, Aretino would have got it on very favourable terms – if he paid for it at all. Over the following decades, as Aretino became one of the most famous men in Europe,

drawing pensions simultaneously from the two great powers of the time – France and the Holy Roman Empire – he never lost an opportunity to trumpet the qualities of Titian's art, to recommend to his correspondents – who included most of the notable rulers, writers, statesmen and churchmen of the age – that they have themselves immortalised by the Divine Titian in paintings that would be more like them than they were themselves. And in doing so, he drew the glow of Titian's genius on to himself. His celebrity and Titian's illuminated each other.

Aretino projected Titian in the role in which he was best known to his contemporaries – the greatest of all portrait painters. Aretino's commentaries on Titian's paintings in sonnets, letters and broadsheets provide a kind of parallel 'text' that interpreted these paintings to their subjects and to the thousands of readers who would never see them, who apprehended Titian entirely through Aretino's words; even though, in many cases, Aretino hadn't seen the painting he was writing about. 'The harmony of colours which Titian's brush has spread,' he wrote of Titian's painting of Eleonora Gonzaga, 'renders visible from without the concord which in Eleonora the handmaids of the noble spirit govern.' Not bad considering the painting hadn't even been started at the time.

There's a danger in standing too close to people who burn as brightly and as unpredictably as Aretino – that you'll get burnt, that you'll become guilty by association, that their bile and spite will one day be turned against you, that your confidences will be broadcast in letters read by half of Europe. Yet Aretino retained a respect for Titian bordering on veneration. While contemporaries regarded Titian's portraits and Aretino's commentaries as being of equal value, Aretino, for all his bluster and egotism, understood that the partnership was not an equal one, that ultimately Titian was greater than he was; and I daresay Titian understood that too.

The Sack of Rome in 1527 brought an influx of exiles and refugees, among them many writers, artists and intellectuals, one of the most notable of whom was Aretino's great friend and carousing partner, the sculptor and architect Jacopo Tatti, called Il Sansovino. Sansovino became the most prominent figure in a new classicising phase in Venice's architectural development, instituted by Doge Andrea Gritti

– who just happened to be Titian's most powerful protector in the Venetian administration. The clearing of the jumble of shops, slums and slaughterhouses around the Basilica of St Mark, and the building of the Procuratie Vecchie and Nuove – the majestic colonnaded buildings that front St Mark's Square – together with Sansovino's masterpiece, the Library of St Mark, all date from this period.

Aretino, Sansovino and Titian became an inseparable triumvirate – *i tre compari*, the three cronies – Venice's most famous writer, her most influential architect and her greatest painter – a nexus of artistic and social influence around which many other important figures converged.

The parties and banquets, where the chosen among the aristocrats and merchants of Venice mingled with visiting celebrities, poets, artists, intellectuals and the greatest courtesans of the time, took place mainly in Aretino's house on the Grand Canal, just up from the Rialto and opposite the fish market, a property Aretino had been given use of by the aristocrat Domenico Bollani (a man like Aretino would never be expected to pay for anything).

Yet, however hard Aretino gleams, however loudly he talks – and Aretino never seems to stop talking – Titian never quite comes into focus beside him. There's the sense that even for his great friend, Titian remained something of an enigma. 'I myself am so fond of brothels,' Aretino told Sansovino, 'that the large amount of time I don't spend in them almost kills me. But this is not the case with Titian ... What really makes me marvel is that whenever he sees lovely ladies, and no matter where he is, he fondles them, makes a to-do of kissing them and entertains them with a thousand juvenile pranks. Yet he never takes it any further.'

When the revels were over, however late the hour, Titian would take a gondola from the steps below the house – the *porta d'acqua* – and head back to his home on the still half-developed north side of Venice, back to the placid, safe, domestic world of his family and his servants.

Titian's wife Cecilia died in 1530, giving birth to their second daughter Lavinia, the first having died in infancy. The Duke of Urbino's agent wrote, warning his master that his portrait might be

delayed as the artist was too disconsolate to work; though this was, it must be said, only the day after Cecilia's death. Titian's grief has often been interpreted as a factor in a change in direction in his work at this time. And, however novelettish that may sound, there is an apparent shift in emphasis. The great monumental works that established him – from *The Assumption of the Virgin* through the paintings for Alfonso's *camerino* and *The Madonna di Ca' Pesaro* to the violence and passion of *The Death of St Peter Martyr* in the Church of Santi Giovanni e Paolo – were behind him. There was a concentration on smaller, more portable works: portraits and devotional works that tend to be domestic and intimate in feel. While it has been claimed that the Virgin in the *Madonna and Child with St Catherine* (the so-called *Madonna of the Rabbit*) represents Cecilia, it is actually the sumptuously dressed Catherine, her face slightly averted as she holds the infant Christ, who appears more a portrait of a real person. Focusing on the Madonna and Child, we look past the saint's rather pretty, pointed, slightly upturned features seen slightly in shadow. Of noble birth, hence the white satin dress and gold-embroidered scarf, Catherine was martyred as a virgin, but here she wears her hair up, in the manner of a married woman, to denote her mystic marriage to Christ – and to hint, too, at the model's relationship with the dark-bearded shepherd seated with his flock, further away in the right of the painting. Completely fanciful, of course, until you realise how many figures in Titian's paintings do relate to real people. The Virgin sits directly on the minutely detailed emerald grass, in the pose associated with the 'Virgin of Humility' – which gives the scene the look of a family picnic – while her son, entranced by a rabbit sitting on the grass, reaches up to touch St Catherine's chin.

It has been pointed out that only a man who had known the joy and peculiar anguish of fatherhood could have produced such a tender, unaffected – and essentially realistic – portrayal of family life; could, as Crowe and Cavalcaselle put it, 'have seized at a glance those charming, but minute passages which seldom or ever meet any but a father's eye'.

After Cecilia's death, Titian took the children, including the babe-in-arms Lavinia with a wet nurse, up the long mountain road to Pieve di Cadore. When he returned, he had with him his younger sister

Orsa, who was to become the 'sister, daughter, mother, companion and steward of the household', as Aretino observed. In the following year, 1531, Titian moved his family into a house in an area of the northern part of the parish of San Canciano known as Biri or Sbiri Grande (the first part of the name from an archaic word meaning watch or police), a district that was then still semi-rural in character, an area of sheds and gardens that had only recently been drained – its marshy shoreline still riven by small streams. Not far to the east lay the Church of San Francesco della Vigna and the harbour designated for the use of the people of Cadore, around which clustered the huge timber-bearing rafts.

Known as the Casa Grande, not so much because of its size but to distinguish it from another property in the same area, the house had been completed only four years before, for a nobleman named Alvise Polani who died shortly afterwards. Titian rented the *piano nobile*, the principal floor of the house, in this instance the top floor, with its tall windows and views out over the Lagoon, for forty ducats per annum. Six years later, in order to get rid of nuisance tenants, he also took the mezzanine floor immediately below, and set about establishing a lifestyle appropriate to a man of his importance. A formal garden was laid out which, on one warm and memorable summer evening in 1540, reminded a distinguished visitor of the 'delicious retreat' of Sant'Agata in Rome.

'It was so well kept, so beautiful and consequently so much praised,' wrote the Florentine grammarian Francesco Priscianese, who was invited for dinner with Aretino, Sansovino and the historian Jacopo Nardi. He was treated, he wrote, to 'the most delicate viands and the most precious wines', and, apart from a moment when Aretino exploded at a remark in a letter Priscianese had brought with him, the evening passed very pleasantly.

'Here before they set out the tables – for although the place was shady the sun still made its strength much felt – the time was passed in contemplation of the life-like figures in the excellent paintings of which the house was full, and in discussing the real beauty and charm of the garden, which was a pleasure and a wonder to everyone.

'And as soon as the sun went down, that part of the sea was filled with a thousand little gondolas adorned with beautiful

women, and resounded with diverse harmonies – the music of voices and instruments – which till midnight accompanied our delightful supper.'

A vast white cruise liner was sliding through the Canale della Giudecca, lights blazing, loudspeakers blaring, almost filling the widest channel of Venice's main island group. It was there for a few moments, a great vision of light and noise, a white city in its own right, towering over the ancient waterfront façades. Then it was gone, leaving the jade-green water slurping up over the white stone embankments of the Zattere, leaving Venice to be what it has always been – indifferent. It was a cold April day, the sky overcast, a *traghetto* – a gondola ferry – negotiating its way over the choppy waters, its only passenger a businessman in a loden coat, standing in the traditional way, head bowed, intent, briefcase under his arm, calm as the boat breasted the swell – indifferent.

I could see Marcello Volta seated at a large desk at the rear of his gallery, peering down at his computer, aware of me as I moved frantically up and down the gallery's broad glass frontage, but apparently indifferent. Just inside the window, a tall young man was laying out books on a table. Our eyes met, I smiled, raising my eyebrows imploringly. He looked away – indifferent.

The books were laid out as though in readiness for some kind of event, their covers blue and inscrutably tasteful. The table itself was marble-topped, old, gilded and extremely expensive. But most things Volta sold were old, gilded and expensive enough to convince the buyer that their small piece of the past was of inherent significance. He specialised in seventeenth- and eighteenth-century genre paintings in elaborately moulded frames – garish hunting and carnival scenes, fruit and flowers, heaps of game.

I'd passed the place a hundred times, dismissing it with the occasional snooty glance. Now, since I'd learned that Volta owned a Titian, I was desperate to get inside. But neither Volta nor his coolly handsome assistant appeared to want to let me in.

I moved back along the thick glass frontage, turned the corner, stepped up into the plate-glass entry porch and gave the door one last push. It opened. Maybe Volta had finally decided to press the entry

button. Maybe it had been open all the time. Maybe Volta and his assistant thought I was a lunatic.

Volta sat up very straight behind the big desk, the tips of his outstretched fingers touching. He had the large, imposing head of the old, worldly kind of cardinal who is on more than nodding terms with the unspeakable – with a sad, grave gaze, very pale skin framed by sleek, dark hair. He wore a navy blazer over a grey polo-neck jumper, a pair of gold-framed half-moon glasses hanging at his chest. He phrased his English very precisely, with big, slow, lugubrious vowels.

'The painting you are talking about was part of a private collection in Munich. It was listed as a Titian by Suida in 1933. In 1939, the owner fled to America, and it was assumed that the painting and the entire collection were *de-stroyed* in the Second World War.'

Sixty-three years later, the owner's descendants opened a bank vault in LA, and there was the entire collection. But the heirs didn't know what anything was, and neither did the dealer they consulted. The painting went to auction as a copy after Titian.

'I saw it in a catalogue like this.' He held up a photocopied piece of paper with a grey blur of an image perhaps three-quarters of an inch square. He had immediately recognised the painting, flew to Los Angeles and bid for it. No one else had shown serious interest. The painting was now universally accepted as a Titian.

How much had he paid for it?

'Seven thousand euros.'

He sat back in his chair, his big, dark, impassive eyes on me, but his mind caught up in the logic of the loss, the money, the acquisition and the reattribution. The moral of the story was clear: people who didn't know what things were didn't deserve to have them.

I was sitting on the edge of my chair. The assistant stood close behind me, listening to every word. Where was the painting?

Volta sat staring into space for a few moments, and then he took a key from one of the drawers in his desk and handed it to his assistant.

'If you have time, my son will show you the painting now.'

Volta led me on to one of the back canals, round a couple of corners, through a small garden and into a tall, narrow building. The hallway was cold, echoing and dusty, but richly inlaid with geometric

patterns in black and white marble, the pilasters carved in the shapes of nymphs and satyrs. On the first-floor landing he pushed a key into one of the doors, and turned to me with a conspiratorial smile. 'This is where we keep our real paintings!'

The room was long and high-ceilinged, a row of tall, narrow windows facing on to a canal in the typical manner of a *portego*, the central hall of a Venetian palace, so that it was bright at one end of the room, dim at the other. I was aware of gilded mouldings, frescoes of rustic scenes and more elaborate marble, but I was too preoccupied with the paintings to really take it in. Hanging on an easel towards the back of the room, lit by its very own spotlight, was the painting. A sharp-featured middle-aged man seated by a window, seen in profile, but turning to face the viewer in a pose directly reminiscent of *The Man with the Blue Sleeve* – his right arm and sleeve dominating the foreground of the painting. An ermine collar spilled out over his shoulder, the white fur poking through the slashing in the puffed sleeve of his voluminous black jacket. His eyes were slightly narrowed, a faint smile playing over his pale features. His beard was full, but his hair was cut in a hard-edged, quasi-pageboy style that looked incongruous with his ageing features – his eyebrows severely plucked, accentuating the chalky, slightly mask-like look of the face, as though they'd been drawn on over thick white powder – which perhaps they had.

As Giacomo pointed out, the elaborate, artfully rumpled slashing of the right sleeve was the best part of the painting, the sheer luxuriousness and tactility of the padded black silk wonderfully conveyed in various tints of brown and violet – the effect of black created without using black. And the beige glove so sleekly encasing the left hand – another sign of wealth and prestige – had just the right degree of softness and . . . leatheriness, though painting fur, silk, velvet and leather in 'the Titian style' was probably the first thing you learnt when you entered his studio.

But the face had a slightly disembodied look. The dead white pallor of the lightest areas didn't quite marry with the fleshy mid-tones, accentuating the artificial look of the severely plucked eyebrows – leaving the pinkish highlighting round the nose and eye too obviously exposed. At some point, over the past four and a half centuries, some

of the finest of the glazes that were designed to pull the surfaces of the face together had been removed through over-zealous cleaning, leaving this inchoate, slightly mask-like visage, and the question of what the painting would have been like – how good it would have been – if the face had remained undamaged.

This was Zuan (Giovanni) Paolo da Ponte, a banker who commissioned the portrait on the occasion of the marriage of his daughter, the 'extremely beautiful' Giulia, to Adrian, Signor of Spilimbergo, a small town on the road north of Venice into Friuli. One of the children of this union was the 'famous' Irena di Spilimbergo, one of the great tragic celebrities of the age, a painter who studied with Titian for two years – so legend had it – and was twice painted by the master. All cultured Europe mourned when she died at the age of twenty. Da Ponte's line, meanwhile, had died out with him, and all that remained of him was this portrait and his account books, in which he had recorded the cost of the painting and every last nail used in its framing.

A Titian painting, sort of. Maybe two-thirds, even three-quarters, of a Titian painting. Nearby on another easel was a portrait of a hawk-faced, bearded man in a black velvet cap. Just as the idea of Lorenzo Lotto was starting to cross my mind, Giacomo told me it had crossed his mind too. He had seen the painting in the catalogue of a sale which had been about to take place that very afternoon – in Vienna. It was then ten o'clock. 'Sometimes,' he said, 'it is worth risking a little money to eat good Wiener schnitzel.' He had paid 13,000 euros for the painting. While it wasn't yet accepted as a Lotto, he was confident it soon would be.

I stood there looking at the painting, but not quite taking it in. My mind felt somehow constricted in that dim space, surrounded by a grandeur I could hardly accommodate, by pools of light on paintings that had floated for centuries in the pool of minor old masters which changed hands around Europe for relatively small sums, and which, through the processes of attribution and connoisseurship, and through the sharp eyes of Volta and his son, might one day be elevated to the ranks of masterpieces.

At the other end of the room, closer to the light from the canal, was a small portrait of a rather weak-looking young man also with a

pageboy haircut. 'A Giorgione,' said Giacomo. *A Giorgione?* Was it possible at this stage in history to just buy a Giorgione? 'A probable Giorgione,' Giacomo corrected himself. He mentioned the name of a prominent art historian who had seen the painting and agreed that it was a probable Giorgione. He had even constructed a probable date for it.

On the opposite wall was an extremely poor copy – more an approximation – of Titian's *Diana and Actaeon*, attributed to Schiavone, and, facing me as I entered the next room, a large Tintoretto, a golden vision of mythological flesh, the *Allegory of the Birth of Love*. You could tell from the way the figures seemed to tilt back in space that it was intended to be seen from below, that it was probably a ceiling panel. And because it would only ever be seen from a considerable distance away he, Tintoretto, his son or whichever assistant had actually done the painting, had expended the absolute minimum effort to create the required effect. I was reminded of how many old master paintings, when you looked at them closely, started to resemble fairground hoardings or stage flats. Large areas of shadow are thrown into relief with a few flicks of the brush.

As soon as you take paintings off walls you start to lose some of the sense of awe. When you take them out of their frames and, particularly when you stack them on their sides, you become ever more aware that this stuff is just bits of board and old canvas and thinly applied paint. Well, what else would it be? But it suddenly occurred to me that while we choose – for cultural reasons – to arrest the decay of certain objects, certain images from the past, all of this stuff, all art, even the greatest Titian, was just more junk, more space-occupying clutter, detritus plummeting towards oblivion. I was struck by the fragility of the whole phenomenon – by the incredible narrowness of the gap separating things with immense value from those with none at all.

There was a Tintoretto portrait of a rather mournful-looking senator, an *Ecce Homo* by Veronese, a very Mannerist, almost El Grecoesque *Adoration of the Magi* by Jacopo Bassano. There was a Palma Vecchio *Nude in a Landscape*, a Carpaccio *Christ as Salvator Mundi*. They were all here. All the great names of Venetian art represented by works that were at best marginal, but which, through

Pietro and Giacomo's energy and acumen, had scraped into the category of that which must be preserved.

No Bellini, but two paintings by his principal follower Cima, which were almost equivalent to one Bellini. Almost, but not quite. Even Volta and his son hadn't been able to conjure a Bellini out of the sweepings of other people's attics and the opinions of friendly experts – or not yet anyway.

'Don't think that this is an aristocratic collection or something like that,' said Giacomo, locking the thin and rather rickety door to the apartment.

'So what did your family . . . do?'

'We are fishermen from San Bernardo near Chioggia. My great-grandfather started buying property and art, but my grandfather made bad investments and lost it all in the Second World War. So my father started working and built it all up again from 1953.'

'So are you dealers or collectors?' I asked Volta, as I sat once again before his great desk.

'We are collectors who create our collection through dealing. I deal so that I can collect. The only person in Venice with a good collection from 1490 to 1550 is me. I buy paintings like this,' he gestured to the paintings of game birds behind him, 'and I turn them into great paintings. I exchanged the Tintoretto for twelve paintings like this. And the other dealer was very happy, because it is much easier for him to sell twelve paintings of game birds than a Tintoretto. I would be happy to let a thousand paintings like this go to get one Titian.'

But what about other collectors? The old families of Venice, for example: did they have nothing left?

Volta and his son exchanged looks. 'The old families of Venice,' said Giacomo, 'have sold everything.'

'In the Palazzo Pisani-Moretti you will see *The Family of Darius before Alexander* by Veronese, an enormous painting, still in the room it was painted for. But it is a copy. The original is in the National Gallery in London. It was sold in the nineteenth century.

'When Napoleon came to Venice, the old collections started to break up. Many of the old families – the Cornaro, the Rezzonico – fled to Lugano. They became rich through banking, and they forgot Venice completely.'

But there must have been families who had a kind of spiritual link to the paintings they once owned, who had collections in the mind.

'Even if they had a collection in the mind,' said Giacomo, 'their only interest will be in selling it.'

'The aristocrats of Venice sell what they can,' said Volta with a look of satisfaction. 'And we, the fishermen, buy what we can.'

There was still a glow on the rolling, gelatinous swell of the Grand Canal, though the great frieze of cold stone and damp plaster unfolding in front of the vaporetto was already reduced to a grey blur. The palaces of those who had sold off Venice's heritage, scarpering to Switzerland or simply dying out, were now mostly government buildings, museums, hotels or casinos. Yet some of them were still lived in, divided into glitzy apartments, and in some of them the lights were already on. You got glimpses of chandeliers or of stylish modern light fittings, of vast collections of books filling entire walls. Yet it was all sagging slightly. With the rush hour past, the tourists departed in their coaches or eating in the thousand trattorias and pizzerias, it was as though the great spectacle of the Grand Canal could no longer be bothered to keep up appearances. You could feel how old, tired and precarious it all was. I thought of the damp seeping up through all those ancient, algae-covered foundations and shivered.

8

'The Obscenest Picture'

IMAGINE A GIRL who's offering herself to you, lying back on a bed wearing nothing but a ring and a bracelet, blonde hair spilling over one shoulder, looking back at you with an expression so frank, so utterly unabashed, it's as though she already knows you. A girl whose long, slanting, slightly smoky eyes – far from offering anything as banal as a come-hither – seem simply to be saying (since they can hardly be saying anything else), Here I am – what are you going to do about it?

I know such a girl. Mark Twain knew her, too. He saw her in 1879, on the walls of the Uffizi Gallery in Florence, in a painting he described as 'the foulest, the vilest, the obscenest picture the world possesses'. And it wasn't just the fact that Venus, as she was known, was 'naked and stretched out on a bed. No,' said Twain, 'it is the attitude of one of her arms and hands.' An attitude which, had he ventured to describe, it would have caused a 'fine howl'.

'But there Venus lies, for anybody to gloat over that wants to . . . I saw young girls stealing furtive glances at her; I saw young men gaze long and absorbedly at her; I saw aged, infirm men hang upon her charms with a pathetic interest.'

Twain was a journalist, used to protesting too much for the entertainment of his readers. But there's something about his reaction to what he called 'this beast of a painting', which he speculated must

have been painted for a bagnio or brothel, which doesn't feel entirely disingenuous. And what could she be doing with that hand that could have sent the author of *Huckleberry Finn* hurrying from the room, his brain pulsing with mingled horror and excitement, only to return a few moments later for another look? Why, touching herself. Touching herself – or something very like it.

There are nudes that are nude simply because that is what certain kinds of figures in certain kinds of paintings are supposed to be like – who go unclothed because that's what nymphs and goddesses do – who represent higher ideas such as love, charity, music or the perfection of divinely ordained proportion. But not Titian's *Venus*. While Vasari, who saw the painting in the dressing room of Guidobaldo, Duke of Urbino, described her as 'a young Venus', the painting contains none of the goddess's attributes – the small cupid, for example, seated or standing at her feet – and no other mythologising allusions of any kind.

Sprawled out on the bed that fills the entire breadth of the painting, the long diagonal of her body, sheathed in a creamy golden glow – and how old is she, eighteen, sixteen, fifteen? – she seems to need no justification to be where she is, to be completely comfortable lying there, the warm air playing over her skin and us staring at her.

The Venus of Urbino, as she's become known, isn't captured naked simply because that's how she happened to be at that moment. She's displaying herself to us in a quasi-professional way. Yet if she's brazen, brassy she certainly isn't. And the more you look into those slanting eyes – trusting, accepting, yet very slightly mocking – the more difficult to read they become.

Indeed, if she's just some strumpet – a courtesan or common prostitute – laid out for our delectation, why is there a pair of *cassoni* – the large chests implicitly associated with the wedding rituals of the upper classes – prominently displayed in the background? A couple of well-dressed servants root through these chests, the light of dawn – or is it dusk? – showing through a window framed with a classical column. Expensive leather hangings cover the adjacent walls. While the greatest of the courtesans lived in some splendour, the sense here is of the placid, unchanging domestic round of a very affluent and long-established household.

The Venus of Urbino is the most discussed, written about and speculated upon of all Titian's paintings. When Twain saw her she hung in the Tribune, the octagonal chamber designed by Vasari to house the Medici's most valuable treasures – then the most famous room in any gallery in the world. Now she resides in one of the many white-walled rooms that form a kind of corridor through the Uffizi, the space in front endlessly crowded with tour groups having the same iconographic details pointed out to them in Japanese, English, German, Spanish, French and Italian – the little dog curled up on the bed, a symbol of fidelity; the posy of roses loosely clenched in Venus's hand and the pot of myrtle standing on the far window ledge, both symbols of marriage; the fact that the bride, or brides in general, would probably have been no more than fifteen. And the rumpled sheets: do they mean that the bed has been (slight cough) used? No one mentions masturbation. But then we've grown more broad-minded since 1879. The mere fact of a woman 'naked and stretched out on a bed' no longer gives us pause for thought. And if Venus is happy with her hand lolling between her legs, we hardly stop to think about it. Yet who's to say that Twain didn't have it, in essence, more right?

And in all the hundreds of years' worth of verbiage that have been expended on this painting – on whether it's a wedding picture or a piece of plain and simple rich man's erotica, on its relationship to other works in its genre, its role as a piece of historical evidence, as a product of social circumstances, in the questions of who's looking at who, of who commissioned the painting and why – it's easy to lose sight of the man who painted it and his relationship to the painting.

Titian was nearly fifty when he created the ultimate young man's painting. What did he mean by it? Who did he paint it for? And what was his relationship with the girl on the bed – if, of course, she ever existed; if there ever was a girl who looked like *The Venus of Urbino*.

In another gallery in Florence – one that is famous, but very much less visited than the Uffizi – the Galleria Palatina in the Pitti Palace, where the paintings are packed four or five deep on the immense walls, in a picturesque jumble redolent of the age in which they

were created, is a painting that was for centuries considered among Titian's finest, the so-called *La Bella* – the Beauty. There she stands, very upright, resplendent in a blue dress richly embroidered in gold, the purple velvet sleeves slashed with white silk, her every feature speaking – as Titian's Victorian biographers Crowe and Cavalcaselle saw it – 'of high lineage and distinction'.

A gold chain is draped down a throat and breast 'of exquisite model'. 'The eye is grave, serene and kindly, the nose delicate and beautifully shaped, the mouth divine' – a figure suited to a palace – 'for here we are surely in the highest and best of company.' Yes, those long, almond-shaped eyes, the exquisite, slightly pointing curve of the cheek and chin, the faintly bee-stung mouth. It's *her*, isn't it? Never mind that *La Bella* 'seems so dressed up it would be a shame to undress her', as a friend memorably said of a girl I fancied at school, *Venus* surely is what *La Bella* becomes when she lets that mask of courtliness down, when she gets those cumbersome clothes off – what every woman can be like behind the heavy curtains of the marriage bed. And you remember that it was the practice of Venetian courtesans to attend church dressed in the manner of the most respectable married women, and wearing the most pious and demure expressions.

And once you've spotted Venus in these two paintings, she starts to appear everywhere – coolly revealing her right breast, in *The Woman in a Fur Coat* in Vienna, wearing a feathered hat, an oriental coat slung coquettishly over one shoulder in *The Portrait of a Young Woman* in the Hermitage in St Petersburg. All paintings that were done, as centuries of scholarship have had it, 'from the same model'. And because both *La Bella* and *The Venus of Urbino* came to Florence by the same route, part of the art collection of the Dukes of Urbino, brought in the dowry of Vittoria della Rovere when she married Ferdinando de' Medici in 1631, it has often been assumed that this model was a woman 'known' to the della Rovere, the ruling family of Urbino.

In January 1538, Guidobaldo della Rovere, Duke of Camerino and heir to the Dukedom of Urbino, arrived in Venice incognito, having ridden across the Papal States in disguise – his father, Duke Francesco Maria, being then in conflict with Pope Paul III. At twenty-four,

Guidobaldo was a typical minor Renaissance prince: related by blood or marriage to every other Renaissance prince, major or minor, and possessed of a massive, overweening, potentially paranoid self-regard (his father stabbed a cardinal to death for accusing him of cowardice, when only nineteen), but also generous and gregarious. And whatever else may be said about him, he had a highly developed sense of quality in relation to the visual arts. His great-uncle on his father's side was Pope Julius II, the great patron of Michelangelo. His great-uncle on his mother's side was Alfonso d'Este, the great patron of Titian. That Guidobaldo himself would commission paintings from the greatest artists of the time went without saying.

During his stay in Venice, Guidobaldo paid the first of many visits to Titian's studio and while there he saw a painting of 'a naked woman', which he fell in love with on the spot, and which he decided then and there that he must have at almost any cost.

Or that is what we must surmise happened on that visit about which very little is known, because, two months later, on 9 March 1538, the twenty-five-year-old Guidobaldo wrote from the family palace in Pesaro to his father's agent in Venice, saying he had sent a courier to 'bring me two pictures currently in the hands of Titian'. One was a portrait of Guidobaldo himself, the other a 'naked woman'. The ambassador was, under no circumstances, to allow the courier to return without the paintings, 'even if it means him staying in Venice two months'. And since Guidobaldo didn't have sufficient funds to pay for the paintings, the ambassador was to use all his tact in securing an advance or guarantee of payment from Guidobaldo's mother, the Duchess Eleonora, who was staying in Venice.

In April, the duchess wrote to Guidobaldo telling him she would have his portrait sent as soon as it was ready, but didn't mention the female nude. So on 1 May, Guidobaldo wrote again, expressing concern that Titian would sell the painting to a cash buyer before he had found the money to meet his obligation to the painter. He was even prepared to pawn something in order to raise the money. Guidobaldo was clearly desperate to secure the painting.

It has generally been assumed, in the absence of any other obvious *raison d'être*, that *The Venus of Urbino* was commissioned to celebrate Guidobaldo's marriage to Giulia Varano (heir to the Duchy of

Camerino). But that had taken place four years earlier, in 1534, and, if the painting had been commissioned by Guidobaldo, Titian would hardly have sold it to another buyer and risked alienating a powerful family like the della Rovere.

But again we're moving away from Titian's own involvement in this work. And that's partly because so little is known about the background of the painting, and partly because of the nature of the painting itself. As your eye moves over the body of *The Venus of Urbino*, it follows the movement of Titian's eye and brush as he traced her contours, touching her erogenous surfaces into being – making love to her in the very act of creating her, and drawing your eye into the same movement of the mind. There have been centuries of speculation and fantasy on the idea of the almost fifty-year-old Titian standing at his easel, the beautiful, naked young girl looking complacently back at him – looking, in the painting, as though she knows us, because she knew the man who created her.

Yet for all its immediacy and potency as an image, there's something oddly remote and impersonal about *The Venus of Urbino*. It isn't one of those works that admit us into the artist's mind as he created them, that allow us to chart his thought processes. *The Venus of Urbino* gives the impression of having been brought into being all in one go. Yes, Titian's brush draws your eye across Venus's glowing teenage flesh. But he's pre-empting the movement your eye and mind would naturally have taken. Far from giving expression to his own thoughts and desires as he stood here in the hot, close air of the studio in Biri Grande, Titian is painting your lust, not his – the promise of her warm skin against yours, not his. The sweetest girl in the world isn't there for him, but for you. Whoever you are.

The only concrete things we know about this painting are that Guidobaldo della Rovere bought it in spring 1538, and that, far from creating a record of soft, warm, living fresh lying before him on a real bed, Titian lifted Venus's pose and, indeed, almost her entire body, from a painting completed thirty years earlier by his rival and sometime friend Giorgione.

The Reclining Nude. The very words put the image in a category of old, grand art that removes it from the erotic – distances it from

the fact that it is in essence just a woman lying on a bed. There is a whole lineage of images – including Goya's *Naked Maja* and Manet's *Olympia* – which play with the tension between the nude as generalised Platonic symbol and the fact that we are looking at an actual woman on an actual bed. Yet the reclining nude has become so much the kind of thing we expect to see in Renaissance art, we have to make an effort to see these images as erotic. But when Titian painted *The Venus of Urbino*, there were only a handful of such paintings in existence.

The idea was unknown to the ancients, who saw the male form as the exemplar of human perfection, and when the female did appear – in the *Aphrodite of Knidos* or the *Medici Venus* – it was invariably in a standing form. The phenomenon of the female reclining nude appeared, apparently out of the blue, in the early sixteenth century, and the first known example is Giorgione's so-called *Sleeping Venus*. The goddess is seen serenely dormant in a verdant, but rather overcast landscape – the kind of calm, Veneto landscape, in fact, that formed the background to Bellini's cool, rustic Madonnas – and it is known that she is the goddess because of a cupid, long since painted out, who once sat at her feet.

Whatever the reason Titian decided, or was asked, to undertake a reclining nude, he simply went to the only example he knew – then still hanging in the house of its original owner, Girolamo Marcello, in Venice – and appropriated the entire figure of the goddess; not just the sense of languorous elongation – the angle at which the tapering triangle of the goddess's body slices across the canvas – and the way the right calf is tucked neatly behind the left, but the exact proportions of the slightly attenuated torso, the small breasts and the gently rounded belly.

Giorgione's painting was one Titian knew well: as he had himself finished it, painting in the cupid and the whole of the landscape after Giorgione's death. The farmstead in the background is almost exactly the same as the one in Titian's *Noli Me Tangere*, painted at around this time.

Titian was back to his old trick of purloining the compositions of his long-dead mentors and competing with them – adapting and improving on their work till the examples of those to whom he owed

most in terms of art were almost obliterated. While the serene, ovoid features of Giorgione's *Venus* give her a remote, classicised look, Titian's gazes back at us with an expression that is at once challenging and collusive. While Giorgione's skin is cool, pale, alabaster-like, Titian's is warm, plastic, tactile. And while Giorgione's figure bears no real, sensual relation to her landscape setting (and why should she when Giorgione didn't paint it?), Titian's woman seems entirely to belong in her environment, to be enjoying the feel of the rumpled sheets and the warm air on her body.

Giorgione invented the reclining nude. How horribly pat that sounds: the idea that the man from Castelfranco, to whom no more than ten paintings can be attributed with any certainty, simply pulled this idea out of the air (an idea that was to be endlessly revisited down the centuries) just as the classicising, humanistic culture of the Renaissance was gaining ground in Venice. Very possibly Giorgione did do that, but his image wasn't entirely without precedents – and they lay not in what we now think of as High Art, but in utilitarian objects that adorned the homes of the Italian upper classes.

The *cassoni*, the two ritual wedding chests paid for by the husband's family for the storage of the bride's trousseau, a pair of which appear in the background of *The Venus of Urbino* – their monumental forms based on those of antique sarcophagi – were painted with instructional scenes, improving stories from the Bible or mythology, designed to remind bride and groom of their roles as virtuous spouses. But inside the lids of these receptacles were found more private images: reclining male and female figures – a woman (the bride) lying naked in the lid of one chest, a man (the bridegroom), usually clothed, looking towards her from the lid of the other. Occasionally man and woman would be seen together, engaging in the act for which God had united them. It was believed that the contemplation of these images aided in the conception of beautiful children – and that they had an almost talismanic power to ward off evil of all kinds.

Towards the end of the fifteenth century, ideas about the way images were displayed began to change. For a very small number of patrons, who saw themselves as representatives of what we now think of as the Renaissance and were – needless to say – extremely wealthy, such images moved away from the lids of chests and on to the walls

of the bedchamber as objects of value and veneration in their own right. The Venetian collector Andrea Odoni kept a reclining nude by Girolamo Savoldo hanging above his bed. Federico Gonzaga, Duke of Mantua, kept Sansovino's statue of Venus in his bedchamber – 'an image that fills with lust all who see her', as Aretino observed.

Giorgione's *Sleeping Venus*, far from existing in isolation as a free-standing expression of the artist's vision, was in all probability commissioned by Girolamo Marcello to commemorate his marriage to Morosina Pisani in 1507.

While Guidobaldo della Rovere had married Giulia Varano in 1534, four years before he acquired *The Venus of Urbino*, the eleven-year-old bride had continued to live with her father, and it was only now, in 1538, as her fifteenth birthday approached, that she would move to her husband's home in Pesaro and the marriage would be consummated.

For the fifteen-year-old Giulia, the marriage bed was where the conflict of Diana and Venus, between chastity and passion, would be played out, where she would face the ordeal of consummation, through which she would be transformed from a child into a woman. The painting that hung over it served to remind her of the two sides of marriage. In the foreground, sensuality, passion and pleasure – the intimate world of the marriage bed enclosed by the thick, green velvet curtains that hang down the left side of the painting. And in the background – as though the side of the bed had been cut away to reveal it, the world of everyday responsibility, the servants on their round, with the light of dawn – or is it dusk? – showing through the window beyond. And the line dividing night from day, which cuts the background of the painting almost exactly in two, meets the foreground at precisely the point where Venus's hand closes around her sex.

That hand. I hadn't forgotten it. While the idea of a woman touching herself for her own pleasure was, needless to say, condemned by conventional morality, there was one circumstance in which it was not only permitted, but encouraged. There was a belief going back to ancient times that a woman had an 'emission' equivalent to male ejaculation without which conception was impossible – and that the simultaneous 'emission' of man and wife was the optimum

condition for conception. Medical and theological treatises from the second century to Titian's own time concurred that it was acceptable, even desirable, for a woman to stimulate herself before intercourse to achieve this end.

But even if Titian was aware of this practice, and you suppose he must have been, what would he have meant by the allusion – an allusion that must also be present in Giorgione's painting – and these are the only two paintings that show this precise pose in the entire history of Western art – a kind of gynaecological hint to the wife of his patron? And was that why Guidobaldo was so urgently – desperately – keen to get his hands on this painting: as an instructional image to his *wife*? Guidobaldo had never wanted to marry Giulia Varano in the first place, had given up his lover, Clarissa Orsini, by whom he already had a child, and taken on the eleven-year-old Giulia in order to further his father's strategies against Pope Paul III.

No, as far as Guidobaldo was concerned, the steamy promise of Venus's eyes, the creamy glow of her supple teenage body, were there to remind him of what marriage entitled him to as a man. The childishly simple gesture with which this exquisitely unattainable surrogate wife protected her modesty has the effect of drawing our attention straight towards that which is concealed. And it would go without saying that the best person to embody the thing that every man supposedly wants his wife to be in bed – a whore – would be a whore.

We're back with the young woman with the heart-shaped face and the long, almond eyes, who appears in all those paintings. She was long believed to have been the mistress of Guidobaldo's father, Duke Francesco Maria. But when he wrote to Titian asking him to finish *La Bella* as soon as possible, he referred to her simply as 'that woman in a blue dress'. There was no sign that he knew the woman, or that he even cared if a real model was being used or not.

And the more you look at those four paintings, the more tenuous the resemblance between the women starts to seem. While *The Venus of Urbino*'s eyes are slanted, *La Bella*'s are straight, and her nose is larger and more aquiline. *La Bella*, indeed, is barely a portrait, more a study in the textures of her magnificent blue dress and slashed purple velvet sleeves. *The Woman in a Fur Coat* has a simpering, slightly generic

look that makes you wonder how much of the painting was done by Titian himself. She's become a type, perfect for those quasi-portraits of anonymous but sexy young women that were so popular with Venetian picture buyers. Of the four women, *The Venus of Urbino* is the one that feels closest to being a real person – where the face is seen with the greatest freshness – the one that feels like the prototype for the series; though she, according to traditional chronology, was the last to be painted. Yet that chronology is based on the idea that Guidobaldo commissioned the painting in 1538. But if he had commissioned *Venus*, Titian would never have considered selling the painting to someone else, as Guidobaldo feared. When the young duke arrived in Titian's studio and fell in love with her, *Venus* was already finished – and in all probability had been for some time.

The painting must have been commissioned by someone who failed to make the final payment and never collected the painting. And the number of people who might qualify for such a role is very small indeed.

Passing through Venice in 1534, the Cardinal of Lorraine, one of the most powerful churchmen of the day, had his portrait painted by Titian. And he expressed such an interest in a 'painting of a woman' that Titian had created for another cardinal, Ippolito de' Medici, that the artist was only able to stop him taking the painting through the promise of a similar work for himself. *The Venus of Urbino* may be that painting. Or it may – just may – be the original on which it was based, the painting Titian began for Ippolito de' Medici in 1532.

A handsome twenty-two-year-old with little in the way of a religious vocation, Ippolito de' Medici spent two weeks in Venice in August of that year, on his way home from serving as papal legate to the imperial campaign in Hungary, a sojourn he spent with one of the most legendary courtesans of the time, Angela Moro, called 'la Zaffetta'.

Then at the summit of her beauty, wealth and notoriety – therefore probably also in her early twenties – Angela was already well known to Titian. A close friend of Aretino, and a regular at the poet's soirées, she was praised by him in a famous letter for 'employing cunning – the very soul of the courtesan's art, not with treachery, but with such skill that whoever spends money on you will swear it is he who has gained'.

While staying with her, Ippolito had himself painted by Titian in the apparel of a Hungarian chieftain, and ordered from the artist one of those paintings of supposedly anonymous beautiful women for which Venice was famous. It would have been Titian who suggested that the woman should be seen full-length and naked. Ippolito de' Medici probably wasn't aware such a thing was possible. And having lifted the figure from Giorgione's *Sleeping Venus*, Titian simply grafted on to it the head of the woman with whom the young cardinal had just spent two weeks of bliss, la Zaffetta herself. If you look closely at the painting, you'll see that the head is very slightly small in relation to the body. But Ippolito never took possession of the painting. He died in 1535, at the age of twenty-five, poisoned, it was said, by his cousin and rival Alessandro de' Medici.

If the painting had the same effect on other visitors to the studio as it did on the Cardinal of Lorraine, it seems extremely unlikely it would have stayed there the two and half years before Guidobaldo della Rovere first set eyes on it. And is it likely that Titian would have kept a painting he knew to be a masterpiece hidden away in the stack when it could have been out in the world working for him? But, then again, maybe Titian felt almost jealously possessive towards certain paintings – that they should only go to the right buyer – and at the right price.

It is just conceivable that the references to marriage were added to accommodate what Titian saw as Guidobaldo's imperative – to celebrate the arrival of his young bride, Giulia Varano. And if that should create centuries of confusion for future viewers and commentators, why would he care? He was only the painter.

9

The Flesh Breathes

I HATE TITIAN. I thought Titian was more than just a 'heritage' painter, a superior stately-home artist for people who like their culture safely dead and in the past – an excuse for galleries to print money by putting on overpriced exhibitions. I should have realised it would come to this the moment I discovered he was known in his own time as 'the Prince of Painters'.

I'm in Paris, a city bedecked with vast billboard-size posters, with banners swaying down the façade of every public building bearing Titian's portraits of Isabella d'Este and Aretino, with flyers and placards in every café and hotel foyer reminding you that 'Titien – le Pouvoir en Face' at the Palais du Luxembourg is *the* exhibition of the moment.

I'm in the exhibition now. It's dark, cramped and crowded, the air close and too warm, and everything about the presentation of the exhibition – the careful spotlighting, the deep-burgundy velvet covering the walls – is giving me a message about Titian I don't want to hear: about Titian, the courtier-painter, the great smoothie, the ultimate establishment artist who owed his success to his ability to get round the rich and the powerful. Whose work embodied the ideal of *sprezzatura*, the essential attribute of the perfect courtier, 'the ability to hide effort, to carry out every action with a casual facility and grace'. The master of decorum, devoted to creating sympathetic

embodiments of the aristocratic ideal. And why would I be the slightest bit interested in any of that?

This is an exhibition that defines itself in terms of the grandeur of Titian's subjects – all those cardinals, popes, kings, dukes, emperors and courtiers; all those power-hungry, rapacious, megalomaniac, greedy, vicious, nasty, dangerous, frightening people.

The mainstream tourists are in massive queues at the Louvre. The young and groovy are at the Rauschenberg 'Combines' exhibition at the Pompidou. The beautiful people are at Yvon Lambert looking at Anselm Kiefer. But all of what you might call Middle France is here. Every moderately well-heeled couple up from Bordeaux, Lyons or Rennes for a couple of days has to come to this exhibition. Yet the fact is that even by its own standards it is a very poor exhibition. I rushed to Paris to see an exhibition that transferred from the Museo di Capodimonte in Naples – which has thirty Titians including the incredible *Pope Paul III with his Grandsons* – only to find that most of the Capodimonte paintings have remained in Naples. Of their three portraits of Paul III, they've sent only one, and, needless to say, it's the worst one. What we're left with is three, maybe four, top-notch paintings, eked-out studio products, misattributions, critically damaged works, journeyman pieces and paintings that may well be by Titian, but are, nonetheless, downright dull.

But as to the subjects, the sitters who defined the world of power in Titian's time, everyone's here – or nearly everyone. There are the absolutely great: the popes, emperors and kings – represented by Francis I of France and Pope Paul III. The almost great – the cardinals, marquesses and dukes represented by Isabella d'Este, Francesco Maria della Rovere of Urbino, his son Guidobaldo, for whom *The Venus of Urbino* was painted, and Cardinal Alessandro Farnese, who drew Titian into the web of the papal court. There are the middlemen of the great and the almost great – the chancellors, secretaries, papal legates and imperial envoys, represented by Nicolas Perronet de Granvelle, Chancellor to Emperor Charles V. Then there are the middlemen of the middlemen – the courtiers and intellectuals who served as advisers, flatterers and facilitators – Sperone Speroni, the Paduan dramatist and critic, Pietro Bembo, poet and cardinal, and of course, the dreaded Aretino himself

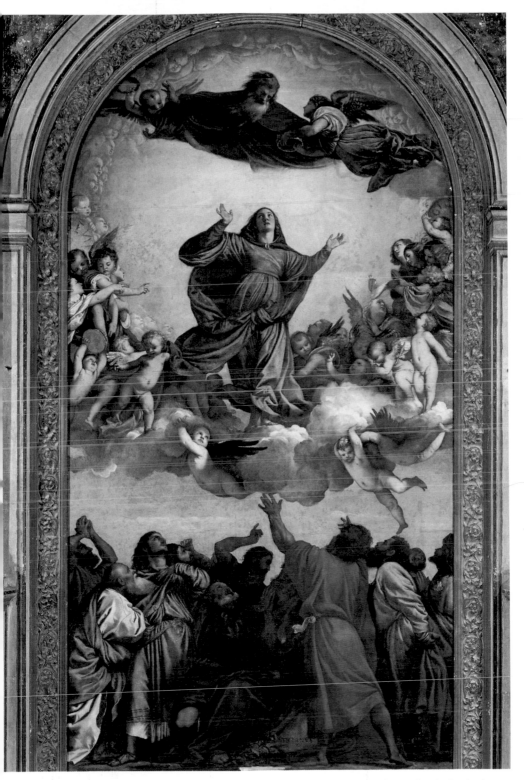

The Assumption of the Virgin (1516–8): completed, when Titian was about thirty, for the high altar of one of Venice's greatest churches, this painting established him among the greatest artists of his time. The apotheosis of Mary, the apotheosis of Venice, the apotheosis of Titian.

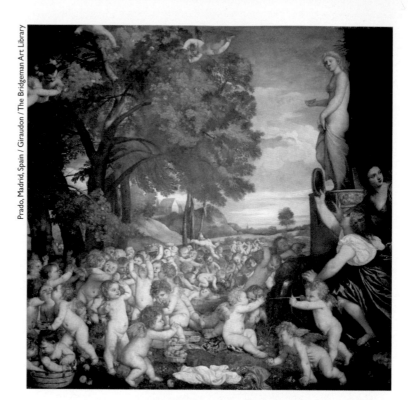

The Worship of Venus (1519)

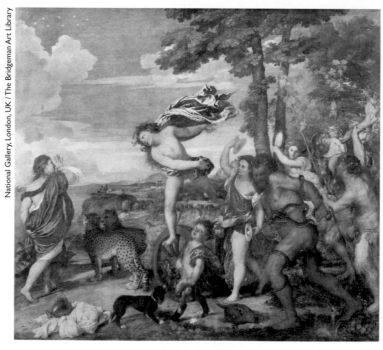

Bacchus and Ariadne (1520–3)

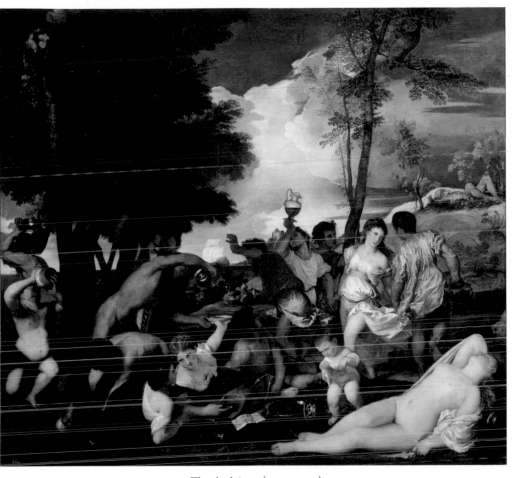

The Andrians (c. 1523–4)

Titian's paintings for the *camerino d'alabastro* (alabaster room) of Alfonso d'Este took five years to complete. While the process caused the duke endless annoyance, he was entranced by the results, a sequence that provided the model for mythological painting for the next two centuries. Erotica at its most intricate and luxuriously discreet. Perfect for the private room of the man who has everything.

Man With a Blue Sleeve (c. 1512): The identity of the sitter in this early portrait remains unknown. Despite conclusive evidence to the contrary, the idea that the painting shows Titian himself has never quite gone away. A man without illusions – who wouldn't be easily impressed by anyone or anything.

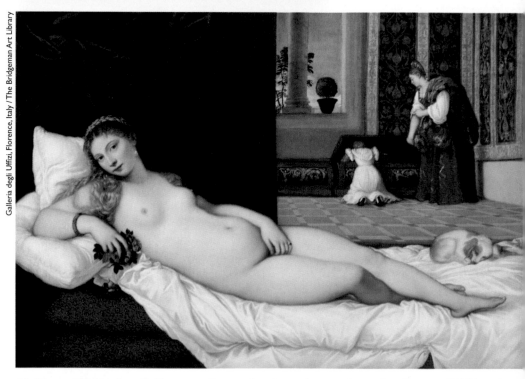

The Venus of Urbino (1538): The most discussed, written about and speculated upon of all Titian's paintings. She seems to need no justification to be where she is, to be completely comfortable lying there, the warm air playing over her skin and us staring at her.

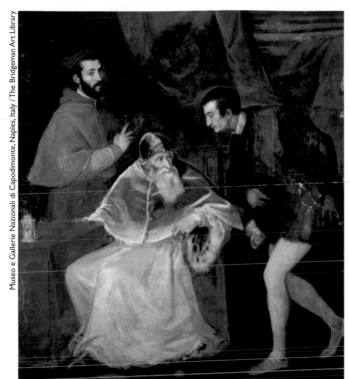

Pope Paul III With his Grandsons (1545): The pope raised his grandsons to eminence according to papal tradition: his favourite and first minister, Cardinal Alessandro Farnese, and Ottavio, Duke of Camerino. But nothing about the execution of this painting went as smoothly as either Cardinal Farnese or Titian would have liked.

The Emperor Charles V at Muhlberg (1548): Titian's great patron made him a knight and Count Palatine. The artist responded with the first and arguably the greatest of all painted equestrian portraits. The very image of the Christian warrior who rides through the Valley of the Shadow of Death and fears no evil.

Portrait of a Knight of the Order of Malta (The Man With a Clock) (c. 1550): Nothing is known about this supposed knight, but the sense of unforced immediacy and the complete consistency of every element in the composition make this one of the most compelling portraits of all time. An image decisive, yet understated, in which the subject is so vividly present you have no option but to say, that man is there.

Diana and Actaeon (1556–9): Arguably the greatest of Titian's mythological paintings for Philip II, and his manifesto on how far the limits of painting can be pushed. Much seems to have been included simply because it was considered difficult to paint, because it embodied the transparency, the capturing of light that is the ultimate province of painting.

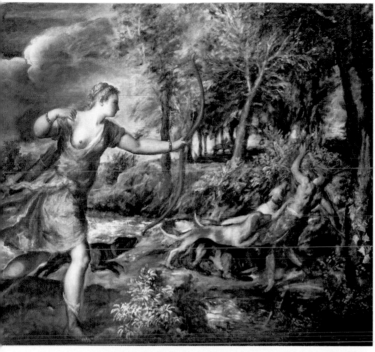

The Death of Actaeon (c. 1565): Announced by Titian in a letter to Philip II in 1559, but never mentioned again, the painting is assumed to have been among those left in the artist's studio at the time of his death. Colours are no longer confined to the objects they describe. Nothing is fixed, nothing entirely static.

The Flaying of Marsyas (c. 1570-6): Ignored for centuries in a palace in what is now the Czech Republic, this painting created a sensation when first seen in the West in the 1980s. The way the agitated brushwork seemed to express the violence of the subject over every inch of the canvas, even the obviously unfinished areas and inconsistencies of treatment, all seemed marks of the painting's modernity.

Pietà (completed 1576): Designed to hang over Titian's own tomb, the *Pietà* was completed during the early days of the plague of 1576, and turned into an enormous ex-voto, a plea that the artist and his son would survive and the family studio continue. If the imagery speaks of hope and salvation through Christ's sacrifice for us, the manner of the painting's execution is imbued with a sense of terror and awe in the face of the oncoming ordeal.

There they sit or stand, large numbers of bearded men dressed in black, looking out of the soft, warm, expensive air of their respective pockets of picture space, the very particles of which exude a sense of rightful privilege – calm, urbane and, above all, credible.

Titian didn't add anything absolutely new to the vocabulary of the portrait. The formats he used, from bust to full-length, had all been employed before. But he gave the form a new informality and expansiveness. He made portraits generally bigger, but only so that his sitters could appear more comfortable and at ease. Titian smoothed out the worst of his sitters' physical defects, while leaving just enough 'character' for us to feel they haven't been entirely idealised. Titian showed the immensely rich and the immensely powerful that they didn't have to try too hard to appear rich and powerful.

The attributes of power are reduced to telling details – the clock, a symbol of temporality and of wealth, the soft leather hunting gloves, a badge of the aristocrat. The chains of office, the golden pendants indicating membership of the highest orders of chivalry, are worn lightly, tucked half out of sight. It is this sense of ease and entitlement that made Titian the model for the aristocratic portrait, all over Europe, right down to the end of the eighteenth century.

All this was there in the exhibition, but in a form that was extraordinarily impoverished for a show that was supposed to be pulling in the whole of France. This show was about as bad as an exhibition could be and still legally qualify as a Titian exhibition. Francis I and Isabella d'Este weren't absolutely bad paintings, but – Francis's having been done from a medal, Isabella's from a painting by another artist done twenty years before – they lacked immediacy. Laura Dianti, the milliner of Ferrara, mistress of Alfonso d'Este, must once have been magnificent in her spectacularly ruched blue silk dress, attended by an exquisitely painted Ethiopian page, but her face had been so over-cleaned that the dark underpainting was coming through.

The portrait of Alessandro Farnese certainly brought out the cardinal's knowing worldliness, though it wasn't by Titian, but by Taddeo Zuccaro, while the full-length paintings of Guidobaldo della Rovere and Cristoforo Madruzzo, the statesman prince-bishop of Trent, were slightly flat and lacking in life.

Pietro Bembo was represented by a studio work – possibly by Titian's son Orazio, it said in the accompanying text. The Sperone Speroni was a touch uninvolving, the Nicolas Perrenot de Granvelle an unjustifiable attribution, and as for the Diego Hurtado de Mendoza, Imperial Ambassador to Venice, was it badly restored or just bad?

Yet Antonio Anselmi, a now forgotten Bolognese poet, then in the service of Pietro Bembo, had the elusive spark of urgency, of hair-bristling physicality, that just about everything else here lacked. There in the image of the young, bearded poet with the likely look in his eye was the sense of a moment of interaction between painter and sitter captured. Why this obscure figure had been accorded this sense of real involvement, when the far better known Spironi hadn't, was difficult to say. Perhaps he had had more time to sit for Titian or – more likely – the Bembo and Spironi were studio copies that Titian had had made from his own originals. Portraits of famous people were desirable commodities, ideal presents for people of power and influence. If you couldn't give someone a portrait of themselves, you could provide one of another iconic figure of the time – preferably one with whom they had close personal connections.

For Titian, painting portraits wasn't just a matter of making money by painting rich people, but of using these images to further his own cause, whether as calling cards to get commissions from even richer, more powerful patrons, or in gaining influential ears in resolving his own material affairs – be that obtaining ecclesiastical benefices for his son Pomponio or getting assistance with the pension and commercial privileges granted by the Emperor Charles V in 1538, but from which, by the 1550s, he had still to see any real benefit.

Looking round, I saw that there was no one in these rooms who hadn't done Titian a favour, who hadn't been in a position to further the artist's interests at one time or another. The only time the poet Anselmi appeared in Crowe and Cavalcaselle's biography was when he wrote – at his mentor Bembo's instigation – recommending Titian to the influential Venetian nobleman Agostino Lando. Bembo himself told the painter that he had intended to pay for his second portrait – completed in 1540 – but was willing to accept it as a present since he would undoubtedly be able to repay the kindness by some appropriate favour.

I'd come to this exhibition with the wrong expectations. I'd come looking for universal masterpieces; what I'd found was Titian's address book rendered in oil paint.

But there in the centre of the wall at the end of the last room was a painting that was not only unquestionably great, but embodied everything the Western portrait had set out to be – an image decisive, yet understated, in which the subject was so vividly present you had no option but to say, that man is there.

A bearded and rather kindly-looking man, his black doublet emblazoned with the cross of the Knights of Malta, his left hand reaching towards a small gold clock – every detail of the powerfully asymmetrical composition reinforced the fact of his presence. The direction of his gaze and the movement of his arm towards the right of the painting balancing the bulk of his figure on the left; the forms of the face all echoing each other – the dark peak of hair at the front of the head, the long nose, the small mouth pursed in a faint smile – while the eyes slightly narrowing gave a look simultaneously of slight amusement and faint vulnerability. The clock denoting both wealth and temporality, the cross of his order and the obviously expensive clothes were all there to convey his status. But since nothing more was known about him, you couldn't be distracted by the 'background' of the painting. What struck you instead was a sense of warmth and humanity – reinforced by the comfortable, unthreatening hang of the right arm.

While the rendering of the various textures of his clothes – the satin collar, the quilted edge of his jerkin, the floral damasked sleeves – was a *tour de force* in varying lustrous blacks, all that fell away around the central focus of the face, in which, as you moved closer, you could see that there was a considerable amount of red – as though you could sense the blood pulsing beneath the paler final glazes.

And there we have it – the defining conceit of the portrait, understood in exactly the terms that Aretino used in his sonnets and letters, that the flesh breathes, that the person himself is there. The idea that the painting can be more like the person than the person is in the flesh, that it can provide a second version of the sitter, that the painting will be mistaken for the real person – as happened with Titian's portrait of Pope Paul III – or, as in the case of Raphael's portrait of Julius II, that it will instil real fear in the beholder.

The portrait as Titian understood it, and as we still understand it, had existed in antiquity, but when Titian did this painting, in about 1550, the form had only been revived for about 150 years. The whole idea still felt novel. And however much we tell ourselves that we've moved on from that way of thinking about painting, that we're no longer interested in paintings simply because they look like the thing they're supposed to be, it is still the degree of force with which the subject has been brought before us that defines our response to the portrait.

For centuries people tried to identify *The Man with a Clock* through the clock on the table – speculating that he was a clockmaker or had some other, more elaborate relation to the notion of time. But, in fact, the clock was a relatively late addition, put there so that his arms didn't just hang gormlessly at his sides. While the creation of this painting would have been immensely laborious, Titian gives the impression that he's taken the man and his appearance in whole, that the immediacy of that first impression has been retained. And while you have to assume that Titian wouldn't have expended such a degree of effort on this man – whoever he was – unless there was something in it for him, it's possible too that he simply got caught up in the image; that having started the painting, he could see it taking a form whose final intensity, whose final power, only he could realise.

10

A Painting About Red

I T HAS BEEN described as one of the first great psychological
paintings, as a devastating study of the corrupting effects of
power, a picture of impotent old age contrasted with vigorous
youth. But as much as anything it's a painting about red – a painting
that's as much about red as Matisse's *Red Studio*, Degas' *La Coiffure*
or any of Rothko's vaporous essays into the contrasting temperatures
of the red hues.

But red in Titian's painting isn't a purely abstract phenomenon or
simply an attempt to replicate effects found in nature. Red here is the
colour of the curia, the papal court, an administrative entity designed
to preserve the integrity of the Christian faith that raised its own
armies, possessed its own lands held in fief by a client aristocracy,
that maintained embassies and spies in every court in Europe. A
hierarchy of men who lived in a state of notional chastity, but were
waited on by a population of bankers, poets, artists, buffoons and
courtesans. A world where the princes of the Church erected palaces
in the city of the Caesars that vied with those of the most powerful
secular rulers of the time, where, needless to say, every pope replaced
the appointments of his predecessor with his own clients and family
members, where the red of priestly vestments signified a willingness
to die for the faith, but where no one, least of all one's brother-priests,
was entirely to be trusted.

And because this painting isn't finished, you get a sense of the way Titian has 'laid in' the composition – blocking in the surface of the canvas with masses of relatively thinly applied colour – the vermilion of the four-pointed cap of Cardinal Alessandro Farnese, who stands looking impassively out at us, matched by the earthy orange-red of the cloth covering the table on which sits the hourglass indicating the brevity of even a pontiff's life. The colder, bluer crimson of the Pope's hat and cape is made slightly warmer to fit in with the overall scheme, as the pontiff turns towards his grandson Ottavio. And the reddish-brown doublet worn by Ottavio, who seems to bear down on his grandfather even as he bows to him, is only slightly darker and colder than the great curtain looped up through the back of the painting, compounding the sense of a world where everything is built on a monumental scale, but nothing is quite fixed or secure.

Paul III, who acceded to the papal throne in 1534, had elevated his grandsons, to the consternation of reforming elements in the Church and all those who had hoped that his Papacy might check the corruption that fanned the flames of Protestant heresy. Alessandro, the eldest and Paul's favourite, was made cardinal at sixteen, while his younger brother Ottavio was appointed Duke of Camerino and married at the age of fifteen to Margaret of Austria, illegitimate daughter of the Holy Roman Emperor Charles V.

In August 1545, just two months before Titian's arrival in Rome, Pope Paul had removed the Duchy of Parma and Piacenza from the feudal lands of the Papacy and installed his son Pier Luigi – the boys' father – as duke. He thereby provoked the anger of the now twenty-five-year-old Ottavio, who had hoped to gain this territory for himself.

It has been supposed, at least since the nineteenth century, that Titian's painting represents the moment when Ottavio went to lay his grievances before his grandfather – a moment, it has been suggested, that Titian himself witnessed. The seventy-seven-year-old Pope turns to reprimand his grandson for his ingratitude and disloyalty, a smile of irritation playing over his narrow features – aware of how much he has compromised himself in promoting these two young men, yet appearing pitifully vulnerable seated there between them.

Within the year, one of the players in this family power game

will have been brutally murdered – an event that was believed to have precipitated the Pope's own death. It has become axiomatic in the folklore of art history that the Farnese were unnerved by the acuteness with which Titian revealed the tensions between them, and that he was impelled to put his brush down virtually mid-stroke. Yet Titian had come to Rome with his own very clear material objectives in mind. How likely was it that he would have risked alienating the very people on whom his hopes rested, on account of something as abstract and as relative as 'the truth'?

On 10 October 1545, Pietro Bembo, cardinal of the Holy See and one of the most influential men of letters of his time, wrote to the prominent Venetian aristocrat Girolamo Quirini in a state of some excitement. 'Titian,' he wrote, 'is here!'

It was Bembo who had first invited Titian to Rome in 1513, when the artist was still only twenty-four. Since then, while he had expressed continual interest in visiting the city of the Caesars, he had turned down every conceivable entreaty from popes, cardinals, dukes and some of the most influential intellectuals of the age. But now Titian and his son and assistant Orazio were ensconced in rooms in the Belvedere Palace in the Vatican, overlooking Bramante's magnificent gardens and close to the Pope's own apartments. Giorgio Vasari had been appointed his guide to Rome's ancient treasures, and every artist in the city was talking about his presence there – many with a concerned eye to their own commissions and appointments.

'Titian has already seen so many fine antiquities that he is filled with wonder, and very glad that he came,' Bembo told Quirini. Indeed, Titian wrote to Aretino soon after his arrival, expressing regret that he had not come to Rome twenty years earlier. Many people had contributed to making his visit a reality – advising, encouraging and providing the material wherewithal – among them Bembo, Quirini and the artist's patron and protector Guidobaldo della Rovere, for whom he had painted *The Venus of Urbino* and who had provided an escort of seven horsemen to convey Titian through the Papal States to Rome. But the influence of one man had proved crucial in persuading the artist to leave his comfortable Venetian milieu: Cardinal Alessandro Farnese, grandson and first minister of

Pope Paul III. At twenty-five, Alessandro was already amassing what
would become the biggest collection of classical sculpture in private
hands in Europe, and had his own court of poets and intellectuals
gathered around him in his palace, the Cancelleria. We see him in
Taddeo Zuccaro's portrait: dark-bearded, cool, watchful, handsome.
Yet there's something unnerving, something almost primeval, in the
forward, incising set of the mouth. He was at that moment one of
the most influential men in Europe.

Rome had all but been destroyed in one of the most notorious events
of the sixteenth century – the so-called Sack of Rome, when the
Emperor's unpaid troops had run amok through Italy, entering
Rome on 6 May 1527 and practically razing the city in eight days of
burning, raping and looting. Churches, monasteries and palaces were
destroyed and looted of every precious object. Forty-five thousand
people were killed or displaced. For years Rome was a non-place, a
burnt-out disaster area, its artistic community dispersed throughout
the courts of northern Italy. Most never returned.

But now Rome was on the rise again, rebuilding herself on a scale
bigger, grander, more opulent than before. The city was a vast building
site as broad new avenues were driven through the jumble of the
medieval city, ancient churches refurbished and new ones built. Work
was resumed on the great basilica, rising on the site of the ancient
Church of St Peter – its building and design overseen by the last of
the great hero-artists of the High Renaissance, the man against whom
Titian had always instinctively measured himself – Michelangelo. And
all this was being brought into being with the aim of proclaiming one
message – the survival of the orthodox Roman Catholic dogma and of
the city of Rome itself.

And everywhere alongside the half-built modern city stood the
overgrown remnants of ancient Rome – the crumbling triumphal
arches and temples, the palaces and circuses of the Caesars – which
had been such a critical influence on the cultural upheavals of the
previous century, but which no one at that time thought to preserve.

The Farnese were a minor baronial family from the borders of
Umbria and Lazio who had married into the great Roman feudal
families at the time of Ranuccio Farnese, a condottiere and captain-

general of the papal armies, and grandfather of Alessandro Farnese the Elder, the future Pope Paul III. Taught by the maverick classicist Pomponio Leto and in the court of Lorenzo de' Medici, Alessandro Farnese was one of the best-educated and most astute individuals ever to accede to the throne of St Peter. A natural politician, he managed to thrive under both the hated Borgia Pope Alexander VI and under his successor and arch-enemy, Julius II. Yet in some ways he was hardly a priest at all. The father of three children, he became Bishop of Montefiascone and of Corneto before he'd even been ordained, and was elevated to the role of cardinal at least partly on account of Alexander VI's passion for his sister, the famously beautiful Giulia Farnese. He was elected Pope in 1534, at the age of sixty-six, precisely because he was old and not likely to live long – a compromise choice between the warring factions in the Sacred College. But somewhere along the road to becoming Christ's Vicar on Earth, Paul is understood to have undergone a profound spiritual experience, and he had no intention of leaving this world without making at least some impact on the destiny of Christendom.

Titian first painted Paul in Bologna in 1543, in a likeness that was in its time considered almost miraculous. Seated in a chair covered in the same deep-crimson velvet as his own *mozzetta*, or cape, the Pope appears slightly lost in his voluminous garments, the bare head slumped slightly forward, the eyes peering out beyond the viewer full of a slightly anxious spirituality, a mixture of self-conscious humility and a certain wariness. The neutral background and the way the figure fills the frame create a sense of intimacy bordering on claustrophobia. And there's a tension running through the frail limbs – and through the entire painting – the angle of the head and the long, square-cut beard echoing a diagonal sweep, down towards the right hand, the long simian fingers splayed out over the velvet-covered purse in a way that looks oddly defensive (the smallest finger curved inwards, the three bigger fingers symbolising the Trinity, the central one bearing the Ring of the Fisherman, the Pope's personal seal). And because the subject is seen slightly from below, both hand and purse appear slightly large in relation to the head.

The purse, the *bursa*, was associated with the distribution of coins to the people during the papal coronation, a practice that recalled the

customs of the Caesars and underlined the political and civil as well as spiritual nature of the papal role. And even before Paul's election as Pope, the freedom of his spending from his innumerable lucrative benefices had made him an immensely popular and admired figure among the people of Rome.

Titian spared none of the marks of age on the Pope's yellowing features. Yet there's a formidable energy and alertness in those dark, beetly eyes, and the same feral quality in the set of the mouth that we observed in the portrait of his grandson Cardinal Farnese. Yet to the contemporary viewer everything about the painting denoted a saintly humility: the bare head – unprecedented in papal portraits – since it was the viewer who was expected to approach the Pope bareheaded, while the balding head and thick beard were traditional attributes of St Paul.

Paul had chosen his papal name with care. Like the apostle, he was a man with great experience of the world on whom it had fallen to unify and revive the Church. But in doing that, he had two particularly formidable figures to contend with: the arch-manipulator Francis I of France and his brother-in-law and rival for the domination of Europe, the Holy Roman Emperor Charles V.

Paul had gone to Bologna to meet the Emperor with the aim of deciding the future of the Duchy of Milan – whether it should be ceded to the Pope's grandson Ottavio, and on what terms. Titian, who had been summoned by Cardinal Farnese, met up with the papal party at Ferrara, then followed Paul and his retinue of cardinals and bishops from Bologna to Parma, and the nearby town of Bussetto, where Pope and Emperor finally met on 21 June 1543.

Paul found time during all the comings and goings of this great meeting to sit for his portrait. Charles, meanwhile, had brought with him a painting of his wife, the beloved Empress Isabella, from which Titian was to make his own portrait. And how did the man from Cadore feel, finding himself suddenly at the centre of European events, courted by the rival overlords of Italy – the spiritual and temporal rulers of the Christian world? Daunted? Intimidated? Overwhelmed? How could he allow himself to feel any of these things? Now in his mid-fifties, he was the Divine Titian, someone to whom a great deal was already owed by both of these parties.

* * *

Titian's first contact with the Farnese had come in 1542, when he painted Paul's younger grandson, the twelve-year-old Ranuccio, as he passed through Venice. This painting made sufficient impact that an immediate formal invitation was issued for Titian to appear at the papal court in Rome, a request that was renewed with pressing insistence the following September. Aware of Titian's well-known reluctance to leave Venice, the scholar Gian Francesco Leoni, an associate of the Farnese, put forward the only inducement he thought likely to move the artist – the prospect of a benefice, an ecclesiastical living, for his son Pomponio. And he found the artist very responsive to the idea. 'I think,' Leoni wrote to Alessandro Farnese in September 1542, 'that he would trust entirely to your courtesy and liberality, if you should acknowledge his talents and labours by the promotion of his son.' And he added, 'Quite apart from his ability, Titian seemed to us a most reasonable person, pleasant and obliging – something to be taken into account when dealing with men of the kind he is.'

Drawn from the revenues – tithes and taxes – from a particular piece of land, a benefice guaranteed the holder an income for life in return for specified spiritual duties. In the gift not only of the popes, but of the feudal owners of the land in question, these positions were an established way of paying for services, of securing loyalty, without the necessity of raising cash. The duties involved might be no more onerous than the preaching of one sermon a year. In some cases, the incumbent never visited the church attached to the living. In some cases, there was no church. A churchman from a prominent family might be in possession of dozens of such 'privileges'. Cardinal Farnese himself was the holder of no fewer than sixty-four *benefici*.

Pomponio had been granted his first benefice – Medole, near Mantua – in 1530, when he was just six years old, a token of esteem and appreciation to his father from one of his most important patrons, Federico Gonzaga, Duke of Mantua. Jubilant at this acquisition, Titian had decked the child out in priestly garb as a way of advertising his good fortune to his friends. While he later observed, a touch ruefully, that Pomponio did 'not seem much inclined to be a churchman', that didn't stop him accepting a second benefice on Pomponio's behalf nine years later – a canonry in the Church of Santa Maria della Scala

in Milan, a gift from Emperor Charles V, a living that was to become notorious for the unsuitability of its incumbents.

Now Titian had set his sights on a benefice more richly endowed than either of these, the abbey of San Pietro in Colle, in the diocese of Ceneda, near Serravalle, an area conveniently positioned halfway between Venice and Cadore, where he already owned land. And the duties would hardly tax the twenty-one-year-old Pomponio, as the abbey in question hadn't even been built. The problem was that this living already had an incumbent, Giulio Sertorio, Abbot of Nonantola and Archbishop of San Severina.

We see Titian in a self-portrait painted at around this time, now in his late fifties, grey-bearded but still vigorous, exuding an impulsive energy, one hand on the table in front of him, the other resting on his thigh – as though about to leap to his feet and deal with something or someone; a demanding, but not unreasonable person.

The painting has an air of calculated informality, the sumptuous clothes – the fur-collared pelisse and silk-sleeved doublet – the gold chain indicating his patent of nobility – appearing not quite finished. Yet there's nothing casual or accidental about the way Titian has captured his own formidable bone structure. To portray himself in this three-quarter pose, looking off to the right, eyes raised towards the middle distance, would have required a complex arrangement of mirrors. Titian has shown his features, the domed forehead and prominent, aquiline nose, with a firmness designed to convey a sense of *terribilità* – the quality of temperamental grandeur considered essential to high-grade creativity at that time – a quality most associated with his great rival Michelangelo. But as for self-analysis – the kind of frank, apparently unguarded self-scrutiny that is the hallmark of all the greatest self-portraits – that doesn't even begin to happen.

In September 1544, the papal nuncio in Venice, the eminent poet Giovanni della Casa, was shown a painting – a reclining nude – *Danaë*, that Titian was preparing for his master, Cardinal Alessandro. It showed the princess who, in Ovid's *Metamorphoses*, is ravished by Jupiter, king of the gods, who appears in the form of a shower of golden coins. Lying back on a great mound of pillows, knees

raised, thighs parted, Danaë looks up tenderly to where her divine lover appears – coins spitting out of a golden cloud, her face slightly averted so that the shadow of a curtain falls across it, half obscuring the smile of rapture playing across her features. One of the sheets is coiled round her right thigh, while her fingers pull at the bedclothes, the whole scene, the figure, the cupid standing at her feet, transfused with a melting, golden warmth.

'The nude your reverence saw in Pesaro is a nun compared to this one!' wrote della Casa, referring to *The Venus of Urbino*. He went on to say that if a sketch could be provided of Signora Camilla's sister-in-law, Titian would be prepared to attach the head of that lady to the figure in this painting. 'Signora Camilla's sister-in-law' was a reference to the cardinal's mistress, Angela, a prominent Roman courtesan, whose features might be transposed on to the hottest, most sexually explicit nude yet created if – and this is the essential point of della Casa's letter – the cardinal would only assist Titian with the matter 'which would be the culmination of his happiness': the transfer of the *benefice* of San Pietro in Colle to his son Pomponio. Della Casa went on to confess that Titian had already given him a portrait of Our Lord by his own hand, 'corrupting me in such a style that it suits me to be his agent'.

While Titian was in Bologna, at work on the portrait of Paul III, Antonio Maria Sertorio, brother of the current holder of the benefice, had arrived in the city to discuss the terms of compensation, should the living pass to Titian. There was no question that the sums involved – to be paid by Cardinal Farnese – would not be generous, but just as terms were about to be agreed Farnese took ill and left Bologna. While Titian was informed by Farnese's secretary that the transfer of the benefice had been agreed – a fact that Titian plaintively reiterated in several letters to Farnese – he heard no more from the cardinal for many months.

The following March, Titian wrote to the cardinal's secretary under Aretino's direction, invoking Alexander – who was always honourable in his dealings with his court artist, Apelles – and urging the cardinal to keep a vow 'made by the holy clemency of the Pope in respect of the benefice'. The now fourteen-year-old Ranuccio Farnese was prevailed upon to entreat his elder brother on Titian's

behalf ('Titian being a most estimable person I beg to recommend him most honestly,' he wrote). Michelangelo was approached to weigh in on behalf of his 'brother in craft' in separate letters from Titian and Aretino. Carlo Gualteruzzi, a friend and translator of Bembo and secretary to Ottavio Farnese, was appealed to by Aretino, as was Ottavio himself. All to no effect.

Cardinal Farnese had been extremely preoccupied with his role as papal legate as France and the Empire went to war in spring 1544. But the signing of the Peace of Crespia, which he brokered between Frances I and Charles V the following September, increased Titian's hopes of gaining the cardinal's attention, and in December he wrote asking for Farnese's intercession in a long-running dispute with the monks of Santo Spirito in Isola.

In the meantime, Titian had sent the two portraits of the late Empress Isabella, painted from the likeness given to him in Bussetto the previous year – together with a letter apologising to the Emperor for not presenting the paintings to him in person and begging to be allowed to correct any faults himself. 'For the rest I refer to what Señor Don Diego will say respecting my affairs, and I embrace the feet and hands of your Majesty, to whose grace I most humbly beg to be recommended.'

With it went a letter in which Aretino spelt out the matters that Titian had discussed with Don Diego Hurtado de Mendoza, the imperial envoy in Venice: namely that nothing had come of a grant to import corn from Naples accorded to Titian nine years before, while his pension to be drawn on the treasury of Milan remained unpaid.

Here was Titian, painter to the most powerful men in Europe, with little to show for it: his pension from the Emperor – the Caesar Universalis – hanging on the whims of reluctant Milanese bureaucrats, while the benefice for his son, on the promise of which he'd undertaken so much work for the Farnese, remained beyond his grasp.

So, in the summer of 1545 – when all the key members of the Farnese family were comfortably ensconced in Rome – Titian wrote to Cardinal Farnese expressing his intention of coming to Rome and painting every member of the papal household, 'including the cats'.

* * *

While three of Paul's grandsons were made cardinals, the second eldest, Ottavio, was married at fifteen to Margaret of Austria, illegitimate daughter of Charles V, in order to consolidate links with the Emperor, whose support Paul needed in his attempts to resolve the conflicts in Christendom and in his more personal ambition of carving out a Farnese state in central Italy.

Ottavio was a typical Renaissance princeling out of the same mould as Guidobaldo della Rovere – vain, arrogant, self-centred, but not utterly uncultured. And in gaining the lands and titles he felt were his by natural right and destiny, he had one overwhelming advantage – the fact that his grandfather was Pope – through which fortunate circumstance he had also become son-in-law of the Holy Roman Emperor. Indeed, the Duchy of Camerino had already been withdrawn from Guidobaldo and given to him. He had been deprived of the Duchy of Milan, but now – with an heir on the way – he had set his heart on another, almost equally rich dukedom, which had only been in papal hands a relatively short time – that of Parma and Piacenza. Instead, he watched in disgust as this prize was given to another claimant – his father.

One of the first things Paul had done on becoming Pope in 1534 was to make his son Pier Luigi – the father of Alessandro, Ottavio and Ranuccio – captain-general of the Church and Gonfaloniere, papal standard-bearer, the Church's highest military honour, a move that was entirely in accord with the practices of previous popes. Pier Luigi, rightful successor to the leadership of the Farnese family, had been married at sixteen, fathered his first child Alessandro, the future Cardinal Farnese, at seventeen, and was only thirty-one at the time of his father's accession. While he had been legitimised by Pope Julius II at the age of two, a pained awareness of the circumstances of his birth is said to have been the key aspect of a personality forged in the mercenary armies in which he had marched since adolescence.

In Titian's only surviving portrait, Pier Luigi is shown half-length in black armour, a dagger in one hand, the baton of the papal command in the other – a soldier unfurling a great banner behind him. He appears vigorous, choleric, his long face black-bearded, dominated by a large, hooked nose and a confident half-smile.

Fearless and extremely strong, Pier Luigi took part in the siege of Rome under the Emperor's banner, though his defence of his

family's properties in the city led to accusations that he had fought on both sides. His stewardship of his rural domains, which verged on outright brigandage, saw him threatened with excommunication by Pope Clement VII, and he never quite lived down the suggestion that he was involved in the rape of the Bishop of Fano, after which the young churchman died.

With Pier Luigi created duke in August 1545, just two months before Titian's arrival in Rome, Parma and Piacenza was now the private domain of the Farnese family. There was an immediate objection from Emperor Charles V, who had been hoping to absorb the territory into his own sphere of influence through the appointment of his son-in-law, Ottavio. While the move alienated many of the Pope's own supporters, the bitterest protest came from within his own immediate family, from his grandson, and Pier Luigi's son, Ottavio himself.

The Emperor had urged his envoy in Rome to press Ottavio's claims with particular insistence. But Paul had calculated that with the Empire and Papacy now in alliance against the German Protestants, and with the first session of the Council of Trent about to open on the Emperor's territory, the Emperor's actions were unlikely to veer beyond words of complaint.

When Titian arrived in Rome, Pier Luigi still hadn't been physically installed in his new dukedom. A climate of tension and suspicion reigned in the various Farnese palaces and in the corridors of the papal apartments. Exactly how much of the circumstances of this internecine conflict the artist was privy to is impossible to say, but you have to assume all of it.

One afternoon, Vasari brought a most distinguished visitor to meet Titian in his rooms in the Belvedere – Michelangelo. The seventy-year-old artist and had abandoned painting and sculpture in pursuit of pure, divinely inspired space and proportion through the practice of architecture, and did not at this stage in his life feel the need to bother with other people. He had nonetheless made time to go and see Titian, and the two men, who had almost certainly met during Michelangelo's brief sojourn in Venice in 1529, greeted each other warmly.

There was Vasari, whose exposition of the dialectic of *disegno*

and *colorito* was to have such an impact on the way art was thought about over succeeding centuries, standing in the same room with the artists who most exemplified these opposing ideals. Over here was Michelangelo, the Florentine, Vasari's hero, whose art – rooted in drawing, but fundamentally sculptural in character – expressed 'a perfection that nature itself is scarcely able to emulate'. Michelangelo, the cantankerous individualist, who slept in his work clothes and didn't feel the need to explain himself to anybody.

Over there was Titian, the Venetian, fifteen years Michelangelo's junior, the worldly diplomat-artist (a diplomat for whom? For himself), a sensualist in principle, if not always in practice, whose 'pleasant manner' had been noted even by Michelangelo, whom Michelangelo acknowledged as 'a painter from his mother's womb', yet who was regarded still by the two Tuscans as a representative of an alien, half-oriental tradition.

During the course of the visit, Titian showed them his painting for Cardinal Farnese, *Danaë*, to which he must at that time have been putting the finishing touches, and which, with its melting, golden female forms, must have seemed the absolute antithesis of everything the Florentine/Roman tradition stood for: about temperature and tactility rather than contour and geometry, about the diffusion of form into light and atmosphere, about the concrete rather than the ideal – about what appears to be rather than what ought to be.

And 'naturally,' Vasari recorded in *Lives of the Artists*, 'they praised it warmly, as one would with the artist present'. But after they left, Michelangelo appeared preoccupied, then began to discuss Titian's method, commending it highly, 'saying that his colouring and his style pleased him very much, but that it was a shame that in Venice they did not draw well from the beginning and that the painters there did not pursue their studies with more method. For the truth was, he went on, that if Titian had been assisted by art and design as much as he was by nature, and especially in producing living subjects, then no one could achieve more or work better, for he had a fine spirit and a lively and entrancing style.'

And that, as Vasari added, 'was nothing but the truth. If an artist has not drawn a great deal and studied carefully selected ancient

and modern works, he cannot by himself work well from memory
or enhance what he copies from life, and so give his work the grace
and perfection of art which are beyond the reach of nature – some of
whose aspects tend to be less than beautiful.'

But is that the purpose of art, to expunge from the view of experience
everything that is 'less than beautiful'? Michelangelo saw nature as an
enemy to be overcome as he strained for a perfection that transcended
anything to be found in what he referred to, rather dismissively, as
'living subjects'. Titian admired the dynamism and intensity of
Michelangelo's figures – had always acknowledged the Florentine as
the one great figure with whom he felt obliged to compete; though
he understood implicitly that Michelangelo's path and Michelangelo's
imperatives were fundamentally different from his.

When he was asked, a few years later, why he employed such bold
brush strokes, he replied, 'Sir, I am not confident of achieving the
delicacy and beauty of the brushwork of Michelangelo, Raphael,
Correggio and Parmigianino. And even if I succeeded in emulating
them, I would be judged with them or considered an imitator. But
ambition, which is as natural in my art as any other, urges me to
choose a new path on which to find fame, much as those others
acquired their fame from the way they followed.'

And while Michelangelo's figures exist apart from the world, each
in its own space, hermetic within its own intensity of experience,
Titian's figures were thrown into dynamic interaction. Titian
made the brush marks visible, losing the minuteness of detail that
can only be seen from a static perspective. He never pursued the
ugly or the grotesque, but as he moved painting away from static
monumentality, much that was 'less than beautiful', a lot of the
inconvenient unloveliness inherent in 'living subjects', flowed into
the picture space.

In taking on the subject of the Pope and his grandson, Titian can't
but have been aware of a masterpiece by another great master of the
Florentine/Roman tradition, a painting created nearly thirty years
before: Raphael's *Pope Leo X with his Cardinal Nephews*, which he
would have known from the excellent copy in the ducal palace in
Mantua. And if by any chance he didn't know the painting, Cardinal
Farnese, who had commissioned Titian's own work, certainly did.

The importance of the *nipote*, the cardinal-nephew, had arisen from the fact that pontiffs did not – officially at least – have children. It was accepted practice that every pope would elevate at least one male relative – a nephew, cousin or grandson – to the Sacred College of Cardinals, who became, in almost all cases, ministers of state. And the promise of dynastic succession was almost inevitable. By the time Raphael completed his painting, sixteen popes, including Leo himself, had been cardinal-nephews before acceding to the throne of St Peter.

In Raphael's picture, the Medici Pope's imposing, bull-necked bulk dominates the centre, seated at a table at which he has been reading, flanked by the red-robed figures of the cardinal-nephews – both cousins – who form a kind of royal escort to the relative who has raised them to their positions of eminence. Seated facing the Pope on the left is Cardinal Giulio de' Medici, and looking directly – and compellingly – out at the viewer over the Pope's shoulder, while gripping the papal chair with both hands, is Cardinal Luigi de' Rossi. Cardinal Alessandro must have wanted to create a similarly potent image of his own family when their power and influence were at their height – a painting that would endorse his own aspirations to the papal throne. And while the obvious person to have joined him in the painting would have been his youngest brother, Ranuccio, who had just been made cardinal at fifteen, he chose instead the brother to whom he was closest in age, the one who most needed to be seen in close proximity to Christ's representative on earth – Ottavio.

But nothing about the execution of the painting went as smoothly as either Cardinal Farnese or Titian would have liked.

The Pope was 'too old, too ailing and too peevish to visit the painter's room frequently', as Crowe and Cavalcaselle put it. And while there's something reptilian in the set of Ottavio's head as he leans in towards his grandfather that could be construed as redolent of a naked, complacent, shameless self-interest, Titian probably fell back on this full-profile pose to disguise the fact that the young duke never sat for him. Having been reprimanded by the Pope, he may have kept himself to his own palace. Far from standing at his canvas as the Farnese family's internal politics were played out in front of him, Titian was forced to invent the entire scene.

While the figures in Raphael's painting are far from idealised – the Pope appears corpulent, slightly myopic, even a touch seedy – their arrangement is static and monumental, the figures of the two cardinals slotted securely behind the dominant central figure of the Pope – the classical columns in the background, suggestive of Roman solidity and permanence.

But Titian breaks apart that sense of timeless security and inevitability, throwing his figures into dynamic motion, making them interact in what he convinces us is a moment of real time. And the orange-red curtain that hangs in the background has been pulled to one side in a great sweep of fabric, breaking up the rectilinearity of the background with a looping arabesque that balances the curving form of the Pope's shoulder, while enhancing the sense of movement, of flux and unpredictability. And you can't help but be reminded of that slightly ridiculous scene in *Hamlet* where the prince stabs Polonius through the curtain in his mother's room.

The Pope turns abruptly as his grandson approaches, bowing before his grandfather, sweeping his hat before him, one hand gripping the hilt of his sword, his legs in their white tights almost dancing across the canvas – the secular ruler come to pay his respects to Christ's representative on earth, who just happens to be his grandfather. And we can sense some of the Pope's tetchiness – so irritating to Titian – in his expression. There's little here of the grandeur and perceptible saintliness of Titian's earlier portrait. Paul sits hunched in his seat, neck shrunk back into the crimson velvet cope that seems to overwhelm his shoulders, the silken cap, or *camauro*, pulled low over his brow in a way that looks slightly foolish, that compounds the sense of a man in his dotage, who isn't as much in control of events – and of himself – as he thinks he is. And he looks up with an expression at once wily, perplexed and irritated as Ottavio looms over him, his pale features with their long nose, drooping eyelids and rather weak chin presumptuously, overpoweringly close to those of the Pope.

Standing behind the Pope's chair, Alessandro looks out at us, benign and humane, wonderfully handsome with his thick beard and grave, dark eyes. He's the one who has commissioned this painting, on whom Titian's hope of realising the benefice for Pomponio rest,

and who would have been most prepared to sit for the painting, despite the massive, other demands on his time. Titian has softened the tough, predatory look we noted in Zuccaro's portrait – made the eyes wider, lessened the forward, incising set of the mouth and jaws. Yet we note that his hand rests proprietorially on the back of the Pope's chair. While it is Luigi de' Rossi, rather than Giulio de' Medici – the future Pope Clement VII – who holds the papal seat in Raphael's painting, Rossi, in all probability destined for the papal role, died before he could achieve it, in 1579.

It's one of the central conceits of our idea of the portrait that the artist, through the intensity of his looking, achieves perceptions that go beyond those of the average man – that he can see into the sitter with a clarity that transcends even his own everyday opinions and feelings – that he can't help but reveal the inner truth of what is before him, whether he wills it or not. Just as Goya, the nineteenth-century liberal, found himself portraying the Spanish royal family as halfwits, so Titian, the Renaissance courtier-artist, couldn't help but reveal the corruption and treachery at the heart of papal family politics.

Yet there's no evidence that the Farnese were anything other than pleased with the painting. Indeed, Vasari, who was there at the time, explicitly states that they were. Titian certainly intended to finish the painting on a second visit to Rome scheduled for the following year, but before that could happen there was a further fatal complication.

History has castigated Paul III for trying to carve out a Farnese state to be ruled by his son. But he was only following the example of his predecessors Alexander VI and Leo X, both of whom had embarked on similarly shameless strategies of familial aggrandisement – and both with disastrous consequences.

Having alienated the feudal families of Piacenza through ruthless taxation and angered the party of the Emperor through his expansionist ambitions, Pier Luigi Farnese was cornered in his palace by a group of the local nobles and butchered in cold blood – his body hung from a window as both an announcement and a warning. This action was fomented with the approval of Ferrante Gonzaga, the Emperor's governor in Milan, with the almost certain knowledge of the Emperor himself – with the intention of demoralising and weakening the Pope.

Grief-stricken, Paul decided to take Parma and Piacenza back into the papal territories. But Ottavio, who saw this dukedom as rightfully his, moved his troops to occupy Parma – in defiance of his grandfather and the Emperor. It is said that the Pope's anger and distress at Ottavio's actions, together with his disappointment at the connivance of his favourite Cardinal Alessandro, broke his heart. His death on 10 November 1549, at the age of eighty-one, came after a violent argument with the once beloved Cardinal Farnese.

Titian, meanwhile, was long gone. Having discovered that the benefice of San Piero in Colle was being pursued by more powerful figures – Cardinal Salviati and the Duke of Ferrara – for their own clients, Titian cut his losses and accepted the more modestly endowed benefice of San Andrea del Fabbro, situated conveniently close to Venice in the diocese of Treviso. He returned to Venice by way of Florence in June 1546, having stayed in Rome for nine months.

While he had agreed to return to Rome the following year, he wrote to Cardinal Farnese on 24 November 1547 begging his forgiveness and expressing his disappointment at being unable to present himself to His Holiness on account of another engagement – one which, he implied, he had no option but to undertake. By the time Farnese received the letter, Titian and his assistants were crossing the Alps in the depths of the January blizzards, proceeding into Germany by way of Trent and Innsbruck, on their way to Augsburg and the court of Emperor Charles V.

II

A Burnished,
God-like Glow

W E SEE HIM riding out of dark woods at dawn, seated
superbly confident on his black charger, his face tilted
slightly upward, looking nobly onward towards duty
and destiny. In Titian's painting *Charles V at Mühlberg*, the Emperor
wears the armour he wore during his great victory over the German
Protestant princes, chased with gold, the breastplate engraved with
the image of the Virgin. Around his neck hangs the insignia of the
Golden Fleece, the order of chivalry founded by his great-grandfather
Philip the Good of Burgundy. In his right hand is a spear: not the short
stabbing spear he used in battle, but a long spear of the sort carried
by Roman emperors – which is carried, too, by the central figure in
Dürer's engraving *Knight, Death and the Devil*, the embodiment of
the Christian warrior who rides through the Valley of the Shadow
of Death, but fears no evil.

Charles V, like the Roman emperor Augustus, was born with the
sign of Capricorn in the ascendant in the first degree, an omen seen
by contemporaries as presaging inevitable greatness. Grandson on
his mother's side of Ferdinand and Isabella, the so-called Catholic
Kings, who drove the Moors from Spain, and on his father's side of
Emperor Maximilian I, 'The Great', architect of Habsburg hegemony
in central Europe, Charles inherited a greater share of the European

continent than any other ruler before or since. Duke of Burgundy at six, he became King of Aragon, Castile and León and of Naples and Sicily at sixteen, Archduke of Austria, King of the Romans and Holy Roman Emperor Elect at nineteen.

'God has raised you above all kings and princes of Christendom,' Charles was told by his chancellor Mercurino Gattimana, 'to a power such as no sovereign has enjoyed since your ancestor Charlemagne. He has set you on the way towards a world monarchy, towards the unity of all Christendom under a single shepherd.'

Born in Ghent in Flanders, Charles was brought up by women, by his elder sisters Eleanor, Isabella and Mary, under the supervision of his aunt, Mary, Archduchess of Austria. His first language was French, his second Flemish. Slight in build, born with a lantern jaw so pronounced that it was impossible for him to fully close his mouth or chew his food, he cultivated manly skills, riding, hunting and swordsmanship, and developed a steely, distant manner. And his first loyalty, beyond the demands of nationality, philosophy and even of family, was to the tenets of the Order of the Golden Fleece, which combined the demands of chivalry and of Christianity in the mystical idea of the crusade. It was Charles rather than the Pope who was the driving force behind the reform of the Church through the Council of Trent. In the early days, even Luther had hopes of him: 'God has given us a young and noble ruler to reign over us, and has thereby awakened our hearts once more to hope.' But Luther had reckoned without the Emperor's pathological abhorrence of heresy in any form.

King of Spain, Charles didn't speak a word of Spanish when he first visited these lands at the age of seventeen. German emperor, he visited his German lands only nine times. There was no official language to his rule, no official residence, no capital. Wherever Charles was at any given time, from Andalusia to the marches of Hungary, was the centre of the Empire.

Yet one way that Charles could make himself known to his subjects was through images – through portraits, copies of which could be distributed throughout his immense domain; and which, through the new printing technology, could be varied, improved upon and

endlessly duplicated. Charles came to believe there was only one artist capable of seeing him as he wished to be seen, an artist whom he seems to have regarded as a kind of friend – a man before whom even the overlord of Christendom, the Caesar Universalis, was prepared to kneel.

There's a tiny sketch in the museum in Besançon, barely more than a few rapid strokes of the pen, that is traditionally believed to represent Titian's reception at the court of Augsburg. The potentate is seated on a dais, surrounded by a group of courtiers, dwarfs and buffoons. Before him, tall and self-assured in his big-collared coat, stands the artist. And while the faces have been slashed in so cursorily it is impossible to read any direct expression, we can see that he wears an air of peculiar self-possession, of supreme confidence in the value of what he has to offer.

Indeed, it is the potentate, seated on his throne, who is leaning forward, listening attentively to a man beside him who must, we assume be a translator – hanging on his visitor's every word. And Titian, for all his confidence, is aware that, after all his time spent schmoozing the middlemen of the Empire, charming the imperial ambassadors, endlessly writing to the imperial secretaries and treasurers, providing paintings as presents for the governors and chancellors, he is finally once again face to face with the man with the ultimate power, the universal ruler, the Emperor himself.

Titian's first meeting with Charles V was not propitious. Federico Gonzaga of Mantua, one of the most loyal of Titian's patrons and proponents, and a vassal of the Emperor, took Titian with him when he went to meet Charles in Parma in 1529 – with the expectation that Charles would have his portrait painted. But Charles, in Italy for the first time, and by no means certain who this Venetian was, sent Titian on his way with a derisory gift of one ducat.

Federico's next attempt at bringing emperor and artist together was more successful. In 1530, when the Emperor passed through Mantua on his way from Bologna, where Pope Clement VII had crowned him emperor, he was greeted with a breathtaking spectacle, devoted to the subject of his own greatness – fifty noble youths clad

in white carrying a canopy over him, suspended from silver staves, as he rode through a succession of specially erected triumphal arches. Over the following weeks, the Emperor was pampered and fêted, entertained with elaborate masques, exquisite music and the most sumptuous feasting that the most refined court in Europe could provide – all in the company of Federico and his mother Isabella d'Este, by then the most legendary woman in Europe. It was during this stay that Charles, examining the various paintings distributed through the palace, became acquainted with Titian's art. The day before his departure, Charles raised Mantua from a marquisate to a duchy, and proclaimed Federico duke. And when he finally left, it is understood that he took with him several paintings by Titian. When Charles returned to Mantua two year later, Titian was immediately summoned to paint his portrait.

In his book dedicated to Charles, *Paraphrase of the Gospel of St Matthew*, the philosopher Erasmus advised the monarch against commissioning portraits because, 'if there is anything praiseworthy in them, it is due not to you, but to the artist whose genius and work they represent'. But he also averred that, 'God placed a beautiful likeness of himself in the heavens – the sun. So for every mortal man he set up an image of himself – the king.' And seeing himself in Titian's painting, captured three-quarter length in armour, holding a naked sword, Charles V felt that this was the only painting of himself that had come close to realising that ideal. If every other painting had made him seem uglier than he already felt he was, this one made the most of his pale skin, his blue eyes and golden auburn hair. It subtly masked his protruding lower lip with the red-gold beard, and while it didn't do away entirely with the long lantern jaw, it modified it, made it appear manly and resolute. As for the armour, the ultimate test of the painter's skill, its steel sheathed his body in a burnished godlike glow.

Before leaving Bologna, Charles gave Titian a present of 500 ducats and, on returning to Spain, granted him the rank of Count Palatine and Knight of the Golden Spur. Describing Titian – according to the conventional rhetoric of the time – as 'the Apelles of the century', the patent of nobility conferred on him the right to appoint notaries and 'ordinary judges' and the power to legitimise

the illegitimate offspring of persons under the rank of prince, count or baron. In 1536, Titian was granted a concession to export corn from Naples, a privilege which was in theory worth as much as 300 ducats a year. In 1541 he was granted a pension of 100 ducats per annum payable from the imperial treasury in Milan. But the duty payable on each load of corn made it difficult to make money from the former privilege, and, by the time Titian set out for Augsburg late in 1547, he still hadn't seen a penny from the latter.

'Wherever the eye turned there were signs of recent battle. Broken lances, shattered muskets and torn-up harnesses littered the ground. And all along the road, soldiers were dying of their wounds and from want of sustenance. Around Wittenberg all the villages were deserted. The inhabitants had taken flight, leaving nothing behind them. Here the corpse of a peasant, a group of dogs fighting for the entrails; there a landsknecht with just the breath of life left to him, but the body putrefying, his arms stretched out at the widest, and his legs far enough apart to put a bar between them.'

So wrote the lawyer Bartholomew Sastow on riding through Saxony in the aftermath of the Battle of Mühlberg. Charles had hoped that an accommodation could be reached with the Lutherans on critical points of theology, thereby avoiding a schism within Christendom. But having failed to reach an accord at the Augsburg diet of 1530, and having brought his struggles with France and the Turks to an at least temporary resolution, he entered into a league with Pope Paul III against the north German Protestant princes whose Schmalkaldic League was becoming a significant power block, threatening the authority of the Empire itself. 'If I failed to intervene now,' he wrote to his sister Mary, 'all the estates of Germany would be in danger of breaking with the faith. I decided to embark on a war against Hesse and Saxony as transgressors of the peace against the Duke of Brunswick and his territory. But this pretext will not long disguise the fact that this is a matter of religion.'

Exploiting the hatred between the two principal Protestant leaders, Johann Friedrich, Elector of Saxony, and his cousin Duke Maurice, Charles encouraged Maurice to invade the Elector's lands. Johann Friedrich pushed Maurice back and pressed on into neighbouring

Bohemia. But the local Protestants failed to rise in support, while imperial forces invaded Saxony from the south, pressing into the Protestant heartland, surprising the Elector's outnumbered forces at Mühlberg on the Elbe on 24 April 1547 – bearing down on them through thick mist.

By this time, the Emperor was suffering acutely from asthma, exhausted by the ceaseless travel and strife that had characterised his reign and in agony from gout. As he rode on to the field at Mühlberg in his gilded armour, Charles was said to have resembled a ghost encased in steel, his red beard heavily streaked with grey, his cheeks hollow, his skin deathly pale. Yet he sat very upright on his horse as he drove the beast over the ford of the Elbe and saw the Elector Johann Friedrich, a stocky figure in black armour, led a prisoner from the field. The Elector hung his head in shame, blood pouring from a gash in his cheek.

'Do you now acknowledge me as Roman emperor?' demanded Charles.

'I am today but an unfortunate prisoner,' responded the Elector, 'and beg your Imperial Majesty to treat me as a born prince.'

'That,' said Charles, 'I cannot agree to do.'

All of Germany was now at the Emperor's feet, but it was almost eight months before Titian was ordered to Augsburg to create a memento worthy of the moment.

Augsburg was one of the richest cities in Europe and one of the coldest, grim beneath January skies. Its privileges as an Imperial Free City had been revoked to curtail the power of the Protestant burghers, the guilds suppressed, the Catholic aristocrats restored to their former influence. In Augsburg, only the Imperial Court glittered – assembled for the diet, the parliament of electors and nobles, that would decide Germany's future.

There were few among the Emperor's prominent courtiers who had not had their portraits painted by Titian. And among the merchant princes of Augsburg, who now stood proudly around the Emperor, many had learnt business, and even made their fortunes, at the Fondaco dei Tedeschi in Venice – the Welsers, Höchstetters and above all the Fuggers. Augsburg weavers who diversified into banking, becoming proverbially the richest family in Europe, the Fuggers had amassed the enormous sums necessary to ensure

Charles's election as emperor. The Emperor was, even now, staying in the Fugger palace.

While the Emperor's younger brother Ferdinand, King of the Romans, was to be seen at many of the balls and dinners that were given over this period – laughing, cracking jokes with the court buffoons and putting everyone at their ease – the Emperor himself took his meals alone, eating copiously as was his habit, but barely uttering a word. He would then retire to a corner by a window, sitting quite still as he listened to the endless stream of petitioners with their requests. The Venetian diarist Marin Sanudo noted the shabbiness of the black-clad servants who waited on him. While the mansions and palaces of his bankers and courtiers shone, the Emperor himself was penniless.

Yet he seemed to perk up at Titian's arrival, asking after Aretino and expressing his desire to give a dowry to the great trickster's daughter, who had been named Austria in a gesture of half-mocking homage to the Habsburgs.

Titian had brought with him two paintings: a reclining female nude, a gesture which echoed the gift of the *Danaë* which had been such a success with Cardinal Farnese in Rome, but greatly toned down, a proper Venus, classicised and intellectualised by the presence of a cupid; and an *Ecce Homo* – an image of Christ crowned with thorns – the grave but muscular figure seen against a black background. Charles was pleased by the painting's air of brooding piety, while the nude – we understand – was given away.

Titian and his seven assistants produced eighteen paintings during his eight-month stay in Augsburg, almost all of them portraits: of the Emperor's sister, Mary, Dowager Empress of Hungary, her relatives Christine and Dorothy, Marie-Jacqueline of Baden, Anna, consort of Albert, third Duke of Bavaria, both daughters of Ferdinand, King of the Romans, who was himself portrayed in armour, his sons Maximilian and Ferdinand, Emmanuel-Philibert of Savoy, the Duke of Alva, the Emperor's chancellor Nicolas Perronet de Granvelle, Cardinal Madruzzo, Bishop of Trent, and even Johann Friedrich, Elector of Saxony, whose death sentence for rebellion had been commuted, staring baleful and bull-necked, his great bulk executed in a detailed and deliberately Germanic style intended as a tribute to the Elector's court painter Lucas Cranach.

The intention was to make a record of the Habsburg family, of which replicas would be distributed around their palaces throughout Europe, a project that included the larger part of the seventy paintings produced for Charles, his sister Mary and son Philip over the following seven years.

Reading Titian's letters from Augsburg, Aretino could hardly contain himself at how frequently the painter was admitted to converse with the Emperor. Titian's rooms had been moved closer to the Emperor's so that Charles could call on him more easily. Giovanni della Casa, papal legate in Venice, wrote to his master Cardinal Farnese, in an astonished tone, telling him that, 'Master Titian has spent a long time with his Imperial Majesty painting his portrait and seems to have had plenty of opportunities to talk with him, and reports that his Majesty is in good health, but exceptionally anxious and melancholy.' Even the Protestant philosopher Melancthon, sitting in his study far away in Wittenberg, was aware that 'Titian the painter has constant access to his Majesty'.

In April 1548, Titian wrote to Aretino saying that the Emperor would be represented wearing the armour he had worn and seated on the horse he had ridden at Mühlberg. This was the first full-length painted equestrian portrait, which carried with it echoes of Roman imperial statuary, and established the model for every state equestrian portrait from Rubens, Velázquez and van Dyck onwards. On first hearing of the painting, Aretino wrote to Titian suggesting that he add allegorical figures: Religion perhaps, walking before the Emperor, or Fame, sweeping down with her trumpet and chalice, as was seen in Apelles' long-lost portrait of Alexander. But Titian wanted to create an image that would speak for itself, in which majesty would be conveyed not through symbols, but by the dignity and inner nobility of the emperor himself – qualities that would be conveyed entirely through Titian's painterly skill.

Yet looking at the painting in detail, it's apparent that Titian never saw Charles on horseback. The Emperor's steed is just a black shape beneath its crimson panoply, while the sense of equestrian movement is conveyed almost entirely by the expression on the Emperor's face, the set of the head and the thrust of the jaw – yes, that appalling Habsburg jaw – and their relation to the composition as a whole.

As always with Titian we're given just enough of the truth to distract us from what isn't true about the painting. The Emperor's face is chalky pale, the beard densely streaked with grey, the lines around the eyes dense, the features drawn – but taken as a whole the effect of that faintly smiling visage against that immemorial sunrise – or is it sunset? – with its flaming bars of crimson and lemon yellow is one of intentness, nobility and resoluteness. And it was only the head that was painted with Charles present, possibly only the head that was painted by Titian at all. As you move outward from the central figure, you can see that much of the darkened background landscape is quite weakly painted. Yet the perfect positioning of that head on the large canvas sets the composition off, compounds the sense of graceful, yet inexorable forward momentum around which the whole composition is built.

It was while this picture was being painted that the most famous incident in the relationship between Titian and Charles V took place. One day when Titian was in his studio, standing working on a platform in front of the great canvas, there was a commotion in the corridor outside. The door was flung open and a group of halberdiers, the elite imperial guard, entered the room, 'Caesar!' cried a page, and there was the Emperor walking – or in all probability limping – towards the platform and the painting. And Titian, moving towards the edge of the platform, disconcerted by the noise, the sudden interruption and the unexpected appearance of the Emperor, dropped his brush. But how did Titian, a man who had spent most of his life with a palette in one hand and a brush in the other, who was not easily flustered, and who was by now well used to the presence of the Emperor, manage to drop his brush? How did an artist, much of whose success was due to his knowledge of how to behave with the great and the good, allow himself to commit this appalling faux pas?

But there it was: Titian up on his platform with his palette, and the brush lying on the ground with everyone – the halberdiers, the page and the members of Titian's workshop – all staring at it. And before any of the assistants had the chance to rush forward and pick it up, the Emperor – who had probably never picked up anything in his life before – took a few effortful steps forward and stooped to pick up the filthy instrument of Titian's trade. And straightening

himself, he passed the brush up to Titian, who bowed low saying, 'Sire, one of your servants does not deserve such an honour.' To which the Emperor looked him directly in the eye and said, 'Titian well deserves to be served by Caesar.'

There you have it, in a version freely adapted from 'Le Fils de Titien', a story by Alfred de Musset, which manages to get just about every other circumstance of the artist's life wrong. A defining myth that freezes Titian's reputation for all time as the artist before whom the ruler of half the world was prepared to stoop. You hardly need to know anything more about him.

Rather than having the Emperor trampling over the bodies of his enemies, as Aretino suggested in one of his letters, Titian showed Charles cantering through a tranquil, park-like landscape, riding out to inspect the field of battle in the manner of the Roman Caesars. Charles was, at that moment, forcing through the Augsburg Interim, a decree ordering all Protestants to readopt traditional beliefs and practices, while allowing their clergy to marry and the laity to receive communion, and wanted to appear magnanimous.

But it is probable that the Emperor cut a far less heroic figure in real life than he does here; that, because of the agonies of gout, he wore bands of gauze around his feet rather than conventional stirrups. It's even possible that he didn't ride at all, but was carried on to the field of battle in a litter.

Before he left Augsburg, Titian painted one more portrait of the Emperor: Charles seen seated by a window, dressed in black. Around his neck he wears the insignia of the Order of the Golden Fleece. Yet while there is something throne-like about the velvet-covered chair, an impression compounded by the classical pediment framing the landscape beyond, the golden damask wall covering and red of the carpet beneath his feet, the overall feeling is one of calculated modesty: the universal ruler as country gentleman.

While he fixes us with a look of beady determination, his skin is almost colourless, and the way his feet are splayed slightly on the red carpet gives him the look of someone who walks with a stick. At forty-eight, Charles was already old, exhausted by thirty years of perpetual movement and warfare. Looking casually at these two paintings,

Charles V at Mühlberg and *The Emperor Seated*, you'd assume they represented different phases of his life. Yet they were painted at the same time. The Zenith of the Emperor and the Twilight of the Emperor occurred almost simultaneously. And he had already decided the place of his retirement and the manner of his death.

On Titian's last visit to Augsburg, two years later, Charles described to him the image he wanted to take with him on his retirement to the remote monastery of Yuste in western Spain – that he wished to contemplate on his deathbed. It was a vision that Titian realised in the painting *Glory*. On a gently rolling landscape at the bottom of the painting, two tiny figures, probably representing pilgrims, look up in wonder at the figures of the prophets who float in the ether above them. There, almost life-size in the near foreground, is Moses, white-bearded but muscular, holding up one of the tablets of the law. Beyond him is Noah, holding aloft the ark, then David, Ezekiel and a blonde woman, seen from behind, gazing towards heaven, one arm raised, who has been variously identified as the Eurythrian Sibyl, who prophesied Christ's coming, as Mary Magdalene or the embodiment of the Catholic Church. These early upholders of the one God perceive but dimly, via the bolts of divine light piercing the clouds above them, yet all float free, suspended in a hierarchy of grace that ascends through Adam and Eve to the great figures of the New Testament. Highest of all the Virgin, shrouded in 'royal' blue, glances back as she steps forward from the crowd of prophets, upwards towards the Trinity: God and his Son seated in a blaze of incandescent grace, the dove of the Holy Spirit just visible in the golden radiance beyond them. And over on the right of the painting, on a level just below that of the Virgin and Baptist, is the kneeling figure of the Emperor, his white shroud draped around his shoulders, his hands raised in supplication, the imperial crown resting on the cloud beside him, as angels lead him and his long-dead wife Isabella, also in her shroud, towards glory.

While Charles is portrayed as an old man, Isabella appears as young and beautiful as when he first met her. Just behind them, but slightly lower, are their children, Philip – soon to become Philip II of Spain – and Joanna, together with the Emperor's sisters Leonora and Mary. And just below the Emperor's family are two ageing

bearded men. The darker of the two, with his hands parted, eyes raised towards heaven in an expression of terror and awe, may be the Spanish ecclesiastical writer Francisco de Vargas, then serving as imperial ambassador in Venice, or it may be . . . But surely not. Pietro Aretino? The old rogue who effectively blackmailed the Emperor, accepting retainers from the Empire and France simultaneously, then attempted to enlist Charles's support in his preposterous bid to become cardinal, has managed to slip into the Emperor's personal apotheosis. And as for the other, with the thinning, white hair and long, hawk-like nose, face slightly averted as he gazes towards heaven, who else could it be but Titian himself? Presumptuous? Hardly. By this time Titian was almost family.

12

Nothing is Fixed, Nothing Entirely Static

H ERE'S TITIAN HARD at work at his studio in Biri Grande, the voices of the pigment grinders drifting through from the next room, the edge of the air muted by the glutinous vegetable smell of the linseed oil with which the master dilutes his pigments. From further out towards the entrance to the studio comes the fresher, more acid tang of turpentine and sawn wood, and the gutty, animal reek of size, the rabbit-skin glue used to prime the canvases. Titian, though, is oblivious to all that, ensconced in the painting room – the room furthest from the entrance, where he can, if he chooses, work alone – his mind utterly absorbed in what's in front of him. The canvas is a fair size, over six feet by nearly seven, the entire surface blocked in in areas of thinly applied, almost wash-like pigment, masses of furious, flaring darker marks indicating the presence of vegetation and architecture, but all still half-formed. To the left is the suggestion of a male figure, just a few dark, assertive strokes, and, before him, a rolling mass of female flesh, the nymphs surrounding the pool of Diana, a flow of swelling forms – breasts, calves, shoulders and haunches – in places barely formed, in others already partly matted in with white body colour, the beginnings of highlights on the tremulous flesh. Women – young women – perhaps six or seven, it's difficult to tell, bending, turning, crouching, everything still in a state of flux, the outlines of the figure he's working

on blotting out the edges of two or three that were beginning to cohere beneath.

Up on the dais in front of him is just one woman, seated on the edge of the board plinth, feet tucked up against it so she's almost on tiptoe, leaning slightly to one side, as though pulling away from something or someone, her right arm shielding her breasts, a white cloth pulled up between her thighs, looking across in the opposite direction. She looks utterly miserable.

A buxom, pert little person, she had plenty to say when she arrived, plenty of banter to offer the pigment grinders, until she realised she'd be stuck in here for days on end with the sixty-seven-year-old artist scrutinising every inch of her, while appearing – once he'd become absorbed in the rhythm of his work – utterly oblivious to her. She shifts her right buttock, her tiptoed feet losing their position. 'Don't move,' says Titian, not angry, but in the same firm but slightly distant tone he always uses when he's working.

'My legs have gone numb,' she blurts out.

'Not long now,' he says. And she knows he hasn't heard her. Once he's become fully absorbed, nothing exists for him but what is taking place on the canvas in front of him.

'Not long now,' comes the bland murmur again, barely louder than the dull throb of the great canvas yielding to the painter's brush, the creaking of the stretcher, the occasional faint scraping as the bristles describe some particularly vehement curve or angle. Occasionally she'll glance up and catch his eye seeing as much of her as she's let any man see, but not seeing *her* at all – seeing only what he is making of her.

Trying to describe the particular intensity and concentration of lovers after a period apart, the philosopher Antonio Persio found himself making a comparison with Titian's way of working. 'I do not know a better way to describe this than by the example of the great Titian, the father of colour. As I have heard from his own lips and from those who were present when he was working, when he wanted to draw or paint some figure, and had before him a real man or woman, that person would so affect his sense of sight and his spirit would enter into what he was representing in such a way that he seemed to be conscious of nothing else, and it appeared to those that saw him that he had gone into a trance.'

When Titian painted his first sequence of mythological paintings for Alfonso d'Este in the 1520s, he was still following the time-honoured practices learned in the workshop of Giovanni Bellini, only slightly modified by the ideas of Giorgione. The Ferraran ambassador had described seeing the principal figures of the *Bacchus and Ariadne* completed upon the canvas, while the landscape areas around them remained entirely blank. The idea was to evolve perfect forms and perfect areas of painting, gradually slotting them around each other until the entire canvas was filled – a way of working that would have been familiar even to Michelangelo. Much of the background would be the work of other artists – particularly landscapes, in which northern European artists were considered particularly expert.

But by the time he came to work on his second great mythological series, Titian was working on all parts of the painting simultaneously. Rather than looking at figures and objects as separate, isolated phenomena, he was looking at the totality of the action, keeping all parts of the canvas in a state of permanent flux, in which every element existed in relation to everything else.

'He laid in his pictures with a mass of colour,' his sometime assistant Palma Giovane told the writer Boschini,

> which served as a groundwork for what he wanted to express. I myself have seen such vigorous underpainting in plain red earth for the half tones or in white lead. With the same brush dipped in red, black or yellow he worked up the high parts and in four strokes he could create a remarkably fine figure. Then he turned the picture to the wall and left it for months without looking at it, until he returned to it and stared critically at it, as if it were a mortal enemy. If he found something that displeased him he went to work on it like a surgeon, reducing if necessary some swelling or excess of flesh, straightening an arm if the bone was not absolutely right – and if a foot had been initially misplaced, he corrected it, without thinking of the pain it might cost him.
>
> Thus by repeated revisions, he brought his pictures to a high state of perfection and while one was drying he worked on another. This quintessence of a composition he then covered in many layers of living flesh.

The final touches he softened, occasionally modulating the highest lights into the half tones and local colours with his fingers; sometimes he used his fingers to dab a dark patch in a corner as an accent, or to heighten a surface with a bit of red like a drop of blood. He finished his figures like this and in the last stages he used his fingers more than his brush.

Titian had developed this cyclical way of working as a means of ensuring there was a sufficient stream of work – making enough effort to secure the commission and advance before moving on to other commissions to secure further advances. While this way of working was to some extent true of all painters of the time, by this stage in Titian's career it had become pathological. This was now the way he thought of painting: as a series of relatively short, concentrated bursts of effort, in which the entire surface of the painting was open to change and revision, before it was turned back to the wall, the paint allowed to dry completely – the experience obliterated from his mind by time and other work – before he returned to it afresh.

And as time went on, the number of times he returned to a painting became greater, the gaps between them longer and the process of deciding whether it was finished or not more protracted. So the number of paintings stacked in the storerooms of the studio waiting the master's attention grew slowly but steadily larger.

It is certainly true [wrote Vasari] that the method used by Titian for painting these last pictures is very different from the way he worked in his youth. For the early works are executed with incredible delicacy and diligence, and they may be viewed either at a distance or close at hand. But these last works are executed with bold sweeping strokes, and in patches of colour, with the result that they cannot be viewed from nearby, but appear perfect at a distance.

This method of painting is the reason for the clumsy pictures painted by the many artists who have tried to imitate Titian and show themselves practised masters; for although Titian's works seem to many to be created without much effort, this is far from the truth and those who think so are deceiving themselves. In

fact it is clear that Titian has reworked his paintings, going over them with his colours several times, so that he must obviously have taken great pains. The method he used is judicious, beautiful and astonishing, for it makes pictures appear alive and painted with great art, but it conceals the labour that has gone into them.

Yet there were times when Titian sent his model home without doing any work at all, or kept her hanging around the studio half the day in a gown while he attended to business in the outer office of the studio or talked to clients or friends who passed by the premises. For as he told an acquaintance, the doctor Niccolò Massa, there were days when he just couldn't be bothered to work.

We tend to think of artists' studios in terms of bohemian mess – the paint-stained rags and screwed-up bits of paper littering the floor, the mangled books for reference, the minding where you sit because of the sense of paint everywhere, the draughts gusting through badly fitting windows barely mitigated by ill-functioning two-bar fires. Titian's studio wasn't like that. It was a workshop where a demanding, complex technical process involving a number of highly skilled people was being undertaken; a place, according to Vasari, 'visited by all the princes, men of letters and distinguished people staying or living in Venice at that time'. There was someone continually on hand to ensure that the floor was swept, the brushes cleaned and sorted ready for use, the pigments and thinning agents meticulously ordered, the glues, oils, sacks of plaster, the wood for stretcher-making, all carefully arranged, stacked and sorted.

In the typical studio of the time, paintings by other artists hinted at the artist's influences and the tradition from which he sprang, while casts of antique sculpture – or even the real thing – were drawn from by pupils and provided a sense of continuity with the greatness of the past. Completed works awaiting dispatch were kept on prominent display, versions of particularly popular works – *The Penitent Magdalene* and *Venus with a Mirror* – kept framed up ready to be taken away there and then if circumstances permitted.

The person in this world of meticulous labour who had the freedom to take liberties, to improvise, to recklessly dispense with

the time-honoured procedures, was the master himself. 'Never clean your brush!' he is alleged to have said. And didn't Palma Giovane tell Boschini that Titian dipped the same brush in red, black or yellow – so that, while one colour would predominate in each area, traces of the other colours in the painting would bleed through it more or less at random? A visitor described Titian painting with a brush the size of a broom, though whether to establish the initial composition with greater boldness and immediacy, or simply to fill areas of colour more easily, isn't made clear.

But Titian, according to Palma, never painted a figure *alla prima* – straight on to the canvas in one go. 'He used to say that he who improvises can never create a perfect line of poetry.'

When Titian moved to Biri Grande he is understood to have worked in a large, high-ceilinged room on the top floor at the seaward end of the house, tall windows letting in the cool, even northern light preferred by artists. But over the following decade, he had a shed – a *tezza* – in the garden extended and raised in height to form a new studio. How this building, said to have been part brick part wood, was lit is not known. The stonemason's workshop adjacent to Titian's house, which some people believe to have been this studio, is lit today with modern skylights. The relatively shallow walls do not allow for large windows, and it is impossible to imagine Titian working without copious amounts of natural light.

In the few contemporary pictures of him working, Titian is seen not in a paint-stained overall, but in the fur-lined coat which, along with the black skullcap, had become one of his identifying attributes. But few, if any, of these artists had seen him working. Titian, when engaged, needed to be able to work rapidly and vigorously, often with very liquid paint. He couldn't allow his movements to be impeded by having to avoid marking expensive clothes. While he wouldn't necessarily want to be seen in demeaning artisan garb by the many rich and powerful people who came to the studio, there would have been the understanding that the Divine Titian needed to wear what the Divine Titian needed to wear.

Far from hiding himself crabbily away, Titian made a point of making himself available, certainly to the more prominent visitors. Meeting Venice's greatest artist was an essential part of the

experience of visiting his studio, and the almost inevitable sale that would result.

For those permitted entrance to Titian's house there was a sense of flow and continuity between the two spaces. The artist's presence was everywhere in his living environment, in the form of the paintings of which, according to the Florentine grammarian Priscianese, 'the house was full'. Vasari described a number of paintings seen there, including life-size figures of Christ appearing to Mary Magdalene in the appearance of a gardener and St Paul reading, of which, tantalisingly, there is no further record. Arriving in Titian's world, you were surrounded, enveloped, seduced by his vision, and would want, if you conceivably could, to take at least a small part of it away with you.

And always there was the sense of the paintings you weren't being permitted to see – particularly the paintings of Titian's earlier career – which he kept under lock and key, and which, as he grew older, he allowed fewer and fewer people to see.

Artists of the calibre of El Greco, who referred to himself throughout his life as a 'disciple of Titian', and Tintoretto are understood to have worked in Titian's studio. But if they did, they didn't make the slightest impact upon it, and its impact on them was indirect since Titian, as Vasari tactfully put it, was 'never much inclined to teach'.

'Although many people have come to study with Titian, the number who can truly call themselves his pupils is not large; for he has not taught much, and each has learned less or more depending on what he has been able to acquire from Titian's work.'

Rather than provide a nurturing environment for the most talented painters of the day, as his own teacher Giovanni Bellini had done, Titian preferred to surround himself with mediocre artists whom he knew and trusted, preferably with strong familial links, whose obligations were entirely to him, who were capable of doing everything required of them in preparing his paintings and making replicas and copies, but little more than that. And if they were relatives or foreigners with few links to the Venetian art world, so much the better.

The core members of his workshop, alongside his cousins Marco and Cesare Vecellio, were Girolamo Dente, who had joined Titian

as a child, and witnessed Titian's marriage to Cecilia when he was fifteen, and who, when he set up on his own account in the late 1560s, called himself 'Girolamo di Tiziano'; Emmanuel Amberger, son of Titian's friend the Augsburg painter Christoph Amberger, who – according to the art dealer Niccolò Stoppio – was executing the majority of Titian's paintings by the late 1560s. Northern Europeans, such as Kristoph Schwartz, another German, and Lambert Sustris, a Fleming, were considered particularly proficient in landscape. Any work involving mosaic was undertaken by Valerio and Stefano Zuccato – sons of Sebastiano Zuccato, the first artist Titian had encountered on his arrival in Venice in 1498 – who remained close friends, Titian standing by them to the extent of perjuring himself on their behalf during a dispute over mosaics in St Mark's basilica.

But the first person you met on arriving at the studio, the overseer of the enterprise, who balanced the books, ordered the materials and travelled as far afield as Milan and Genoa to collect the master's pensions, was Titian's son Orazio. We see him in Titian's painting *Allegory of Prudence*, perhaps in his thirties, black-bearded, full-faced, with a long, straight nose – looking in all probability much as Titian himself did at that age – a vigorous, handsome man in the prime of life, though his pale eyes look out of the painting, beyond the viewer, with an expression of intense preoccupation. It's an image that invests Orazio with a depth that goes way beyond what can be deduced about him from the documents.

While Orazio is said to have achieved something of a reputation as a portraitist, the few surviving fragments attributed to him – an altarpiece and a tiny crucifixion (a copy of one of his father's paintings) in the Escorial – are extremely pedestrian. Various documents describe him not as a painter but as 'timber merchant at the Zattere'. Orazio, you feel, was interested in every aspect of the family business except the painting.

'When it comes to money,' wrote the ambassador of the Duke of Urbino, 'there is no more obstinate man in Venice than Tiziano Vecellio. And his son, certainly in terms of avarice, is in no way inferior to his father.'

After the death of Titian's brother Francesco, Orazio took over the management of the family's business interests in Cadore, buying

back various properties his uncle had sold. Orazio was forever on the lookout for properties that might be snapped up – fields, farm buildings, houses and shops – always in Cadore or the Serravalle area, never in Venice itself. He invested in a friend's wine business, and applied for a patent for a new kind of flourmill he had developed. Once, when he was in Milan collecting his father's pension, Orazio was the subject of a murder attempt by the sculptor Leone Leoni. While the reason for this was said to be the thousands of ducats Orazio was carrying on him, there was probably something more personal behind it, possibly a woman.

In 1567, Stoppio witnessed a blazing row between Orazio and one Carlo della Serpa over responsibility for potential damages to a valuable artefact that was being dispatched to Bavaria.

The increased traffic in art and antiques between Venice and northern Europe had prompted the emergence of a new commercial class in the city – the art dealers. While Titian and Orazio involved themselves in this trade when the opportunity arose, acting as valuers and intermediary brokers, and providing bridging loans, the kingpin of the trans-Alpine art trade was Jacopo Strada, known as the Caesarian Antiquary because of his dealings with the Habsburg family.

Titian immortalised Strada's foxily complacent features in one of the best of his late portraits, though, according to his fellow art dealer and rival Niccolò Stoppio, Titian considered Strada 'one of the most pompous idiots you will ever find'.

'Strada,' Titian allegedly told one of Stoppio's friends, 'doesn't know anything beyond the fact that one needs to be lucky and to understand how to get on with people, as he has done in Germany, where he shoots them every line you can imagine, and they, being open by nature, don't see the duplicity of this fine fellow.'

Yet Titian was happy for Strada to vouch for the quality of a studio set of his mythological paintings, the *poesie* – to be sold to the Emperor Maximilian – though they were nowhere near the standard of the originals.

'Titian and Strada,' observed Stoppio, 'are like two gluttons at the same dish. Strada is having him paint his portrait, but Titian will take another year over it, and if in the meantime, Strada does not do

as he wants, it will never be finished. Titian has already demanded a sable lining for a cloak, either as a gift or for cash, and in order to get it he wants to send something to the Emperor. Strada encourages his hopes so that he can get his portrait out of him; but he is wasting his time.'

In the *Allegory of Prudence*, we see Titian in profile, behind Orazio, gaunt and saturnine, scowling into the shadows on the left of the painting, while, on the right, Janus-like with Titian, is a fresh-faced youth. This half-antique, half-heraldic conjunction of heads is echoed below by the heads of three animals: the blunt, snout-like muzzle of a wolf beneath the old man, a rather sad-looking lion below the middle-aged man and, below the youth, an eager, panting dog.

When this painting was first written about in the eighteenth century, it was interpreted as a political allegory concerning Titian's first great patron, Alfonso d'Este, poised between the Papacy and the Empire. But in the twentieth century, more attention was paid to the inscription just visible in the darkness at the top of the painting: 'Ex Praeterito – Praesens Prudenter Agit – Ni Futurum Actione Deturpet': Learning from Yesterday, Today exercises Prudence, lest by his Actions he spoil Tomorrow.

Prudence! What a wonderful word: 'Caution, discretion, wisdom applied to practice, attention to self-interest, behaviour dictated by forethought.' You could hardly find a better summary of the way Titian conducted his enterprise. This virtue was represented in classical iconography by three heads, symbolising the ability to look in several directions at once: the head of the wolf – who consumes the past – the lion – always ready for action – and the dog – forever full of hope.

This, then, is the allegory of the *bottega* – of that quintessentially Venetian phenomenon the family workshop – of the Vecellio family business. To the left, the founder of the workshop, architect of the family's place in the world, glowering into the past. In the centre, pondering the problems of the present, is Orazio, his heir, assistant and business manager. And to the right, representing future prosperity, not Titian's grandson, Orazio's son, as would complete the logic of the allegory, but a relatively distant relative – either Titian's second cousin, Marco, or a third cousin, Cesare Vecellio, both of whom worked extensively as his assistants.

While Titian retained a philosophical and sentimental attachment to the idea of the family studio, his attitude towards it remained ambivalent in practice. He went to considerable lengths to ensure the business would continue after his death, yet the fact that Orazio was not a talented painter, and did not have children, suited him on some unconscious level. If Titian wasn't interested in creating another like himself from among the young artists of Venice, nor did he wish to see such a figure emerging from within his own family.

Titian's sense of his own uniqueness – the feeling he had had since childhood, that he could do things that were beyond the reach of other men – was essential to who he was. If Titian had had a whole troupe of sons who had gone on filling the churches and institutions of Venice with Titianesque paintings after he died – as Tintoretto did – we'd have a very different sense of him as an artist. While the fact that Orazio and his wife could not have children is just a simple sad fact, meaningless in itself, we can't help feeling, irrational as it may sound, that if Titian didn't have heirs, it was because at some deep, unknowable level he didn't want them.

Looking again at the *Allegory of Prudence*, the triple-headed embodiment of Titian's world view, we notice one crucial figure missing from this idealised but imperfect allegory of family, the person who should, according to every social norm of the time, have taken the central position in the painting – Titian's eldest son, Pomponio. Pomponio, the priest – the pseudo-priest – who entered holy orders in childhood, but scarcely, if ever, fulfilled any of the practical functions of a priest.

It was extremely unusual for a first son to go into the Church. In the artisan system in which Titian worked, the eldest son automatically became his father's assistant and inherited the business. A clergyman, even if he had children, could not pass on property. Pomponio, destined for the priesthood, at least from early childhood, had been disinherited it seemed – excluded from the family enterprise – before he was even born.

'I swear that I would rather be a whole Aretino than half a Cicero,' Pomponio wrote to his cousin Toma Tito Vecellio in 1544. Having been asked his opinion, Pomponio makes no claims to expertise. 'I have little expertise in one profession and much less in the other. And

take care that you do not deceive yourself, and suppose that I am saying exactly the opposite – characterising myself as a beast, because I speak the gospel truth. And my reply will give you clear evidence of this, since it will give you plenty to laugh about!'

At twenty, Pomponio sees the truth as his prerogative. He is a man not to be deceived by others – or by himself – into saying anything other than what he absolutely means. If he tells Toma Tito that he doesn't know what he is talking about, that is the absolute truth and shouldn't be taken for false modesty. Pomponio is one whose thoughts and words and deeds are above the expediencies that govern the average man, who, if he is to give an opinion, will give it straight out, 'like a whore', so that his words will not be thought 'as those of merchants who go mad in the piazzas in praise of their merchandise'; who would rather emulate Aretino, the blaspheming scourge of princes – who just happened to be his own godfather – than Cicero, the great stylist of classical rhetoric.

Pomponio protests his lack of learning, while throwing in long Latin quotations. He takes sideswipes at pedants, while making ostentatious reference to other writers, from classical poets to Erasmus. He yearns for clarity, yet seems incapable of writing a clear sentence. If it is difficult to make sense of Pomponio's words without seeing the letter from Toma Tito that prompted them, the sense emerges of a man who feels an obligation to speak, whose literary vocation is self-evident – even if he doesn't yet know what form his literary output will take.

Pomponio had grown up with the likes of Aretino, Sansovino and the cream of Venetian high society rumpling his hair as they passed through the parental house. For him the proximity of immense wealth, celebrity and talent was part of the natural order of things. A student at the University of Padua, a priest in possession of two ecclesiastical benefices who had yet to preach a sermon, Pomponio felt he had all the time in the world to decide what to do with his life.

While Orazio had been helping his father from a very early age, Pomponio had known from the beginning that that world of methodical, semi-manual labour wasn't for him. Pomponio had always been a priest. 'Monsignorino – little priest!' as Aretino teasingly addressed him, had worn the tonsure – figuratively, if not

literally – since he was a toddler. And if, as his father observed, he 'didn't seem much inclined to be a churchman', there was nothing unusual in that. Three per cent of the population of Europe were in the Church in one capacity or another, and among educated adult males the proportion must have been far higher. Few of these people can have had a real vocation. And apart from the fact that they couldn't marry or bequeath property, being 'in the Church' placed few restrictions on their way of living.

Take the example of one of Titian's great proponents, Pietro Bembo. One of the iconic literary celebrities of the age, Bembo was secretary to Pope Leo X, official historian to the Republic of Venice, art adviser to some of Titian's most important patrons and amassed one of the great collections of the time on his own account. Twice painted by Titian, Bembo had an affair with Lucrezia Borgia, saw his poetry set to music by Isabella d'Este and wrote *Gli Asolani*, his hugely influential defence of Platonic love, while cohabiting in Padua with his mistress, the beautiful Morosina – and all while a priest in minor orders. He was eventually made cardinal by Pope Paul III. Perhaps Bembo was the kind of churchman Titian hoped Pomponio would become. But if Bembo was able to use his position in the Church to launch himself on a glittering literary career, he had real learning, talent and discipline. Pomponio, as far as we can tell, had none of these things.

In September 1550, when Pomponio was about twenty-six, Aretino wrote a joint letter to Titian and their close mutual friend Sansovino, who was then locked in a bitter struggle with his own son Francesco, who – at about the same age as Pomponio – was determined to become a writer against his father's insistence that he should take up law. Aretino agreed that Pomponio and Francesco had behaved 'in such a way that you ought to deny them not merely luxuries, but bread, and that forthwith'. And yet the great libertine proposed that his two friends should be magnanimous. 'If we old ones were willing to remember what we did at the same age, we would forgive young people their faults and laugh.' His two friends should, he suggested, become younger in spirit. 'Spend freely! Dress yourselves lovingly in perfumed clothes!'

At the same time Aretino wrote a reproving letter to Pomponio. 'You may laugh at moral lectures when they come from a man like

me. But yesterday evening your father came to me in such distress of mind that it made me weep to see him.

'It is not right that the money amassed by the paint brushes, the skill, the labour and the long journeys of that truly great man should be thrown away in riotous living. Go back to your books and give up your licentious habits. As your godfather, I pray fervently that you will go back to the way of living that I long for and desire to see in you.'

But what had Pomponio actually been doing? Running up huge bills in the taverns and the houses of the great courtesans? Entertaining better-born friends in the hope of winning their friendship? Paying off their bills at his father's expense?

Young men, and particularly unmarried young men, were considered inherently unruly, unstable, irresponsible, prone to violence and excessive lust, until socialised by the process of marriage and the accrual of adult responsibility.

Venice was full of young men who, because, of the practice of primogeniture – prompted by the need to keep the family fortune and property intact – would never marry, but lived in apartments in their family palaces and kept the great army of the city's courtesans and higher-class prostitutes in business. Was this the milieu in which Pomponio moved, or aspired to move? In a letter of 1544 to his cousin Toma Tito, he described the companions who were to him 'more than brothers'. Were these companions – and his description reeks faintly of over-enthusiasm – drawn from this sub-stratum of the Venetian aristocracy?

At twenty-six, Pomponio had reached the age when the young aristocrat put on the black 'toga' that signified adult responsibility and assumed the right to sit in the Hall of the Great Council. But Pomponio wasn't an aristocrat. He may have been the son of one of Venice's greatest celebrities, but there were whole social worlds – particularly those centred on the Compagnie della Calza – that were closed to him. Was he, in fact, still a student in Padua? Were he and Francesco Sansovino particular friends and carousing partners? They were of similar age, the same class and similar literary ambitions. Yet while Francesco, who was about two years older than Pomponio, had considerable success as a writer – his *Venice Described* is one of our

principal sources on life in sixteenth-century Venice – Pomponio, as far as we know, never managed to finish a single piece of writing.

Yet for all the anger simmering beneath those early letters – particularly on Titian's part – there was still a sense of warmth and concern between father and son. It was only some years later that real bitterness entered into the relationship, when Pomponio began to resent how much of the income from his ecclesiastical benefices his father was bent on keeping.

Ah, yes. All those endless importuning letters to the cardinals and the great overlords. The journeys to Bologna and Rome. The paintings done for the secretaries and ministers who might be able to oil the wheels of the machinery of state. You didn't think Titian was going to all that effort purely for Pomponio's benefit, did you? While the three benefices were in Pomponio's name, Titian assumed the right to manage them.

Since the first of them, the benefice of Medole, had been granted by Federico Gonzaga, Duke of Mantua, when Pomponio was only six years old, a curate had to be paid out of the income from the living to fulfil its various spiritual functions. Titian discovered in addition – and to his great annoyance – that the benefice carried the burden of an annuity payable to a previous incumbent, who bombarded Titian with demands for money. Although Titian wrote to Federico several times, complaining that the pensioner's endless letters were stopping him from working, the duke did nothing.

Even when Pomponio reached adulthood – he took minor orders in 1544, at the age of twenty – Titian didn't regard him as capable of organising his own affairs.

In 1549, he wrote to Nicolas Perronet de Granvelle, chancellor to Charles V, asking for a *placet* – signed by the Emperor, allowing the Milan benefice to be transferred to another incumbent, since Pomponio was unable to fulfil the obligation of living in the city – though he did enjoy some income from the living for at least another twenty years. In 1554, Titian asked the Duke of Mantua to allow him to transfer the benefice of Medole to his nephew Francesco Vecellio in place of Pomponio. Whether this was in response to some 'further outrage' of Pomponio's, or whether Titian had some more practical reason for wishing to install his nephew in the post, is impossible to know. In

the same year, Titian came into possession of a third benefice, Sant'
Andrea del Fabbro, though Pomponio was not immediately installed
as rector. The enraged son wrote to Aretino, complaining bitterly at
his father's cupidity and bad faith; though in the twenty-four years
in which income had been drawn on ecclesiastical livings held in his
name, Pomponio hadn't performed one of the 'spiritual services' for
which these livings were supposedly endowed.

Aretino seems to have remained on good terms with Pomponio.
Only once did he let the mask of genial reverence towards his friend
the Divine Titian slip in writing – over the degree of finish in the
portrait he commissioned from Titian in 1545. Having noted the
apparent carelessness with which his friend had completed – or not
completed – the sleeves and one of the hands, he was filled with
intense hurt and anger: 'The considerable sum of money that Titian
receives and his even greater greed for more are why he gives no heed
to the obligations he should have for a friend nor to the duty proper
to his family, but eagerly awaits with a strange intensity only that
which promises great things.

'Truly this painting breathes, its pulses beat, and it is animated
with the same spirit that informs me in life. And if only I should have
counted out more scudi for him, the clothes would have been actually
shining and soft and firm as are actual satin, velvet and brocade.'

The sketchiness with which the clothes are rendered in that painting
is now regarded as a fine example of Titian's later impressionistic
brushwork. But for Aretino, this rapid, provisional quality simply
indicated a lack of care. I imagined that Aretino might have received
his first portrait by Titian at a nominal price – possibly even for
nothing. But even after nearly twenty years – twenty years of tireless
promotion of Titian by Aretino – Titian wasn't, as Aretino observed
with some bitterness, giving anything for free.

In 1537, a painting of the *Annunciation* that Titian had begun for a
convent on Murano was rejected as inordinately expensive – at 500
ducats – and a more reasonably priced painting by Giovanni Antonio
de Sacchis, called Pordenone, taken instead. Hailing from Friuli, not
far from Titian's own home region, and about five years older than
Titian, Pordenone had made a good living for himself around the

courts and cities of northern Italy. He had been in Venice in 1532. Now he was back, and he was quickly taken up by those elements in the upper echelons of the Venetian government who felt that Titian had grown too grand, too arrogant and too expensive for his own good. Titian's proponents and protectors in the administration – notably Doge Andrea Gritti – seemed to have grown weary of defending him, and in June 1537 the Senate voted that, since Titian still hadn't completed the battle scene for the Hall of the Great Council that he had offered to provide in 1513 – some twenty-four years earlier – his *sanseria* from the Venetian government would be withdrawn and he would be obliged to repay all sums so far remitted. Pordenone, who had already been commissioned to paint the ceiling in the Doge's Palace library, the Sala d'Oro, was asked to provide a painting to hang between pilasters six and seven of the Hall of the Great Council – directly next to the space allocated for Titian's painting.

Titian immediately began work on *The Battle of Spoleto*, incorporating into the large canvas many of the stylistic tricks for which Pordenone was best known: the exaggerating foreshortening, which made it look as though people and objects were projecting out of the painting – so that the tumultuous movement of men and horses – seen through driving rain – would appear to be spilling from the canvas. Anything Pordenone could do, the painting proclaimed, he, Titian, could do far better. Even before it was finished, the painting was being extolled by Aretino as Titian's greatest achievement to date. By the following year Titian's *sanseria* had been reinstated, while Pordenone died suddenly in December 1538.

Ten years later, one of the great masterpieces of the Venetian tradition was unveiled in the Scuola Grande di San Marco – *The Freeing of the Slave* by Jacopo Robusti Comin. Called Tintoretto, the Little Dyer, after his father's profession, Robusti was short, energetic, secretive and more than a little gauche. Now approaching thirty, he saw himself as the natural culmination of the most powerful tendencies in Western art, the sign over his workshop door promising 'Il disegno di Michelangelo ed il colorito di Tiziano' – The Drawing of Michelangelo and the Colour of Titian. With its vast scale, plunging, dizzying perspectives and exhilarating multiplicity of incident – with St Mark swooping down into the top of the painting to shatter the

hammer with which the slave's legs were to be broken – Tintoretto's painting must have made the works of Titian look rather staid and conservative. Tintoretto, who had idolised Titian since childhood, claimed to have been apprenticed in Titian's studio, and that the master, jealous of the brilliance of his drawing, had him kicked out into the street after only ten days; this, of course, is just the sort of story an empire-building Young Turk would put about concerning the artist it was his destiny to supplant, but Tintoretto never did supplant Titian.

While he had made great efforts to see off the challenge of Pordenone, Titian – who was now extremely preoccupied with his work for the Farnese and the Habsburgs – seems to have taken Tintoretto's sudden rise to fame very much in his stride. What did he care that Tintoretto was working for the Scuola Grande di San Marco when he was working for the greatest men in Europe? Titian's position was now unassailable.

By now, Titian was withdrawing from the Venetian scene, allowing the important commissions for the churches, convents, religious brotherhoods and aristocratic houses to pass to his younger rivals, Tintoretto, Veronese, Bassano and Schiavone.

Yet even as Titian ceased to be a significant figure in the artistic life of Venice, his fame and iconic status were growing. Demand for his paintings – particularly for subjects associated with his greatest patrons – was more intense than ever. And since it was accepted by most of the bankers, officials and minor aristocrats who came to his studio that they would not get anything that was entirely by the hand of the master, his studio became busy producing replicas and variants on particularly popular subjects. Relatively small and affordable works of a tastefully erotic nature provided the staple of this production. *Venus with a Mirror* proved a particular favourite, the seated blonde goddess discreetly covering her breasts with her arm as she admires her reflection in a looking glass held by Cupid. Or *The Penitent Magdalene*, an image that cleverly conflated the pious and the erotic, the first version of which ended up in the dressing room of Guidobaldo of Urbino: the saint, fasting in the desert, clad in nothing but her luxuriant blonde hair, her bloated breasts and erect nipples protruding between her swirling golden tresses as she

gazes heavenward with an expression of rapturous expectation. In later versions, she is clothed, but still voluptuously dishevelled and weeping with grateful ecstasy – a spiritual image seen through the conventions of that quintessentially Venetian genre, the anonymous erotic portrait. When Titian was asked how a fasting hermit could be in a state of such glowing good health, he replied with a twinkle that perhaps this was the first day of her fast.

To acquire a painting that even purported to be substantially by Titian's own hand was now beyond the reach of all but the richest and most influential buyers. In 1555, Gonzalo Pérez, secretary and chief minister to Philip II of Spain – a man well positioned to facilitate the payment of Titian's pension from the Spanish treasury – obtained a magnificent *Adam and Eve*, though even he had to pay the colossal sum of 400 ducats.

Yet Titian was concerned that these studio variants shouldn't appear simply churned out – that they shouldn't damage the prestige of his studio and name. Designs were subtly varied so that few of these paintings were outright copies. He was determined that the value and the mythic cachet of his own contribution – the almost superhuman fluency and sensitivity on which the entire Titian phenomenon was based – should be preserved. That it should be clearly understood which paintings had had an extensive involvement from him. From at least the late 1550s, studio works were signed 'Titianus Fecit', while the cream of his output, into which he put everything of which he was now capable, he signed 'Titianus Aequaes Caesarius', and most, if not all, such paintings were destined for the last and greatest of Titian's patrons, Philip II.

Titian first met Philip in Milan, on the then crown prince's first state visit to Italy in 1548. There he stands in the magnificent torso-length, gold-chased parade armour made for him by Colman Helmschmid of Augsburg, the greatest armourer in Europe, one hand resting on the plumed helmet on the table beside him, the other on his sword – in a pose that was to become one of the standard models for the European state portrait for centuries to come; one of the great bogeymen of British history, who married Mary Tudor and raised the Armada against England, yet who is still revered in Spain as the

man who reigned over the country at the zenith of its influence and power. He looks back at us from beneath his heavy eyelids: pretty in a sulky, edgy, petulant kind of way, his skin very pale, a faint sneer on that unmistakable Habsburg mouth – a young man waiting to show the world what he is capable of. While Titian rendered the armour in far greater detail than was typical of his work at this time, Philip was disconcerted by the shimmering highlight falling over the centre of the breastplate. 'You can see the haste with which he painted it,' he grumbled to his aunt Mary of Hungary. 'Had there been time I would have made him work on it again.'

Still, Philip was sufficiently impressed to summon Titian to Augsburg late in the following year. And after Titian left, Philip commissioned from him ten large paintings and a number of smaller works to be completed over the following ten years. Other than the fact that some paintings were to be religious and others mythological, no subjects were specified. Titian, it seemed, was entirely free to follow his own interests and impulses.

Titian, in return, was to receive a pension from the Spanish treasury of 200 scudi (equivalent to 200 ducats) per annum, while his pension from Philip's father, Charles V, had been doubled to 200 scudi per annum.

It is often claimed that while Charles V had no real interest in art as such, Philip had a genuine feeling for painting, and that, whatever his initial misgivings, he developed a real passion and sympathy for Titian's way of working. But isn't it more likely that, certainly at first, Philip was seduced not so much by Titian's art, or even by Titian the man – though that may have had something to do with it – as by the idea of Titian, by the idea of retaining the services of an artist who had done so much for his father's image, by the prospect of having one of the greatest artists in the world, if not the greatest – and a man forty years his senior – on his personal payroll?

As for Titian, at his current rate of production those ten paintings would occupy most of his time for at least the decade allocated. And if he was to work almost exclusively for one patron, who better than the most powerful man in Europe, who showed every sign of respecting him as a human being, as well as an artist, and who allowed him to paint exactly what he wanted?

On the news of his father's death in September 1558, Philip
withdrew to the monastery of Groenendael, near Ghent, from where
he dictated a letter to the Governor of Milan on Christmas Day of
that year ordering that the pension given to Titian by Charles V, and
payable from the Treasury of Milan — which had so far yielded the
artist only nominal sums — should be paid immediately and in full
— to an amount totalling millions in today's money. Wishing to add
greater authority to this missive, Philip added in his own hand:

'You already know the joy I shall experience in having this matter
taken care of, because it concerns Titian, and I therefore urgently
charge you with the task of having him paid immediately, in such a
way that there will be no need to turn to me again or for having me
issue this order yet again.

'I, THE KING.'

The idea of painting another mythological cycle seems to have emerged
from the *Danaë*, the spectacular reclining nude that Titian sent to
Philip immediately before his second visit to Augsburg in 1550. You'd
think that, after the success of the mythologies for Alfonso d'Este's
camerino d'alabastro, Titian would have been churning these things
out. But Titian, you feel, never embarked on any project without fully
assessing the immense amount of labour and effort needed to meet
his own exacting standards. If there was one quality that overrode his
pragmatism — his desire to see a clearly defined material result from
everything he undertook — it was his perfectionism. Since painting
the Este mythologies, Titian had painted a series of twelve portraits
of Roman emperors for Federico Gonzaga. He had created four
large canvases of the Furies — the punishments of Tityus, Sisyphus,
Tantalus and Ixion for rebelling against the gods — for Mary of
Hungary, Charles V's sister. But the only time he attempted another
cycle of paintings of the scale and complexity of the Este mythologies
was the series of paintings he created for Philip II in the 1550s, which
he called the *poesie* and which have come, over the centuries, to be
regarded as his greatest achievement.

Where the Este mythologies were light, bright and joyous,
taking place in a permanent summer of pure pigment, the *poesie*
are darker, in feeling if not always in actual tone, with the breath

of autumn blowing through them. While these paintings are rich in colour, their hues are more muted, subsumed into layers of light and shadow. And while the series begins breezily, even playfully, with a celebration of light on flesh and feminine pleasure, the mood soon darkens, concentrating on the cruel, fatalistic aspects of mythology, on the punishments meted out to those who offend the gods – even unwittingly – or fall foul of their desires. A world where the pleasures of the flesh turn to torments, where love is torture to the lover and even innocent beauty must be punished.

While the subjects for the *camerino* paintings were provided by Alfonso d'Este and his courtier advisers, now Titian was essentially on his own. He undoubtedly sought the advice of his writer friends, but the conception of the series was essentially his. The chief source of the paintings' subjects was Ovid's *Metamorphoses* – as it was with so many of his mythological paintings – as though he was always raiding the same battered paperback – if, that is, he had read it at all.

And his interpretation of these stories was very free, certainly by the standards of the time. In describing these paintings as *poesie*, he was referring not so much to Ovid's words as his own poetic invention. The mind that moved behind the image was not that of the poet whose texts provided the initial impetus, nor the patron, nor his advisers, but the artist's – and Titian's aim in these paintings was to show that the vision of the painter could be as subtle, as complex and as expressive as any poet's.

Titian seems to have conceived of the *poesie* initially as a series of contrapposti – a term coined to describe a pose in which the top half of the body faces one way and the lower another, but which came to evoke any contrast or opposition, physical or intellectual. Since *Danaë* was seen from the front, the naked Venus in *Venus and Adonis* would be seen from the back, which, as Titian explained in a letter to Philip in 1545, would make the room in which they were shown more 'agreeable'. 'Shortly I hope to send you the *poesia* of *Perseus and Andromeda*, which will have a different viewpoint from these two; and likewise *Medea and Jason*.'

But as he progressed through the series, continually changing his mind about the subjects and the way they would relate to each other, he discovered an underlying subject, a way of thinking about

these paintings that engaged him on a far deeper and more visceral level than the arid posturing of the contrapposti. And that subject was himself.

It was shortly after midday, when the sun was at its highest, 'cracking open the fields with its heat'. Actaeon, young grandson of Cadmus, the hero who founded Thebes, having enjoyed a successful morning's hunting with his friends – 'staining the earth with the blood of wild beasts of many kinds' – was wandering in the forest. All around him the air shimmered in the heat, the sound of crickets almost deafening in the parched brush. Roaming far from his usual paths, he entered a valley, 'thickly overgrown with pitch pine and sharp-needled cypress . . . a place sacred to Diana, goddess of the hunt'. Far in its depths, he came upon a cave, with a spring of cool, clear water spreading into a wide pool in which the goddess, weary from the hunt, would bathe what Ovid called 'her fastidious limbs' – attended by her nymphs.

It was into this scene that Actaeon wandered, a young man in the prime of strength and beauty, moving with hesitant steps through this unknown forest, half-reluctant, but drawn on by the Fates. Titian's *Diana and Actaeon* cuts into the action at the moment when the mortal male and the goddess catch sight of each other – and the young man sees what no man must ever see, the chaste flesh of the goddess of the hunt and the moon. The young hunter reels back in astonishment, while Diana's nymphs, seated and sprawled across the canvas in a range of postures that reveals their sumptuous white flesh in all its tremulous glory, move to cover themselves – the mood of all-female sensuality, of easy accommodation with each other's flesh broken by hostility, alarm and fear. One nymph pulls at the curtain that hangs across the middle of the scene, turning to the goddess in complaint, another shields herself with her arm, another hides behind a pillar; a black maid or slave rises to shield her mistress, while, in the goddess's eye, as she raises a cloth to cover herself, is the malignant gleam that already spells Actaeon's doom.

A stag's skull leaning against a pillar looks forward to the next stage of the story, to what every educated viewer knows will happen to the luckless Actaeon.

There have been many interpretations of the legend on which Ovid's poem was based – and of what Actaeon saw there in Diana's bathing place: that the primitive and innocent hunter discovered his own self-consciousness, that he fell in love with the patron goddess of his art and was punished for his presumption, that he looked into the face of God, for which, according to the teachings of the Bible, he must inevitably die. But Titian's painting gives us a sense of the story that is less portentous and mythic, more immediate and human, with which every man can identify.

Any man who has walked into a room full of women and felt the air prickling at his presence, the sense of easy intimacy freezing – has sensed the discomfort within his own skin at being the *other* – will have some idea of what Actaeon felt at that moment. There's a power generated by women together, women whom you may know, whom you may desire – and for all you know may desire you – but who don't want you there. Actaeon saw what every man wants to see, the easy communal nakedness that can only exist without men – and it was his fate to see it through a man's eyes. His beauty, strength and virility were the very things that would seal his fate. And there in the centre of the group was his nemesis, the ultimate personification of female indifference – who was about to destroy him.

Danaë, the painting with which Titian began the series, was a variant on the painting he had taken to Cardinal Alessandro Farnese in 1545, the daughter of Acrisius, King of Argos, sprawled out on her bed as Zeus makes love to her, impregnating her in a shower of golden coins. And if Farnese's painting had made *The Venus of Urbino* look like a nun – as Giovanni della Casa put it – then Philip's version was almost brutally frank in its portrayal of female desire, the sheet that decorously encircled her thigh in the Farnese painting ripped aside, revealing a real woman in all her lumpy plasticity, laid out naked before us, her feet rather big and unshapely, her lips parted, her eyes rolling upwards as she receives her divine lover.

The painting is packed with contrapposti, conceits designed to tease and flatter the intellect of the educated viewer: the oppositions between the youthful Danaë and the aged crone who catches the coins in her skirts, between beauty and ugliness, pale skin and dark

skin, the front view of the naked Danaë and rear view of the clothed doorkeeper. But what strikes us most about it today is the incredible looseness, even rawness, with which it's painted. Going up close you can see the first lines drawn in under the thinly applied paint. The thin lines sketching in Danaë's left breast and left arm; as though Titian just kept jabbing at it until he got it right, while the line distinguishing the stomach from the top of the right thigh is almost crude. The rumpled sheet looks as though it's been daubed in all in one go, streams of glowing lead white flowing liquid around the model's feet and haunches, with only the off-white of the primed canvas showing beneath.

The glow around the breasts and throat and rib area, the gleaming band of light down the right calf, the free-floating yellowish daub at the base of the neck are all naked patches of paint with no attempt to smooth them back into the form. But as you move away, all you're aware of is the glow of flesh, pale but palpably warm, flesh that both absorbs and emits light.

There had been blatantly erotic paintings before: Giulio Romano's trembling *Two Lovers*, where the presence of the man's erect penis is implied by the gesture of the woman's hand; Correggio's *The Loves of Jupiter*, which Titian may have seen in Milan, and which includes a version of this very subject, in which Cupid pulls the sheet from around Danaë's thighs. Yet Giulio's severe Roman style appears extraneous to the eroticism of the subject, while the powdery delicacy of Correggio's treatment feels sugary and insipid – certainly according to today's tastes. No, Titian's *Danaë* is what we expect an erotic painting to look like: the heat, the glistening, liquid flow of the treatment matching the nature of the subject.

If Philip had been disconcerted by the rapidly executed highlights on his armour, what must he have made of this? Titian must have brought it to him on the assumption that, if Cardinal Farnese was delighted with his *Danaë*, this hotter, franker second version would be just the thing for a red-blooded twenty-three-year-old.

Whatever the prince's reaction, Titian's next painting for Philip, *Venus and Adonis*, was painted in a far more 'finished' and conventional way. Yet for his contemporaries this was the most erotic image of his career so far – the naked Venus reaching out to restrain her lover

Adonis as he leaves her at dawn, striding out to hunt and to what she knows will be his death.

'There is no one, however acute of sight and judgement, who would not think it alive,' wrote the critic Lodovico Dolce on seeing the painting, the pearly, opalescent sheen of the goddess's perfectly formed back, the creamy smoothness of her splayed thighs, as she reaches out to restrain the noble Adonis. 'No one,' he averred, 'so enfeebled by the years, or of such stony character, that all the blood in their veins should not be set alight, melted and moved.'

Of all Titian's works, this was the one from which the largest number of replicas, copies and prints were made. Titian himself had told Dolce that the painting had the same effect on viewers as *The Aphrodite of Knidos*, the ancient statue which so inflamed one young man that he broke into the goddess's shrine and masturbated over the image; though that analogy was invoked so frequently during this period it had become simply the thing to say about any moderately erotic work of art.

So what was it about *Venus and Adonis* that so stirred contemporary viewers? Was it the unrestrained physical passion of the goddess? The contrast between the naked female and the clothed male? Was it the manly indifference of the male, striding out into the morning with his three enormous hunting dogs, his thinly bearded, slightly androgynous face having, as Dolce put it, 'something vaguely of a woman'? Or is it the apparent perfection of the female form revealed through a pose strongly reminiscent of a figure in the Roman relief *The Bed of Polyclitus*, that Titian would certainly have seen in Rome – the neck, shoulders and upper torso twisting round from the splayed thighs to give a perfectly complete view of the exquisitely modelled back?

Yet the very things that made this painting so popular with Titian's contemporaries – the overtly classical allusions, the quasi-sculptural perfection of the modelling, the exaggerated contrapposto – make the painting feel dull and stiff to us, the poses artificial, the faces generically 'classical', the treatment overall lacking in real animation. Even in 1877, Crowe and Cavalcaselle were wondering if there wasn't some earlier, truer, more *real* version of the painting.

Did Titian have a number of different 'styles' that he applied consciously according to what he deduced to be the tastes and interests of the client? Or does *Danaë* look later, more modern, freer, more painterly than *Venus and Adonis*, because it is actually a much later painting – because the *Danaë* now hanging in the Prado isn't the one that Titian brought to Philip in 1551?

While the paintings for the *camerino d'alabastro* were painted under continual pressure from Alfonso d'Este, with specified images and themes that would fill specific spaces in a room that was being built specially to house them, the *poesie* were created on Titian's initiative and it is much more difficult to get a sense of them as a coherent group. Titian intended that they would hang together in complementary pairs on adjacent walls of a single room. But they never were hung in this way, and, in any case, he kept changing his mind about the subjects and the sequence of the paintings. *Danaë*, which provided the initial impetus, was dropped from the series, probably because it was considerably smaller than the other paintings. *Perseus and Andromeda*, in which the heroine is restored to happiness when Perseus killed the sea monster, was to be contrasted with *Jason and Medea*, in which the enchantress is plunged into despair when the hero abandons her. While the former was dispatched to Spain in 1556, the latter was never even started.

It would be wonderful to propose the *poesie* as a single towering aesthetic statement, but *Perseus and Andromeda* doesn't really work as a composition. Perseus, who dives into the top of the painting, in a manner overtly reminiscent of one of Tintoretto's swooping angels, appears about to crash into the water several hundred metres short of his target – if, of course, this is the real, original painting and not a studio copy or variant.

It was only when Titian was actually working on a painting – when the work in progress that might have been standing stacked facing the wall for months, even years, was brought out into the full glare of his attention – that he really engaged with a painting. Titian was either fully engaged with a painting, subjecting it to the intensity of his formidable powers of concentration, or it didn't fully exist for him. And in such moments, the painting was fully alive and in a state of flux. There was no part of the painting that couldn't be changed,

no matter how drastic the requirements and no matter how late in the creation of the work.

While Ovid described the nymphs crowding around the goddess at Actaeon's approach, shielding her with their bodies, while she towers head and shoulders above them, Titian's interpretation is more inherently dramatic: Diana and Actaeon facing each other across the canvas – the nymphs dispersed between them in a catalogue of voluptuous postures – their tremulous, almost gelatinous white flesh contrasting with Actaeon's sun-bronzed sinew. And the fact that the reactions of the nymphs to Actaeon's intrusion is by no means uniformly hostile enhances the sense of sexual tension. Actaeon recoiling, one arm raised, Diana leaning back, head lowered with terrifying malevolent intent. Does he desire her? Of course he does. Setting eyes on her, he must desire her, whether he wills it or not.

Titian situates the scene not in a cave, but beneath the arches of a ruined building surrounded by trees, with a view of brilliant blue sky and what looks like the mountains of Cadore in the distance. This isn't Ovid's desiccated Mediterranean landscape, but the temperate Dolomite foothills, peopled by these voluptuous, pale-skinned Amazons. They're seated on and around an elaborately carved fountain, its great weight sagging sideways, tipping down into the pool that separates Actaeon from the women – creating a sense of disorientation appropriate to a scene in which everything is reflected light, reflections and transparency.

Looking up among the trees on the right of the painting, we see the range of blue mountains rearing higher and nearer. Rather than just being a neat way of creating distance in the centre of the painting – by inserting a view of mountains into the main arch of the ruined building – there's the sense of another great layer of space opening out behind the action, running not parallel, but at an angle to the figures.

The red curtain that hangs down over the centre of the scene, and which was apparently a late addition to the painting, creates another layer of rippling movement, its shadow breaking the flow of light over the succulent, white flesh. And beneath these shimmering surfaces, we can sense another play of forms: all the drawing and

dense underpainting, the constant changes – pentimenti – through which Titian evolved that sumptuous and apparently effortless flow of space, light and volume.

In *Diana and Actaeon*, it's as though we can actually see the trembling afternoon light through which we perceive this scene, in which much, like the stream reflecting the scene and the glass jar catching the light on the edge of the fountain, seems to have been added simply because it is traditionally considered difficult to paint – because it embodies the transparency, the capturing of light, that is the ultimate province of painting, but completely alien to sculpture – contributing to the sense of the painting as a *tour de force*, Titian's personal manifesto on how far painting can go.

In the next painting in the series, *Diana and Callisto*, Titian showed the moment when the body of the nymph Callisto, impregnated by Jupiter, was revealed to the goddess. Dominating the centre of the picture, Diana sits sprawled diagonally across her throne, majestic in her virginal nakedness, as her former favourite is dragged before her, a naked nymph pulling aside her flimsy garments. While she has broken her vow of chastity only through being raped by the king of the gods, still she must be punished.

'Be gone!' cries the goddess. 'Do not defile this sacred spring!'

The glade opens out on to verdant rolling hills, the sun setting on a sweep of blue mountains, the watching nymphs reclining intertwined on the sward, their javelins and bows and arrows lying about them. Through the inverted logic of myth, the attributes of motherhood, the child-bearing hips and formidable thighs, become the uniform of a militant huntress chastity.

The nymph Callisto was turned into a bear – not by Diana, but by Juno, enraged wife of Jupiter. But before she was killed unwittingly by her hunter son Artis, both she and he were flung up into the heavens by Jupiter and turned into the constellations Ursa Major and Minor – the Great and Little Bear.

Titian never got to that part of the story, but in a letter to Philip II of 1559 telling him that *Diana and Actaeon* and *Diana and Callisto* were ready to be delivered, he announced his intention to 'furnish' two further *poesie*, 'Europa on the shoulders of the bull' and the final part of the tragedy of Actaeon. 'In these pieces I shall put all the

knowledge which God has given me, and which has always been and ever will be dedicated to the service of your Majesty.'

Unable to hide from Actaeon's gaze, and unable to lay hands on her bow and arrows, Diana threw a handful of water in his face with the words, 'Now you may tell how you saw me naked – if you can!' Immediately Actaeon's neck began to lengthen, his face to grow more pointed. Antlers sprouted from his brow, his arms lengthened, his hands turned to feet. 'Then,' as Ovid says, 'she put panic in his heart.'

Actaeon ran through the forest, astonished at his speed and agility on the uneven forest floor. Then, seeing his face and horns reflected in a pool, he tried to say, 'Alas!', but no words would come. Actaeon cried, tears running down his stag's face. 'Only his mind remained the same as before.' It was Actaeon's fate to suffer an animal's death with a man's mind.

As he stood wondering whether to run home or hide in the forest, his dogs glimpsed him through the trees – 'Melampus and the wise Ichnobates of the Cretan breed . . . Pterelas, the swift runner, keen-scented Agre . . . Nape, offspring of a wolf.' Ovid goes on naming them for a full half-page – 'the white coated . . . the black haired . . . the slender flanked' – as they give chase, 'over unapproachable cliffs, through places where the going was difficult, and where there was no prey at all' – dogs which all adored their master Actaeon, but couldn't smell him on this terrified stag. Actaeon plunged on through clefts and thickets, 'through which he had so often pursued his quarry', desperate to cry out to his hounds, but hearing nothing but their frenzied barking.

Titian cuts into the story at the moment when the first of the dogs, Melanchaetes, Theridamas and Oresitrophus, fasten their teeth into their master's back and shoulder – sinking 'their teeth in his body till there was no place left for tearing'.

'Actaeon,' Ovid says, 'uttered a sound which, though not human, was yet such as no stag could produce.'

Titian's hounds appear just a blur of fur and muscle, Actaeon, not the fully formed stag of Ovid's description, but a stag-headed man – still in the process of transformation, of metamorphosis – collapsing backwards to the ground. Another dog, black, is on their tail, as a formidable huntress figure – presumably Diana – sweeps into the

left foreground, her skirts fluttering in the wind, having let fly an arrow. And while she isn't mentioned in the text – and doesn't have the goddess's crescent moon on her brow – she needs to be there to represent the motivating anger of the goddess – just as the pool in which Actaeon saw his reflection a mile back along the forest path is seen in the foreground. All of nature seems in an agony of movement: the white glitter of the stream running alongside the path, one with the headlong movement of the hounds; the glittering foliage of the trees and thickets seeming to toss and shake in sympathy; an angry storminess building in the sky in the top left-hand corner of the painting.

This isn't the shimmering summer of the two previous paintings. This feels like autumn in the Middle European landscape of Titian's youth, the background to a nightmare thrash through sodden undergrowth towards death. But does the golden glitter of those swirling tree forms evoke light on autumn foliage or the rush of a wind that parallels, even embodies, the nature of the action? Does the blurring of the golden-ochrish forms that make up the far banks of the stream evoke the way that details are lost in moments of action – the fact that in moving you cannot see, cannot experience, everything? Or are they simply painterly forms waiting for further development? Because, one way or another, this painting isn't entirely finished.

'I find the painting of those dogs very weak,' said a voice close beside me.

I was standing in front of the painting, as close as I could without setting off the alarm or bringing the guards bearing down. Turning to my left, I saw a man some years older than myself peering intently at the pasty mass of dog and vegetation and stricken stag-man. 'There's no muscularity there,' he said, pointing to the painting, and I thought for a moment he was going to touch it. 'There's no real energy. They're just . . . plonked there.'

I'd never seen it like that before. The cursory treatment of the dogs had seemed part of the overall momentum of the painting. But looking at them close-up, in isolation, you could see that, while Titian was a notably brilliant painter of the form and tactility of different types of dog, these didn't have the tension, the furious tautness you'd

have hoped for. The forepaw of the red and white dog fastening itself on to Actaeon's thigh was almost floppy.

'You don't like the painting,' I said.

'Of course I like the painting,' he said glancing across at me with a faint flicker of a smile. 'I've been looking at it for fifty years. But it's not all equally good. Look at this . . .' He moved towards me and the figure of Actaeon. 'That torso is completely stiff.'

Indeed, from his shoulders to his knees, Actaeon wasn't so much crumpling under the onslaught of the dogs as tipping over – his torso artificially twisted, so that more of his back was visible to the viewer. As for the slightly too small stag's head, it was almost comic. 'That is just . . . weak,' said the man.

While I'd been aware of these problems – some not quite consciously – they'd never diminished my enjoyment of the painting. What had struck me most, since I'd started looking at it in real detail – when I began this project – was the leg of the large huntress figure striding in from the left. The area of exposed flesh, between her fluttering skirt and toeless boot, seemed over-finished in a clumpy and literal way that seemed out of key with the rest of the painting – even with the treatment of the same figure's bare arms. I could all too easily see some baroque journeymen painter having added it decades after Titian's death to make the painting more saleable.

'I see what you mean,' said the man. 'But it's never bothered me. I'm not sure why.'

It didn't seem to bother anyone else either. No scholarly analyses registered this anomalous area. Indeed, it was apparently a fact that the leg had been painted before the landscape and the figure of the running dog around it.

But no expert liked the huntress's head: the small, pointed, inexpressive features turning into shadow were just the kind of solution some later artist would have employed to get the painting into a saleable condition, while drawing as little attention to this intervention as possible.

A few feet away hung *Diana and Actaeon*, which had been brought from Edinburgh, from the National Gallery of Scotland, where it had hung since 1945, to hang for a few weeks only, in a temporary

exhibition space here at the National Gallery in London. *The Death of Actaeon*, the painting that continues the story, which Titian originally conceived of as the natural complement to *Diana and Actaeon*, had been brought from the permanent collection to hang alongside it.

The Death of Actaeon was a painting I had been looking at intensively for decades. And seeing it now beside the painting that was, by common consent, the greatest of the *poesie*, I saw it in very different terms.

Even allowing for the fact that the lighting was dimmer than in the gallery where it normally hung, *The Death of Actaeon* appeared blurred and murky beside the gleaming surfaces and pristine colours of *Diana and Actaeon*. While I would shrink from using the word 'perfect' in the sense that Vasari used it – a word that never seems quite appropriate to painting – it was difficult, even impossible, to find anything clumsy or inconsistent in *Diana and Actaeon*. *The Death of Actaeon*, on the other hand, is full of elements that aren't resolved, that don't quite work.

But then, as you moved away from the painting, these elements seemed to fall into place. You became more aware of the totality of the impression – of the way the composition worked in layers of light and shadow – the gleam on the pool in the foreground picked up by the glittering stream and the light on the dog's back, the ochre sward on the opposite bank, and then, through the darkness of the forest, the light against which the silhouette of a mysterious rider can be seen – on which no authority ever comments – a spiralling vortex of light and dark that powers the composition forward; compounding the sense of Actaeon's panic, the dark blood pounding in his temples as he plunges on through the forest. Never mind the weakness of the actual figure. In *Diana and Actaeon*, landscape is something that is fitted in around the figures. In *The Death of Actaeon*, the story exists within the landscape, is told as much through the energy of the landscape as through the figures.

And this landscape is conceived of almost entirely through light.

I was standing with the man, a few yards back from the painting, the dark outlines of other visitors milling in front of it.

'That,' I said, 'is an Impressionist painting.'

'Yes,' he said. 'It absolutely is.'

Looking across to the much brighter, clearer *Diana and Actaeon*, that painting seemed almost indecently over-finished, even slightly literal in comparison. Far from complementing each other, the two paintings almost cancelled each other out.

The Rape of Europa, the painting Titian promised at the same time as *The Death of Actaeon*, was delivered in April 1562. It shows the princess Europa carried out to sea on the back of Jupiter in the form of a white bull, two cupids floating vertiginously overhead, her expression obscured by the shadow of her arm – clearly terrified, yet with her legs parted, one knee raised in anticipation of the ecstasy to come – the sunset melting sea and sky and land into a glow that appears about to dissolve the princess's already flimsy garments. It's the kind of atmospheric effect that is very frequent over the Lagoon, where water surrounded by land intensifies the effects of colour, that Titian would often have observed from the upper rooms of his house. The mood of the painting is of playful, celebratory sensuality. No hideous fate awaits Europa.

The Death of Actaeon, meanwhile, was never mentioned in Titian's correspondence again.

The picture hanging in front of me now is generally assumed to be that painting, a work which, assuming Titian had been occupied with it at around the same time as, or even slightly after, *The Rape of Europa*, would have been painted around 1560 to 1562. The painting is of a similar size to *Diana and Actaeon* – if slightly smaller – and it is difficult to imagine why Titian would have embarked on a painting of this subject at any other moment in his career.

The painting first 'appeared' around 1650 in the possession of Archduke Leopold Wilhelm of Austria, Governor of the Spanish Netherlands, who was amassing one of the great collections of the time – which was eventually to former the basis of Vienna's Kunsthistorisches Museum. But *The Death of Actaeon*, perhaps because it was considered unfinished, was sold on around various European collections before being bought by the British connoisseur Sir Abraham Hume in 1798 – at a time when Britain was moving into the political and economic ascendant and its landed aristocracy were buying up as many masterpieces from the Venetian golden age as they could lay their hands on. Hume paid 200 guineas for the

painting, a very modest sum considering that its notional companion pieces *Diana and Callisto* and *Diana and Actaeon* had sold at about the same time for 2,500 guineas. *The Death of Actaeon* was exhibited in the British Institution in London as a 'sketch' by Titian.

But Titian didn't do full-size preparatory sketches or cartoons. He was reluctant to expend any effort that wouldn't be physically part of the final painting itself. He preferred to evolve the composition within the painting. Indeed, there's no need to make a full-scale cartoon unless the final painting is to be executed by assistants – and, while there are drawings by Titian that were clearly made for that purpose, there are no paintings.

So what is *The Death of Actaeon*? Is it simply an unfinished painting of circa 1560 – a painting which, had it been completed, would have had a level of finish consistent with the three great *poesie* – *Diana and Actaeon*, *Diana and Callisto* and *The Rape of Europa*? A painting that would have hung between the first two works, as the next part of the story of Actaeon, in one unbroken flow of form and colour?

But for the painting to be brought up to that degree of stylistic consistency, much that gives it its sense of gusting flow would have been blocked out by further layers of scumbling and glazing. The flurry of dogs and doomed stag-man would have been brought more into focus. The stormy, ominously ethereal sky, thinly painted in a blackish, slightly greenish blue, would have been covered by a harder, brighter and more solid ultramarine – the standard colour for the painting of sky – as it appears in *Diana and Actaeon*. The sketchiness of the huntress's dress, dabbed in thin, wash-like marks suggestive of fleeting, windswept movement, would have been formalised into something resembling the cold, almost architectural mass of the curtain hanging across the action in *Diana and Actaeon*.

Unfinished areas in painting look implicitly wrong – disjointed and insubstantial – like Actaeon's legs, which are hardly there, defined by the edges of other forms, so you can see the foliage through them; or the rawness, the chalkiness and pastiness of the dogs. But the fluttering dress and the greenish tint of the sky fall perfectly back into the muted, autumnal gloom, balancing the umber-like brown of the ground, the greenish gold of the shaking trees. If Titian was intending these colours to be in a completely

different – much harder, brighter, colder – key, why didn't he make them like that in the first place?

If Titian is presenting us here with an unfinished, *accidental* landscape, how come it accords so perfectly with an atmosphere, a mood and appearance that exist in nature?

Looking at the painting with modern eyes, you would assume that it had been executed in one single burst of energy. In fact, the painting has gone through innumerable changes, revisions and refinements, probably involving at least one other artist, but principally by Titian himself; and these developments may have taken place over a decade or longer. *The Death of Actaeon* may have been begun around 1559, at about the time Titian announced it to Philip II. But the painting as we see it today represents a completely different phase of his career.

Titian's approach to paint had never been entirely conventional. From early in his career he had been taking liberties with the layering of pigments – with the opaque scumbles followed by translucent glazes – by which objects were traditionally given a sense of body and substance. Yet the figures at least in *Diana and Actaeon* and the other great *poesie* are all painted according to accepted principles. But in parts of *The Death of Actaeon*, this time-honoured way of working has been abandoned altogether: opaque and translucent layers interweave in apparently random order. Colours are no longer confined to the objects they describe, as was the vermilion of Ariadne's scarf in *Bacchus and Ariadne*, painted four decades earlier, or even the similar hue of Actaeon's boots in *Diana and Actaeon*. In *The Death of Actaeon* 'local' colour, the actual colours of objects, is transmuted by light and movement.

From relatively early in his career, Titian had been allowing colours to overlap to an extent that was unusual at the time. As he went on he deliberately exploited these effects, creating 'vibrating edges', so that nothing is static; everything is in a state of dynamism and movement. By the time he came to *The Death of Actaeon*, Titian was dipping his brush in, say, an opaque acidic yellow-green and making free play with it over the surface of the painting. Then he would do the same with a contrasting colour, a more liquid red-brown glaze, so that layers of colour run in and out of each other under the surface of the painting, creating that sense of whirling,

blurring movement and flow in which nothing is fixed, nothing entirely static.

Yet Titian wasn't able to bring this painting to a state of final resolution. The painting, as far as we know, never left his studio. Having been begun for Philip, it may have become something that Titian knew the Spanish king would neither understand nor appreciate. He may have felt a sense of inherent dissatisfaction, even irritation, with the painting – was confronted each time he returned to it by a record of previous frustration and irresolution.

Or perhaps there was something in the image of a man punished for the act of looking – for seeing things that are beyond the reach of the average man – that felt too personal, that made him reluctant to part with the painting.

Looking at *The Death of Actaeon* with twenty-first-century eyes, we can't help but see it as a proto-Impressionist painting, one that looks forward to Constable's large landscape sketches – created a good two and a half centuries later – the autumn foliage gleaming against a precipitous rain-laden sky – and Constable may well have seen the painting in Abraham Hume's collection. But while Constable did his sketches out in the open air, with the rain, wind and sun blasting on to them, *The Death of Actaeon* was painted indoors. While it would be nice to think that there were drawings – that Titian filled entire notebooks on his journeys up to Cadore – none has ever been found; and it is most unlikely that any ever will be. There are, in fact, remarkably few Titian drawings of any kind. *The Death of Actaeon* was painted entirely from memory and imagination. Titian's sketchbook was in his head.

13

The Pure White Gleam
of the Holy Spirit

THE SKY WAS overcast, the immense rolling distances bathed in a layer of grey, suffocating heat, the hazy outlines of great mountains rearing on the horizon. From the window of the train I could see sagging scrub oaks and umbrella pines, yellowing, wind-blown grass, immense granite boulders, industrial estates, builders' yards and the last of Madrid's satellite housing developments. And way up the line, silhouetted against the thinly forested hillsides, the grey outline of the Royal Monastery of El Escorial.

Somewhere on one of the nearby hilltops there was said to be a seat, hewn from solid granite, from which Philip II had been able to watch progress on the building of his great palace.

On his abdication Philip's father Charles V had retired to the remote monastery of Yuste in the far west of Spain, where he ended his days gazing on Titian's painting *Glory*. Philip's own final resting place would echo his father's, but on a scale far larger than anything Charles had ever dreamed of, its grandeur tempered by an austerity that reflected Philip's self-image as the ultimate Counter-Reformation ruler. Here he intended to gather round him the earthly remains of his forebears, going back to his great-grandparents, Ferdinand and Isabella. Here the flame would be kept for ever burning, with masses and psalms sung for the souls of the Spanish kings day and night in perpetuity.

A vast granite monastery, of which the king's own rooms would occupy only a small part, the Escorial was dedicated to St Lawrence, on whose day Philip had won his only significant military victory, at St Quentin in 1557. And the structure of the complex – the rigidly symmetrical grid of courtyards that surrounded the central basilica – was designed to echo the form of the gridiron on which St Lawrence was roasted alive.

The monastery contained sacred relics of a number and importance that made it the holiest shrine in Christendom, a library which was in its time the largest in the world and, in the many chapels and sacristies, in the monks' refectories and in the royal apartments, a collection of more than three thousand paintings. Every consignment from Titian to Philip II contained at least one religious work, and, while the *poesie*, the other mythological paintings and the many portraits were hung in the royal palace in Madrid or in the Pardo hunting lodge, the vast majority of the religious works were sent to the Escorial. *The Nativity*, *The Last Supper*, *The Agony in the Garden*, *Ecce Homo*, *Christ Carrying the Cross*, *The Crucifixion*, *The Entombment* – Titian's religious paintings in the Escorial might be conceived of as one great cycle on the life and Passion of the Saviour, though they were never hung together. Even today many are kept in out-of-the-way parts of the monastery where they are never seen by the general public.

The most important of the relics, however, were kept in a chamber behind the high altar. Here, among thousands of other treasures, was a thorn from the Crown of Thorns, the handkerchief used by the Virgin at the foot of the Cross, one of the nails used in the crucifixion and the heads of 105 saints. They were stored in tall cupboards, in rows of golden caskets fashioned in the form of human heads and encrusted with jewels.

Philip took particular pleasure in showing the relics to his children. Entering the chamber behind the high altar he would ask to see particular objects, and, removing his hat, he would kneel, taking the relic in his hands and kissing it. 'His children would imitate him,' wrote the king's secretary and librarian Padre Siguenza. 'These things happened to us alone and in secret in that room.'

The moment I heard of the existence of that room, I knew I would have to enter it.

The first time I visited the Escorial, fifteen or so years ago, the sun had blazed down on the rolling plain, and, as the train approached the Escorial, I saw high on a mountaintop the hazy outline of an immense cross. What was it: a collective expression of the mystical piety of the Spanish people? A piece of bombastic garden furniture designed to be seen on the skyline from the Escorial? It was only later that I discovered that it was the Valle de los Caídos, the Valley of the Fallen, the monument created by Franco to the dead of the civil war and the site of his own tomb.

On my first visit to Spain, as a student, I had made two crucial mistakes: not taking enough money and losing my passport. This meant days hanging round Madrid with just a handful of pesetas. I divided my time between lying on the stone benches outside the Prado reading *The Alexandria Quartet* and looking at the paintings inside. While I can barely remember what *The Alexandria Quartet* was about, I feel I know every inch of every painting in that building by Titian, Velázquez and Goya.

Between the Prado and the Escorial, there are more Titian paintings in Madrid than anywhere else in the world, and there would be dozens – perhaps a good hundred – more if it hadn't been for fires in the Alcázar and the Pardo Palace in the seventeenth and eighteenth centuries. At the time of that first visit, they hung in a large square room to the left of the central hall. From there you moved on into more enormous rooms, all lined with fading golden damask, with Velázquez's enigmatic masterpiece *Las Meninas* hanging at the end of a long, oval space framed by the four marvellous paintings of the court dwarves. There was *Las Hilanderas* – the Spinners; *The Forge of Vulcan*; *The Bacchantes*: big paintings, their silent, slightly gloomy stillness contained in their enormous frames. In those big, light yet sombre rooms, you encountered each picture as a world opening out beyond the frame, pictures that you could enter for hours at a time, that you could inhabit like the largest kind of novel. Paintings that you could go on looking at for ever.

There were vast rooms full of Rubens paintings. There were the Spanish mystical paintings of Ribera and Zurbarán, all spot-lit saints and skulls and agony. There were El Greco paintings in a long,

narrow gallery – a corridor, literally and metaphorically, between the
Spanish mystics and the urbane mainstream of Titian and Velázquez.
Upstairs there was Goya – the tapestry cartoons, the Events of 2 and 3
May 1808, the Black Paintings. But the centre, the mainstream of the
place as it was laid out then, was Velázquez. And behind Velázquez
there was Titian.

Is there any other culture – with the possible exception of ancient
Egypt – that has defined itself more through images of its kings?
And you could see in the Prado how that all emanated directly from
Titian: from his portrait of Charles V riding gravely out of the dawn
at Mühlberg. From Philip II in armour; the Empress Isabella; the
towering *Glory* that Charles commissioned to look at as he passed
into the next world. The Catholic propaganda paintings for Philip
II, *The Allegory of Lepanto* and *Religion Succoured by Spain*. While
only two of the *poesie* remained – the molten *Danaë* sprawled on her
bed and *Venus and Adonis*, they'd somehow got hold of two of the
mythological paintings from Alfonso d'Este's *camerino d'alabastro* –
The Worship of Venus and *The Andrians* with its sumptuous female
nude slotted so neatly into the bottom right-hand corner. All were
there, looking very old and grand, and a bit shabby and yellowed.
And as you moved into the Velázquez rooms you could see how the
painterly touch behind that understated grandeur had fed directly
into Velázquez. Not the early, dirty-realist, Caravaggio-influenced
Velázquez, but the later more stately Velázquez of the large
equestrian portraits, of the princesses and infantas in their massive
skirts that encircled them like great tables, the court buffoons, the
philosophers, the ministers of state. Velázquez, who was even more
of a social-climbing careerist than Titian, absorbed the lessons of the
Venetian artist's generously loaded brush, the tact and discretion
implied in the textures of soft leather and velvet that seem to dissolve
as you move in towards the canvas, and he created around the inbred,
ritualised milieu of the Habsburg court a silent, artificially lit world
of his own invention. Velázquez was Titian's spiritual descendant,
just as his subjects were the physical descendants of Charles V and
Philip II. Velázquez studied Titian's paintings – these very paintings
– in the Royal Collection, just as Rubens did on his visits to Spain in
1624 and 1628, and every other court painter down to Goya in the

late eighteenth century. The great age of Spanish painting flowed directly out of Titian.

That was the inescapable message of the Prado as it was under Franco, and as it still was when I paid my first visit to Spain two years after his death. When I returned in 1990, nothing had changed. I came again in 2000, and it was all still exactly the same. Nothing had changed, and it was impossible to imagine that it would. The hang of those paintings, the narrative they proposed, was an inalienable part of what Spain was. It couldn't be changed. Those paintings couldn't be moved. But when I arrived this time, I found they had been.

The whole of the back of the museum was a vast building site where a new extension was being built, and, where once the flow of visitors had been relatively modest, there were now huge queues from opening to closing – for the permanent collection, for the temporary exhibitions, for the bookshop, the cafeteria, the cloakroom. Visitors crowded the gallery packing themselves on to every area of seating, staring into space with glassy, gobsmacked, what-am-I-doing-here? expressions – phones flashing as people posed for photographs, filmed the paintings, filmed each other, played games, the very air vibrating with the sound of text messages being received.

And while the rooms devoted to the displays of Velázquez and Goya were much the same as they'd always been – the inviolable centre of Spanish culture, you couldn't touch them – much else had changed. When I came to that large, square room where the Titian paintings had always hung, they weren't there. Black marks on the now threadbare damask showed where they'd once been, but the room was full of El Greco paintings.

Titian was now confined to two much smaller rooms, an uncomfortable jumble of works of all periods with little sense of a theme or narrative. Several critical works were away on loan in Washington and Osaka, while others – including the Catholic propaganda paintings *The Allegory of Lepanto* and *Religion Succoured by Spain*, which, although studio works, had always seemed essential to what Spain was – had been consigned to storage. *Charles V at Mühlberg* and *Adam and Eve* were in other galleries with compare-and-contrast displays with paintings by Rubens – who I noticed seemed to be holding his own very well. But not Titian. From having

been the great font of the Spanish tradition, Titian was now just another non-Spanish old master, his position usurped by his former pupil El Greco, who, though Greek, had at least spent a good half of his life in Spain. El Greco had never found favour with Philip II, and his visionary quasi-expressionism sat more easily with what people talked of as the New Spain than the works of Philip's official artist. For much of the previous century, the country had been preoccupied with the vanished glories of its so-called Golden Age, when Spain, the defender of Catholic orthodoxy, dominated Europe. Now people wanted to explore freer, less rigid, more generous ideas of Spanish history and identity. Those images of the Spanish kings, which had seemed such an unchangeable, immovable part of what Spain was, had been moved. Titian's presence, meanwhile, Titian's influence, Titian's significance had shrunk.

As I got out of the taxi I was aware of the vast, bare, four-square façade of the Escorial rearing beyond the immense forecourt, reduced to a dark silhouette as a great cloud passed overhead. I remembered having read that, under Franco, its stern, four-square forms – 'el stilo Escorial' – had become a kind of official architectural style, echoed in countless administrative buildings throughout Spain.

I had with me a sheaf of e-mails testifying to months of enquiries to museum directors, curators, press officers and other, more shadowy figures in the offices of the Patrimonio Nacional, requesting access to those Titian paintings not accessible to the public and, if possible, to the holy relics. The result had been a summons here to meet the Administrative Director.

A young man in a tweed jacket and tie led me around a succession of granite staircases into a spacious office where a couple of big-haired, middle-aged women were at work in a slow, languorous, rather disdainful way. There was a lot of large, old, unvarnished wooden furniture and prominently displayed photographs of the king and queen and their children. In an inner office, a handsome young man with thick, dark hair and big, intense, but not particularly welcoming eyes was seated behind a large desk. He, too, was wearing a tweed jacket with a woven tie in a big knot over a big-collared and probably very expensive shirt. I wondered if this was official summer

dress for those working in the Department of Royal Monuments, a kind of English smart-casual that must have been suffocatingly uncomfortable in that African heat – though it was me in my shirtsleeves who was pouring with sweat, while he was a picture of composure.

'This will be a preparatory visit,' he told me in excellent but ominously earnest English. 'You will see Titian's *Martyrdom of St Lawrence*, which is in the Old Church. You will see the *St Jerome*, *The Agony in the Garden* and other works in the public picture galleries. The reliquaries and *The Crucifixion* you will see on your next visit when you have a letter of authorisation from the Gabineta de la Prensa of the Commission for Royal Monuments.'

I sat there stupefied. A few minutes before I had been sitting on the train, speculating – rather fancifully, I thought – on the idea of the Escorial as the embodiment of Philip II's totalitarian bureaucracy, and here I was in the Escorial, apparently at the mercy of that very bureaucracy.

I had realised it wouldn't be as simple as just turning up, that there would be a degree of formality, if not downright difficulty, involved. That's why I'd spent months exchanging e-mails with this man's colleagues, explaining my requirements in painstaking detail to people with at least seven interlinked surnames who had to be addressed as Señor Don or Señora Donna, who passed me on to other departments and other officials, to even grander and more unapproachable people, until finally I'd received an e-mail instructing me to be at this office at ten o'clock that morning, as I now was. I had assumed that that was the letter of authorisation.

'You must write, explaining your requirements and provide a letter from your publisher on their official stationery.'

Instead of diving across the desk, grabbing him by his expensive lapels and asking him why he hadn't provided me with this information when I was still in London and such a document would have been relatively easy to organise, I said simply, 'But I'm leaving on Saturday.'

It was now Wednesday. A second visit would have to take place on the Friday. Even if I got my publisher mobilised the following morning, how long would it take for the request to work its way through the corridors of their black Spanish bureaucracy?

I decided to take a slightly different approach. Since I was here now, would it really hurt anyone if I just quietly slipped in and, you know, saw *The Crucifixion* and the relics anyway?

The young man looked back at me with a sad and disappointed expression. These things were inside the monastery itself. To enter would be to disrupt the spiritual life of the place, something that could only be allowed once the appropriate permission had been granted.

So the monastery was still functioning?

He stared at me, his big eyes wide. 'The monastery is *alive!*'

A guard appeared, a tall, slightly stooping fellow with lank fair hair and the sullen, reluctant air of a gaoler, swinging a bunch of enormous iron keys. 'Juan will accompany you on your visit to the Old Church and the picture galleries.'

I explained that that wouldn't be necessary. Since these places were on the tourist itinerary I could make my own way round in my own time.

'That will not be possible. Since you are on an official visit, it is necessary for you to be accompanied at all times. You will spend one hour on your visit, then you will leave the Royal Monastery of El Escorial.'

As soon as we were out of the office, my gaoler handed me over to a shorter, stockier, more junior colleague. I spent no more than fifteen minutes on my official visit, before thanking the guard and heading out into the sunshine now blazing over the forecourt. Then, having left him enough time to get back to the guardroom or whatever they called it, I headed back into the palace, joined the tourist queue and slipped back into the Royal Monastery of El Escorial.

The Escorial has barely aged. Its brute granite surfaces have hardly weathered or softened. The place feels as rigid and didactic as when it was created: a place coldly logical in its clarity and execution, with few curves, almost nothing, indeed, in the way of ornament – none of the cupids, cornucopia, carved capitals, allegorical figures, mythological allusions we imagine essential to sixteenth-century architecture – almost no sculpture of any kind, almost no reference to anything outside itself. Just flat pilasters, four-square piers supporting endless bare, barrel-vaulted colonnades around square courtyards, with rows

of blank, green-shuttered windows, the silver slate of the roofs above glinting in the pitiless sunlight.

And while the basic conception was Roman, there was something weirdly modern about those rows of small windows set into the long, blank, unrelievedly flat façades.

The sacristy where Titian's *Crucifixion* hung was a long room with a lot of old dark wood and a black marble altar at one end. A monk, a short man in a cardigan, was putting vestments on a very modern-looking portable clothes rack. Here I was, inside the monastery, disrupting its spiritual life. Against all expectation my publisher had immediately faxed the Commission for Royal Monuments, and by lunchtime the day after my previous visit a fax was waiting for me at my hotel, instructing me to be at the Escorial on the Friday morning. But, it added in capitals at the bottom of the piece of paper, 'NO ES POSSIBLE ACCEDER A EL RELICARIO'.

The monk studiously ignored my gaze, while the tall, blond gaoler, who seemed in an amiable mood today, made idle conversation with him, swinging his great chain of ancient keys. *The Crucifixion* was, in all honesty, a pretty dull work, particularly in view of the efforts I'd made to see it. Five minutes would have been quite enough time in this room under normal circumstances. As it was I made notes on every inch of Titian's painting and an inventory of the other paintings in the room, including minor works by Rubens and Giordano, feeling obliged to take up as much of the blond gaoler's time as possible. As for the *relicario* – that mysterious room behind the high altar where the relics were kept – I had far from given up on that score.

My friend Incarnación, an art historian in Madrid, had told me that I must make every possible effort to enter that room. She herself had seen a number of the reliquaries, while attending a course for teachers at the monastery. They were brought out and laid on tables: golden caskets, encrusted with jewels, many in the form of the heads of beautiful women, but smiling – always smiling.

Was there, I had wondered, a weight of mystery and sacredness that made it impossible for one to enter the chamber behind the high altar itself? 'Absolutely not!' she scoffed at the idea. Then what was the problem? She shrugged. 'It is like that in Spain. It is always like that.'

I nodded to my gaoler to indicate I was done. He nodded, straightened himself, and I decided to make my move.

'Y *el relicario?*' I said.

'*El relicario?*'

He moved towards the door, pulling at the keys and beginning to sort through them.

But then, as he reached the door, he stopped mid-stride and pulled out his mobile phone. I could hear someone talking very faintly at the other end of the line. He turned the phone off and gave me a sad smile. '*No es possible.*'

An enormous door at one of the junctions of bare colonnades gave a glimpse into the basilica, a vast, gloomy space, with light flooding in from the bare granite cupola into the dim well of the church below. Even the vast banks of flickering candles, the heavy gilded altars and the swirling baroque frescoes on the barrel-vaulted ceilings couldn't dispel the sense of sombre, barren monumentality.

Immense marble steps the colour of ox blood – like great slabs of black pudding – led up to the high altar, behind which rose a marble-pillared screen three storeys high, surmounted by a gilded Passion group, and flanked on either side by marble colonnades. And into these were set gilded, life-size figures, all facing the altar and kneeling in prayer. To the left were Charles V with his wife and sisters, their golden cloaks emblazoned with the double-headed Habsburg eagle, to the right the family of Philip II, their cloaks bearing the arms of Spain. The effect was oddly theatrical, as though these people had grabbed the boxes closest to the action – at the base of the great altar screen, but still far higher than the ordinary mortal could aspire to. And underground, directly beneath the altar, lay the octagonal chamber in which the kings of Spain were interred in grey marble sarcophagi.

I had a distinct memory of seeing Titian's *The Agony in the Garden* here on my last visit, fifteen years before – the kneeling Christ in his robes of crimson and ultramarine spot-lit against the darkness. But there was no sign of it now. For all the unbelievable expense that had gone into creating this church, there were no great paintings. The images in the high altar screen were mostly copies of Raphael and

Veronese. Most of the Escorial's most significant paintings were now in the Picture Gallery, and so badly lit by a mixture of neon strip light and reflected light from outside that it was difficult to tell how good they were.

St Jerome was seen through a bleary neon glare, the balding, bearded saint kneeling in his cave in the wilderness, clad only in the loose pinkish cloth he would wear again in Titian's final *Pietà*. *The Agony in the Garden* was just a blur of matt and shiny darknesses, in which the image was practically invisible, though the massive craters in the paint surface were all too apparent. And it was difficult to imagine that *The Last Supper* would have seemed a great painting, whatever the condition.

A sign pointed up another bare granite staircase to the Palacio Austria, the Habsburg apartments, a succession of fairly small, white-walled rooms, with blue and white tiles to waist height and terracotta-tiled floors gleaming in the light reflected from outside – elaborately marquetried doors the only touches of real opulence. Compared with the mad, jewel-box palaces being constructed elsewhere in Europe at the time the effect was genuinely monastic.

From the long salon at the far eastern end of the palace you could see out over the blue, pine-covered *vega*, the valley to the east opening out into a hazy immensity that seemed to roll away into infinity.

Philip's own bedroom and study lay through double doors off one of the larger rooms, both quite small and relatively modest. The bed, hung with Flemish tapestries, was in the same position in which it had stood when he died in it in 1598.

Through a door beside his bed you could see into another chamber, small and dark, with the outlines of marble columns just visible in the dimness. Between these columns was a window, and beyond that an indeterminable murk. Staring into the half-darkness, I was aware of a lighter shape on the right-hand side of the window, and beyond that another very faint light, filtered through a space far larger than the one I was standing in now. And, with a shudder, I realised that from Philip II's bedroom I was looking through into the vast space of the basilica, and that the lighter shape in the foreground was the arrangement of white flowers beside the high altar.

That was the way they did it. Charles V had had his room at the

monastery of Yuste positioned so that he could see into the church –
so that, as he lay on his deathbed, Titian's *Glory* would be visible on
the high altar. Philip had placed his room right beside the altar so
that he could participate in mass from his bed. If he looked in one
direction, he could see out of the window into his light-filled garden.
If he looked in the other, he could see into the perfumed dimness of
the basilica. In one direction this world, in the other the next.

On Philip's desk, beside a small portable altar fashioned from solid
silver, stood an engraving of Titian's *The Martyrdom of St Lawrence*,
by far the most important work of art in the entire complex, and one
I had yet to see.

How do you paint night? Do you paint your scene as if it was day and
then darken it? Do you choose scenes which have sufficient artificial
and natural lighting – from fires, torches, candles and, of course,
the moon – that they come ready floodlit? Do you provide a kind
of conceptual spotlighting, so that important parts of the action are
bright as day, simply because we need to see them? Or do you just
paint as much or as little as you can see, and to hell with the viewer?

In 1558, Titian completed a memorial altarpiece for the Venetian
nobleman Lorenzo Massolo to be placed in the Church of the
Crociferi, on the north side of Venice, just a short walk from Titian's
own house. It showed the martyrdom of Massolo's patron saint:
St Lawrence writhing on a great grill, like a white-hot bed, as he
receives the blessed light from heaven.

It is difficult to get close to the painting, which is very badly lit
and blackened by centuries of smoke and candle grease, but the
immediate impression is of a muffled confusion of muscular effort:
the determined, but unfocused fervour of the executioners, forcing the
saint down on to the grill, as they stoke the flames beneath, heaving
in great bundles of faggots, their shoulders and biceps caught in the
glow from the braziers looming in the darkness overhead – and by the
light of the fire under the grill. A man lunges at the saint with a two-
pronged spear, while a bare-chested horseman carrying a Habsburg
banner is in heated discussion with a spearman. Or we presume it's
heated, because we can't see their faces – the former's obscured by
his huge helmet, the latter's by shadow – any more than we can tell

what those figures are doing, walking down the steps of a colonnaded building in the background. The old medieval convention whereby executioners, torturers and their victims all wore the same beatific expression has been blasted into the darkness. All here is incoherent movement, violence and chaos in which the brutal oppressors have their way. Yet there, at the very climax of his agony, the naked saint reaches up to receive the divine light, which appears through a gap in the impenetrable blackness at the top of the painting. There are two kinds of light here: the red heat of fire, anger and passion, and the pure, white gleam of the Holy Spirit which bathes the saint even in the midst of his torment.

Six years after the completion of this painting, in July 1564, Philip II wrote to his envoy in Venice, García Hernández, requesting a painting of the same subject from Titian, for the church of his new palace, the cornerstone of which had been laid the previous year. Philip indicated that in view of the painter's advanced age he would be prepared to accept a work by pupils. His ambassador, who had had to go to great lengths to persuade Titian to complete another major work commissioned by Philip, *The Last Supper*, suggested that it might be easier simply to buy the earlier painting from the Church of the Crociferi. Indeed, the friars indicated they were prepared to sell their *Martyrdom of St Lawrence* for the extremely reasonable – even derisory – price of 200 ducats. Titian being away in Brescia, his assistant of forty years standing Girolamo Dente – described by Hernández as second only to the master himself – offered to make his own copy of the Crociferi painting for a mere fifty ducats. But before this information could be conveyed to Philip, Titian returned and declared that he would create an entirely new work from scratch.

The Iglesia Vieja – the Old Church – is the oldest part of the Escorial – a long, low, shed-like room. You can imagine it standing alone on the rocky plateau before it was buried by the immense bulk of the monastery-palace. The remains of the Spanish kings were interred here before the building of the pantheon, and choir stalls still stand around its walls, from which the monks could sing continual masses and psalms for their souls.

The Martyrdom of St Lawrence completely dominates the room, an enormous painting, about fourteen feet by eleven, set in a

monumental construction of jasper and marble, with gilded screens before it on either side, with Titian's *Nativity* on the left and a copy of the *Entombment* from the Prado on the right.

Brilliantly lit, it seems at first even more of a chaotic mass of movement than the earlier painting – the composition essentially the same, but with the action shoved forward into the front of the painting, a mass of lunging limbs and slicing, moonstruck highlights. The colonnaded building behind had been replaced by a great arch with a wild, cloud-swept moon floating in the darkness beyond, and some kind of indecipherable landscape feature – or was it a fountain? – with a mysterious figure – or was it a statue? – leaning forward with a spear. High above the writhing figure of the saint, two angels, one holding a crown, float in the air inside the room or atrium where the action is taking place – not emitting light, but caught in the light from the two braziers that send clouds of sparks shooting into the darkness overhead, where a statue of Nike, holding smoking incense, stands ghostly in the dimness.

In the foreground, one of the torturers moves to turn Lawrence on his gridiron, as the saint shouts out, 'You can turn me over – I am cooked on this side! Now test the work of your god Vulcan, if you can!', a taunt to the pagan god of fire and metals, patron deity of the blacksmiths who had made the instrument of his death.

A boy in green, meanwhile, his bare feet lit with alarming brightness in the glare from the gridiron, appears to be trying to push back the crowd of soldiers. But who is he, with his strangely intense, changeling look? Is he a mere formal device, there to provide contrast with the group of milling soldiers, or does he refer to something specific in the narrative? And as you look closer, you see that his upraised wrists are crossed, as though he were manacled. Is he pushing back the soldiers, or is he trying to escape into the crowd?

Everything here is pushed towards the surface of the painting – not just the arrangement of figures, but the paint itself. Spatial coherence is sacrificed in favour of expressive force. The impressionistic approach of the former painting becomes the expressionistic approach of the latter. Rather than creating a coherent gradation of forms into darkness, Titian seems to make everything of equal importance, a crowding mass of forms all at an almost equal distance.

He's concerned not so much with what things look like as what they feel like – as though he wants to elicit a response as much through the intensity with which the paint has been got on the canvas as through what it is supposed to evoke. And parts of this painting are incredibly loosely painted.

The two principal figures framing the saint – the back of the man crouching to poke at the flames, the arms and legs of the man striding towards us, stabbing at the saint with that oddly curving spear – are jabbed on to the canvas with marks that make their flesh look almost incandescent, and may have been smeared on with the fingers – which leaves you in no doubt that you're looking at paint. And that wild-eyed white horse is surely a forebear of the terrifying, murdered, dying horse in Picasso's *Guernica*.

But the painting wasn't intended to be seen in the hard glare of the spotlights that play over its surface today, but surrounded by banks of flickering candles – some muted daylight filtering in from the dome overhead. Destined for the high altar of the basilica, the *Martyrdom* would have been visible only as a mass of highlights – flame, flesh and gleaming halberds – against darkness. Would its rawness have been apparent at that distance? Maybe Titian had decided that everything needed to appear close to the surface to be visible at all.

In the event, the painting was deemed the wrong size for the high altar and remained in the Old Church. It could conceivably have been added to or cut down, but Philip seems to have preferred the assembly of nine mediocre paintings that currently adorn the massive altar screen.

When Philip was shown the ambassador's letter concerning the various options for *The Martyrdom of St Lawrence* – buying the painting from the Crociferi, commissioning a completely new painting from Titian or making do with a copy of the earlier painting by Girolamo Dente – Philip scrawled in the margin, 'Buy the one for fifty ducats.' This is the true voice of the great, dream patron, the man supposedly so sensitive to the nuances of Titian's art – who was using all the gold of the Americas to build one of the most bombastic palaces ever created – going for the cheapest option to save a few ducats. Didn't he realise that Dente's painting would inevitably be mediocre in comparison with a work by the

master himself? 'Buy the one for fifty ducats!' And he added, 'Titian's should not be taken unless it differs from the first – for then there will be two.' What did he mean by that? Since he hadn't seen and never would see the Crociferi painting, why would he care if there was one or two versions? Unless, of course, he was considering buying both the Dente copy and Titian's new version – or perhaps the Crociferi painting and Titian's. If the composition isn't substantially different, get the cheaper one! And this for the central focus of a church that was costing Philip untold millions – the holiest shrine in Christendom. Didn't he realise that when Titian reworked a composition he always made significant developments – he always made it something *more*?

When Titian's previous devotional work for Philip, *The Last Supper*, arrived at the Escorial it was found to be too large for the monks' refectory where it was intended to hang, and it was decided that it should be cut down. The Spanish painter Juan Fernández Navarrete, who had studied with Titian in Venice and was now salaried to work at the Escorial, made passionate protests against this 'mutilation' – and begged to be allowed time to make a copy. All to no avail. The top two feet of the painting were heedlessly sliced off and further cuts made on all sides.

Titian claimed to have spent seven years on *The Last Supper*. He had written repeatedly to Philip during 1564, telling him that the painting was finished, asking for specific instructions on where it should be sent, but never actually sending it. In Venice, meanwhile, García Hernández informed Philip that the painting was not finished – that it would not be finished for a good three months. Titian, it was inferred, was deliberately delaying completing the painting – giving the Treasury of Milan time to pay the arrears on his pension – before sending any more major works. In October 1564, Ambassador Hernández informed Philip that the painting was now finished, while informing the first minister, Antonio Pérez, in a separate letter, that the painting was 'a marvel, one of the best things Titian has done – as I am told by the masters of the art and all who have seen it'. And the fact that Titian had not yet sent the painting was due entirely to his covetousness and avarice. But what did this covetousness and avarice amount to? Simply that

he didn't want to send the painting without some sort of guarantee that he would be paid for it.

Remember that coldly magisterial note, written by Philip on Christmas Day 1558, the year his father died, ordering that all sums due to Titian be paid without delay – and signed 'I, the King'? You didn't think that worked, did you? In March 1559, Orazio went to Milan to collect 2,222 scudi payable up to the end of that year. But five years later, no further payments had been made. While the aim of Philip's policy was to centralise, to establish a chain of command that would allow him sole and sovereign power throughout his lands, he was reliant on an unwieldy network of client rulers and hereditary allies, governors, ministers, secretaries and civil servants – many of them several weeks' travel away – for his orders to be carried out. Never mind that Ferrante Gonzaga, younger brother of Federico Gonzaga and the Governor of Milan throughout much of this period, clearly didn't like Titian. Against the endlessly accumulating, competing claims made against the treasuries of Milan, Naples and Madrid, the demands of one *Venetian painter* – however legitimate – would have seemed insignificant, something to be endlessly relegated to the bottom of the pile.

In August 1564, Philip wrote again to the Duke of Sessa, Governor of Milan, and to the Viceroy of Naples, pressing that all moneys due to Titian be paid as soon as possible. But when payment was made to Titian the following year, he found that an amount 'equal to some years' pay' had been withheld, and the remainder forwarded in the form of a warrant for rice. *A warrant for rice?* Here was an artist who had provided one of the most powerful men in the world with paintings that were even then considered among the greatest masterpieces ever created, and here he is being expected to make up the money owed to him through the tax saved from importing rice!

Reading through Titian's correspondence you find yourself aghast at yet another importuning letter, yet another demand for money, yet another incident that turns a painting of transporting magnificence into a bargaining chip in the process of self-advancement. Reading through all these endless missives in their high-flown ambassadorial prose, their ever more tortuously unctuous formulas ('Having ascertained from your Reverence's communications that your

Lordship's singular courtesy had deigned to approve the letter I lately sent . . .'), the exhortations to be allowed to kiss his Lordship's hand, you find yourself wondering if there is any end to this man's venal, conniving self-interest.

But what did this self-interest amount to other than the desire to gain a reasonable recompense for works that had cost him endless thought and labour and considerable expense in terms of payment of assistants, cost of materials, time lost to other projects – recompense that was years in arrears and must by this time have amounted to the equivalent of millions of pounds? Titian had devoted the best of his labours to one patron, and decades on he was still having to grovel for the payment to which he was legitimately entitled. Perhaps that's one of the many reasons why, despite endless invitations from the Habsburg family over a period of nearly forty years, Spain's greatest painter never did visit Spain.

14

Still in the Game

'THEN THE SOLDIERS led him into the hall called the
Praetorium. And they clothed him in purple and plaited
a crown of thorns and put it on his head. They began to
salute him saying, Hail, King of the Jews! And they beat him about
the head with a reed and spat on him, and bowing their knees
worshipped him. And when they had mocked him, they stripped
him of the purple, and led him out to crucify him.'

St Mark's gospel sets this incident in the early afternoon, but the
action in Titian's painting seems to be taking place at night – though
that may just be to accentuate the sense of anguish and turmoil,
a flash forward to the moment at the sixth hour when 'there was
darkness over the face of the land'. The muscles of the soldiers and
Christ's pale skin gleam in the light from the blazing chandelier
swinging overhead, swirling clouds, like black smoke, seen through
the archway beyond, cut across by the reeds – more like staves – with
which the soldiers belabour the Saviour; though nothing about their
movements could be described as realistic.

Titian first tackled this subject in the early 1540s, in a painting
for a brotherhood in Milan devoted to a relic – one of the thorns
from the original Crown of Thorns. The result was one of Titian's
oddest paintings, a work generally seen as an attempt to come to
terms with an approach to painting that had evolved in Florence

and Rome twenty years earlier, and was now the height of fashion in Venice. Not so much a movement, more a tendency, a generalised, but pervasive trend – an apparent reaction against the serene and harmonious classicism of Raphael and the early Michelangelo – the forms of what became known as Mannerism tended towards elongation and expressive distortion. Poses were devised for their expressive potential rather than their anatomic plausibility. Lighting was heightened, perspective exaggerated or made ambiguous. Limbs, necks and even heads were elongated, muscles exaggerated, figures contorted into gravity-defying postures that were designed to express the emotional content of a scene in heightened rhetorical terms rather than to re-create the action in a physically coherent and believable way. This phenomenon became known to later commentators – like the late-seventeenth-century critic Gian Pietro Bellori – as *la maniera* – the Manner, the term Mannerism being coined only in the early twentieth century. While the prime exponents were essentially second-rate artists – Pontormo, Rosso Fiorentino, Raphael's assistant Giulio Romano and, in its later phase, Bronzino and Giorgio Vasari – there was no artist, not even Michelangelo himself, who was not in some way touched by this sensibility.

In the early 1540s, Titian produced a number of works that showed apparent Mannerist influence. A group of ceiling panels for the monastery of Santo Spirito, showing exaggerated foreshortening, was a project originally begun by Vasari on a visit to Venice in 1542 (and it says something about the mood of the time that Titian was picking up the discarded commissions of the upstart Vasari). The large *Ecce Homo*, which features Aretino in the role of Pontius Pilate, showing the humiliated Christ to the crowd, employs foreshortening in the foreground figures that gives the scene something of the look of a 3D diorama.

But Titian's most overtly Mannerist painting was *The Crowning with Thorns*, and it's an oddly uncomfortable experience: the supposedly expressive splaying of Christ's slightly flabby legs, the implausible interweaving of the figures; the way the chain-mailed figure among the soldiers surging into the painting from the right has his arm round the helmeted man who is taking the reed from Christ's

hand – for no reason other than to give a deliberate and fashionable impression of artificiality.

The reeds – more like staves – of the three soldiers attacking Christ form a kind of triangle around his head – but to what purpose? The soldiers' postures are dramatic, but they don't *explain* what they're doing. Are they beating him? Are they trying to force the Crown of Thorns on to Christ's head or prise it off? The Stakhanovite posture of the massively muscled figure on the left makes him look as though he is forcing open some enormous iron door with a crowbar. The focus of the brushwork is tighter and sharper than is typical of Titian's work at that time, while the primary colours of the soldiers' tunics have an acidic crudeness.

Titian, whose entire art was based on optical plausibility – who was interested in exploring what he could actually see, or couldn't see, rather than what the norms of art told him he ought to be able to see – clearly felt ambivalent about the experience. After this brief interlude, his work abandoned all trace of Mannerist influence. Why, then, did he revive this composition right at the end of his life?

The colours in the second *Crowning with Thorns* are darker and earthier, the paint thickly impasted in places, in others barely covering the canvas – the sharp edges of the Milan painting not so much blurred as stabbed out of existence. The figure of Christ looks as though it has been slashed rapidly on to the canvas in a last-ditch attempt to bring the image into being – the pale pink flesh shot through with red, as though you can see the blood pulsing up from the lower layers of paint, the legs and lower areas of the robe blurring where Titian has smeared the paint on with his fingers.

And this sense of effort, even of desperation, matches the violence of the image. The postures of the stave-wielding guards still don't work. Nobody, you feel, would stand like that in order to do whatever it is they're trying to do. The image of the crown being forced on to Christ's head with the reeds had, in fact, been established in Christian iconography from the Middle Ages. But here it has become something else. If the Milan painting is slick and flash, the work of an artist sure of his ability to excel in any style, the later painting has a harrowing sense of having been fought into existence – that these figures look the way they do because the artist couldn't get them on to

the canvas in any other way; that their primitivism and effortfulness express the anguish of the scene, not just in their appearance, but in the way they're painted.

It has been suggested that, far from being a late, radical reinterpretation of the earlier painting, the second *Crowning with Thorns* is simply a crude studio copy, made as a record before the finished work was shipped to Milan in 1542. It has been argued, too, that the painting owes its appearance to its lack of finish, that, had it been completed, it would have looked far more conventional, more of a piece with other paintings of this period that are known to have been sent to Philip II.

But a studio copy would have been far more slavish and literal. And while there are parts that are obviously unfinished, like the boy holding a bundle of reeds at the bottom right, his face a confused blur, or the transparent end of Christ's robe trailing down the steps, the most important forms, Christ's head and shoulders, the dark-hatted soldier who cuts across him, the gleaming biceps of the Stakhanovite soldier are all resolved in their own terms – however awkward and hard won they may appear. The glistering white highlights on Christ's neck and shoulders – traditionally one of the last areas of paint to be applied – are in place. The only way to make them appear more conventional and more finished would be to obliterate them altogether.

So what did Titian think he was doing in this painting?

The taste for these difficult final works is generally considered a twentieth-century phenomenon – a product of Modernism, of the 'taste for fragments and late style', as one expert put it to me. Yet as early as 1877, Crowe and Cavalcaselle were asserting that the second *Crowning with Thorns* represented the best of the late Titian. Their tastes tended generally towards more pedantically finished works, but even they couldn't help responding to the energy and brutal truth of this painting. The more finished works produced by Titian's studio at this time, such as the Catholic propaganda picture *The Allegory of Lepanto*, were for them 'official' paintings that betrayed 'a want of natural inspiration', while the *Crowning* was an 'original' painting that showed 'Titian labouring for his own satisfaction'. Even then there was the idea that, since *The Crowning with Thorns*

was 'not commissioned by anyone, was not composed for any known patron', Titian must have been creating pictures like this essentially for himself.

But why would he have wanted to take on a work of this size – the painting is over nine feet high – and this subject, *for himself*?

Had Titian retained a niggling sense of dissatisfaction about the earlier painting – a sense felt under the skin that he could and should have treated the subject in a truer, better way? Was there some personal interest that made him want to return to this particular subject? Or was this just a manifestation of the monomania of old age, the obsessive revisiting and reworking of certain patterns – visual ideas that were in his system and kept re-emerging in an involuntary, reflexive fashion?

Titian's seventeenth-century biographer Ridolfi, a painter himself, who met people just about old enough to have known Titian, states that, 'although he was reduced in his extreme old age and almost completely deprived of sight, imitating the famous Apelles, not a day passed without him creating something with charcoal and chalk'.

That – a bit of gentle drawing, some relatively modest painting on smallish boards and canvas – is about the level of activity you would expect of a frail, eighty-something artist who is going on working because drawing and painting are what he has always done, the only things that make him feel he is still fully alive. Not large, physically demanding paintings that would have required mounting ladders or scaffolding. And for all the profound differences in mood and execution between the early and late versions of *The Crowning with Thorns*, certain aspects are disconcertingly similar. Indeed, the basic compositions of the two paintings are essentially the same.

Titian hadn't seen the painting in Milan for thirty-odd years. While he had a highly developed visual memory, and could probably have drawn up a convincing approximation of the painting off the top of his head, the proportions of the two paintings and certain details – the shining pate of the bald soldier lunging in from the right, for example – are too close in shape and conception, if not in treatment, for some form of record not to have been used.

Since Titian didn't make preparatory scale drawings, the earlier image could not have been transferred to the second canvas using *spolvero*, the time-honoured method employed by Giovanni Bellini

– involving pricking the drawing with minute holes and forcing
through chalk dust; and in any case, the proportions of the figures
are not exactly the same. There must have been a drawing, or even
an engraving (though no engravings are known, and it's difficult
to imagine every copy could have been lost). Something had made
Titian return to this image, something that went beyond a sense of
personal exploration.

Looking again at the unfinished figure of the boy with the bundle
of reeds, we see a standard device from the traditional altarpiece – the
figure, usually a child, who looks out at us inviting us to pray for the
souls of the donors in purgatory.

Titian had spent his entire life working to commission, creating
images with specific practical functions. When he began his career
devotional images in private houses were still kept covered for much
of the time. Such images had tangible spiritual power. It is impossible
to imagine that Titian could have conceived of an image of this
kind, and on this scale, just existing, 'for its own sake'. No, when he
embarked on the second *Crowning with Thorns*, he was still accepting
commissions. Titian was still in the game.

There's a painting in the Villa Borghese in Rome described as a
'pastiche after Titian', from which van Dyck made a drawing in the
early seventeenth century, and from which numerous prints have
been made. It shows an old man – bearded, skull-capped, hawk-
nosed – looking in all essential details like Titian – his hand resting
on the stomach of a buxom, bonny and much younger woman, who
fairly towers over him. And while his rheumy eyes are fixed firmly
on her breasts, she looks out at us with an impassive yet knowing
expression. And set into a corner of the painting is a skull, a reminder
of the transience and futility of all desire, of the fact that even Titian,
the great connoisseur of female flesh, the artist whose work most
represents the unashamed enjoyment of the senses, who has been
surrounded – you would assume – by the most beautiful women,
has been reduced to this pitiful, fumbling dotage, this pathetically
unequal match of obsessive old age and indifferent youth.

Titian had been protesting his advanced years for decades. As
early as 1548 – when still in his fifties – he was describing himself

as old. A sense of venerability had been essential to his image, even when he was relatively young. In paintings and engravings by other artists, the white beard, the broad brow, the skullcap were always present – signifiers of experience, of a worthiness of awe, respect and, not least, sympathy. Indeed, when Titian referred to his age he was usually about to make a demand for money.

It had been understood by the Venetian authorities, at least from the mid-1500s, that Titian should be excused the duties required of him by his *sanseria* – state pension – including providing portraits of the doges, on account of his advanced years.

Now, nearly twenty years on, Titian really was old. And even now he was exaggerating his age, claiming in one of his last letters to Philip II in 1571 that he was ninety-five, when he can have been no more than eighty-two. Pleading for some word as to how his painting *Tarquin and Lucretia* had been received, he claimed that he did not know how he would survive 'in this my old age', amid 'the calamities of the present time, when everyone is suffering from the continuance of war'.

Venice had been in a state of all-out war with the Ottoman Turks since 1570, the Turkish battleships sailing so close to Venice that the sandbanks around the Lagoon were fortified and the most navigable waterways blocked with sunken ships. Tension ran high in the city, with a climate of suspicion and paranoia towards Venice's non-Christian communities, particularly the Jews.

Yet it's difficult to imagine that these developments had much direct impact on Titian's well-cushioned life behind the walls of the house in Biri Grande. Probably all times seem calamitous to an eighty-year-old – the sense of hastening collapse, dimly perceived external events mirroring the ruin of everything worthwhile and worth living for. Titian's last letters have a quality of monomanic senile obsession: the continual pleading of poverty, the never-ending complaints at the non-payment of dues, most of which had long since been remitted. And Philip had long since stopped responding to them.

Most of Titian's close friends and notable contemporaries were dead. Aretino had died in 1556, literally laughing. He fell off his chair at a party, hit his head and suffered an apoplectic seizure. After the priest had administered extreme unction, Aretino opened his

eyes and growled, 'Now that I am oiled, save me from the rats!' –
then expired. The third member of the Triumvirate, the architect
Sansovino, died in 1570. The artist's brother, sometime assistant and
business partner, Francesco, departed this world in 1550, while his
eldest daughter, Lavinia, was traditionally understood to have died
in 1561.

Titian's *sanseria* and his pension from the Treasury of Milan had
both been transferred into Orazio's name. While he was as famous
as he'd ever been, his celebrity was now of the order where it hardly
mattered whether he was alive or not. Indeed, it had long been agreed
among observers of the Venetian art scene that little more could be
expected of Titian. As early as 1566, Vasari had written that 'during
these last few years Titian would have done well not to have worked,
save to amuse himself, for then he would have avoided damaging
with inferior work the reputation won during his best years, before
his natural powers started to decline'.

'Everyone says he no longer sees what he is doing,' added the art
dealer Niccolò Stoppio. 'His hand trembles so much that he cannot
bring anything to completion, but leaves everything to his pupils.'

Yet those who wrote Titian off were judging him on the few
works that now made their way from his studio into the churches
and public buildings of Venice; paintings like the *Annunciation* and
the *Transfiguration* in San Salvatore, which Titian himself, according
to Vasari, didn't rate highly. More personal paintings, such as the
second *Crowning with Thorns*, remained in his studio and were seen
by very few people.

It's easy to form the impression that the aged Titian was an
isolated, lonely figure. In fact, he can barely have been alone for a
minute. His house still functioned as his business premises, and his
studio, though not as active as at the height of his career, was still a
working entity, which Titian confidently anticipated would go on
providing a living for his family long after his death. He still hoped
that his *sanseria* from the Venetian government and his pension
from Philip II would be passed on to Orazio, and to that end he had
announced a series of ten large paintings of the life of St Lawrence for
the Escorial, which he informed Philip would be executed with the
help of Orazio and 'another very talented pupil of mine' – probably

Emmanuel Amberger. There were still visitors, hoping to buy or simply to be in the presence of the most famous artist in the world. More importantly, he was surrounded by an extensive network of family members and other more or less related dependants.

Titian had nine grandchildren, the eldest then approaching twenty. His younger daughter, still in her twenties herself, lived close by, as did his cousins and sometime assistants Marco and Cesare Vecellio. His nephew by marriage, Giovanni Alessandrini, a notary – almost certainly appointed by Titian himself – did a considerable amount of work for the artist, while Giovanni's elder sister, Cecilia, was married to Celso di San Fior, another notary, who had acted as Titian's commercial agent in the Serravalle area and was now living and working on his behalf in Venice itself.

Then there was Livia Balbi, née Tinto, another niece, whose husband Gaspare had a couple of run-ins with Titian, but went on working for him in various commercial capacities, while Livia was recorded in 1574 as living in Titian's house. Most importantly, Titian's elder daughter, Lavinia, who was formerly believed to have died in 1561, probably remained alive until 1574. We see her aged about thirty in a portrait known as *Lavinia as Matron*, a rather stolid figure – small-mouthed, narrow-eyed and long-nosed – but proud in her many pearls, a big, red jewel resplendent on her breast, an elaborate feather fan in her hand, proud to be the daughter of the greatest artist in Venice, who was able to provide the colossal sum of 1,200 ducats for her dowry, and even more proud to be the spouse of a landowning nobleman of Serravalle. While her husband Cornelio Sarcinelli seems to have been a rather insensitive, overbearing character, Lavinia doesn't look as though she'd be easily done down by anybody.

If we'd had the opportunity to visit Titian we'd have found him surrounded by all these very ordinary people, none of whom would have appeared 'interested in art' – who probably hadn't read a book between them (if, indeed, Titian had himself) – but all of whom were dependent to some extent on their great relative, their lives inextricably bound up with his. Titian was too important, too valuable an asset to too many people, to be allowed the luxury of solitude. And Titian, I dare say, wouldn't have had it any other way. These were, after all, 'his people'.

We see them in the *Madonna della Misericordia*, an adaptation of one of the classic late-medieval images – the Madonna, her arms outstretched, providing shelter – mercy – with her cloak; an image that can still be seen on many buildings in the vicinity of Titian's house, indicating that they were once the property of the Scuola Grande della Misericordia. Titian, closest to us seen at a three-quarter angle from the rear, identifiable by his white beard and hawk nose, kneels bareheaded before the Madonna, the gold chain of his knighthood clearly visible over his black cloak. Close beside him, black-bearded, looking up open-mouthed, rapt, at the Madonna, Orazio; and opposite them, richly dressed with her arms folded over her chest, Lavinia. Over to the left are various other bearded men; the most prominent, a curly-haired young fellow in armour, may be Lavinia's husband Cornelio Sarcinelli.

There they kneel, united in blood, flesh and faith before the Madonna, and apart from Titian's chain they could be any affluent Cadorin family in Venice.

As for the two women kneeling beside Lavinia, their long veils embroidered in gold trailing the ground behind them, they could be Titian's nieces, Cecilia and Lucia, or the nearer of them, her blonde hair clearly visible beneath her veil, may, just may, be Titian's younger daughter Emilia. Married in 1568, and therefore probably born around 1548–50, when Titian was about sixty, Emilia was a product of life in Biri Grande, of the coming and going of assistants, relatives and servants in the big house on the Lagoon. Presumed to be the daughter of one of the maids, Emilia is known about only through her marriage certificate, which wasn't discovered until 1933. Because of this paucity of evidence, it has been assumed that Emilia was never fully part of the family, that she wasn't accepted by the other children, but was kept among the servants and married off at the first possible opportunity. Yet the dowry of 750 ducats provided for her marriage to the grain merchant Andrea Dossena, though not approaching the enormous sum laid out for her elder half-sister Lavinia, was still more than respectable.

Emilia's presence may lurk in various of Titian's paintings; conceivably in a painting known only through a copy by Rubens, showing a bright-eyed, rather minxish-looking girl holding up a

fan which looks to us like a small flag, her eyes disconcertingly dark against her dyed blonde hair and pancake make-up. Titian sent it to Philip II in 1559, declaring it to be 'the portrait of she who is the absolute mistress of my soul. And in truth, though painted, I could not have sent anything dearer or more precious.'

While it was assumed for centuries that this must refer to the old artist's mistress, it has been understood latterly that such words would be applied only to his daughter. Yet by this time Lavinia was approaching thirty, already the doughty figure in *Lavinia as Matron*. What about Emilia? If Emilia married in 1568, at the age of twenty – at the very oldest – she would have been no more than eleven when this painting was dispatched to Philip II – about five years younger than the girl in the painting. But what if there had been some cause that delayed her marriage? What if the absolute mistress of Titian's soul was kept at home to go on looking after the ageing artist? What if, far from being banished to the servants' quarters, Emilia, at least fifty years his junior, provided the real succour of his final years?

The only person in Titian's domestic milieu who might remotely be described as 'cultured' was his young assistant and secretary, Giovanni Mario Verdizotti. A cleric of good Venetian family, a painter and writer, who wrote most of the letters of Titian's latter years – and in later life wrote several treatises on Titian's work – Verdizotti was given two paintings – figures of Apollo and Diana – by the artist, who, Vasari observed, Verdizotti 'loves and honours as a father'. While these sentiments were almost certainly reciprocated by Titian, he was unable to resolve such feelings in relation to his own son, also a priest, Pomponio.

In 1563, an agreement had been drawn up between father and son, signed by the papal legate in Venice, in which it was established that, while Pomponio owned the rights to his various benefices, he gave Titian the right to manage them in return for paying him an allowance of twenty-five ducats per month – a more than comfortable income by any standards.

The fact that there is no known correspondence over the following four years suggests that this arrangement worked satisfactorily. But in 1567, Pomponio wrote to Titian in a state of near-hysterical fury, complaining of his father's failure to pay taxes on the income from

the three benefices. 'With the above mentioned benefici having been decimated by various increases – as you know better than I – and you never having paid the debts obligated to you, a few days ago, a cask of wine and various other things that I was saving for my own consumption were carried off. I sent word to you immediately seeing that you have made me give up everything, and my affairs are falling into total ruin, thanks to you – so that you cannot at any time protest before the great legal presidents that you did not know!'

He had, he said, left a copy of the letter at the gate of a public notary of St Mark's, thereby making the matter public.

There was Pomponio Vecellio, now in his mid-forties, living betwixt and between. Having received major orders in 1563, he was eligible to serve as rector in Fabbro – not far from Venice, but still, as far as he was concerned, in the sticks – no doubt comfortably ensconced with his housekeeper, living on the rapidly dwindling income of three benefices; continually cursing the father who had 'made him give up everything', and through whose financial negligence the wine was now being whisked off his table – yet who didn't reply to his letters.

Six months later, Pomponio fired off another half-coherent, probably drunken salvo, which he copied to the Signori Sopra Gastaldi, complaining that he still hadn't received monies owed to him by his father. Titian responded within three days with a letter sent via his notary, addressing his son as 'Reverent Sir, formerly Pomponio' and 'Your Reverence', referring to the 'means' his son has used against him – 'means which are turned into shame and damage solely against you, since it is a father's duty to hide the misfortune and shame that arise from a disobedient son'.

'I beg you not to give me any further occasion for the pain and trouble that have been my sole meditation, labour and fast over the sweat I have expended in order to obtain three honourable *benefici* for you, putting you on your way to becoming rich and great, which Your Reverence didn't want, even though it allowed you to live your life as you wanted.'

The two men never spoke again.

Amid the day-to-day comings and goings of the Vecellio household, there came the last great glittering moment in Titian's life, his final

public appearance, when, in July 1574, King Henry III of France visited Venice. The Venetian government, which was hoping to establish closer ties with France, took the opportunity to give the young monarch a welcome he would never forget – an event that went down in the annals of Venice as the most magnificent the city ever saw. Swept across the Lagoon in a fleet of golden gondolas, Henry and his party disembarked at St Mark's through a triumphal arch specially designed by Palladio and painted by Tintoretto and Veronese. And amidst the masques and the music, the banquets for thousands at which the napkins, plates, cutlery and the very tables they lay upon were fashioned entirely from sugar, the king took the time – at his own initiative – to visit Titian's studio. And he hardly came incognito. With him were the Dukes of Ferrara, Mantua and Urbino, all well known to Titian.

Now physically very frail, the world's greatest artist – the last survivor of an age that was agreed, even then, to have been among the most remarkable the world had ever known – came out to meet them, entertained them in the garden on the Lagoon, with the snow-covered peaks of Cadore just discernible in the blue distance. Titian, according to legend, made the king a present of every picture of which he asked the price. And while it's hard to believe he could have been quite that generous, it is inconceivable that he did not make some gesture worthy of the grandeur of the occasion.

Far from being 'in want of many things' as he had complained to Philip's secretary, Antonio Pérez, in 1574, Titian, whose pensions from the treasuries of Milan and Spain were now paid more or less up to date, was cash rich. And while he was creating paintings like *The Crowning with Thorns*, which appeared dragged into being with the last effort of which he was capable, whose rawness suggested they could be painted in that way and no other, he was – apparently at the same time – producing other paintings in a completely different style which corresponded far more to traditional ideas of 'finish'. I'm not talking about the Catholic propaganda paintings *The Allegory of Lepanto* and *Religion Succoured by Spain*, which – though very well received in Spain – were largely done by assistants. I'm talking about a painting that was in the last but one consignment of works

sent to Philip II in August 1571, that is still regarded by many as representing the gold standard for late Titian, and that was described by the artist himself as having cost him more effort than anything he had produced for many years: *Tarquin and Lucretia*.

Naked, except for her jewellery, Lucretia, the virtuous patrician woman, falls back on her bed, tears streaming down her face as she tries to fend off her assailant, Tarquinius Suetonius, who bears down on her, knife in hand. Having heard Lucretia's husband boasting of her virtue, Tarquin was sent into a rage of lust. Breaking into her room as she slept, he forced himself on her, threatening to kill her slave if she did not submit to his demands. There is something unbearably poignant in the expression of hopelessness and terror on Lucretia's face – her eyes wide, her teeth just visible, indicating fear. We know that the following day she will take the honourable course, committing suicide – by the knife – in front of her family, after urging her menfolk to avenge her shame, thereby forcing Tarquin into exile and bringing about the end of Etruscan rule in Italy. The right of the scene is entirely on Lucretia's side. She is the heroine of the tragedy. And it is a tragedy, not a mere crime based on the grossness and selfishness of one party. Tarquin is, in a sense, as much a victim as she is. The flushed face, the whiteness of the terrified eyes, and above all the fact that her beautiful if very ample body is naked before us, pressed down against the rumpled sheets and pillows, all indicate one fate for Lucretia. Her oppressor, on the other hand, is entirely clothed, except for one vermilion stocking sagging round his knee – the inflamed red indicating his submission to brute instinct. Tarquin, his wild eyes impervious to her humanity, the upraised blade glinting against the heavy curtains of the bedroom, grabbing hold of her arm with his left hand – as she attempts feebly to push him away with the other – his red-bearded face thrust towards hers.

There's no question here of some parts of the painting being finished and others not. The sheets, Lucretia's baby-soft skin, Tarquin's voluminous crimson breeches, the heavy green silk curtains looping through the background, even the valence at the base of the bed, where some of the pinkish-brown underpainting has been left exposed to create a shot-silk effect – everything has been brought to a coherent, if not identical level of finish. The relative looseness of the brush marks

playing over Lucretia's soft, baby-pink flesh – enhancing the sense of her vulnerability – means something very different from the minutely rendered, tangled golden thread of Tarquin's jerkin; the touch of female flesh that every man has the right to feel, the nakedness of the passive receiver before the clothed form of man, the giver, the active principle. Titian wants us to feel the full horror of what is happening to Lucretia; but at the same time he wants us to understand and identify with the enraged desire that is driving Tarquin, that is setting in train events that will cause him to lose his kingdom, and bring about the break-up of the established order.

The painting concerned a prince, and it was intended for the private rooms of a prince: Philip II, a man who would have understood the predicament of another prince in a very different way to you or I. Who understood that his duties and obligations were different from those of the average man; who prided himself on his mastery of his desires and passions, knowing that they had more profound, potentially more tragic, consequences. Philip understood the link between desire and obligation on a level that was both personal and universal, having recently had the onerous duty of ordering the execution of the Counts of Egmont and Horn – his brother knights in the Order of the Golden Fleece, and the architects of his great victory at St Quentin – for opposing the reinstatement of the Holy Inquisition in Flanders – and having blocked every attempt to have the two men pardoned. If a painting was to hang on Philip's walls, it was inconceivable that the person wielding power should not be a sympathetic – if possibly tragic – figure. And for us to understand Tarquin as tragic, it is essential that we should experience at least a flicker of arousal.

Yet while Titian clearly saw this painting as a grand narrative, a *tour de force* in the tradition of the *poesie*, *Tarquin and Lucretia* has a number of critical flaws. The days of the Titian painting that appears 'perfect' – that parades its consistency of finish with a near-arrogant flourish – are long gone. Every one of Titian's last paintings has some inconsistency, some awkward or unresolved element that isn't quite integrated into the painting or betrays the involvement of other hands. And it's according to how you interpret these problems that you decide what Titian was doing in his last days.

From an anatomical point of view, the axis of Tarquin's body and legs simply doesn't work. While the legs are facing away from us, kneeling on the bed as he presses between Lucretia's thighs, the upper part of his body is facing round towards us so that we can see his facial expression. This may have been intended as a piece of sophisticated contrapposto, but it looks wrong. The foreshortening of Tarquin's bare arm, raised with its glinting dagger, feels crude, and even the rolled-up sleeve fails to conceal the fact that the arm doesn't fit plausibly into the rest of the body. We lose track of Lucretia's right leg as it passes behind Tarquin. It is impossible to believe there's a fully formed limb behind there.

We tend to assume that the clumsiness of such passages must point to the involvement of assistants. Yet they could simply be evidence of the artist's own failing powers, of the fact that Titian, with his shaking hand and failing eyesight, could no longer hack it. Yet if we look at an even later work, the *Pietà* – supposedly the last that Titian ever painted – we see that the few rapid, gestural brush strokes with which the Magdalene's breast and shoulder have been slashed on to the canvas perfectly express the feeling of form and volume, that Titian's sense of how these things would look, of the precise effect his brush marks would create at virtually any distance from the canvas, was undimmed.

But, then, there's something a little too theatrical, too overtly rhetorical about *Tarquin and Lucretia*, the feeling that the figures have been forced into these positions in order to tell us what is happening. Rather than evolving the composition through the rapid, vigorous underpainting that Palma Giovane described to Boschini – with the many changes in the figures' postures recorded in the underlayers of the painting – Titian borrowed the composition from one of the many popular prints of the subject then in circulation. These varied greatly in style and quality. While the one that Titian's most closely resembles, by the minor Flemish engraver Léon Daven, wasn't among the most elevated, Titian, as always, would have been confident that he could transform this already commonplace image into something that no other artist could hope to emulate.

Tarquin and Lucretia is one of the paintings put forward when people draw contrasts between finished and supposedly unfinished

examples of Titian's late work. It is argued that a painting such as the second *Crowning with Thorns*, about which there is no documentation – but which is understood to have been left behind in Titian's studio at the time of his death – would have looked a lot more like *Tarquin and Lucretia*, in terms of finish, had it ever been brought to completion.

But if *The Crowning with Thorns* was intended to look like *Tarquin and Lucretia* you would assume that the kind of agitated, hard-fighting underpainting seen in *The Crowning with Thorns* lurked beneath the well-finished surfaces of *Tarquin and Lucretia*. It doesn't. Having lifted the idea of the composition from a second-hand, popular source, establishing his own version of it relatively quickly, Titian made very few changes to it. The considerable amount of effort he put into the painting – evident in the micro-layers of dust between the levels of pigment – went into the expressions on the faces and into creating a *tour de force* of sumptuous contrasting texture.

The Crowning with Thorns, meanwhile, isn't a painting in the manner of *Tarquin and Lucretia* abandoned at an earlier stage of completion. It is simply a different kind of painting.

All his life, Titian had prided himself on his ability to second-guess the interests and expectations of the people who were paying him. In fact, he probably over-estimated his ability to match his style to the tastes and needs of practically any client. At the same time he was very aware of what people expected of him in terms of style, and liked to surprise and disconcert with subtle shifts in treatment and degree of finish – though only so far as they would be pleasurable to the client. If we accept that the first of the *poesie*, the fluid and impressionistic *Danaë*, was followed by the more conventional and smoothly finished *Venus and Adonis*, then we have to accept that Titian saw himself working in a number of different styles or manners that could be employed in different contexts. It could be argued, then, that *Tarquin and Lucretia* was created in response to the perceived tastes of one kind of client, Philip II, and *The Crowning with Thorns* for a very different kind of buyer. But how likely is it that Titian could – or would even have bothered to – maintain such a self-conscious and technically demanding approach into extreme old age?

If we look back to *The Death of Actaeon* we see that Titian had departed from – abandoned even – the time-honoured, painstaking

order of layering paint – of opaque scumbles and translucent glazes – by which a sense of physical substance had traditionally been built up in oil painting, in favour of a freer and – we would assume – more expressive way of working. In *Tarquin and Lucretia* the traditional order of paint layers is maintained – respected. How likely is it that, having broken from a way of working learned from his teachers, the Bellini, decades before, into a way of applying paint that must have felt more instinctive, more personal, he would then have gone back to his old way of working, an approach that must have felt laboured, constricting and artificial? Just as *The Death of Actaeon*, far from belonging to the era of the *poesie* – the 1550s – probably postdates *Tarquin and Lucretia* – and therefore attained its current appearance in the last five years of Titian's life – so *Tarquin and Lucretia* and *The Crowning with Thorns* represent different phases of Titian's development.

Tarquin and Lucretia was dispatched to Spain in August 1571, at which point Titian had five years to live; five years in which he went on putting marks on canvas, keeping an increasingly desultory eye on his business affairs and never quite retired – but went on experimenting and developing, while continually modifying and revisiting existing paintings.

It is a very Early Modernist approach to art – a way of thinking rooted in the Romantic Movement – to assume that the rougher, the rawer and the less finished inevitably represents the freer and truer. But there was even in Titian's time an understanding that the unfinished – the non-finito – could be expressive in its own right; an idea that went back to the sculptor Donatello in the late fifteenth century, and was exploited by Michelangelo, who deliberately left surfaces rough in his later works, stressing the effect of the gouge marks in the stone to indicate how far short the work had fallen of the superhuman ideal to which he aspired.

Titian's pupil Palma Giovane told the critic Boschini that 'the most sophisticated connoisseurs found Titian sketches entirely satisfactory in themselves, and they were greatly in demand since they showed the way to anyone who wished to find the best route into the Ocean of Painting'. Since Palma was referring to the *abbozzo* – the initial 'laying-in' of the composition with colour – to

a stage in a process rather than something that would be sold – he must have been referring to unfinished works that went on the market after Titian's death; and he made his comments to Boschini many years after the event.

It is, on one level, absurd to generalise about Titian's ways of working (even from one painting to the next), to talk about 'kinds' of paintings, as though an artist of his breadth and fluency would have been prepared to stick rigidly to one 'style' in each painting. Far from being a sudden departure from the methods of the Bellini, the freer, more expressive techniques seen in *The Death of Actaeon* – which give that painting its appearance of modernity – are apparent, to a degree at least, even in parts of *Diana and Actaeon* and the other great *poesie*, completed as much as fifteen years earlier. Titian had been developing and extending the established ways of applying paint almost from the outset of his career. Rather than having different 'styles', Titian had a repertoire of effects and degrees of finish, which he employed in varying ways with the conscious aim of making each painting unique.

Nonetheless, there is another version of *Tarquin and Lucretia* in existence, painted in a manner closely approximating that of *The Crowning with Thorns*, in the key of melting browns and golds and reds thought typical of those late, raw, undocumented Titians, yet with a generic quality, a crudeness even, about the faces that suggests that the painting isn't by Titian himself. Too much of the agitated brushwork feels simply agitated for its own sake, doesn't help to explain the form, as Titian's always does. Yet it suggests that the idea of a raw, stark last style, far from being an invention of the twentieth century, was sufficiently understood and appreciated in his own time for Titian's assistants to consciously mug up paintings in that manner for a clientele – albeit a small one – for whom the mixture of spontaneity and non-finito, the sense of striving for something that could never quite be achieved, represented desirable ideals in their own right.

A Roman soldier, a captain of the Praetorian Guard, who converted many to Christ, St Sebastian survived martyrdom by being shot with arrows before being beaten to death on the orders of the

Emperor Diocletian. And because the wounds from the arrows were thought to resemble the bubos, the tumours that were one of the first symptoms of bubonic plague, he became one of the saints most invoked in protection against the plague. In painting he was portrayed as a physically beautiful young man, naked except for a loincloth, the arrows penetrating his body at the points where the bubos most commonly occurred – in the groin and the armpit. That there was a degree of eroticism implicit in the image was understood and generally accepted.

Titian's first attempt at the subject was in the *St Mark Enthroned with Saints*, a *sacra conversazione* of the kind associated with Giovanni Bellini, painted during the great plague epidemic of 1510–12 that killed Giorgione – the shadow covering St Mark's face symbolic of the terror still hanging over the city. Here Sebastian stood serene at the side of the image, removed from the agony of his martyrdom, his smooth flesh rendered with a degree of glowing warmth and plasticity that astounded contemporary viewers. In Titian's next significant portrayal of the saint, in the Averoldi Altarpiece, painted ten years later, Sebastian wears an air of Michelangelesque idealised tragedy, his heroically muscled body hanging heavy from the tree of his martyrdom – an image that was the talk of Venice when first seen in 1522. Each of these earlier paintings can be seen as representing the era of its creation.

Now, fifty years on from the Averoldi Altarpiece, with the city on the verge of another cataclysmic epidemic, Titian returned to the subject in a painting that belonged to another age altogether – a mystical vision of the saint in exaltation, staring heavenward before a sky riven with apocalyptic chaos. The tree behind him is reduced to a dark blur, the body of the saint punctured by arrows in his arm and chest and midriff, formed from feathery flashes of paint as though the body were breaking down into the surrounding darkness. The reddish light falling on the saint, as if from some immense conflagration, and the blood trickling down his leg, compounds the mood of sacrifice and ecstatic suffering.

If the first of Titian's *St Sebastian*s might be seen as representing the serene classicism of the Early Renaissance and the second the heroic idealism of the High Renaissance, this last version of

the saint represented what? The mood of doubt and uncertainty that characterised the aftermath of the Renaissance – a period that had seen the break-up of Christendom in the Catholic–Protestant schism, the atrocities of the Sack of Rome, the Copernican scientific revolution that challenged the order of the God-centred universe?

Titian didn't think in terms such as 'Early' and 'High Renaissance'. But he understood all about changes in fashion and the social order and the immense gulf in time and consciousness that separated Bellini's era from the period of his own old age. It has been claimed that the imagery in certain of Titian's religious works provides evidence of sympathy for the Catholic reform movement; that details in other works refute aspects of orthodox Catholic dogma to a near-heretical degree; that Titian was in contact with Galileo's circle through his secretary Giovanni Mario Verdizotti.

It is certainly true that Titian's later religious works appear to reflect Counter-Reformation dictates on sacred images as laid down in the last session of the Council of Trent – in the way they emphasise direct emotional engagement with the subject by eliminating extraneous detail, making the images immediately comprehensible even from a distance. One of the ways Titian did this was by highlighting the subject or the central narrative incident against a dark background in a way that looks forward to Caravaggio and Rembrandt. Yet Titian had been producing works like these years before the Council of Trent even met. And once you've realised that you can show the Virgin or Saviour against a plain background as you would in a portrait – as Titian did in the *Ecce Homo* of 1549 for Charles V – it became apparent that it was a very much quicker and cheaper solution for the artist than having to fill the space with buildings, landscape or other figures.

Yet this starkness does inevitably intensify and personalise the experience for the viewer. The artist having cleared away the clutter of donors and other associative, anecdotal detail – the dogs, the putti, the people leaning out of nearby buildings – the viewer becomes isolated with the subject. The experience becomes less collective, deeper, more intense, more personal. The extraneous is dispensed with, just as the world beyond the walls of the house in Biri Grande was receding beyond Titian's field of vision.

The mood in *St Sebastian* is visionary. We're looking up at the figure, which almost fills the narrow canvas, as a sculpture does a niche. The canvas has been extended from the original waist-length composition, and our eyes are drawn inexorably up the long body towards the face – the head seeming to press up towards the top of the canvas; the eyes swivelled up towards heaven, lips parted, brow creased in a mixture of anguish and spiritual rapture – the eyes with their gleam of faraway fervour already remote from the agonies of this world. Instead of the dense, opaque darkness of the *Ecce Homo* there's a smouldering swirl of dark cloud, bars of pink and orange evoking a sunset that seems to dissolve into the ashy earth. As in the *Nymph and Shepherd*, another problematic work of this period, which deliberately evokes and refutes the bucolic innocence of Titian's early mythology paintings, there's a sense of the serene blue distances of those formative landscapes breaking down into apocalyptic chaos. The windswept background of the *Nymph and Shepherd* is dominated by a shattered tree stump, a slightly ominous pink glowing through a miasmic grey, while the sky on the left in *St Sebastian* breaks down into indecipherable, near-abstract marks suggestive of some cosmic conflagration. On the ground below, a blurred mass of lighter marks shows where the saint's breastplate would have lain, had Titian finished the picture. There had been a minor outbreak of plague in Venice late in 1575, the number of fatalities rising during the spring of 1576. This painting was probably commissioned as an ex-voto, designed to commemorate a vow made for the deliverance of the patron and his family. The fact that the painting was never finished suggests that the patron died in the plague that devastated the city over the following months – as, in all probability, did the artist himself.

15

The Last Painting

THE ARCHBISHOP'S PALACE in Kromeriz was a place of vast, ornate rooms that could be viewed only through a guided tour – in Czech – the large crowd listening with immense patience as every piece of furniture was itemised, every minor painting, every vase, every one – it seemed – of the hundreds of roebuck heads crowding the walls of the hunting hall, shot during the visit of Tsar Alexander III and the Emperor Franz Joseph in 1885, each with the name of the prince or duke who shot it neatly inscribed beneath. I was back in Habsburg territory. In 1848, a congress of Slavic deputies was held in the palace's massive white and gold assembly room to hammer out a constitution that would save the already ailing empire. But I don't suppose that Franz Joseph (the great-great-great-great-great-great-great-great-great nephew of Charles V) could have imagined then, or on his subsequent hunting trip, for which the palace was entirely redecorated, that he would effectively be the last Habsburg ruler. All of which has nothing to do with how Titian's most controversial painting came to be here.

In the throne room, a large, wood-panelled chamber covered in a chequer board of paintings mounted directly on to the walls – mostly mediocre copies of paintings from Vienna – was a black panel, between the two main windows, where *The Flaying of Marsyas* hung until the 1960s.

As soon as the guided tour was over, I rushed upstairs to the picture gallery, hoping to get there before the rest of the throng. But the rest of the throng never came. The gallery remained deserted. And, in the fifth room, I found the painting, rather poorly lit from above by four small spotlights, so that you really had to look into it to see what was going on – and hung rather high on the wall, so that you were looking directly into the atrocity, your eye-line level with Apollo's hand and knife, his face lit by the glow from Marsyas's livid flesh as he calmly tore the skin from the hapless satyr's body. And below that was the haggard, inverted face of Marsyas himself, hanging upside down, staring reproachfully back at me out of the ashy dimness.

In Ovid's *Metamorphoses*, the satyr Marsyas found a set of reed pipes discarded by the goddess Athena and, delighted with the sound they made, challenged Apollo to a competition on the understanding that the winner could do what he wanted with the loser. Apollo won playing his lyre, and to punish Marsyas for his hubris – his presumption in challenging a god – he skinned him alive.

'Help!' Marsyas cried. 'Why are you stripping me from myself? Never again, I promise! Playing a pipe is not worth this!' But in spite of his cries, the skin was torn off the whole surface of his body: it was one raw wound. Blood flowed everywhere, his nerves were exposed, unprotected, his veins pulsed with no skin to cover them. It was possible to count his throbbing organs and the chambers of his lungs, clearly visible within his breast.

> Then the woodland gods, the animals who haunt the countryside, mourned for him – his brother satyrs too . . . and the nymphs and all who pasture woolly sheep or herd cattle in these mountains. The fertile earth grew wet with tears, and when it was sodden, received the falling drops into itself and drank them into its deepest veins. Then from these tears it created a spring which it sent gushing forth into the open air. From the source, the water goes rushing down to the sea, hemmed in by sloping banks. It is the clearest river in Phrygia, and bears the name Marsyas.

Titian shows the satyr suspended by his feet from a tree – his hairy ankles secured with disturbingly festive-looking red ribbons – his

bound hands hanging on the ground beneath his head, as the kneeling Apollo strips the skin from his chest, a bearded Scythian shepherd going to work on his shaggy haunches. To the left, a youthful musician crowned with laurel leaves looks up with an expression of anomalous, light-hearted exaltation, bow poised to strike the strings of his violin, while to the right a satyr approaches, bucket in hand, and King Midas, who was called upon to judge the competition, gazes impassively on. A small, naked child-faun looks out at us as he strokes, or perhaps restrains, a large dog, while, at the very bottom of the painting, a tiny, shaggy-tailed dog laps at Marsyas's spilled blood.

And all around this incident, nature is in a flurry of agitation, the vegetation of the forest a furious mass of rustling leaves, the sky crowding in around the figures in a mass of whirling smoke-like marks, white muted with earthy reds and browns. There is no distance in this painting, no comforting orderly elsewhere – no way out of the image – the figures crowded on to the surface of the painting seem unnervingly near, figures, flesh, foliage, air, flaring up on to the surface of the canvas in masses of featherlike marks.

Marsyas's flesh seems to ripple over his body in blue rivulets, running in a near-liquid mass blurred on to the canvas with the artist's fingers – yet which feels nonetheless agonisingly alive. But the most disturbing thing about the painting is the apparent passivity of the onlookers: the musician, the satyr, the little boy-faun and the pensive Midas. What are they doing? Why are they there? And, since they don't appear to be doing anything to stop it, they are implicated in the horror. And as we look into the face of Midas, his hand over his mouth in that troubled gesture, the old man condemned to look on, to observe whatever is before him without flinching – at the broad brow, the long nose and the pointed white beard – we see that they are Titian's own features.

Before the 1980s, *The Flaying of Marsyas* was hardly known. It is believed to have been among the paintings left in Titian's studio at the time of his death, but of the circumstances surrounding its creation absolutely nothing is known. In 1620 the painting was bought in Venice by Thomas, Earl of Arundel, a favourite of James I, and the most influential collector in England at the time. After his death in 1654, the Howard collection was sold in Amsterdam, and *The Flaying*

of Marsyas bought, along with several other Titians, by the Cologne dealers Franz and Bernard von Imenstraed. In 1673, they sold the painting as part of a job lot of two hundred Venetian paintings to Karl von Lichtenstein-Kastelkorn, the fabulously wealthy Archbishop of Olmuc, who put it in his summer palace in Kromeriz. From then on, the painting was all but forgotten, rarely seen by scholars, but known by repute as a morbid curiosity of dubious authenticity. Even after the Austrian scholar Frimmel declared it a genuine Titian in 1924, the painting's authenticity was often contested. In 1962, the Czech art historian Jaromir Neumann included it in a definitive catalogue of Titian's works of the 1560s, and it was moved from the palace staterooms to a privileged position in the picture gallery. But it was only when it appeared in London in the Royal Academy's blockbuster 'Genius of Venice' exhibition in 1983 that *The Flaying of Marsyas* was really seen by the rest of the world.

Beside the jewel-like colours and lustrous surfaces of Tintoretto, Veronese, Bassano and even of the younger Titian, the painting had a quality of blasted rawness that made everything around it appear callow and facile. The lack of prettifying antique finish, the blurring of the distinction between subject and background, the 'all-over' nature of the treatment – the way the agitated brushwork seemed to express the violence of the subject over every inch of the canvas – even the obviously unfinished areas and inconsistencies in treatment, all seemed marks of the painting's modernity. The uncompromising bleakness of the subject, the deadpan nature of the treatment – the complete absence of the melodrama and hysteria you'd expect to find in, say, a baroque treatment of the subject – seemed to tap into a strain of nihilistic pessimism that runs through Western culture from *King Lear* to *Waiting for Godot*.

The Flaying of Marsyas was a harrowing message from history about how a great artist even in extreme old age – perhaps particularly in extreme old age – could arrive at a statement that completely transcended the aesthetic norms of his time. This was Titian's testament to his followers, his final meditation on the nature of suffering, a painting in which, according to the British art historian Lawrence Gowing, 'the tragic sense that overtook Titian's *poesie* in his seventies reached its cruel and solemn extreme'.

I saw the painting on that first outing in the West. I saw it again, twenty years later, at the monumental Titian exhibition at the National Gallery in 2003. It's one thing to see a painting like this in the crowded rooms of an exhibition, surrounded by people cooing about what a magnificent, extraordinary work it is, and quite another to be alone with it hour after hour. Yet what I found most disturbing about this painting as I sat there in the deserted gallery in Kromeriz was the idea that the picture hanging on the wall in front of me wasn't the painting I'd come halfway across Europe expecting to see.

While the subject may have been unfamiliar to twentieth-century gallery goers, it was far from peculiar to Titian. Raphael, Perugino, Tintoretto, Bronzino, Parmigianino and many others all created versions of the story of Apollo and Marsyas. Titian, indeed, didn't even invent his own composition, but took his starting point from a fresco by Giulio Romano in the Palazzo Te in Mantua, an image he may have known from a drawing that is still in existence.

The disposition of the figures, with the shepherd standing above Apollo and the bucket-carrying satyr approaching from the right, is too similar to be accidental. But where Giulio shows the incident from the side, Marsyas flexing his leg in agony, Titian twists the axis of the image towards the front, so that Marsyas's shaggy legs, spliced to the branches with those cruelly mocking red ribbons, are pulled apart in a striding movement that animates the top half of the canvas, while his half-flayed torso hangs directly parallel to the picture plane in a manner inescapably reminiscent of images of Christian martyrdom; which makes the painting, in effect, an inverted crucifixion.

The boy-satyr who looks out at us recalls the image of the child who invites our prayers in the typical Early Renaissance altarpiece, while the little dog, lapping up the satyr's blood, far from reflecting the darkness of the aged Titian's imagination, was a standard device in images of Christian martyrdom.

Titian would have witnessed scenes of real brutality during public punishments in Venice: people dragged through the crowds to be beheaded, hanged or broken on the wheel in the Piazzetta outside the Doge's Palace – and don't think that mere squeamishness or some vague sense of humanity would have kept him away.

Yet, however inured Titian may have been to images – and even the reality – of violence, and however casually the story of Apollo and Marsyas may have been invoked in the culture of the time, it is inconceivable that he could have engaged with the idea of flaying without bringing to mind one of the most notorious incidents of the time, an event that haunted the Venetian imagination for decades – which came to be seen as a kind of secular martyrdom, a martyrdom for the Venetian state: the fate of Marcantonio Bragadin, Governor of Famagusta, the last Venetian enclave in Cyprus.

After a siege of thirteen months that saw the inhabitants reduced to starvation, the Venetian garrison surrendered to the overwhelming Turkish forces on the understanding that all lives would be spared. At first, the evacuation proceeded smoothly, but after a dispute between Bragadin and the Turkish commander, 350 of Bragadin's captains and soldiers were beheaded and cut in pieces. Bragadin was kept alive for a further two weeks and subjected to appalling cruelties before being skinned alive in Famagusta's central square.

Two months later, on 6 October 1571, the combined naval forces of the Holy League – Venice, the Papacy, Spain and Genoa – destroyed the Turkish fleet at Lepanto off eastern Greece. But the euphoria with which the news was greeted in Venice – with firework displays over the Lagoon and the entire Grand Canal lit with torches – was tempered with residual horror at Bragadin's fate.

Yet for Titian's contemporaries, like the critic Lodovico Dolce, the story of the flaying of Marsyas was uncomplicated. The satyr was guilty of hubris, the arrogance that invites disaster. He had challenged the gods and, like Actaeon – torn to death by his own hounds for looking on the naked Diana – he must be punished. This was the inexorable logic of myth.

Lying on the seat beside me was a booklet I had bought in the palace bookshop, written by a Czech scholar, which gave a more obscure reading of the painting. Packed with diagrams that divided the painting according to the Golden Section – the supposedly divine proportion that underpins most, if not all, Renaissance painting – the text argued that, rather than being a mere illustration of an antique fable or a more generalised meditation on the nature of suffering, the painting was a mystical allegory in which, far from being destroyed

by Apollo, Marsyas is 'initiated' by him – raised to a higher level of consciousness.

In one diagram, diagonals connecting the various elements in the composition formed an inverted star, at the dead centre of which lay Marsyas's navel, the part of the body which, according to occult lore, forms the centre of every circle.

In the Neoplatonic philosophies developed during the Renaissance, which tried to reconcile pagan mysticism with Christian morality, Apollo, god of reason and light, was associated with Christ – the 'way', the redeemer. Dante had called out, at the beginning of the *Paradise*, for Apollo to liberate him from the prison of the body. In the interpretation expounded in this booklet, *The Flaying of Marsyas* was an allegory of the arts in which the lower music of the pipes, which excites the body and the senses, is defeated by the higher music of the lyre, the divine music which carries the soul to heaven. So the apparent martyr, Man-Marsyas, is redeemed by Christ-Apollo, his trial by physical suffering leading to his purification, as he is washed with water by his fellow satyr, cleansing his soul of earthly inclinations.

Two circles radiating around Marsyas's navel represented spheres of consciousness – a central one, closest to the navel, containing the kneeling Apollo, the head of Marsyas and the Scythian shepherd, represented the lower life ruled by instinct. The outer circle, holding the figures of the fiddle player, the satyr with his bucket of water and the small boy-satyr, represented higher spirituality.

And on the line between the two spheres sat the philosopher-king Midas – the intermediary – who hasn't yet attained the higher level of consciousness but who understands the significance of what is taking place before him, a figure played by Titian himself, who, according to this text, was a master of esoteric symbolism, consulted by artists and architects on matters of numerology and Neoplatonic lore.

Sitting on the seat in the middle of the gallery, looking across at the dark whirl of the painting, I felt tired. I was weary of theories and counter-theories. On top of all the impressions I had formed of Titian – the canny businessman, the formidable craftsman, the great poet of the senses – now I was being asked to consider Titian the occultist, Titian the magus.

It was apparently true that Titian had advised his friend Sansovino on the proportions of the Church of San Francesco della Vigna, a building which, like most of Titian's paintings, was based on the mystic number seven. But then, because he had studied classical geometric principles since childhood, Titian's use of the Golden Section and the Fibonacci Series would have been instinctive. Probably most Renaissance paintings were based on the number seven.

But that didn't mean that the booklet in my hands could be written off as the quirky ramblings of some provincial academic. Its ideas were touched on in one way or another in most analyses of the painting. And while there's no shortage of violence, energy and anger in Titian's paintings – from the nocturnal chaos of *The Martyrdom of St Lawrence* to the knife-point rape of *Tarquin and Lucretia* – *The Flaying of Marsyas* is oddly tranquil in mood; a tranquillity that feels unnerving – an aspect of Titian's disturbing detachment – until you realise that it was probably intended to be taken at face value. The standing musician figure celebrates Marsyas's release from the bonds of the flesh, while the satyr with the bucket, who can – if you want to see it that way – be described as cheerful, has come to complete Marsyas's initiation by washing his wounds – never mind that the idea of water on raw flesh is too excruciating even to think about – and why else would he have the bucket? Indeed, looking back towards the bottom of the painting, meeting Marsyas's harrowing stare, you have to ask yourself what that expression means – if, far from reproaching us for our inaction, Marsyas isn't simply accepting his fate with equanimity. Certainly there's little sense of protest.

It isn't as though people in earlier times were entirely indifferent to the horror of such images. In Giulio Romano's drawing the satyr cries out, his body racked with pain, his right leg flexing in agony, while Midas shields his eyes from the horror. Ovid, who lived fifteen hundred years before Titian, encourages us to empathise with the agony of Marsyas as his screams fill the forest. But, then, Ovid intended his tales of the cruel and arbitrary punishments meted out by the gods as a veiled critique of the Emperor Augustus. In Titian's time, these stories were reinvented as allegories of power, of the oblivion facing those who rebel against divinely ordained authority.

Mary of Hungary, sister of Charles V, had commissioned a series of paintings from Titian for her chateau at Binche in Flanders, of the Furies, of the torments visited on those who defied the gods – on Sisyphus, for example, condemned to push an immense boulder up a hill, for ever. Beside them hung paintings by her court artist Michel Coxcie of *The Contest between Apollo and Marsyas* and *The Flaying of Marsyas*. Was Titian's painting of the latter subject intended eventually to replace Coxcie's effort, a work that was abandoned when Binche was sacked by the French in 1554?

Was that what Titian was interested in exploring in his last days? Recondite meditations on the relative merits of high and low art? Abstruse allegories about the redemption of the soul? Yet another painterly reification of the power of the Habsburgs?

Yet Titian would never have accepted that a painting could be a mere ragbag of resonances. There had to be some underlying central meaning. If Titian had taken on a subject such as this, it was because someone had asked him to. Far from being Titian's moral testament – one of the most personal of all his works, his final statement on the pitilessness of the cosmos – *The Flaying of Marsyas* was just another commissioned work. And it wasn't his first attempt at this subject. As with *The Crowning with Thorns*, it was a return to an image he had tackled many years earlier. Behind *The Flaying of Marsyas* are hidden other images, other paintings of whose existence we are only dimly aware.

On either side of the painting, the windows were filled with the white glitter of the Grand Canal, the reflected shimmer dancing up over the walls and ceiling of the great room. And in the shadow between the two tall windows, but clearly visible in the brilliance of the reflected light, were the features of the inverted Marsyas, the glow of his livid flesh reflecting on to the face of the god, perhaps even more strongly than in the painting in Kromeriz, the same gauzy crimson scarf trailing over Apollo's back. Yet where the boy-satyr and the larger dog should have been, a white jug lay on the ground, and, rather than playing a modern violin – a viola da braccio – the musician figure held a classical lyre to his ear, his look of exaltation replaced by a knowing, even a mischievous expression as he stared directly out of the painting at the viewer.

It was as though I was looking at the ghost of the other painting, a projection of it in the mind that troubled because it was obviously closely related to it, but was too different from it in too many details and overall treatment to be derived directly from it, to be anything approaching a copy.

The owner of the painting stood beside me, tall and spare in a Harris tweed jacket. 'I bought it not so much as a painting,' he said, 'as an intellectual problem.' And the nature of that problem was what precisely we were looking at.

'Some parts, I think, are better than the painting in Kromeriz, for example . . .' He pointed to Midas's forehead, the pensive eyebrows and the long nose – all universally agreed to resemble Titian's own features – the hand covering the mouth in that troubled gesture. They were more smoothly painted and with a more obvious sense of three-dimensional form, the old king's jewelled tiara seeming more of a piece with the hair and the rest of the head than the one in Kromeriz, which always looked to me as though it had been added later; though whether they were actually better I wasn't quite convinced.

Since I first arrived in Venice, I'd thought of the image of the aristocrat hanging on in his crumbling palace, surrounded by heirlooms, some of which went back to the time of Titian, as essential to the kind of book I was trying to write.

Now here I was, standing in the study of a palace on the Grand Canal, being shown a Titian painting by its owner, a member of one of the city's most illustrious families. Never mind that there were no aristocrats in Italy, the nobility having been abolished in 1948. That my host, a noted architect, didn't live in this building, but rented the apartment as an office. That, far from having been in his family for centuries, the painting had been bought by him only two years before. And that it was a Titian painting that had almost certainly never been touched by Titian.

Marsyas's head was crude and mask-like, the head and shoulders of the satyr with the bucket and the Scythian shepherd painfully laboured and pedestrian in comparison with the agitated painterly energy of the figures in Kromeriz. Indeed, the whole painting seemed to have been conceived in a completely different spirit. Rather than crowding on to the surface in that flurry of apparently

impressionistic brush marks, the figures and the background were clearly differentiated, their forms more rounded, even Apollo's naked torso, which remained sketchy and inchoate, half-formed in the Kromeriz painting. The figures, the trees and the clouds floating in the blue sky all receded in space in a relatively conventional way.

This wasn't the ghost of the painting in Kromeriz. It was the ghost of a different painting altogether. It had hung for centuries in a private collection in Venice, written off as a grotesque pastiche, before being 'discovered' after the revelation of the Kromeriz painting in the 1980s as a possible clue to the evolution of that work. But still no one had been able to summon any real enthusiasm for the painting. It had hung in a backroom at Volta's gallery for years, the canny father and son obviously not considering it worthy of inclusion in their own collection, before my host bought it as a poor studio copy of dubious provenance.

That Titian had copies made of his paintings by members of his studio as a form of record is generally accepted, though very few such works remain in existence. The painting I was looking at now was, conceivably, one of them. And if it departed from the painting in Kromeriz in terms of feel and treatment, that wasn't simply because whoever had done it was too incompetent or too lazy to copy that painting as it actually was, but because it represented a completely different period of Titian's development.

It was generally accepted that the painting now in Kromeriz was at some time in the ownership of Titian's former pupil, Palma Giovane, who had made his own revisions to the painting. X-rays showed that beneath the standing Apollo/musician figure there was another character altogether, playing not the modern viola da braccio, but an ancient lyre, and standing in a position very like that of the figure in the painting in front of me now. Indeed, if you examined the viola in the Kromeriz painting, you saw that it was painted in a literal, pedantic style out of key with most of the rest of the painting. Was it not possible that Palma had also added the boy-satyr and the larger dog, covering up the white amphora that occupied the same area of the Venice painting? Was it possible that this painting was a copy of the Kromeriz painting as it had looked before Palma Giovane got his hands on it?

Yet when you compared the treatment of form and space and light in the two paintings – the sunny blue sky with evenly spaced, almost decorative clouds – the carefully delineated tree trunks receding in space in the Venice painting, and then the agitated blurring of the Kromeriz painting – it was apparent that the Kromeriz painting had never looked like this painting; not unless Titian had reworked the picture so extensively that he had entirely obliterated one from an earlier period. (And while that wasn't impossible, it didn't seem typical of Titian's way of going about things.)

The framing of the figures and the central tree against the blue sky with clouds, seen slightly from below, put me in mind of another important tree in another important painting – the Tree of the Knowledge of Good and Evil in Titian's *The Fall of Man*, painted around 1555, about twenty years before the painting in Kromeriz.

In the early seventeenth century, a painting of *The Flaying of Marsyas* was described as hanging in Venice, in the collection of a Signore Michele Spietra della Contrada. This painting was sold in 1656, but another painting of the same subject was recorded in the eighteenth century in Modena. Was it possible that these two paintings were the same work – the painting from which the picture in front of me now had been copied?

But once again we're losing track of Titian himself. Once again his paintings have become objects floating in time – vehicles for theory and the accumulation of data – that have all but lost their connection with the man who created them. Titian had returned to this subject in his last years, just as he had with *The Crowning with Thorns*. While pagan subjects were unfashionable in the spiritual climate of the Counter-Reformation, there may have been some sophisticated, and probably very wealthy, connoisseur who would have valued such an image, particularly when rendered in the painterly non-finito of Titian's last style. Or had the artist, sorting through the racks of paintings in his studio – the unfinished or uncollected works, the prototypes of popular subjects kept for making replicas and variants – come across some form of record of the earlier version of *The Flaying of Marsyas* – conceivably even the painting that was in front of me now – an image, no matter how bad, that had inspired him to have another attempt at the subject?

We imagine Titian still painting in his studio in his last days, shaky-handed, his sight so diminished he can barely see what he is doing, carrying on painting as a kind of reflexive therapeutic activity, because it is almost the only thing that confirms he still has some function and purpose in this world – creating those final paintings almost by accident.

Yet looking at the version of *The Flaying of Marsyas* in Kromeriz – the vigour with which those shaggy, striding legs have been brushed in against the lighter chaos of the sky behind, the way the arms of the Scythian shepherd have been touched into existence literally with the artist's fingers over the darker underpainting, the animal energy of the satyr leaning in on the right, the steely tension running through the right arm carrying the bucket, we have to face the fact that these are among the most powerful passages Titian ever painted. The hand and eye that created them retained a formidable grip on their chosen medium. And, standing back from the painting, and noting its relatively narrow tonal range – the fact that it lacks dramatic contrasts of light and dark or of colour – we have to concede that whoever painted it was very far from blind.

As I peered through the entryphone panel into Titian's garden, there were at first only the faintest pinpoints of light. I thought for a moment that it had been boarded up from the other side. But then the patches of light grew larger, and I could see that the vegetation had grown out over the pathway, obscuring the view of the house beyond. Bare and black, the thorny tangle gave the garden a beleaguered, derelict look, though from what I could make out of the house itself it looked much the same as before.

Venice in February seemed to have reverted to an earlier version of itself, to have become again just the place where the Venetians lived; another slightly grumpy northern Italian town – a city of dark tenements, riven by gaunt alleyways and areas of still, dead water, into which the beams of the low winter sun seemed barely to penetrate. And once the sun went down it was bone-achingly cold.

It was dusk. I had in my pocket a letter, addressed to the owner or any other occupant of Titian's house, written in an oleaginous, ambassadorial prose almost worthy of Titian himself, explaining the

purpose of my project and stating why it was necessary for me to see the interior of the house – if at all possible. My daughter's child-minder, a student of Italian and Russian – and half-Italian herself – had translated it. I had asked her not to overdo the oleaginousness, but she said Italians liked to make a good impression.

Still, I was only half-optimistic. Visitors, even in earlier centuries when the judicious proffering of a coin guaranteed access to most things, had found it difficult to gain entry. Josiah Gilbert, nineteenth-century author of *Cadore or Titian's Country*, had found the occupant – a *signora* – most unresponsive to his interest, and had to content himself with paying a neighbour to look down into the garden. Indeed, I had never met anyone who had actually been inside. Most scholars I had encountered seemed to feel that, since the interior had been substantially – even completely – remodelled, the building held little interest, and a friend of mine, a Venetian art historian who lived nearby, though he had made numerous attempts to peer over the wall, seemed to think it was 'almost impossible' to get inside.

The stonemason's workshop that was believed by some to have once been Titian's studio was shut and seemed now to be used as a storeroom. Through the glass doors, I could just make out the interior piled to the rafters with large objects shrouded in plastic sheeting.

It was almost dark as I turned into the Campo Tiziano. At the end of the tiny square, beyond the ancient wellhead, was another gateway into Titian's garden, and along the bare front of the adjacent building five front doors, each with a row of polished brass bell plates beside it. What was I going to do? Just ring bells at random? The end door would be the one to go for. Titian's own rooms, as I understood it, had been at the garden end of the house on the top floor, with the view over the Lagoon towards Cadore. But the whole building was in darkness, the larger upper windows all shuttered. Curved quasi-baroque bars projected from the mezzanine floor, which Titian had taken over to get rid of troublesome tenants, while the barred windows of the ground floor, which was traditionally used for storage, had a dusty, opaque, half-derelict look. But then, as I moved closer, I noticed a faint glow emanating from one of them – the window to the right of the second door from the end.

Moving slowly and quietly forward, I peered between the bars and found myself looking into a kind of workshop – dark and low-ceilinged, with a number of figures working intently over benches by the light of small lamps. I stepped back as the door swung open, and a middle-aged man in a loden coat stepped out. He was carrying a briefcase and looked as though he had been there on business. I proffered fumbling greetings, then handed him my letter. He read it with an expression of some concern, then rang one of the bells.

A woman's voice came over the intercom. The man spoke rapidly and intently into it. Then he turned to me with a polite smile. The woman was on her way. The door swung open and I was looking into Titian's house. The hallway was very brightly lit, the walls stripped back to bare pinkish brick along one side, white-painted wooden panels on the other. The woman, perhaps in her late fifties, seemed mildly perplexed, but not unfriendly. The man showed her the letter, explaining the situation as he understood it. She took the letter and read it with some care. A man appeared behind her in the doorway; pale and expressionless, he studiously avoided my gaze. He took the letter, and read it with a doubtful look.

The woman gestured for me to come inside. There was a large mirror along one side of the hall. A stone staircase at the far end led to the upper floors, and, beside it, set into the wall, was a painted silhouette of Titian, looking rather as he did in the statue in Pieve di Cadore.

'It isn't the original,' said the woman. 'That is in the Museo Correr.'

Now I was in the house. But would I be allowed to proceed further? After more discussion, the woman told me I should return at ten the following morning, when her daughter, who spoke English, would be there. I noticed that the door on the right, which must have led into the workshop, shone – a door of gold. On it was a brass plate bearing the word 'Battiloro'. The woman touched her chest and gestured to the man. '*Battiloro*,' she said. The man stared at the ground as though obscurely humiliated by the entire situation.

The following morning at ten I was back at Titian's house clutching a box of chocolates. I had looked up the word *battiloro* in my pocket Italian dictionary, but it wasn't there. The daughter, a pleasant-

looking person in her early twenties, stood by a dark, old desk just inside the entrance to the workshop. Beyond her in the low, wood-panelled room, women sat working intently at their benches.

She led me back into the hall up the white stone steps, which she told me were original – and, though they were very worn, I couldn't bring myself to quite believe it – on to a landing and down another flight into a dark corridor. All the time I was telling myself that I was in Titian's house, walking on stones that Titian himself had walked on. But we were moving too fast for me to really take it in. Did everything look old, or did everything look relatively new? It was impossible to tell. Then we were in the garden, walking through that space into which I'd peered so many times – but from the opposite direction. And it looked a lot sprucer and better tended from this angle than it did through the narrow grille of the entryphone.

The young woman told me that her family had rented the ground floor of the house since 1924. While they didn't have use of the garden, they had access to one particular area. We must be respectful, she said, so as not to offend the owners of the house. And who were the owners of the house? They are not here, she said.

As we approached the door to the street, she pointed to the small brass plate with its tiny grille, through which I'd peered so many times. 'This is very old,' she said. 'You can look into the street and see who is there.'

'So it's not an entryphone?'

'An *entryphone* . . .? No.'

Beside the door was a shed, in which her father, the pale, diffident man of the previous evening, sat at a hammer-like press. He glanced up, a touch sheepishly, as we entered. The hammer came thumping down on some dark substance, and, as he raised the hammer, the substance on the bench glinted. Gold.

'We are *battilori*,' she said. 'Gold-beaters.'

He held the diaphanous wafer up to the light, and turned to me with a smile. The thickness of the gold was measured as it always had been – by light. When he could see the sunlight passing through it was ready.

'The gold for the mosaics in the dome of St Mark's was all made in this house. The gold that covers the angel on the top of the Campanile, the gold for the gondolas of Venice, it is all made here.'

After glancing into a room where two women were powdering the leaves to keep them separate, we went back along the corridor and up the short flight of steps. From the landing I had a glimpse up the stairwell into the upper part of the house, where Titian himself had lived. I wondered if it would be possible for me to have a very quick glance up there.

'It is better not to, because that is where the owners live.'

But the owners weren't there.

'No, but there are the other residents.' I could sense she was becoming anxious.

Not even the tiniest look.

'I beg you, please do not.'

Back in the workshop, the young women breathed on the gold – just the faintest, most perfectly judged exhalation – as they cut it into neat squares. And all the time the reddish gold seemed to be in motion, a substance so fine it was scarcely quite material, that seemed almost liquid as it rippled over the benches, sensitive to even the tiniest current of air – before it was expertly caught, flattened and captured on to tissue. It seemed appropriate that this quasi-alchemical activity involving colour, texture and light should be taking place in Titian's house.

'Once there were three hundred *battilori* in Venice. We are the last ones. When I get married I will make a big cake and cover it completely in gold. I am a gold-beater's daughter. This is what I must do.'

I gave her the chocolates, and she handed me a small packet. 'Here is gold. When you are ready you can make a *risotto al nero di seppie* – risotto with squid's ink – and lay the gold on top. The gold and the black will look very beautiful together.'

As I headed off across the tiny square, I was aware of someone walking behind me. I turned to see a young man, slight in build with a wispy beard and dark glasses. He must have left the house just after me. I greeted him, and he responded cautiously, peering up at me over his dark glasses. He spoke English, and I asked him if he lived in the house. He said he did.

In the house of Tiziano?

'Yes.' He gave a guarded smile. He seemed the studious type; I took him for a fan of British and American Indie rock, someone I could easily get on terms with.

'What's it like living in Titian's house?'

He shrugged. 'It's great. To think of someone like that living in your house. It's . . . fantastic.'

'Have you seen any ghosts?'

'No, but I hope to.'

I wondered if I should ask to see his apartment. But it felt awkward – an intrusion. And I had just been in Titian's house.

'You like Titian's paintings?' I said.

'Of course.'

'Which is your favourite?

'*The Venus of Urbino.*'

'I knew you were going to say that,' I said.

Two days later, I was back in the tiny square. I thought I'd been in Titian's house. But I hadn't – not really. I'd been on the ground floor – where nothing of value was kept because of flooding – rooms which were used for storing – what? Jars of oil and wine, bags of flour for making bread? The upper part of the house, the mezzanine floor where the nuisance tenants had lived and the *piano nobile*, Titian's own domain, had remained tantalisingly off-limits – just a few feet away up those worn white stone steps. And the *battilori* – for all their kindness – only worked there. They had a very different relationship to the place than someone who lived there, who slept in the rooms through which Titian had moved, day in, day out.

It was Sunday afternoon, relatively warm, with a light, hazy winter sunshine. The window into the *battilori*'s workshop appeared impenetrably dark, as though they'd never been there. Indeed, the entire place appeared deserted, the windows towards the seaward end all battened down with thick brown shutters. Then I noticed that one of the windows on the top floor, two storeys above where I now stood, was unshuttered, a sun blind rolled loosely above it, a box of geraniums on the window sill.

I pressed the top bell, and I waited. There was no reply. I was almost relieved. That, perhaps, had been the owners' bell, and the daughter of the *battilori* had said they weren't there.

That left one more bell. I glanced up again at the unshuttered window, open a few inches in the winter sunshine. It was Sunday afternoon. These people were Venetians. They would be fed up to the back teeth with the interest of outsiders. What did they care if they happened to live in Titian's house? But, then, I was leaving Venice that night, and I had no plans to return. This was my only chance. I reached out and pressed the bell.

After a few moments there was a click, and I heard a woman's voice make a grunted response.

'*Buongiorno*. Is the – *il proprietario* – there?'

There was a burst of rapid Italian.

'*Scusa?*'

I heard a blunter phrase with the word '*nessuno*' – nobody, no one. Then underlining the message in English: 'Nobody!' The intercom went dead.

Why had I used the word 'owner'? She thought I meant the absentee landlord, when I meant the tenant, whoever lived in the house – *her*. Could I bear to ring the bell again?

'*Sì*.' The voice on the intercom was tight and hard.

'I'm very sorry to bother you. I'm an English journalist writing a book about Ti—'

'This is a private house. There is nothing to do with Titian here.'

'But . . .'

'I'm sorry.'

I walked away over the tiny *campiello*, along the alley and stood looking down into the freezing waters of the Rio dei Gesuiti. On the other side, a broad, blank wall shielded the back of the Church of the Gesuiti, where the first version of Titian's *Martyrdom of St Lawrence* still hung.

I had had a perfect opportunity the day before with the Indie fan. He was young, informal, open-minded – sort of. I could have talked him round. But I'd been so pleased at having been in the house at all, I'd let the moment slip by. It occurred to me that the woman on the other end of the intercom might be his mother. I turned back towards the Campo Tiziano.

I heard the intercom clicking into operation, but there was no voice.

'*Parla inglese?*' I said.

'*No.*'

'*Francese?*'

'*Un po'.*'

The barriers fell away, and I saw the way clear before me. '*Désolé de vous déranger, madame. Mais, j'ai une lettre vraiment importante – pour vous!*'

The intercom buzzed, and I stepped inside Titian's house.

As I mounted the worn white stone stairs, I saw the woman standing on the landing above – the woman with the fair hair, the glasses and the prominent teeth whom I had met going into the garden with her shopping that evening two years before. I had guessed then that, while she wasn't unkind, she wouldn't easily admit me into her house. I'd been right.

She read the letter carefully, then she led me up the last flight of steps, where the daughter of the *battilori* had begged me not to go. At either end of the top landing were dark wooden doors. She pointed to the one at the northern end, beyond which Titian's own principal rooms had been. 'That is where the owners live.'

'And where are the owners?'

'They are not here.'

She led me into a large and very light sitting room, with tall windows and an extremely high ceiling of dark, parallel beams. The room was attractively furnished with light-coloured sofas and modernish pictures, and so large that an entire extra floor had been inserted into the rear, accessible by a staircase running up one side of the room. But on this side, facing the *campo* and the garden, you had the full original height of the room. Looking out through the window I could see down into a neighbouring garden with a single bare tree and beyond it the back of the building – now the stonemason's workshop – that may have been Titian's studio. Now I did feel as though I was in Titian's house. I could imagine Titian's niece, Livia Balbi, who was reported to have been living in the house in 1574 – and whom I had always imagined as a rather coarse harridan – leaning out of the window to yell at someone in the yard below. I could imagine the servants, the assistants and Titian himself moving across the short stretch of garden between the house and the studio.

If I tried very hard, I could imagine the 'fine paintings, of which', according to the Florentine grammarian Priscianese, who dined here in 1540, 'the house was full' – that had hung in this very room, whose walls were big enough to accommodate all but the very biggest works Titian ever produced. And if I tried very hard, I could imagine the place as Pomponio found it when he arrived here early in September 1576, to find the shutters closed, furniture and other objects thrown about and the stench of death still thick in the air.

All those with the wherewithal and the opportunity had already left the city. Their houses stood shuttered and deserted. At the beginning of June 1576, the papal ambassador wrote that 25,000 had fled Venice, an estimate that accounted for about one-sixth of the population.

Plague began with the poor, in the most overcrowded, insanitary districts where the air was foulest. Plague was understood to be first and foremost a disease of the air, that developed through noxious miasmas which formed over places as a sign of divine displeasure. That the disease was contagious had been recognised for centuries – giving rise to a whole range of preventative measures, many very effective. But the precise means of contagion were imperfectly understood. Malnutrition, polluted water, putrefying refuse, careless hygiene and loose morals were all thought to be contributing factors. And once established, the contamination thrived in confined spaces, in the stinking, overcrowded tenements of the Venetian slums. The poor suffered first and most in any plague epidemic. Yet it was considered a defining symptom of 'true plague' that, once settled, it would strike at people of all classes, no matter how spacious and well ventilated their houses, no matter how virtuous and well ordered their manner of life. Indeed, the most terrifying thing about plague was the randomness, even the capriciousness, with which it struck. Beggars and vagrants might be left in perfect health, while members of Venice's most exalted families were seen naked in the pest-houses, stripped of every badge of rank and trace of human dignity.

The surest means of ensuring survival was to leave the city, as Titian had done on many other occasions. He had the money, and he had somewhere for himself and his family to go – his house in Serravalle, and the possibility of moving further north to Pieve if

it became necessary. But he was now old and very frail. There was a belief, particularly among those of a religious disposition, that it was impious to attempt to evade one's destiny. Penitence was the appropriate response to a challenge such as the plague, and it was futile to try to escape the preordained date and manner of your death. There was a counter-argument that fleeing, surviving and continuing to support your dependants might also be part of God's plan. But while such a course would have been understandable in a man of thirty or even fifty, it would have appeared unseemly in a man of over eighty – even if he had had the physical strength to attempt it. And if Titian had wanted to go, it was now too late. All routes in and out of the city were closed.

There had been a minor outbreak of plague the previous July, the number of fatalities increasing over the following months. Between August 1575 and February 1576, 3,696 deaths were attributed to the plague. While winter slowed the progress of the disease, with few deaths between March and May, thirty-one people died in the first week of June, causing widespread panic. Statutory measures for times of plague epidemic were brought into effect by the Health Office – the Provveditori di Sante. All assemblies, schools, concerts, fairs and markets were banned. Every dog and cat that could be found in the city was put to death. Any house discovered to be infected was immediately isolated, the sick sent to the Lazaretto Vecchio for treatment, the healthy to the Lazaretto Nuovo for forty days' quarantine. Household goods were removed for disinfection or simply burnt. Close contacts of the sick were confined to their homes, the doors of which were boarded up. Districts where the plague was particularly virulent were placed under collective quarantine and only priests and doctors permitted to enter.

But within days of these measures being brought into effect, a team of five university professors arrived from Padua at the invitation of the Collegio, headed by Girolamo Mercuriale, professor of practical medicine, who had decided before he even left Padua that the disease besetting Venice was not plague.

The impositions of the Health Office would have brought trade to a standstill, ruining many in the merchant classes and forcing thousands among the poor into destitution. And while the *lazaretti*

were by all accounts quite pleasant places under normal conditions –
clean and spacious with a diet far better than most Venetians enjoyed
from day to day – at times of epidemic they became places of dread.
Who wanted to see their children or parents or spouse stripped
naked and carried away to a hideous death among thousands of other
tortured souls? Who wanted to see their worldly goods carted away to
be burnt on the orders of a few doctors and bureaucrats who were, in
all probability, exaggerating the situation for the furtherance of their
own interests? It was incumbent upon those in power to postpone the
moment of diagnosis as long as possible.

A debate was convened in the Sala del Maggior Consiglio, in the
presence of the doge, between those who defined the disease according
to symptoms and those who defined it according to specified over-
arching criteria. The doctors of the Venice Health Office pointed to
the presence of bubonic tumours behind the ears, in the armpit or
groin of most victims. The Paduan professors argued that, since most
of the victims were drawn from the poorer classes, the illness was not
fatal in all cases and insufficient numbers of people were contracting
it, it could not be considered 'true plague'.

When the doge and his officials decided to back him, Mercuriale
offered to treat the victims of the disease on the condition that the
Health Office was put under his control. The sealing of houses
and use of the *lazaretti* were immediately curtailed. The use of the
traditional white boats to transport victims and the painting of crosses
on infected houses were abandoned.

A great wave of relief passed through the city. The Paduan
professors were the heroes of the hour. Entering the houses of the
sick without fear, they were fêted as saviours wherever they went.

But, then, in the last week of June, the death toll rose to ninety-
five. In the first week of July it reached 171. Too late, it was realised
that delays in diagnosis had exacerbated the spread of the disease.
The Paduan professors now found themselves in quarantine.

Titian had been working on the painting that would hang over his
own tomb for months, if not years. He had a long-standing agreement
with the monks of the Frari that, in return for this work, he would
be buried in the Chapel of Christ, in the church that had seen two of

his greatest triumphs, *The Assumption of the Virgin* – the painting that had swept him to European fame – and *The Madonna di Ca' Pesaro* – his monumental reworking of the traditional *sacra conversazione*. The painting Titian conceived of for this space was not in any sense modest.

Almost exactly a century before, at the height of another plague, Titian's teacher, Giovanni Bellini – then approaching fifty – had painted a votive altarpiece, perhaps the most serene and majestic of his *sacri conversazioni*, for the Church of San Giobbe, showing the Madonna enthroned beneath a gold mosaic cupola, flanked by saints, including two of the great plague saints – Job (Giobbe) and Sebastian.

Now Titian, who had returned so many times in his career to the ideas of his teacher and of his other great mentor, Giorgione – and always with the intention of bettering them – attempted to square the circle one last time with a painting that was a kind of apocalyptic restatement of the classic *sacra conversazione*.

Beneath a gilded mosaic cupola that was at once an overt homage to Bellini, and a reference to Venice's Byzantiane past, Titian showed the pietà – the Virgin holding the body of the dead Christ – the crowd of the holy that hems in the Virgin in Bellini's painting replaced by just two saints, figures conceived with a stark monumentality. The pure and limpid daylight that bathed Bellini's painting – so essential to its sense of reassuring serenity – had given way to a nocturnal foreboding, the scene lit by blazing lamps around the monumental niche that rises behind the Madonna and a torch carried by a rather sinister-looking putto.

The saints in Titian's painting aren't the popular plague saints Roch and Sebastian, whose cults were frowned upon in the new Counter-Reformation orthodoxy, but two more mainstream, more establishment saints: the Magdalene, the reformed prostitute who was the first witness to the Resurrection, who, Titian told a visitor to his studio long years before, had particular importance for him, and St Jerome, who gave up everything for meditation in the desert and translated the Bible into Latin, whom Titian had painted at least three times before, always with features strongly resembling his own.

And in the centre of the painting, close between the two saints, but somehow remote, somehow beyond them, was the pietà, the Virgin

and Christ – the tenderness and intimacy of the Madonna and Child echoed, projected forward into the hours after the Saviour's death. The mother holds her dead son, who is now physically far bigger and heavier than she is; an image that had become irrevocably associated with an artist who embodied completely different aesthetic ideals, yet against whom Titian had always consciously pitted himself – Michelangelo. The Florentine sculptor had made the image of the pietà his own, in three transcendent masterpieces, in the last of which, created to stand over his own tomb – but never finished – he showed himself in a dominant position, as Joseph of Arimathea, supporting the body of the dead Christ.

Titian showed the Virgin not as aged, haggard and grief-stricken, as she would actually have been, but as young and serene – as Michelangelo had portrayed her in his first great pietà in the Vatican – existing already in a dimension beyond time; holding the pale, waxen, yet curiously weightless body of her son. And at her feet, naked except for the pink identifying cloth of St Jerome, the artist has shown himself with his pointed beard and thinning white hair, kneeling, holding the hand of the Saviour, his right hand tenderly supporting the master's shoulder – and peering up into his blessed face. And while it would have been considered unacceptable in the spiritual climate of the Counter-Reformation for an artist to represent himself as a saint – still less touching the body of the blessed Saviour – Titian would have argued that it wasn't him, but St Jerome, that this was simply the way he painted old men.

The painting was full of symbols of the Resurrection, the hope of redemption extended to every Christian: statues of Moses and the Hellespontic Sybil, both of whom foretold the Crucifixion and the Resurrection; the plinths on which they stood carved with the faces of lions, whose whelps die for three days, only to be reborn as their fathers breathe life back into them; the pelican picked out in mosaic in the golden half-cupola, who tears apart her breast to feed her young with her blood – an ancient symbol of sacrifice and the Eucharist – while the dark-winged angel hovering above the scene is holding an Easter candle.

Yet if the imagery speaks of hope and salvation, through Christ's sacrifice for us, the manner of the painting's execution is imbued

with a sense of terror and awe in the face of the oncoming ordeal –
the atmosphere of nocturnal bleakness, the small scale of the figures
against the brutal starkness of the architectural background, the
exhilarating looseness of the handling of the paint, so different from
Bellini's cool, clear forms; the certainty and the serenity expressed by
Bellini's painting – they're all gone for ever.

Yet Titian has mitigated this pessimism through the act of painting,
by choreographing and validating his own death, something which,
as a painter, as a creator of images – perhaps the *greatest* creator of
images – is within his power.

After its completion, the painting was exhibited in the Frari, in
the Chapel of Christ. But the chapel was the focus of a cult based
around a miracle-working crucifix, and the friars were reluctant to
disrupt this worship. The painting was removed from the chapel in
March 1575, on the orders of the papal legate. Piqued, Titian decided
he wouldn't be buried in Venice at all, but in his own country, in the
Vecellio chapel in the parish church of Pieve di Cadore.

The painting was now back in Titian's studio, and, a year later,
as the number of deaths from plague was mounting in the city, two
tiny paintings were added to the work – illusionistic images, leaning
against one of the lion plinths, as casually and matter-of-factly as if
they were leaning in a corner of Titian's studio. One was a shield
bearing the arms of the Vecellio, surmounted by the double-headed
Habsburg eagle, which Titian as knight and count of the Empire
was entitled to use. The other was a traditional ex-votive painting,
showing an old man and a young man kneeling before a pietà floating
in the sky – the white-bearded old man was Titian, the dark-bearded
younger man, kneeling behind him, Orazio. Simply, even crudely
painted – possibly by Orazio – the tiny image turned the entire
painting into an enormous ex-voto, a plea that the artist and his son
would survive the oncoming epidemic and the studio continue. But
even as Titian hung on in his house, still apparently alive, Orazio had
fallen sick and been taken to the Lazaretto Vecchio.

Situated on a small island beside the Lido, the world's oldest plague
hospital was designed to hold some three hundred patients. By August
1576, it was crowded with eight thousand of the chronically ill and

dying. It was, wrote the notary and chronicler Rocco Benedetti, 'like Hell itself'.

> From every side came foul odours, a stench that none can endure. Groans and sighs were heard without ceasing, and at all hours clouds of smoke from the burning of corpses were seen to rise far into the air.
>
> Nothing could be done for the dead but to lift them from their beds and throw them into the pits. It often happened that those who were close to death or senseless without speech or movement were lifted up by the corpse-bearers as though they had expired and been thrown on to the heap of bodies. Should one of them be seen to move hand or foot or signal for help, it was truly good fortune if some corpse-bearer, moved to pity, took the trouble to go and rescue him. And many, driven to frenzy by the disease, especially at night, leapt from their beds and, shouting with the fearful voices of the damned, ran hither and thither, colliding with one another, and suddenly falling to the ground dead. Some who rushed in frenzy out of the wards threw themselves into the water or ran madly through the gardens, and were then found dead among the thorn bushes, all covered in blood.
>
> Some who miraculously returned from that place alive reported that at the height of that great influx of infected people there were three or four to a bed. And we should not be surprised if scarcely one in ten survived, and if hundreds died every day upon those beds, stinking and blackened as they were.

The quarantine island of the Lazaretto Nuovo was in comparison 'a mere purgatory – where wretched people lamented the death of relatives, their own pitiful plight and the break-up of their houses'. Condemned hulks from the Arsenale were towed out into the Lagoon and moored around the Lazaretto Nuovo, expanding the numbers in the hospital to around ten thousand. And still more boats kept arriving from the city, crowded with *sospetti* – those suspected of bearing plague.

New hospitals were established on the islands of San Lazarro and San Clemente, presided over – like the *lazaretti* – by Capuchin friars,

who worked to the point of collapse, yet rarely succumbed to the plague themselves. And when the bodies could no longer be burnt because of the great stench, a new cemetery was established on the Lido. In previous epidemics, the bodies were carefully wrapped in sheets, but now they were simply dumped into the pits, quicklime poured over them, followed by a layer of earth, then more corpses till the pit was filled. So tens of thousands of corpses were disposed of by a great army of workers drawn from the prisons and the galleys and pressed into labour on pain of death.

Meanwhile, the squares, alleys and canals lay almost deserted, the fetid waters shimmering in the brilliant sunlight, the black smoke from the charnel fires drifting over the glittering Lagoon – the doors of thousands of houses around the city crossed with planks as a sign of death by plague. The stench of the charnel fires was always present, the black smoke so thick over the Lagoon that it threatened at times to block out the sun.

There was little sound along the empty back canals save for the shouts of the *pizzigamorti* – the corpse-bearers – as their boats slid along these corridors of fetid slime. They were hated and feared for their brutality, for their free hands on the property of their victims and their apparent indifference to the dangers posed by their work – men so brutalised they thought nothing of entering infected houses, handling the stinking corpses and even putting on their clothes; men who, in an inversion of the rightful order, were thriving, profiting, at this time of mass distress.

In paintings of the time, the boatmen and the plague victims are all shown near-naked and well-muscled, the pale corpses marked by petechial spotting, manhandled from bridges and canal sides into the narrow boats. The living victims, the heads of the men wrapped in bands of white cloth, the women sprawling *en déshabille* – reaching out imploring to the saint who tends to be the focus of such paintings, be it St Roch or Carlo Borromeo, Archbishop of Milan, hero of that city's 1576 epidemic, who was later canonised for his efforts.

In that climate of fear and suspicion it was fatal, Francesco Sansovino wrote in his *Cose Notabili*, 'for anyone to fall ill of whatever ailment, as fathers forsook their sons, sons abandoned their sires, wives their husbands, husbands their wives, and bodies were carried

unaccompanied to the *lazaretti*'. On a more compassionate note, Rocco Benedetti recalled onlookers weeping as 'the poor infected victims were carried down to their doors by their sons, fathers and mothers, and there in the public eye their bodies were stripped naked and shown to the doctors to be assessed'.

But the most wretched fate, Benedetti observed, was reserved for those who lived alone, who had no one to lend them assistance and died in misery. 'When two or three days passed without their appearing, their deaths were suspected. And the corpse-bearers, entering the house by breaking down the doors or climbing through the windows, found them dead in their beds or on the floors or in other places to which the frenzy of the disease had carried them.'

It was long believed that Titian was alone at this time, his servants, assistants and relatives having deserted him or having died or been carted off to the *lazaretti* themselves. Already succumbing to the deadly illness, he wandered half-dressed and deranged through the otherwise empty house in Biri Grande – a prey to thieves and looters, who may have broken into the house while he was still alive. But where would all his dependants have fled to? What would they have had to gain from leaving the relatively spacious and secure environment of the Biri Grande – where they might at least be sure of something to eat – to starve in more crowded and dangerous conditions elsewhere? Some relatives would have departed for the Serravalle region and for Cadore at the earliest opportunity. And no one in the house could have died or they would all – including Titian himself – have been taken to the Lazaretto Nuovo.

In a speech made to the Great Council in August 1576, the Doge of Venice, Alvise Mocenigo, acknowledged that many signs of God's wrath had been ignored – a previous outbreak of plague just six months before, fires in the Arsenale and in the Doge's Palace itself, the resumption of hostilities with the Turks. Now the full force of divine displeasure was being visited on the city. On 4 September, after three days of prayer by the doge and senators, a public and solemn vow was made that a church dedicated to the Redeemer would be built, and that every year on the anniversary of the city's deliverance from the plague, the doge and senators would lead a procession to this church. While it took some months before all restrictions were lifted, it went

down in the lore of the city that the decline in deaths from the plague dated from the making of this vow. By that time, however, Titian had been dead for over a week.

Titian was given the last rites by the priest from the Church of Santi Apostoli in the early hours of the morning of 27 August 1576. At dawn the following day, his body was accompanied to the Frari by twenty-three of the canons of St Mark's, where it was given a short, but solemn funeral before being buried in the Chapel of Christ. Since it had been decreed that no one who had died of the plague should be given a funeral or buried in any church of the city, it must have been understood that Titian died of other causes. His death certificate stated that he had died of a fever, and that he was 103 years old. Orazio, who stood to inherit his father's entire estate, died four days later, his body thrown into a communal pit at the Lazaretto Vecchio.

Anyone in their right mind would have been trying to leave Venice, not enter it. The stench of the burning bodies could be smelled from tens of miles away, the clouds of black smoke hanging over the Lagoon visible from vast distances over the flatness of the Venetian plain. And since the causes of contagion were only hazily understood, the possibility of infection was everywhere, the deadly spores hanging in the still fetid air, coating the doors and walls of every building, clinging to clothes, curtains and furniture. It was impossible to imagine one could enter that city, where tens of thousands had already died, and return alive.

Yet as soon as he heard of his father's death, Pomponio set out from his living at Favoro, and headed straight for Venice. It was necessary for incoming travellers to provide a bill of health proving they came from a plague-free area. But Pomponio didn't have time for that. He paid a boatman to drop him on the north shore under cover of darkness, and headed straight for the house in Biri Grande.

It is understood that the house had been sealed on the orders of the authorities – planks nailed over the front door in the form of a cross. But Pomponio, as a family member and – most importantly – as a priest, was able to enter. How did he get in? Did he have a key? Did he break open a side door? Was there a gardener or other retainer hanging about the place, or had one of the doors simply been left

unlocked? The garden, once considered so remarkable, untended and unwatered for weeks must have been a half-dead tangle of weeds and overgrown shrubs.

There's something about entering a building in which you've spent a significant portion of your life – the way you know its form and structure instinctively – physically – no matter how much it's been altered. This was the house where Pomponio had lived since the age of seven, where his father – the figure to whom everything with Pomponio always returned – had lived and worked and died, alongside his younger brother, with whom Pomponio must have maintained some kind of relationship since Orazio had acted as his legal proxy only two years before.

For all the bitterness and hatred he had felt towards his father, it's impossible to imagine that Pomponio did not feel powerful mixed emotions towards this place. Or was it already just a valuable shell, to be stripped of its contents and sold off at as high a price as possible?

The place must have been in some disarray, half in darkness, the curtains pulled any old how. Household objects, many of them valuable, littered about, obvious evidence of theft or looting – gaps on the walls where pictures would have been, objects obviously missing from the shelves – pilfered by the *pizzigamorti* – cupboards and drawers hanging open. And the stench of plague, described by contemporary commentators as indescribably awful, still hung in the air.

But, of course, we're still assuming that Titian died of the plague. Given the probability that he didn't, the house would not have been sealed, the *pizzigamorti* would not have visited; though any servants or relatives still living in the house would have been confined there for forty days as associates of Orazio.

Pomponio must have known that his father had died intestate, that for all his prudence over matters of money and property, and despite the fact that he was surrounded by notaries – many of whom he had 'created' himself – Titian had never made a will. Given that Pomponio was a priest, Emilia illegitimate and Lavinia no longer alive, it was simply assumed that Orazio would inherit everything.

As soon as he arrived at the house, Pomponio began going through its contents, from paintings and legal documents to glassware and

towels, making his own inventory. On 22 September, nearly a month after his father's death, Pomponio gave power of attorney to Francesco Brachieri, an art dealer with whom his father had had extensive dealings, to remove the sum of thirty ducats from Orazio's account at the Tiepolo-Pisani Bank. Having subjected himself to the danger of infection, Pomponio was now eager to leave Venice as soon as possible. But broke, as always, he was forced to borrow money from Brachieri.

Before leaving he applied to the Giudici del Proprio, the judges who determined issues of inheritance, to be recognised as Orazio's heir, a request that was granted in his absence on 23 October. He also arranged for his financial agent, Celso di San Fior – husband of his cousin Cecilia Alessandrini – to move into the house in his absence. Pomponio was concerned not only about thieves and looters and the possible actions of his creditors, but about the intentions of his brother-in-law, Cornelio Sarcinelli, widower of his late sister Lavinia.

Cornelio had had little contact with Titian since his marriage to Lavinia in 1555. Every other male member of the family had been drawn into Titian's web of interests, and found themselves performing small commercial services on behalf of the master. But not Cornelio. While he was happy to dine out on his father-in-law's reputation when it suited him, he had always been rather irritated by talk of the importance of his wife's family – given that they were socially inferior to his – and of the greatness of her father. Cornelio preferred to remain in his ancestral fastness in Serravalle, and now that his father-in-law's fortune was at stake, he chose to wait till the danger from the plague subsided before making his move. This he did in a court order of 15 February 1577, stating that Celso di San Fior had ten days in which to produce a *cedula testamentaria* made by the late Titian, in which it was stated that in the event of Orazio's death without legitimate issue, his own children would be the sole beneficiaries of the fortune, property and paintings of their grandfather, Tiziano Vecellio.

Celso and Pomponio denied the existence of any such *cedula*. While Cornelio failed to produce any evidence to corroborate these claims, he managed to get a judicial seal put on part of the house, which Pomponio then had removed on 7 March. On 26 March, an

agreement was reached whereby Pomponio was free to remove all seals on his property, while Cornelio's children would receive all Titian's property in the Serravalle area, including houses and fields at Castel Roganzuolo, Conegliano and Serravalle – with the exception of one house in Serravalle.

What was Pomponio doing? Having subjected himself to such dangers to consolidate his claims on the estate, he was now ceding the greater part of his father's property to a man with no legal entitlement whatsoever. While Pomponio felt some magnanimity towards his sister's children, he seems to have been won over by his brother-in-law's boorish but persuasive personality.

Where was Pomponio over this period? Back in his living in Favoro? He certainly wasn't in Venice or he would never have allowed Cornelio to move into the house in Biri Grande, to use its contents and enjoy the pictures as though they were his own.

Cornelio later claimed that Titian had paid insufficient taxes, and three rooms at Biri Grande had been sealed by the authorities. Pomponio, he claimed, had invited him to move into the house in return for helping him deal with these matters – and that in order to meet the payments he had arranged for various items from the house to be sold in the Ghetto.

Pomponio denied ever making any such invitation. But on 24 July, he and Cornelio made a joint complaint against 'persons unknown' over robberies that occurred in Titian's house following his death. A proclamation was made by the Quarantia Criminale that Titian and Orazio had left 'many goods of very great value, credits, writings, accounts, instruments, notes of many debtors, leases and receipts, objects of gold, silver and jewels, other furniture and innumerable paintings of no small value', many of which 'had been taken away, usurped, robbed and concealed' by unknown persons.

The idea that Titian's house was looted after his death is based entirely on this single document, a complaint that was made nearly a year after the event – assuming the alleged looting took place immediately after the artist's death. No evidence was offered to back up this statement, and no action taken by the authorities. It was simply a statement for the record.

But what did it mean, 'innumerable paintings of no small value'? Not paintings of 'great value' or 'beyond price'. Probably they were relatively small paintings for domestic devotional use – and easily portable – Madonnas, crucifixions, possibly by Titian himself, but more likely by his studio, by Orazio or by other artists.

There is no evidence of large-scale looting having taken place in Venice during the plague of 1576. While Titian's house might have been subject to a more modest break-in – assuming it was ever left empty – it is unlikely the thieves would have taken paintings of any size, which would have been cumbersome, difficult to sell and easily traced. Pomponio had been there in a matter of days. If he had noticed evidence of serious theft or looting, it would have been in his interest to report it as soon as possible. But he had waited nearly a year.

And wasn't the nature of some of the things taken inherently suspect? 'Credits, writings, accounts ... notes of many debtors, leases and receipts...' Why would common thieves have bothered with any of that?

Having been through the contents of the house, Pomponio may have noticed that various valuable items were missing. Whether or not he was impressed by his brother-in-law's talk of thieves and 'persons unknown', he would have been mindful of the fact that he, Pomponio – constantly short of money – had made his own visits to the Ghetto with objects from the house over the preceding months.

But the apparent accord between the two men did not last. On 16 September, Pomponio obtained an injunction preventing Cornelio from 'offending, injuring or molesting' him, his agent Celso di San Fior, his brother-in-law Andrea Dossena (Emilia's husband) or any of Andrea's brothers. He then obtained a court order that Cornelio should leave the house immediately, and had a seal placed on it. Cornelio, though, had no intention of going anywhere. The house, the paintings and other objects of value had effectively been ceded to him when Pomponio 'invited' him to stay there the previous April. Appointing two of his cousins to act for his children, he obtained a decree at the Magistrato del Mobile on 19 October, awarding the children the whole of Titian's estate. But Pomponio had this judgement overturned on appeal.

A settlement was finally reached the following May (1578), in which it was agreed that Cornelio would pay Pomponio the very

substantial sum of 435 ducats and hand over all books and papers belonging to Titian in his possession, including the artist's patent of nobility awarded by the Emperor Charles V.

Pomponio had inherited everything except for the property around Serravalle that he had already voluntarily ceded to Cornelio's children. Cornelio, meanwhile, was left fulminating about money he'd paid to Pomponio's creditors, for expenses incurred in looking after the house, about loss of earnings while away from his interests in Serravalle and about various improvements made to the house from which he would not now see any benefit.

Pomponio had, however, agreed to cease proceedings against Cornelio over items removed from the house. The list of items corresponded very closely to the objects the pair had reported missing the previous July as stolen after Titian's death. They included 'money, three gold chains, one of them bearing a medal Titian used to wear; fourteen rings with good rubies and diamonds; bowls of silver and of copper; two vases, twenty-five salt cellars; twelve silver spoons; six silver forks; Flemish shawls and cloth; a cross with two jewels in it; a clavichord; and pictures of various kinds.'

The paintings 'stolen' from Titian's house, which have touched such a nerve in the minds of scholars, writers and art lovers over nearly two centuries – but which seem to have been accorded no more importance or value than the salt cellars, the silver forks or the Flemish shawls – were presumably either sold by Cornelio in the Ghetto or taken to his house in Serravalle.

I was in the Accademia, taking one final look at Titian's *Pietà*. It was my last evening in Venice, past six on a cold Sunday in February; the place was already practically empty. The gallery closed at seven. My plane left at half past ten.

The guards had already moved to the last room in readiness for the final departures, and I was alone with the *Pietà*, impressed once again by its monumental finality and foreboding, the last painting, the one painting for which you would leave all the others behind – which seemed to sum the others up.

Since Titian was buried in the Frari, the painting never was sent to the church in Pieve di Cadore, as he intended, but was sold by

Pomponio to his father's sometime pupil Palma Giovane, who made certain revisions. While these consisted only of modifications to the putto hovering in the niche and the addition of glazes to smooth over the transitions between the pieces of mismatching canvas, they allowed him to claim joint ownership of the painting. He added a prominent inscription, on the plinth beneath Christ's feet: 'What Titian left unfinished, Palma reverently completed and dedicated the work to God.' So Palma laid claim to be regarded as Titian's legitimate successor, in which to an extent he succeeded, becoming the most prominent painter of early-seventeenth-century Venice in a style that was a dull, repetitive rehash of the ideas of Titian, Tintoretto and Veronese.

Palma left the painting to the Church of Sant' Angelo, where it remained till the church's closure in 1810. The painting was moved to the Accademia, where, having been reduced to a state of extreme decrepitude – 'almost to its end' – it was put on a list of works to be sold or exchanged for works of other Italian or foreign schools. Yet the painting had hung on here in Venice, undergoing various cleanings and restorations, in a building that was a kind of museum of the death of the city.

The room in which I was standing was once part of the Convent of the Lateran Canons, designed by Palladio. As you followed the corridor round you entered the magnificent vaulted hall that was the Church of Santa Maria della Carità, through which you descended into the *albergo* – the meeting place – of the Scuola della Carità, the oldest of the six *scuole grandi*, with its painting by Titian, entirely filling the wall above the main doorway. *The Presentation of the Virgin* – the only painting Titian ever undertook in the quintessentially Venetian narrative tradition of the *scuole grandi*.

A Napoleonic decree of 1807 had turned these sequestered buildings into a gallery to house the paintings and other treasures taken from the city's suppressed and closed churches, convents and charitable institutions. Here in the greatest gallery of Venetian painting in the world it was possible to read Venetian culture, to understand the relationship between the painting and the society it served – through Gentile Bellini's paintings for the Scuola Grande di San Giovanni Evangelista with their crowds of Venetian worthies,

through Carpaccio's St Ursula cycle, Tintoretto's paintings for the Scuola Grande di San Marco, through Veronese's *Feast in the House of Levi*, painted to replace Titian's destroyed *The Last Supper* in the refectory of the convent of San Zanipolo – all in a building that was a monument to the destruction of that very culture.

As I stood before the *Pietà*, struck – as I had been many times before – by the powerful diagonal formed by the figures, the striding Magdalene, the Virgin and Christ, the kneeling St Jerome-Titian, as decisively abstract in its way as anything in any modern painting – wanting to make one last attempt to capture the painting completely with my senses and emotions (which, of course, you never can) – I glanced at my watch; quickly computing the time it would take to get the vaporetto to the airport bus stop at Piazzale Roma, I realised I was about to miss my plane.

I headed quickly back through the galleries, empty of people but full of living paintings, towards the entrance: under the great canvases of Tintoretto and Veronese, past the earlier and slightly smaller works of Palma Vecchio, Lorenzo Lotto and Sebastiano del Piombo. As I entered the Early Renaissance room, and took in the life-size standing female nude – just a few flakes of surprisingly bright orange-pink pigment on plaster – that was all that remained of Giorgione's frescoes for the Fondaco dei Tedeschi – I realised with a pang that I was hurrying backwards through the history of Venetian painting, past many of the works I'd spent the past three years thinking and writing about. There in a side room was Giorgione's *Tempest*, down the next flight of steps the room with the Bellini altarpieces, dominated by the San Giobbe Altarpiece, greatest of the *sacra conversazione*. Then I was running through the long hall full of the gilded altarpieces of the Vivarini, Domenico Veneziano and all the other late-gothic precursors of the great age of Venetian painting. And as I rushed out into the freezing night it occurred to me how little there was in that place of Titian. For, while he had succeeded in dominating that world as it reached its cultural zenith, he had also transcended it.

In 1580, Pomponio sold the lease on the house in Biri Grande to Cristoforo Barbarigo, a Venetian aristocrat and member of the family

who were among some of Titian's earliest patrons, through whose influence, Vasari claims, he had gained his commission for the frescoes at the Fondaco dei Tedeschi over seventy years earlier. Barbarigo also acquired several of the paintings left in the house, including *Venus with a Mirror*, the earliest and best of the many Penitent Magdalenes and the late, dark, apocalyptic and still unfinished *St Sebastian*.

Pomponio then disappeared from history. According to Titian's biographer Ridolfi, Pomponio's younger brother Orazio 'wasted his money on alchemy'. But perhaps Ridolfi made a mistake. Perhaps he actually meant Pomponio. For the pursuit of the miraculous seems better suited to the elder brother's more fanciful, more wayward temperament. Certainly the materials involved in the pursuit of the Philosopher's Stone were extremely expensive. And whatever Pomponio did with the considerable amount of money he inherited from his father – wherever he went and however he chose to spend the rest of his life – it is understood that he died penniless.

The rest of the paintings in the house and studio were sold at about the same time as the house, and, whether finished or unfinished, Titian's last dark, raw paintings were of particular interest to the artists of the next generation. Palma Giovane acquired *The Flaying of Marsyas* and the *Pietà*, while Tintoretto bought at least four paintings from Titian's house, including the small, late *Ecce Homo* and the second *Crowning with Thorns*. According to legend, Tintoretto had seen the latter painting in Titian's studio, when the master was still alive, and had begged to be given it. In fact, the two men were never on such cosily informal terms. But now Tintoretto had something by the artist whose presence had dominated his life and career – in whose studio he claimed to have started out – one of his older rival's most intense and personal paintings, a work that allowed him to see into the dead master's mind, which, according to Crowe and Cavalcaselle, he hung 'in his own atelier as a model of what a modern painting ought to be'.

In 1574, Tintoretto had been awarded a *sanseria* and had taken over the role that had never existed in official statute, but which Titian had in effect created for himself, that of Official Painter to the Republic of Venice. In 1577, just months after Titian's death, a fire in the Doge's Palace gutted the Sala del Maggior Consiglio,

destroying the images on which such sums had been expended by the Venetian government, and such time, effort, intriguing, politicking and infighting by the painters of Venice – the works of the Bellini and the Vivarini, Carpaccio, Pordenone, Perugino, Giovanni Bellini's *Humiliation of Barbarossa* which Titian completed, his own *The Battle of Spoleto*, reckoned by some to be his finest painting, and the remaining frescoes by Gentile da Fabriano and Pisanello, that linked that great room back to the Gothic world of the Middle Ages. They were replaced by enormous paintings by Tintoretto, Veronese and Bassano, the wall behind the doge's throne filled with Tintoretto's immense *Paradise*, the largest oil painting ever created.

Venice had survived the wars and plagues of the early sixteenth century because it had the sheer, brute cash wealth to withstand just about any adversity. Yet even then – though few perceived it – the city was in a process of economic and political decline. Venice's population never reached its former level after the catastrophic plague of 1576, during which a third of the inhabitants died, including Titian himself.

With Tintoretto's death in 1599, the great age of Venetian painting came to an end. Venetian art became just another dull, minor, parochial tradition. While it revived briefly in the eighteenth century with Tiepolo, Guardi and Canaletto, Venice never again saw anything remotely approaching the grandeur of the age of Titian.

Acknowledgements

I am indebted to Professor Charles Hope of the Warburg Institute for sharing many insights, particularly concerning Titian's family, and for his generosity and patience in answering a great many questions. I would also like to thank Professor Augusto Gentili and Professor Lionello Puppi, both of the Universita Ca' Foscari, Venice; Dr Miguel Falomir of the Museo Nacional del Prado; Jill Dunkerton of the National Gallery, London; Professor Bernard Aikema of the University of Verona.

My gratitude is also due to Guerrino Lovato, Pietro Scarpa, Antonio Foscari, Mario Berta Battiloro, Alec Cobbe, Professor Brian Pullan, Richard Palmer, Jurgen Schultz, Jan Willem Hoenig, Ketty Gottardo, Daniella Carr, Luisella Romeo, Sharon Reed and William Sargent, Thomas Almeroth-Williams, the press offices of the Vienna Kunsthistorisches Museum and the National Gallery of Art, Washington.

I am grateful to Guerrino Lovato for the theory concerning Bartolomeo d'Alviano and *The Tempest*; to Charles Hope for the theory concerning Ippolite de' Medici, Angela la Zaffetta and *The Venus of Urbino*; and to Jill Dunkerton for many insights into Titian's working methods. The interpretation of these ideas is my own, and any factual errors in this book are entirely my responsibility.

I would like to thank a number of artists for sharing their ideas

about Titian: Chris Christophorou, Thomas and Clare Newbolt, Lino Mannocci.

For translations of original sources I am grateful to Charles Hope for his translation of the letters of Niccolo Stoppio and the writings of Marco Boschini and Antonio Persio; and to Richard Palmer for his translation of the diary of Rocco Benedetti.

I would like to thank my editor Michael Fishwick, my agent David Godwin, Alexandra Pringle, Anna Simpson, Richard Collins, Alexa von Hirschberg and all at Bloomsbury.

I would like to acknowledge the assistance of a grant from the Arts Council of England in the writing of this book.

Lastly, I would like to thank my wife, Julia, and my daughter, Rachel, for their patience throughout the writing of this book.

Index